LODGING IN FRANCE'S MONASTERIES

Eileen Barish

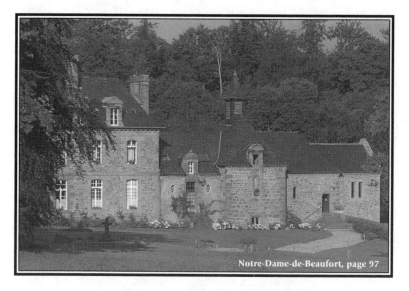

Notre-Dame-de-Beaufort, page 97

INEXPENSIVE ACCOMMODATIONS
REMARKABLE HISTORIC BUILDINGS
MEMORABLE SETTINGS

Lodging in France's Monasteries

by Eileen Barish

ANACAPA PRESS

P.O. Box 8459, Scottsdale, AZ 85252
Tel: (800) 638-3637

www.monasteriesoffrance.com

ISBN #1-884465-23-4
Library of Congress Catalog Card Number: 2002-190103
Printed and bound in the United States of America

Also by Eileen Barish

Lodging in Italy's Monasteries
www.monasteriesofitaly.com

Lodging in Spain's Monasteries
www.monasteriesofspain.com

While due care has been exercised in the compilation of this directory, we are not responsible for errors or omissions. Information changes and we are sorry for any inconvenience that might occur. Inclusion in this guide does not constitute endorsement or recommendation by the author or publisher. It is intended as a guide to assist in providing information to the public and the listings are offered as an aid to travelers.

SPECIAL SALES

Copies of this book are available at special discounts when purchased in bulk for fund-raising and educational use as well as for premiums and special sales promotions. Custom editions and book excerpts can also be produced to specification.
For details, call 1-800-638-3637.

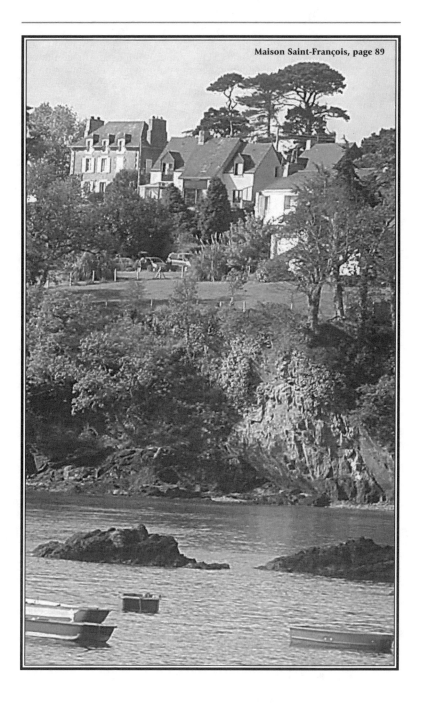

Maison Saint-François, page 89

ACKNOWLEDGEMENTS

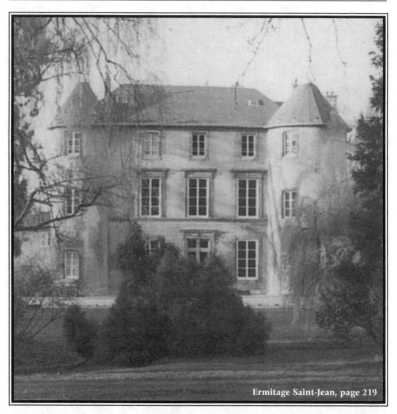

Ermitage Saint-Jean, page 219

This book would not have been possible without the diligent efforts of *Francesca Pasquini*, our research manager and colleague. From the onset, her *determination and thoroughness was apparent in every stage of the project. Not only did she carefully document the research data accumulated from hundreds of interviews, but she filled her reports with insight into France, its customs, traditions, geography, linguistics and enchanting peculiarities. Thank you Francesca. Understanding the consuming nature of research, we are also grateful to Dario Pasquini for his patience. And thanks to Karen for her editorial input.*

Since nothing in life is possible without love and encouragement, I am eternally grateful to Harvey, my number one champion. And to Nona, Kenny, Chris and especially to Katie for always believing. Eileen Barish

CREDITS

Author — Eileen Barish
Publisher and Managing Editor — Harvey Barish
Senior Researcher — Francesca Pasquini
Cover Design — Tom Blanck
Book Layout — Jean-Claude Valois
∞

The author and publisher are greatly indebted to the people and organizations that so generously supplied the photos for this book. First and foremost we would like to thank the monasteries, convents and maisons that provided the photos used to illustrate their institutions. We are also grateful to the local and regional tourist bureaus throughout France. Special thanks to the New York office of the French Government Tourist Board for their help, and to Dr. Ernesto Pasquini for the wonderful photos of Mont-St-Michel.

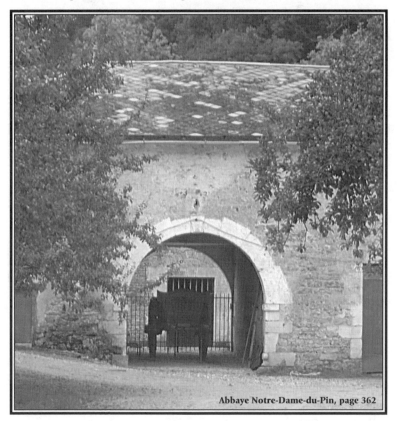

Abbaye Notre-Dame-du-Pin, page 362

This book is an introduction to hundreds of France's monasteries, convents and maisons that extend hospitality to guests. It is organized as follows.

Section One: Monasteries offering hospitality to all

These establishments welcome everyone regardless of religion, with or without a spiritual purpose. Listings in Section One describe the monastery, its setting, history, architecture, artwork, products made by the order, folklore and surrounding tourist sites. It provides all the information needed to make an informed lodging decision and the wherewithal to reserve a room as per the following sample.

Accommodations
Type and number of rooms, indicating private or shared baths.

Amenities
Meals and facilities available to guests.

Cost of lodging
Lodging and meal rates are approximate. Some rates are quoted on a per person basis while others are per room. When no rate is given, the monastery or convent either requests only a donation or reserves the right to determine the rate when reservations are made, depending on the number of people, number of meals and time of the year.

Directions
Directions to each location are provided by car and public transportation.

Contact
(Information includes the person in charge of hospitality, address, telephone, fax and where available, website and email address.)

Contact person ..Directrice
Name of Monastery..L'Abbaye
Address..BP 1
Zone, City, Country......................22750 St-Jacut-de-la-Mer, France
Tel/Fax.........Tel: 0033 (0)2 96 27 71 19; Fax: 0033 (0)2 96 27 79 45
Website..www.abbaye-st-jacut.com
Email address.. abbaye.st.jacut@wanadoo.fr

How to make a reservation
A sample reservation letter in French and English can be found on pages 16 and 17. We recommend that letters be sent in both languages.

Section Two: Monasteries offering hospitality for spiritual endeavors
These establishments welcome guests specifically for retreat, vocation or other spiritual purposes. Listings in Section Two include the basic contact information necessary to make a reservation.

TABLE OF CONTENTS

TABLE OF CONTENTS

TABLE OF CONTENTS

TABLE OF CONTENTS

TABLE OF CONTENTS

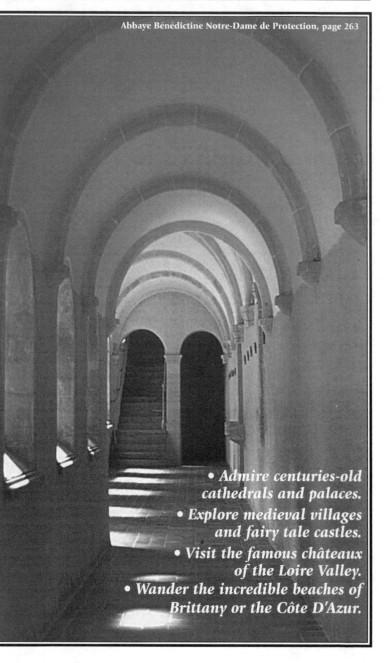

Abbaye Bénédictine Notre-Dame de Protection, page 263

- *Admire centuries-old cathedrals and palaces.*
- *Explore medieval villages and fairy tale castles.*
- *Visit the famous châteaux of the Loire Valley.*
- *Wander the incredible beaches of Brittany or the Côte D'Azur.*

Spend a night or a week at a monastery and come away filled with the essence of France, its history, art, architecture and local traditions

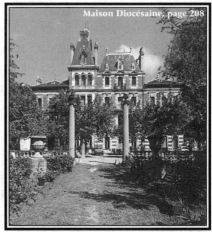

Maison Diocésaine, page 208

Awaken each morning to church bells ringing out over perched villages and ancient walled towns. Mingle with the locals at the daily market. Enjoy a glass of Bordeaux or hot chocolate in a friendly cafe. People watch from an atmospheric plaza. Stroll the medieval quarters and cobblestone streets of a quaint hamlet. Admire France's idiosyncratic timber-framed houses and royal castles, as charming today as they were hundreds of years ago or visit a bastide, a town layout unique to France.

Open to all, regardless of religious denomination, lodging at monasteries is a unique experience, a *new* approach to travel that Europeans have been enjoying for centuries. Whether you prefer the sophistication of a city, the allure of the countryside or the simplicity of a tiny walled village, each of the monasteries described in this guide represents a singular experience, an experience that will linger long after you've returned home.

But perhaps most remarkable is the very low cost of accommodations and meals. Rates range from a voluntary donation to an average of 30€ per night. And many monasteries serve meals for just a few euros more. Others often have kitchens and dining rooms where guests may prepare their own meals. What is common to each is cleanliness, graciousness, beauty, safety and a divine sense of serenity.

Monasteries are an integral part of France's history and heritage and are emblematic of the country's diverse culture. There are monastery locations to suit every taste. Choose a site in a sleepy village backdropped by snow-capped mountains. Reserve a room in an ancient city still enclosed by 13th century walls or a tiny hamlet overlooked by a massive fortress. Stay in a convent with ocean views. Make Corsica your destination and explore the pristine wilderness and earthy Mediterranean towns of the island.

Hôtellerie Notre-Dame de Lumières, page 391

More than just lodging particulars, *Lodging in France's Monasteries* provides history-laced vignettes offering insight into the little known villages and attractions surrounding the monasteries. Information not readily found in other guide books. In addition to extensive research into the small towns and villages of France, the customs and folklore of the regions are also covered. You'll learn about places unspoiled by tourism, places that have remained unchanged for centuries.

What's in a name? Monastery, convent (abbey, sanctuary), or maison. Historically, monasteries housed monks whereas nuns resided in convents. A maison is a guest house owned and generally managed by an order. Over the centuries, much has changed and the gender of the order in residence and its designation as monastery or convent is no longer gender specific.

Monastic orders have traditionally offered hospitality to travelers. This book introduces you to that remarkable travel resource and to a custom that allows you to immerse yourself in another time and place. Staying at a

monastery is a rewarding experience but it is important to remember that a monastery is not a hotel and should be regarded accordingly.

The monasteries described in Section One offer hospitality to all without any religious obligation.

The information necessary to plan a trip is included: contact person, address, telephone, fax (and where available, email address and website), amenities and a description of accommodations and rates. A sample reservation letter in French and English will help you with your travel arrangements. You can book reservations by letter but faxing and telephoning may prove more effective. When calling or faxing, be certain to take into account the time difference and avoid waking someone in the middle of the night. For those institutions that offer email portals, we suggest emailing your requests.

Section Two is a listing of monasteries that offer hospitality to guests who would like to sample the religious life or experience a time of spiritual retreat. Pertinent contact information and special requirements are provided.

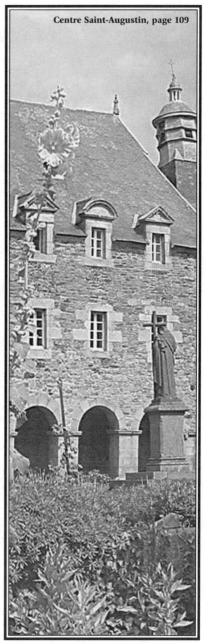

Centre Saint-Augustin, page 109

To make a reservation by mail or fax, this sample letter is appropriate.

It is suggested that you write in both English and French and make your reservations well in advance.

Just fill in the blanks indicated by **{brackets}** with your specific travel information.

{Date}

Père Hôtelier
Amicale et Couvent du Bischenberg
Boite Postale 155
Bischoffsheim
67214 Obernai Cedex, France

Dear Père Hôtelier,

I would like to make a reservation for {number of people in your group} and wish to stay {indicate number - 1, 2, 3 etc.} nights beginning {day/month/year} until {day/month/year}. We would like to reserve a (type of room with or without bath).

Please contact me and let me know if the above reservation request can be arranged. Please also include the cost of the room and what deposit, if any, is required.

As soon as I hear from you, I will send you a check. If possible, please respond in English.

Thank you for your kindness and courtesy. I look forward to visiting your institution. Best regards.

(Signature)

Your Name
1234 Any Street
Santa Barbara, California 93101, United States
Tel: (805) 555-1234, Fax: (805) 555-2345
Email: your.email@aol.com

The English to French translation guide will assist you in composing your reservation letter.

IMPORTANT: Unlike the U.S. style, the European order of numerical dates is day/month/year.

Translation Guide

Title
Mother / Mère
Father / Père
Friar / Frère
Sister / Sœur

Months
January / janvier
February / février
March / mars
April / avril
May / mai
June / juin
July / juillet
August / août
September / septembre
October / octobre
November / novembre
December / décembre

{Date}

Père Hôtelier
Amicale et Couvent du Bischenberg
Boite Postale 155
Bischoffsheim
67214 Obernai Cedex, France

Cher Père Hôtelier,

Je voudrais faire une réservation pour (number of people) et désirer séjourner (indicate number - 1, 2, 3 etc.) des nuits, du (day/month/year) jusqu'au (day/month/year). Si c'est possible nous voudrions réserver une (type of room with or without bath).

Dans l'attente d'une réponse de votre part à l'adresse ci-dessous, nous aimerions aussi savoir le prix d'une chambre et le montant de la caution, si requis.

Dès que nous recevrons vos nouvelles, nous vous enverrons le chèque. Si possible soyez si gentil de nous répondre en anglais.

Avec nos remerciements anticipés, nous vous prions d'agréer, Père, nos salutations distinguées.

(Signature)

Your Name
1234 Any Street
Santa Barbara, California 93101, United States
Tel: (805) 555-1234, Fax: (805) 555-2345
Email: your.email@aol.com

Room Options
Single Room / Chambre simple*
Double Room / Chambre double*
Triple Room / Chambre triple*
Quadruple Room / Chambre quadruple* (or Chambre Familial*)

*For room with private bath add... "avec salle de bains"
*For room with shared bath add... "sans salle de bains"

SECTION ONE

Monasteries Offering Hospitality to All

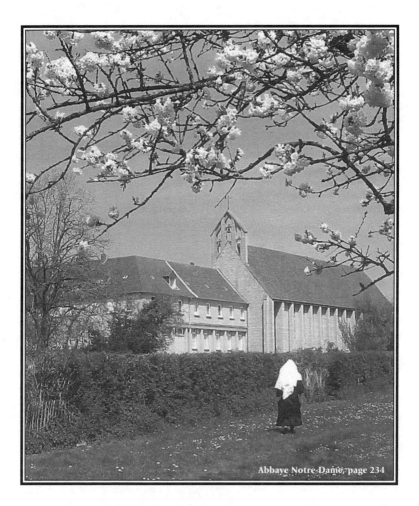

Abbaye Notre-Dame, page 234

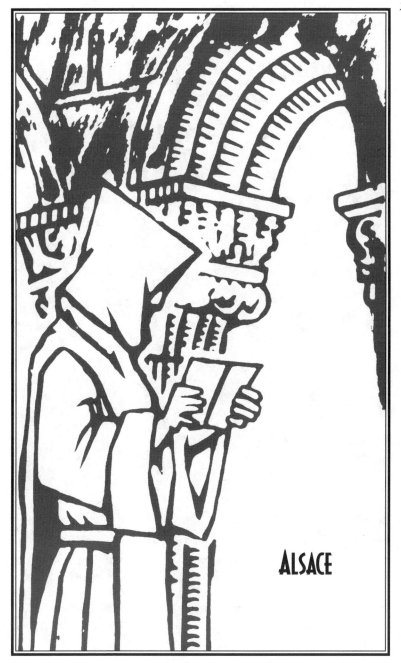

ALSACE

AMICALE ET COUVENT DU BISCHENBERG
Pères Rédemptoristes

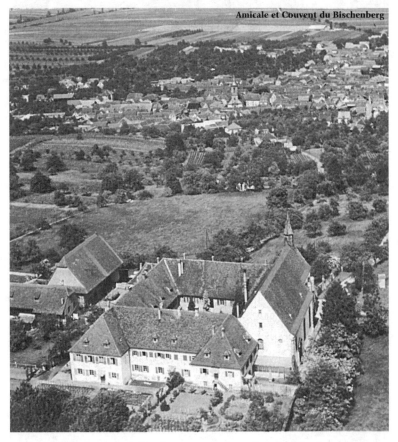

Amicale et Couvent du Bischenberg

Crowning a pretty hill, the convent is a few hundred yards from Bischoffsheim. Founded by the Redemptorist Fathers in 1820, the convent was closed by Bismarck from 1873 until 1895. The chapel of the convent is dedicated to Notre-Dame de Sept-Douleurs. Built in the 16th century, it shelters beautiful stained glass windows and a polygonal vaulted choir.

The monastery is sited near the top of the 1,200' Bischenberg hill at the foot of Mont Ste-Odile, between Obernai and Rosheim. Surrounded by a vineyard and fruit orchard, the monastery looks like a flower bouquet in the spring. There is a beautiful panorama from the monastery that encompasses the Alsatian plain and many of its quaint villages. The views also encompass the Black Forest and on a clear day, the Swiss Alps.

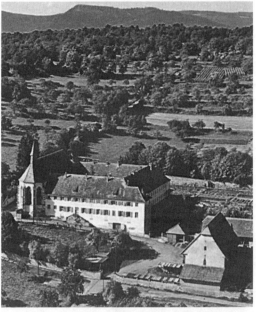

Amicale et Couvent du Bischenberg

The first mention of Bischoffsheim dates back to 662 when it was sold to the bishopric of Strasbourg. Two important castles were built there: the Oberschloss in 1326 and the 15th century Renaissance Niederschloss, both of which have partly survived the devastation and wars of the past. Nestled against the mountain, the small village of Bischoffsheim has become a popular destination thanks to its International Congress Center.

Of Celtic origin, Alsace became part of the Roman province of upper Germany. It lies between Germany and the forests of the Vosges and is the most Teutonic of France's provinces. It is renowned for its *foie gras* and *choucroute* (sauerkraut). The typical half-timbered architecture of its villages evokes fairy tale images of the Black Forest. The houses exhibit a distinctive construction style. They were built by filling the space between the timbers with either bricks or wattle and daub (vines used as a wicker-like woven mat between the timbers that was then covered in mud). Although this style of architecture is common throughout the region, the unique arrangement of the timbers sets each locality apart from the next.

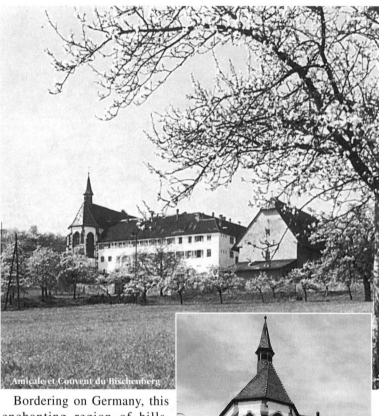

Amicale et Couvent du Bischenberg

Bordering on Germany, this enchanting region of hills, rolling fields and forests has a rich Jewish heritage. Nowhere else in France will visitors find the sheer number of 18^{th} and 19^{th} century synagogues, or a Jewish community with such a rural history. One hundred and seventy-six synagogues were built in Alsace between 1791 and 1914; nearly every town and village had one. But although the 18^{th} and 19^{th} centuries are well represented, little remains of medieval Jewish structures as there was a ban on synagogue construction from the 14^{th} through 18^{th} centuries. Similar in manner and custom to Jews

from Eastern and Central Europe, Alsatian Jews developed characteristics unique to them: a synagogue liturgy called *Minhag Elzos* and a dialect called *Judeo-Alsatian* (akin to Yiddish). Tourist offices throughout the region offer guided Jewish heritage tours.

The convent is not far from medieval Obernai, a town that retains the flavor of authentic Alsace. The townspeople speak Alsatian and during their many festivals, the women dress in traditional garb. The Renaissance and medieval timbered houses and the twisting streets wind around a lively, golden-hued marketplace and add to the overall appeal of the setting. Shaded by lime trees, Obernai's old ramparts remain as testament to its varied history. Tour de la Chapelle, an ancient watch-tower, dates from the 13th and 16th centuries. The Eglise St-Pierre et St-Paul is a cavernous neo-Gothic structure. Odile, Alsace's seventh-century patron saint, was born in Obernai and is buried in Chapelle Ste-Odile southwest of town. There is also a neo-Romanesque synagogue dedicated in 1876 and rededicated in 1948.

Obernai

Boersch is a small medieval town at the bottom of the Vosges, a couple of miles from Obernai. Its rich historical patrimony is reflected in three fortified Gothic gateways. Remains of 14th century murals that once adorned them are still visible. 16th century houses and a town hall delineated by a turret with mullion windows are at the heart of the old quarter.

Molsheim, a former bishopric and fortified market town, is also near-by. It boasts an appealing center filled with important historical, archeological and architectural sites. The ramparts recall the heroic struggles of the Middle Ages. Winding alleyways lined with stone-fronted houses offer glimpses into the past. In the same vicinity, Barr, a wine-growing village, is nestled in vineyard-covered hills and defined by winding cobblestone streets.

Accommodations
10 double rooms, baths are shared. Both men and women are welcome.

Amenities
Towels and linens can be provided on request.

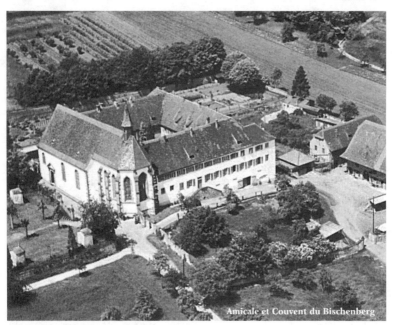

Amicale et Couvent du Bischenberg

Cost per person/per night
14.00€, does not include breakfast or the use of the meeting rooms.

Meals
Only breakfast can be provided on request. Other meals may be prepared in a kitchen that guests may use.

Directions
By car: From Strasbourg take Autoroute A 35 south to D 422 towards Obernai. Exit at Bischoffsheim.

By train: Get off at Bischoffsheim and take a taxi to the convent.

Contact
Write a letter (or fax) to:
Père Hôtelier
Amicale et Couvent du Bischenberg
Boite Postale 155
Bischoffsheim
67214 Obernai cedex, France
Tel: 0033 (0)3 88 50 41 27
Fax: 0033 (0)3 88 48 07 95

LE LIEBFRAUENBERG
Protestant Center

A very active Protestant center in a natural and relaxing setting, Le Liebfrauenberg has been occupied since the start of the Christian era when it became a pilgrimage site devoted to the Virgin Mary. In the 14th century a chapel was built in her honor. Le Liebfrauenberg is installed in the heart of the North Vosges Regional Nature Park, an arena of marked hiking, biking and equestrian trails that lead past rural communes and châteaux. The area is also home to Wingen-sur-Moder, the Lalique crystal works.

Although the complex was enlarged at the beginning of the 16th century, it was destroyed during the time of the Reformation. Rebuilt and enlarged in the 18th century, it became the manor where Jean Baptiste Boussingault, a famous chemist, lived in the 19th century. He was profes-

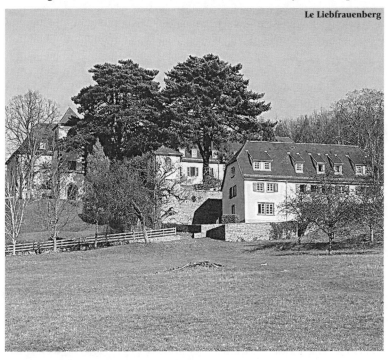

Le Liebfrauenberg

sor of chemistry at Lyons and later professor of agriculture and analytical chemistry at the Paris Conservatoire des Arts et Métiers. He is known for his research on the nitrogen cycle. Boussingault's experiments, however, were not limited to agriculture; his research also included work on atomic weights and the properties of steel alloys.

In 1954 the association "Maison de l'Eglise" bought the property and converted it into a conference center. It hosts groups, families and young people and organizes activities throughout the year.

Goersdorf is a small village nestled in a wooded valley far from the noise of the nearby cities. Apart from the beautiful natural setting, the area has numerous attractions: museums on art, history and popular traditions; castles and fortresses; military itineraries on WWII's historic Ligne Maginot; and archeological and religious sites.

In picture-book Wissembourg, a frontier town possessing the essence of Alsatian character, the Gothic church of St-Pierre-et-St-Paul is enriched by a 12th century rose window, a 30' high mural of St-Christopher (15th century) and an octagonal tower. The close-by Protestant church once had as pastor Martin Bucher, friend and follower of Martin Luther.

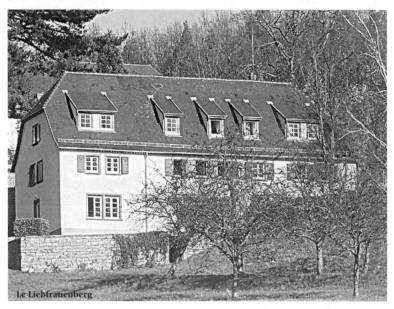

Le Liebfrauenberg

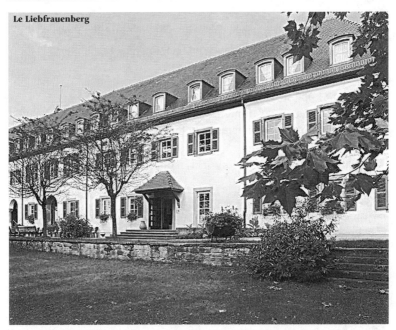
Le Liebfrauenberg

Several small but noteworthy villages are in the vicinity. Hunspach, with its half-timbered farmhouses and flowering orchards, is an unspoiled gem and among the most beautiful villages of France. Medieval Dambach la Ville is recognized for the preservation of its half-timbered houses and narrow picturesque streets. Hoffen is another inviting Alsatian village. During the Middle Ages, it belonged to the Abbey of Wissembourg. Its traditional houses display flower-bedecked windows. The "Liberty Tree," a regal lime planted during the French Revolution stands on place du Tilleul.

Accommodations
Hospitality is offered both in the main house and the youth hostel. Main house: 28 rooms with showers and toilets; 10 rooms with showers; 10 with washbasins. Rooms are single, double or family.
Youth hostel: 10 rooms with 2 to 6 beds for a total of 45 beds.

Amenities
Towels and linens are provided. The center is accessible to the disabled. There is parking, a TV room, elevator, several conference rooms and a chapel.

Cost per person/per night

Single room:

Full board 43.00€ to 47.00€ depending on the type of bathroom.

(Half board deduct 5.50€ from the full board fare).

Double room:

Full board 41.00€ to 43.00€ depending on the type of bathroom.

(Half board deduct 5.50€ from the full board fare).

For updated information on fares, visit the website or call the center.

Meals

All meals can be provided. Many special dietary requirements can also be met.

Directions

By car: From Wissembourg, take D3 to Lembach and then take D27 about 8 miles. Continue in the direction of Goersdorf and follow the 'Liebfrauenberg' signs. From Haguenau, take D27 to Woerth, D28 to Soultz-sous-Forêts for 0.8 miles, then D677 to Goersdorf and follow the 'Liebfrauenberg' signs.

By train: Get off at Haguenau station and take a taxi to Goersdorf. With advance arrangements, the center will provide transportation for 8.00€.

Contact

Responsable pour l'hospitalité

Le Liebfrauenberg

Eglise Autrement

Centre de Rencontres et de Formation BP 9

F - 67630 Goersdorf, France

Tel: 0033 (0)3 88 09 31 21

Fax: 0033 (0)3 88 09 46 49

Email: contact@liebfrauenberg.com

Website: www.liebfrauenberg.com

MAISON SAINT-GÉRARD
Redemptorist Fathers

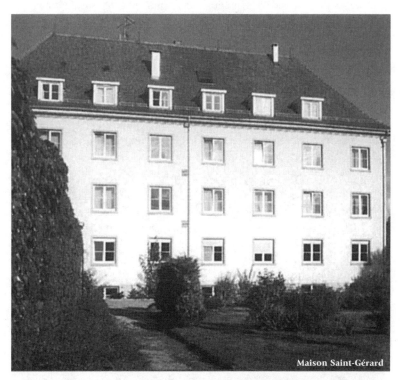

Maison Saint-Gérard

The maison was founded by the Redemptorist Fathers in 1932. Until a few years ago it was only used for spiritual retreats. At that time, it was totally renovated and now accommodates individuals and groups seeking relaxing holidays. Elderly visitors and the disabled are also welcome. The house is in a shaded niche, enveloped by its own park and forest.

Established in the 12th century around the Hohenstaufen castle, Haguenau sits on the Rhine plain at the edge of an immense forest that fans out around the city and is a sanctuary of calm and beauty in the northern plain. Its museums feature Alsatian crafts and history. Many historical events took place in Haguenau including the great imperial hunts.

Haguenau is the fourth largest city in Alsace. An important industrial center with a long historical background, the first settlements date back to prehistoric ages, but its apogee occurred during the Imperial Period. At that time it was one of the ten cities of Alsace which adhered to the mutual alliance pact called "Decapole." The colorful story of Haguenau is illustrated in the Musée Historique, a neo-Renaissance building constructed between 1900 and 1905 and in the Musée Alsacien, housed in a 15th century structure.

Monuments include the church of St-Georges (12th-13th century), a harmonious blend of Romanesque and Gothic architecture and the church of St-Nicolas founded in 1189 by Emperor Frederick Barberousse. Other sights include Porte Wissembourg, the only vestige of the 13th century walls that in ancient times protected the city and Tours de Chevaliers (c.1235), once a prison.

Dating to the 13th century, Haguenau's Jewish community is one of the oldest in Alsace. Its historic synagogue was built in 1821 and, like most in the region, was damaged by the Nazis during WWII and later restored. The cemetery was consecrated in the 16th century but the oldest tombstone is from 1654. The Musée Historique sustains a collection of Jewish artifacts.

Nearby Betschdorf is an archetypical Alsatian town of timber-framed houses dating from the 18th century. Pottery is a traditional craft of the town, with roots stretching back to Gallo-Roman times. Today the tradition lives on with the salt sandstone technique wherein the pottery is painted with cobalt blue before firing. For centuries the knowledge of the unique glaze has passed from generation to generation. There is a pottery museum and workshop open to the public. A local specialty of the town is *tartes flambées*, hot, crispy tarts topped with fruit or cheese. Another village known for its pottery is Soufflenheim, about six miles from Betschdorf. The handcrafted pottery is earth colored and often decorated with flowers.

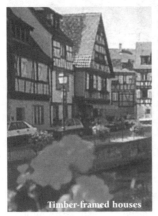
Timber-framed houses

Accommodations

The maison offers hospitality to men, women and groups. All rooms have private baths. 30 rooms are completely accessible to the disabled. 100 beds in single, double, and family rooms (4/5 beds). All rooms are equipped with telephone and TV.

Amenities

There are two meeting and two dining rooms.

Cost per person/per night

Consult website.

Meals

All meals can be provided on request.

Directions

By car: On A4, exit at Haguenau. Once in Haguenau follow the signs (which are clearly indicated) to the house .

By train: Get off at Haguenau and take a taxi to the maison.

Contact

Anyone who answers the phone
Maison Saint-Gérard
11, rue de Winterhouse
67500 Haguenau, France
Tel: 0033 (0)3 88 05 40 20
Fax: 0033 (0)3 88 93 02 22
Email: maison_st_gerard@libertysurf.fr
Website: www.chez.com/maisonstgerard

MAISON SAINT-BERNARD
Oeuvre de Lucelle

Lucelle resides at the border between France and Switzerland, about eighteen miles from Germany. An extremely peaceful location, it is immersed in the verdant landscape of the Alsatian Juras and offers the pleasures of relaxing walks along the river Lucelle. The name Lucelle derives from Latin and means "Cell of Light" (Lucis cella).

The maison is quartered in a lush wooded valley on a site once occupied by a Cistercian monastery that played an important role in the region. Historically, and until the French Revolution, the village belonged to the Cistercian abbey of the same name. The town's coat of arms is derived from the monastery's seal. Today, however, the only remains of the Cistercian complex are a part of the walls, a stone portal and some 17th century caves now occupied by the restaurant of the house.

A priest and an association manage the maison and host meetings, retreats and workshops year-round. The house is open to individuals, groups and families coming to enjoy the beauty of the area. The center organizes daily excursions in Alsace, Switzerland and Germany.

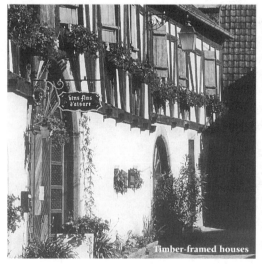
Timber-framed houses

Alsace has the look and feel of a foreign, non-French country. The older half-timbered houses, many with wooden balconies, are identical to those across the Rhine in Baden.

To see Alsace at its most typical, follow the *Route du Vin* through scenic terrain dotted with wine-producing villages. Since Roman times, the Alsatians

have tamed the hillsides which are crisscrossed with footpaths through the vines. Local costumes, wine festivals and much of the region's wine production reflect the area's Germanic roots.

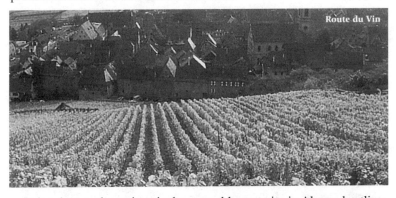
Route du Vin

Quite close to the maison is the second largest city in Alsace, bustling, industrial Mulhouse. It boasts a handsome old town center lapped by waterways - the Doller, the Ill and the Rhine-Rhône - and is known as "The City of Twelve Museums." The Musée National de l'Automobile displays 500 rare European cars including priceless Bugattis, Alfa Romeos, Mercedes and Porsches. The Musée Français du Chemin de Fer harbors Europe's largest vintage train collection including the former French presidential car with a lavish interior by glassmaker René Lalique. Mulhouse has a remarkable city hall and a delightful zoological and botanical park. Just outside of town is the Ecomusée d'Alsace, a 37-acre "village" of sixty 15th to 19th century traditional Alsatian houses transplanted from every corner of the province. The village is complete with stables, a forge and an oil mill.

The town of Eguisheim is an easy day trip north from the maison. Ideally located on the *Route du Vin*, the town dates to the Middle Ages. Its charm resides in its fountains, winding flower-filled alleys and the beauty of the countryside. The name of the city comes from "home of Egino" the Count of Eguisheim. Archeological research reveals that tens of thousands of years ago, homosapiens from the Dordogne lived in the region. At the core of the fortified city are traces of a 13th century castle and three towers. The castle was built by Count Eberhard, nephew of Sainte-Odile. In 1049 Bruno of Eguisheim was born in the town; years later he became pope.

Accommodations
150 beds in rooms with 2-6 beds. All rooms have a private bath.

Amenities
Towels and linens are supplied. Meeting rooms, chapel and TV room. The maison is accessible to the disabled.

Cost per person/per night
Double room half board 40.00€ to 44.00€, full board 44.00€ to 48.00€ plus additional charge of 0.50€ per adult per day (tax).
For a single room add the additional charge of 12.00€.

Meals
All meals can be provided on request.

Directions
By car: From Mulhouse take D 432 to Altkirch. From there proceed on D 432 to Lucelle.
By train: Get off at Mulhouse and take a bus to Lucelle.

Contact
Responsable pour l'hospitalité
Maison Saint-Bernard
68480 Lucelle, France
Tel: 0033 (0)3 89 08 13 13
Fax: 0033 (0)3 89 08 10 83
Email: cerl3@wanadoo.fr
Website: http://www.generation-nouvelle.com/seminaires
 www.tourisme-lucelle.com

NOTES

AIR ET VIE - CENTRE MONIER
Managed by a lay organization

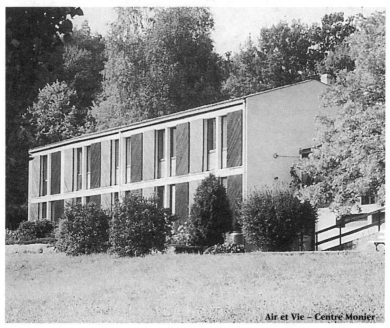

Air et Vie – Centre Monier

Installed in a woodsy setting, the center offers spiritual retreats and relaxing holidays. A Jesuit Father resides in the center and organizes various activities year-round. The house sits atop a hill dominating Marmoutier. The center's locale offers the opportunity of walking and hiking excursions in a peaceful environment.

The center was founded in 1958 by a group of sisters who wanted to open a retirement home that would also be open to all for holidays and spiritual retreats. They asked Père Monier (1886-1977) a famous Jesuit preacher to help them realize a center of cultural and spiritual exchange. He did so and remained at the center until his death. In 1996 the retirement home section was closed. There is a library of literature that guests may peruse concerning Père Monier.

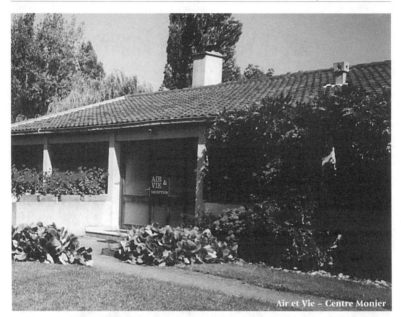

Air et Vie – Centre Monier

The small town of Marmoutier was the former site of a great abbey which was destroyed during the French Revolution. The unusual abbey church with its 11th century Lombardic style façade is all that remains of the once important institution. The architectural patrimony covers a range of styles as exhibited in its Romanesque façade and Gothic nave and choir. In the course of recent excavations, relics of a pre-Romanesque church and a wooden sarcophagus were unearthed. They can be viewed in a crypt beneath the church.

The Musée d'Arts et Traditions Populaires de Marmoutier is sheltered in a 16th century, half-timbered building. It includes Jewish objects from rural Alsace, an ancient *mikvah* (ritual bath) and a secret room used as a synagogue during the years Jewish houses of worship were illegal in Alsace.

The Alsace region is tucked between the Vosges and the Rhine. A beautiful, fertile valley beneath vine-covered foothills, it is a place of fairy tale villages, historic cities and the rivers and canals that link them. From Marlenheim in the north to Thann in the south, the *Route du Vin*, runs along the foothills, traveling through a scenic tableau of villages distinguished by medieval towers and feudal ruins.

The architecture of nearby Saverne is so beautiful - ribbed pilasters and columns crowned by Corinthian capitals - that the city has been dubbed the "Alsatian Versailles." The Marne-Rhine Canal runs through and around the compact historic center with a lock directly in the middle of town. Pleasure crafts take turns passing through a lock located between the 14th century Recollets Cloister and the impressive pink sandstone Château de Cardinal de Rohan, once the home of the prince-bishops of Strasbourg. A monumental pool reflects the château's colonnaded façade and elegant gardens. The château shelters museums containing local treasures from Gallo-Roman times to the modern age.

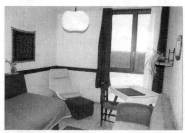

Accommodations
13 single and 5 double rooms, each with private bath. Both men and women are welcome.

Amenities
Towels and linens are supplied. There is a meeting room, TV room, chapel and parking.

Cost per person/per night
Provisional cost for full board 36.00€ to 67.00€.

Meals
All meals are included.

Directions
By car: From Haguenau take N340 to Brumath. From there take A4 south about 24 km following the signs to Saverne, Nancy, Metz, Paris. Exit at "Sortie 45" and take N404 after Saverne. Near Otterswiller, take N4 about a mile and then D259 to Marmoutier center.
By train: Get off at Saverne and take a taxi to Marmoutier.

Contact
Anyone who answers the phone
Air et Vie – Centre Monier
Sindelsberg
BP 43
67441 Marmoutier cedex, France
Tel: 0033 (0)3 88 70 61 09
Fax: 0033 (0)3 88 03 22 40

HOSTELLERIE DU MONT SAINTE-ODILE
Order Diocese of Ottrott

Ottrott is one of the area's "Villages in Flower," a designation that defines the village as a pretty locale with charming old houses and lanes surrounded by forests and vineyards. Ottrott is renowned for the ruins of once mighty castles, its wine (rouge d'Ottrott), the Windeck Botanic Garden and, most of all, the monastery of Mont Ste-Odile.

Mont Ste-Odile has a long and fascinating history. The site, atop a mountain overlooking the Alsatian plain, was occupied in the prehistoric era by Celtic tribes. The tribes left a wall dating from 100 BC along with enormous sacrifice stones and megalithic fences. The Romans also occupied this dramatic perch that they called *Altitona*. As typical of them, they built paved roads and an entrance gate, now known as the "Roman Gate." South of the hôtel-lerie, a path leads to a view of the peculiar "Pagan Wall," a looping 6 mile circuit of rough stones. Its origin is a mystery but may have marked the bounds of a Celtic encampment.

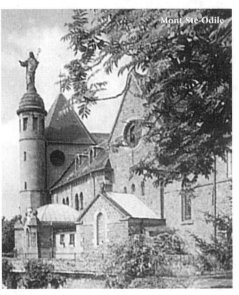
Mont Ste-Odile

The most interesting part of Mont Ste-Odile's history began in the 7th century. At that time a child was born to a Merovingian duke named Etichon. Not only was the child female, a detriment in itself during that period, but she was also sickly and blind. The duke ordered his firstborn killed but instead the child's mother gave the girl to a nurse who hid her in a convent. On the day of her christening, at the age of twelve, the child recovered her sight and hence the name Odile, the girl of light.

When Etichon learned that his daughter had survived, he wished to arrange a marriage for her. Seeking to escape her father's authority, Odile sought refuge on the mountain. When her father was about to seize her, the mountain opened and hid Odile. The father was impressed by the miracle and gave the castle of Hohenbourg to Odile so that she could turn it into a monastery. It is said that Odile performed many miracles throughout her lifetime. When she died her body was placed in a coffin that is still intact.

In 1546 a fire forced the nuns of the original order to leave the monastery and they never returned. The Prémontrés priests saw to it that the monastery survived and it became a popular pilgrimage site. During the French Revolution they too were forced to leave. In 1853 the monastery became the property of the Bishop of Strasbourg. Today the priests of the diocese and a religious community manage the complex.

The town of Ottrott produces red wine, rare in Alsace, and lays claim to two medieval châteaux. The village is engulfed by forests and vineyards and is among the most significant locations for Alsatian gastronomy. Its old houses and lanes lie in the shadow of the once mighty castle with its exceptional position at the foot of Mont Ste-Odile.

Ottrott is not far from Colmar, a quintessential Alsatian town, its streets threaded by the Lauch and Logelbach rivers. A section of town known as Le Petite Venise charms visitors with swans that float gracefully on the narrow canal. The ambience of the town has been well-preserved since the Middle Ages. Many small squares and narrow streets are pedestrianized. The ancient balconied houses lining the canals are detailed with ornate façades, paintings and gables. Their reflection in the waterways that drift through the city adds to the elegance of the setting.

Colmar boasts two famous works of religious art: set in a 13th century Dominican convent which overlooks the leafy Logelbach, Musée d'Unterlinden houses Matthias Grünewald's early 16th century Isenheim altarpiece; Martin Schongauer's celebrated painting, *Virgin of the Rosebush*, is preserved in the Gothic Eglise Dominicains.

The Musée Frederic-Auguste Bartholdi celebrates the Colmar-born sculptor of the Statue of Liberty. Bartholdi also executed a statue of Martin Schongauer. Within the museum, the Katz Room contains a fine

collection of Jewish ritual objects and synagogue furnishings. There are several other worthwhile sites. Maison des Têtes is distinguished by 106 tiny grimacing faces sculpted into its façade; Maison Pfister with its slender stair turret and flower-accented façade is considered the loveliest house in the old town; and the Koifhus, a galleried structure with a Burgundian tiled roof, was the former customs house.

Part of Germany until 1681, Colmar's Jewish community dates back to the mid-13th century. The medieval settlement was located between the present rue Chauffour and rue Berthe-Molly. The Consistoire Israélite du Haut-Rhin was

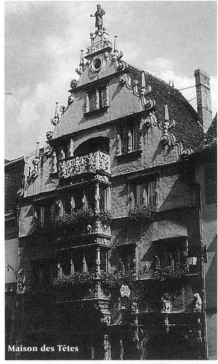

Maison des Têtes

originally built in 1840. A neo-Romanesque synagogue typical of France during this period, it was destroyed by the Nazis during WWII and then restored.

Accommodations
60 single and 80 double rooms plus 2 family rooms (4 beds). 70 rooms have private bath, 15 have showers and 55 have only washbasins. Both men and women are welcome.

Amenities
Five dining rooms including one self-service that may be used by guests. Menus include the specialties of the region: homemade delicatessen, local wines and produce. There is a large private parking lot and several meeting rooms guests may use.

Cost per person/per night
Lodging 44.00€, half board 70.00€, full board 95.00€.

Meals
All meals can be provided on request.

Special rules
Closed January 5-18 and November 13-26.

Directions
By car: From Strasbourg take A35 and exit at Rosheim. Take N422 to Obernai and then D426 to Ottrott. From Ottrott follow the signs to Mont Sainte-Odile.

By train: Get off at Barr or Obernai and take a taxi to Mont Sainte-Odile.

Contact
Anyone who answers the phone
Hostellerie du Mont Sainte-Odile
Mont Sainte-Odile
67530 Ottrott, France
Tel: 0033 (0)3 88 95 80 53
Fax: 0033 (0)3 88 95 82 96
Email: info@mont-sainte-odile.com
Website: www.mont-sainte-odile.com

 NOTES

FOYER NOTRE-DAME DE REINACKER
Franciscan Sisters

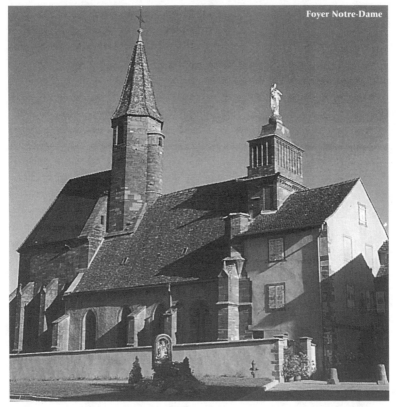

Foyer Notre-Dame

The Foyer Notre-Dame de Reinacker sits just outside the village of Reutenbourg in a locale dedicated to the worship of Mary. During the 14th century, pilgrimages were made to a simple building; however, in the 15th century, the present church was constructed. Its architecture is Gothic Flamboyant and reveals some interesting statuary.

Although pilgrimage to the shrine started long before 1350 the origins are undocumented. It is known that in 1350 an almost complete reconstruction of the shrine took place. Later additions included the tower of

the choir (1693) and the restored façade (1827) which is surmounted by a statue of the Virgin. The pilgrims greet the statue while passing under the façade however, the true object of the veneration is sheltered within the interior. It is called *Vierge Miraculeuse* because of the miracles obtained due to her intercession. On the left altar is a Pietà (1443). The stained glass windows of the vault are enriched by fine decorations.

Reutenbourg is a small town and part of the Canton de Marmoutier. Its church of St-Cyriaque, an edifice of the 12ᵗʰ century, was remodeled in the 18ᵗʰ and 19ᵗʰ centuries. Most of its Romanesque elements were lost during the renovations. Facing the shrine of Notre-Dame de Reinacker is the Koppkreutz cross, erected in 1783 on a 1,200' hill.

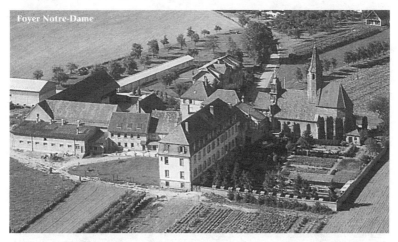
Foyer Notre-Dame

Sheltered by the Vosges, Alsace enjoys a semi-continental climate with hot summers and long warm autumns, ideal for wine growers and visitors alike. An improbably beautiful place, Alsace is the stuff of which fairy tales are made - medieval towns and villages with half-timbered houses and slopes contoured with row upon row of vines.

Wedged between the Latin and Germanic worlds, Alsace is a cross-roads of historical and cultural trends. The region has always been an object of desire as witnessed by its peaks topped with ruined fortresses built for defense. It was in 1648, under Louis XIV, that Alsace was united with the Kingdom of France. Then came the political wrangling between the French Republic and the German Empire evidenced by the fact that the province's nationality changed four times between 1870 and 1945.

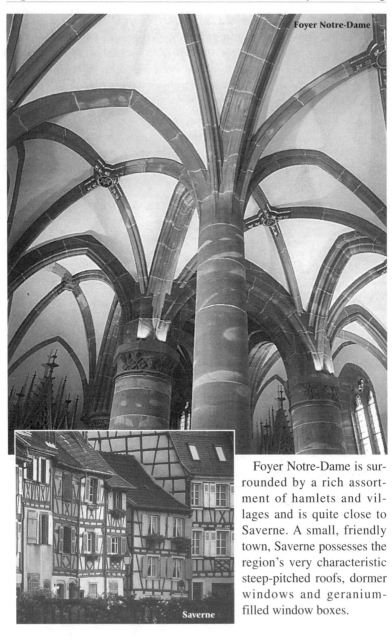

Foyer Notre-Dame

Saverne

Foyer Notre-Dame is surrounded by a rich assortment of hamlets and villages and is quite close to Saverne. A small, friendly town, Saverne possesses the region's very characteristic steep-pitched roofs, dormer windows and geranium-filled window boxes.

One of the outstanding monuments in Saverne is the vast red sandstone Château des Rohan. Its north façade has high Corinthian pillars and overlooks a park. Designed in an austere classical style, it was originally built as the residence of the bishops of Strasbourg. Constructed between 1779 and 1789 by the architect Nicolas Salins for Cardinal Louis-René-Edouard de Rohan-Guéméné, work was halted by the French Revolution and the nationalization of the clergy. During the first half of the 19th century, the castle was in ruins and threatened with demolition. Between 1853 and 1857, Emperor Napoleon III restored the facility to accommodate the widows of senior officials and soldiers who died in the service of France. After the War of 1870 the castle was transformed into barracks. It now shelters a small history museum, cultural center, primary school and youth hostel.

Immediately outside the city, a popular walk leads through woods of chestnut and beech to the ruins of the Château du Haut-Barr. The castle is dramatically sited on three green rocks atop a slender sandstone ridge. Views from the ruins are impressive, stretching across the wooded hills and over the plain towards Strasbourg.

Just north of Saverne, the town of Bouxwiller is home to the Musée Judéo-Alsacien. Installed on several levels of a synagogue typical of small town Alsace, the museum conserves permanent and temporary exhibits detailing rural Jewish life in Alsace through the centuries including the ways in which holidays, weddings and rituals were celebrated.

Accommodations
35 rooms and 60 beds: 12 single, 19 double and 4 family rooms (4 beds). All rooms have a private bath.

Amenities
Towels and linens are supplied. Meeting room, parking and chapel.

Cost per person/per night
Provisional cost only. For updated costs contact the foyer.
Lodging only: 25.00€, full board 36.50€.

Meals
All meals can be provided on request.

Directions

By car: From Strasbourg take N4 north to Saverne. After Wasselonne and before Singrist, turn right by following the signs to Jetterswiller and Couvent de Reinacker. From Saverne take N4 towards Strasbourg. Near Marmoutier (do not enter in the city), turn left and follow the signs to Reutenbourg.

By train: Get off at Saverne and take a taxi to Reutenbourg. With advance arrangements, the Foyer Notre-Dame can provide transportation from Reutenbourg.

Contact

Sœur Hôtelière
Foyer Notre-Dame de Reinacker
Lieu-dit Reinacker
67440 Reutenbourg, France
Tel: 0033 (0)3 88 70 60 50
Fax: 0033 (0)3 88 71 42 44
Email: srs.reinacker@wanadoo.fr
Website: www.notredamedereinacker.com

 NOTES

MONASTÈRE DE BÉNÉDICTINES DU SAINT-SACREMENT
Bénédictines du Saint-Sacrement

Monastère de Bénédictines

The monastery is quartered inside the Romanesque fortifications of Rosheim. The structure was used as a spa until 1862 at which time a group of Bénédictine nuns from Lorraine took up residence and founded the monastery. Shortly afterwards the nuns opened a boarding school for girls that became quite well known throughout France. The school was closed after the Nazi invasion in 1939. The 18th century complex has a chapel embellished by a 16th century Pietà.

The city has been inhabited since the Neolithic era. The first mention of the city dates to 778 AD when it was called Rodasheim. It was a religious possession of the Monastery of Ste-Odile and a town of the empire. In 1354 it became part of the "Decapole," (a pact of mutual alliance among ten cities of Alsace). The towers and portal have survived the centuries and bear witness to the high status of Rosheim during the Middle Ages.

With its decorations of sculpted beasts and an octagonal tower, the church of St-Pierre et St-Paul is a splendid example of Romanesque art. In the *Mittelstadt*, the old quarter, the antique houses are embellished by pots of geraniums and quaint shop windows. It is also the locale of the harmonious neoclassic church of St-Etienne. Among Rosheim's treasures is the Maison Romane, an elegant mansion of the 12th century, the oldest in Alsace.

Alsace stretches like a narrow ribbon from the Swiss border in the south to the German border north of Strasbourg. The famous *Route du Vin* winds its way through seventy-five miles of storybook villages past houses with gabled roofs and chimneys topped with stork nests. Influenced by the German language, architecture and cuisine and cradled by the Vosges and the Rhine, it represents an altogether alluring setting.

Molsheim is a charming old town near the north end of the *Route du Vin*. The town has remains of ramparts and an ancient fortified gateway. It shelters the *Metzig*, a Renaissance building erected in 1554. Truly Alsatian in design, the structure is accented by gables, a *perron* (an outdoor stairway leading up to a building entrance), a graceful balcony and loggia. A belfry crowns the latter where two angels strike the hours. The first floor is now a museum; the ground floor is devoted to wine tasting – Riesling, of course.

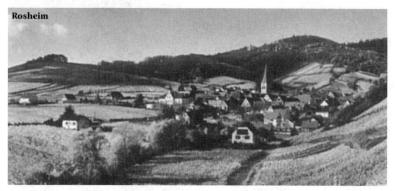
Rosheim

Heading south from Rosheim are two interesting towns, both of which specialize in the production of wines. Ribeauville has a long history and was first mentioned under Ratbaldovillare in an official document ca. 768 AD. It meant "Ville of Ratbold" which, in old German, signified the "boldest man of the counsel." The small town is comprised of walls and houses distinguished by wood beams. It was once the property of the Lords of Ribeaupierre, protectors of the traveling musicians and actors who filled the town every September 8th (birthday of the Virgin Mary). The tradition continues. Visitors still gather to hear musicians stage a show in tribute to their ancient sponsors.

Riquewhir is a uniquely picturesque town whose layout and structure have not changed since the Middle Ages. Partly walled, the 11th and 12th century houses along the cobbled streets maintain their courtyards, galleries, bow windows, old wells and fountains. All of the architecture is scrupulously preserved. Even the lifestyle of the townspeople continues as it has for centuries and revolves around winemaking. The aroma of Winstub, their particular wine, lingers in the air throughout town.

Accommodations

Hospitality is offered to single women, families or groups. No single men or groups of men are allowed unless they are religious representatives. Recently renovated, there are 30 rooms with 1 to 6 beds per room for a total of 45 beds. Some have only a sink, or a sink and a shower. Baths are outside the rooms. The small dorms with 6 beds have a private bath and small kitchen.

Amenities

Linens and towels are provided. There is a dining room, meeting room, conference room, library and garden.

Cost per person/per night

Voluntary contribution.

Meals

All meals can be provided on request. Half board or full board is the norm.

Products of the institution

The nuns produce hosts that are sold throughout France and abroad.

Special rules

Punctuality at meal times is required. Breakfast 7:30 – 8:45; lunch 12:30; dinner 7:00.

Directions

By car: From Strasbourg take A35 west and exit at Rosheim. The monastery is located in the center of town.

By train: Get off at Rosheim, take a taxi (no bus) or call the monastery and they will arrange transportation.

Contact

Ask for the "Sœur responsable pour l'hospitalité" or call the direct number 0033 (0)3 88 50 28 95

Monastère de Bénédictines du Saint-Sacrement

1, rue Saint-Benoit

67560 Rosheim, France

Tel: 0033 (0)3 88 50 41 67

Fax: 0033 (0)3 88 50 42 71

Email: info@benedictines-rosheim.com

Website: www.benedictines-rosheim.com

ASSOCIATION FOYER DE NOTRE-DAME
Lay Association

Positioned in the center of town, the foyer was opened in 1923 to host young women in need of support and shelter. In later years it became a center that hosted mainly female students, a tradition that continues today. However, during the summer months, June 1st through September 15th, the foyer is open to all guests.

Foyer de Notre-Dame

Strasbourg is the capital of Alsace and owes both its name "the city of the roads," and wealth, to its position on the west bank of the Rhine, one of the great natural transport arteries of Europe. Originally Celtic, briefly Roman, alternately French and German, it wears its centuries with remarkable grace. Since Strasbourg grew along two rivers, the Rhine and the Ill, a boat tour is an excellent way to absorb the architectural splendor of the city.

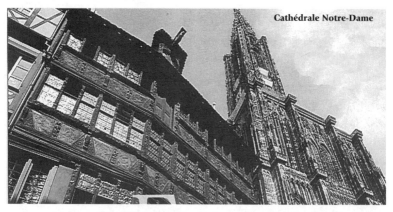
Cathédrale Notre-Dame

A prosperous, dignified city, it retains an ancient medieval section known as "Petite France," where timber-framed houses and gently flowing canals evoke the medieval trades of tanning and dyeing. Visible throughout the city is the outstanding filigree spire of the pink Cathédrale Notre-Dame de Strasbourg. A wonderful example of Gothic architecture

and a masterpiece of stone lace work. The
sandstone edifice is one of the most gracious
cathedrals in France, so lovely in fact that it
inspired the poetry of Goethe. Its majestic
façade, begun in 1284, has three portals richly
embellished with carvings of biblical scenes.
The spacious interior is artistically rich:
stained glass windows, 14th century tapestries,
a Flamboyant Gothic pulpit and the splendid
Pillar of Angels. Installed in 1574 and a high-
light of the church is the famous
Astronomical Clock whose complex mechan-
ical figures perform at noon each day. The
cathedral's crowning glory, however, is the
vibrantly colored rose window.

Astronomical Clock

Adjacent to the cathedral, Musée de l'Oeuvre Notre-Dame chronicles the
development of arts in the Upper Rhine from the 11th through the 17th cen-
turies and contains much of the church's original sculpture. The museum
courtyard exhibits Jewish tombstones from the 12th through 14th centuries.

The Jewish community of Strasbourg, which made a comeback from
its devastating German occupation in WWII, retains its predominantly
Alsatian character. The population is scattered throughout the city but
many of the 17,000 remaining Jews live in the area around the main syn-
agogue, a fashionable neighborhood near the Parc des Contades. The
Synagogue de la Paix was built in 1958 to replace the synagogue
destroyed by the Nazis. The impressive interior contains a circular sanc-
tuary nestled beneath a Star of David. Ashkenazi services are held in the
synagogue while those in the Sephardic tradition are held in the
Synagogue Rambam at the same location (1a, rue du Grand-Rabbin-
René-Hirschler).

Strasbourg's old Jewish quarter, on rue des Juifs (one of the city's old-
est streets), includes the site of a 12th century synagogue (at # 30), a
Jewish bakery (at # 17) and a surviving 13th century *mikvah* (ritual bath)
at #20 rue des Charpentiers. Number 15, constructed in 1290, is the only
remaining building from this period that was inhabited by Jews. Musée
Alsatian houses an exhibit of Jewish ritual objects and a model *shtiebel*
(prayer room).

A walk around the city can start at the cathedral and include the Pharmacie du Cerf, ca. 1268, reputed to be the oldest pharmacy in France and the Château des Rohan, just one of the many homes of the cardinal-bishops of the Rohan family. The château houses three museums including the Musée des Arts Décoratifs with its renowned collection of ceramics.

The bold modern architecture of the pink granite and glass Musée d'Art Moderne contrasts with the centuries-old houses. Ringed by the swan-flecked Ill, Old Strasbourg's ancient houses, canals and covered bridges, seem too scenic to be true. An abundance of monuments, churches and museums adds to the city's appeal. To the west by the Ill are four medieval towers, formerly linked by *Ponts-Couverts* (covered bridges), once part of the 14th century ramparts. To the north is the winsome rue du Bain-aux-Plantes with scores of Renaissance houses.

Throughout the centuries, converging influences have created a rich cultural heritage in Strasbourg. From that arose many artistic endeavors including Vieux Strasbourg ceramics, stained glass and stone lace work. The city's cuisine also reflects the diversity of its past with dishes such as *pâte en croûte*, a pate baked in a pastry crust; *choucroute*, sauerkraut with ham and sausages; and Alsatian Jewish desserts such as *strudel* and *streusel*.

Accommodations
50 single rooms, each with private bath. A few can be converted into doubles.

Amenities
Towels and linens are supplied. There is a meeting room and TV room.

Cost per person/per night
Lodging and breakfast 25.60€.
Half board 32.00€.
Full board 38.40€.

Meals
Breakfast is included and all meals can be provided.

Special rules
Punctuality at meals is required.

Region: Alsace **City: Strasbourg**

Directions

By car: From A4 exit at place Etoile/place Haguenau.

By train: Get off at Strasbourg and take a taxi or bus to the cathedral.

Contact

Anyone who answers the phone

Association Foyer de Notre-Dame

3, rue de Echasses

BP 70

67061 Strasbourg, France

Tel: 0033 (0)3 88 32 47 36

Fax: 0033 (0)3 88 22 68 47

Email: foyer.notredame@wanadoo.fr

 animatrices.afnd@wanadoo.fr

Website: www.foyer-notre-dame.com

 NOTES

AQUITAINE

MAISON DIOCÉSAINE
Property of the Diocese of Bayonne

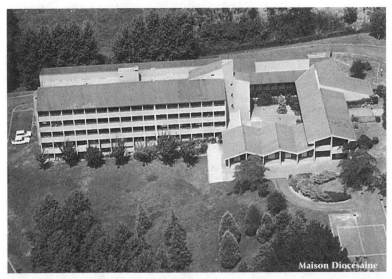

Maison Diocésaine

Founded in 1915 the maison was once the old seminary of Bayonne. Today it offers hospitality to anyone seeking a relaxing atmosphere. The house is ensconced in its own park and woodland but close enough to Bayonne that it can be reached on foot. The sea is also accessible, less than four miles from Bayonne.

The capital of the French Basque country, Bayonne occupies land between two rivers, the Nive and the Adour. Once an historic frontier fortress, it is now an elegant city with arcaded streets and a thriving port dating from Roman times. It retains a Basque flavor with tall half-timbered houses and woodwork painted in Basque tones of green and red. Bayonne has given its name to the bayonet invented in the city in the 17th century.

Grand Bayonne, the old town, lies within the ramparts on the left bank of the Nive. It is home to the 13th century Cathédrale de Ste-Marie. Northern Gothic in style, the church is defined by twin towers, a lovely, almost secretive, cloister and a striking 13th century apse with dramatic

flying buttresses and a double row of windows. Its design is based on the cathedrals of Soissons and Rheims. The nave is characterized by stained glass windows and ancient sarcophagi.

The arcaded rue du Pont Neuf is at the heart of the attractive pedestrian zone on the Petit Bayonne. Musée Bonnat, named for native son Léon Bonnat, provides an unexpected treasure trove of 13th and 14th century Italian art. Highlights also include Goya's *Self Portrait*, Ruben's *Apollo and Daphne* plus works by Murrillo, El Greco and Ingres. An entire gallery is devoted to high society portraits by Léon Bonnat whose personal collection formed the original core of the museum. Musée Basque, sheltered within a 15th century building typical of the region, provides insight into Basque customs and culture: seafaring, costumes, traditions, arts and crafts and the quintessential Basque game of pelota or jai alai.

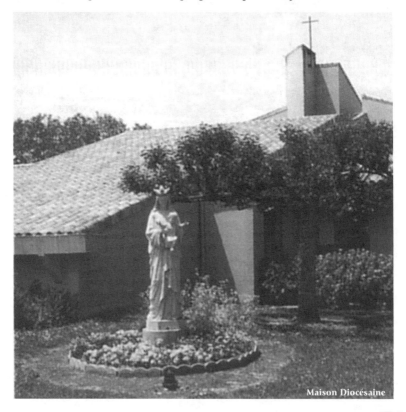

Maison Diocésaine

Around the year 1500, Sephardic Jews fleeing the Spanish Inquisition arrived in Bayonne, bringing their chocolate manufacturing trade with them. To this day, hot chocolate remains a specialty of the area. Some of the oldest Jewish cemeteries in France are located in the small villages near Bayonne: Bidache dates from 1690; Payrehorade, 1628 to 1737; and Labastide-Clairence, 16th century.

Close-by Biarritz is one of the most famous seaside resorts in the world. Once a tiny fishing village near the Spanish border, it was favored by Napoleon III, Empress Eugenie, members of the English royalty and other famous dignitaries. It remains a fashionable haven, its beaches undeniably beautiful, its streets lined with tamarisks and hydrangeas. The promenade, "La Perspective," has remarkable mountain views. In Biarritz nearly every villa has a story. It is said that the Villa Belza (Basque for black) owes its name to a West Indian governess who saved the children of the Dubreuil family during the French Revolution. In gratitude for her bravery, the owners of the villa changed their name to Belza-Dubreuil.

Nearby Guethary was once a fishing port but is now a place of handsome villas, most built in true Basque style. The parish church occupies a commanding position and harbors a 15th century processional cross.

Not far from the maison are two intriguing places to visit. Espelette is a village of wide-eaved houses that feature maroon-colored shutters with maroon peppers dangling from window frames. Even the disc-shaped gravestones are special and present an altogether pleasing picture, so much so that Espelette has won the title of "Prettiest Village in France." Aside from its beauty, Espelette's principal source of renown is its large red pimento. Much used in Basque cuisine, the pimentos were brought to the town from the Americas by explorers in the 15th century. Pottok ponies, a native Basque breed once favored for work in British coal mines, but now raised for riding, are peculiar to Espelette and its environs. Herds of them are a common sight on the upland pastures.

Cambo-Les-Bains is an old spa enclave. The new part of town with its ornate houses and hotels radiates out from the baths over the heights of the river Nive. The old quarter is an archetypical Basque village of whitewashed houses and a galleried church. The main attraction to Cambo-Les-Bains is the Villa Arnaga, less then a mile from town. This larger-

than-life Basque house overlooks an almost surreal formal garden. The villa was built for Edmond Rostand, author of *Cyrano de Bergerac*. It's an unusual, very kitschy place with a minstrels' gallery, fake pilasters, allegorical frescoes, portraits and memorabilia.

Accommodations
80 beds in single and double rooms. Rooms have washbasins and showers. Toilets are shared.

Amenities
Towels and linens are supplied. TV room, private parking and meeting rooms.

Cost per person/per night
Provisional costs only.
Single room 17.00€; double room 25.00€ breakfast included.
Meals (only Monday through Friday) 10.00€.
10% advance payment within 15 days after the reservation.

Meals
All meals can be provided.

Special rules
Curfew at 9 PM.
Breakfast 7:30-9:00, lunch at 12:30, dinner 7:15.

Directions
By car: Exit at Bayonne sud on A83 and follow the signs towards Bayonne-Biarritz. At the third roundabout take the road indicating "Domaine Universitaire." The maison is on the hill to the left.
By train: Get off at Bayonne and take a taxi or bus # 7 or 2 from the "Hôtel de Ville." Get off at the "Université" stop.

Contact
Anyone who answers the phone
Maison Diocésaine
10, avenue Jean Darrigrand
64115 Bayonne cedex, France
Tel: 0033 (0)5 59 58 47 47
Fax: 0033 (0)5 59 52 33 98
Email: maisondiocesainebayonne@wanadoo.fr
Website: http://www.diocese-bayonne.com/2_xtaction/maison_dioce-saine/conditions_accueil.html

SARL L'ARRAYADE
Property of the Bishopric of Dax
Managed by lay personnel

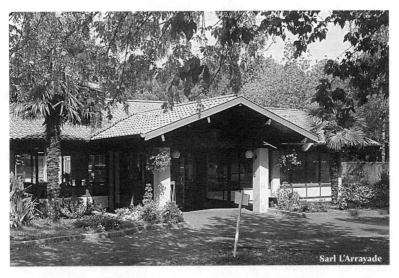

Sarl L'Arrayade

L'Arrayade, which in local dialect means sunny, was once the seminary of Dax. A few years ago it changed its focus and now hosts all guests. Situated in an alluring position, a little over a mile from the center of Dax, L'Arrayade is enclosed by a park and offers year-round workshops and retreats in addition to relaxing holidays.

The town occupies a privileged situation in the heart of the forest of the Landes, between the Atlantic and the Pyrénées. A mosaic of scenery, it encompasses the forest region to the plains of the Adour, lakes and ponds to the chain of dunes and fine, sandy beaches. Famous for its rugby, festivals, bullfights and food, Dax was also the first thermal spa of France. Every year more than 100,000 visit the city.

The source of the Adour begins in the Pyrénées, at the foot of Mt. Tourmalet, crosses the département of Landes, continues to the city of Bayonne and then flows into the Atlantic to the place called "La Barre."

At one time it was the major transportation route of the département. Part of the route passed over a stone bridge built by the Romans. Washed away in a flood in 1770 it was first replaced with a wooden bridge and then in 1857 by the current structure. The watermark left by the floods can be seen against the arch on the left bank. The promenade along the Adour is overseen by the classical 17th century Cathédrale Notre-Dame.

Dax has many interesting monuments including the statue of Jean-Charles De Borda. Born in Dax in 1733 the renowned mathematician and physicist is one of the fathers of the metric system. A maritime engineer, he applied his triangulation theories to previous surveying methods and invented numerous navigational instruments. The maritime school of the French Marines was named after him.

Although only a small part of the Gallo-Roman ramparts remain in Dax, archeologists have described the fortifications as "the most beautiful and most complete type remaining in France." Built in the 4th century, the ramparts are 12' thick, 30' high and endowed with 46 round towers and 4 massive doors. The thermal spa of Dax has been well known since the time of Emperor Augustus and traces of the Roman wall remain. Named after Nèhe, a Scandinavian goddess of waters, the Warm Fountain symbolizes the city. Built in the 19th century on the site of the Roman baths, the fountain has an output of 634,000 gallons per day with a temperature of 147° F. The source of the thermal liquid results from a fault dating from the time of the rise of the Pyrénées. There is a subterranean circuit where high

Warm Fountain

temperature and mineralization of the water are acquired at great depth. In the pond of the fountain, especially after sunny periods, there is a bloom of algae, part of the water's natural healing properties called "Dax's Péloïde."

According to legend, a Roman legionnaire leaving for a campaign and knowing his dog, crippled with rheumatism, could not follow him, threw the animal into the mud of the Adour river. To his utter amazement when he returned, his dog was alive and cured. The Roman baths of *Aquae Tarbellicae* were then born around the famous Warm Fountain. It became the place where Roman legions went to recuperate after their campaigns.

The Cathédrale Notre-Dame Ste-Marie is a classic style neo-Greek structure erected in the 17th century on the site of an ancient Gothic building constructed by the English during their 300-year occupation of the town. The 12th century oval door, called the "Apostles Door," was classified by the National Historical Society in 1884. The beautiful stalls of the canons, dating from the ancient cathedral, have been preserved. The high altar and the altar of the Virgin were the work of the brothers Mazetti. The 17th century organ chest was created by Caular, a local cabinetmaker. Recently restored, the chest is one of the most beautiful of France.

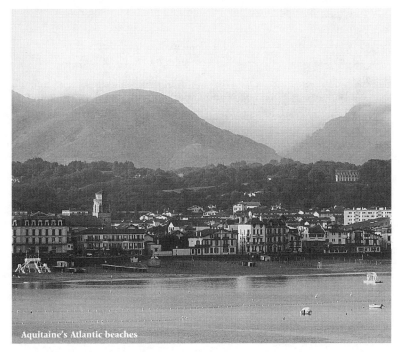

Aquitaine's Atlantic beaches

The Aquitaine region of southwest France is quite beautiful. From the emerald pastures of Limousin to the snowcapped wilds of the Pyrénées, from the Dordogne to the Atlantic beaches, the region is a spectacular montage of rugged mountains, lush valleys, tree-shaded waterfalls, storybook castles and villages hidden behind turreted walls. Of course, there's also the wonderful food - foie gras, truffles, roast duckling, forest mushrooms and, naturally, vineyards featuring the great Bordeaux.

Nearby Mont-de-Marsan is a bullfighting mecca that attracts bullfighters from Spain and France. There is also the course landaise, a less bloodthirsty event, where participants vault over a charging cow.

Accommodations

45 single, 24 double and 1 triple room. Some of the rooms have private baths, the remainder have only a washbasin. Showers and toilets are located near the rooms.

Amenities

Towels and linens are supplied. Meeting rooms, TV room, private parking.

Cost per person/per night

Lodging only:

Single with private bath 27.00€, with shared bath 22.00€.

Double with private bath 31.00€, with shared bath 27.00€.

Meals

All meals can be provided on request. Half and full board are offered only to guests staying longer than 3 days.

Breakfast 3.50€.

Lunch and dinner 10.00€ each.

Directions

By car: Exit at Orthez on A64 and take N117 and N10 to Dax. When making reservations, request the local map available to guests.

By train: Get off at Dax and take a taxi to L'Arrayade.

Contact

Anyone who answers the phone

Sarl L'Arrayade

26 bis, rue d'Aspremont

40100 Dax, France

Tel: 0033 (0)5 58 58 30 30

Fax: 0033 (0)5 58 58 30 31

Email: arrayade@yahoo.fr

 reservations@arrayade.cef.fr

Website: http://arrayade.cef.fr

CENTRE D'ACCUEIL MADELEINE DELBREL
Bishopric of Périgeux

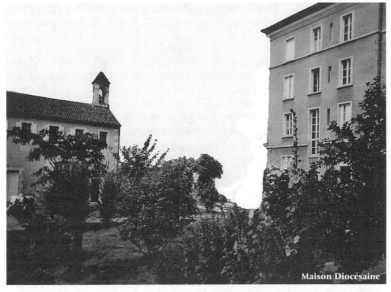

Maison Diocésaine

The center was once the seminary of the city. When it closed in 1969 it was converted into a guest house for groups, individuals and families for vacations and spiritual retreats. Quartered in the center of Périgeux, amidst its own spacious park, it is conveniently located for daily excursions into the lovely environs.

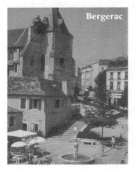

Bergerac

Périgeux is an ancient and gastronomic city and, like its neighbors Bergerac and Riberac, should be visited on market days when the stalls in the medieval sections offer local specialties. Périgeux is famous for its pâtés, notably goose livers and truffles, its chief exports. The city is divided into three parts, two of which are worth visiting; the present day section around the Byzantine Cathédrale St-Front; and La Cite, a

medieval quarter and once the important Gallo-Roman settlement of *Vesunna*. Remains from Roman times include arenas, the Vesunna tower and an amphitheater. The 12th century cathedral has five domes topped by cupolas. Its interior is adorned with Byzantine-style chandeliers. In the old town, the longest and finest street is the narrow rue Limogeanne; it is lined with Renaissance mansions many of which are now boutiques and patisseries. Throughout the area, fine Renaissance houses remain, including St-Louis where a turreted watchtower leans out over the street. Musée du Perigord exhibits some very beautiful Gallo-Roman mosaics and a number of exquisite Limoges enamels. Particularly arresting are the portraits of the twelve Caesars.

Nearby Brantôme sits in a bend of the river Dronne, whose still, water-lilied surface mirrors the weeping willows of the riverside gardens. On the north bank of the river are the church and convent buildings of an ancient abbey. Bergerac, also close-by, is replete with drinking fountains on street corners and a cache of medieval era houses. Musée Régional de la Batellerie is in the heart of old town. A statue in honor of Cyrano de Bergerac reposes on the square outside the museum. The museum's displays include barrel-making and river trading. In the old port, the flat-bottomed boats called *gabares* once exchanged goods for barrels of wine. (In the Middle Ages, merchants used rivers as the best way of trading goods with inland towns.) Markets are held Wednesday and Saturday mornings beneath the belltower of place de l'Eglise.

The greatest concentration of prehistoric sites in France is found near Périgeux along the Vezere river. Les Eyzies-de-Tayac is encompassed by caves and grottoes, many adorned with primitive art. More than 300 animal figures are carved on the walls of the Grotte des Combarelles; the paintings of horses, bison, mammoths and reindeer in the Grotte de Font-de-Gaume are second only to Lascaux.

The city of Bordeaux is near enough for a day trip. It boasts a population of over half a million and is an obviously rich enclave - as it has been since the Romans established a trading center there. But it was the 18th century French urban renewal that made it the beautiful city it is today. The stunning place de la Bourse and its arc of merchant houses is the centerpiece of a string of popular riverside quays. The Sunday market overlooks ships moored along the wharf. Place du Parlement is an asym-

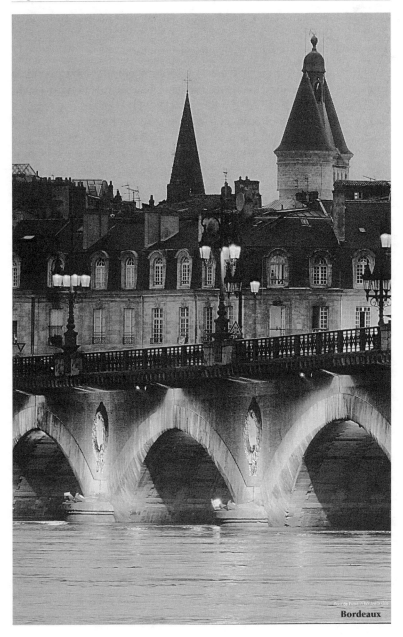

Bordeaux

metrical jewel and Vieux Bordeaux is an inviting pedestrian quarter. Place des Quinconces, with its statues of Montaigne and Montesquieu, former magistrates of the city, dominates the core of town.

Aquitaine's oldest and largest Jewish community can be found in Bordeaux, where evidence of Jewish settlement dates back to the 4th century. Toward the end of the 15th century, Jews fleeing the Inquisition of Spain and Portugal settled in Bordeaux under a grant from King Henry II. They were called Conversos or Marranos (Jews forced to convert to Christianity but who still practiced Judaism in secret). In the relative safety of their new homeland, the Jews gradually became more open about their heritage and established a Jewish section in the parish cemetery. In addition, Jews from Provence began to settle in Bordeaux and by 1753, the Jews of Bordeaux gathered for prayer in seven private locations.

By the beginning of the 18th century, Bordeaux was home to almost 2,000 Jews. At three different times in the 18th century, expulsion orders were issued but each time the community found a way to have its stay extended. During the 19th century two renowned wineries were established by Jews: Baron Nathaniel de Rothschild founded Château Mouton-Rothschild in 1853 and his cousin Baron James founded Château Lafite-Rothschild in 1867. During WWII two thirds of Bordeaux's Jews were deported. Today not much remains of the Jewish district but traces can be seen on the rue Cheverus just off the rue Ste-Catherine pedestrian mall, once known as Arrua Judega. There is also a city gate on rue de la Porte-Dijeaux, once called "Jews' Gate." After the war, the few Jewish survivors who remained rebuilt the Grande Synagogue. The current structure is highlighted by Carrara marble and is the largest synagogue in France.

Accommodations
75 beds in 40 double and one triple room. All rooms have a private toilet and washbasin. Showers are shared.

Amenities
Towels and linens are supplied. There are five meeting rooms, private parking and a TV room.

Cost per person/per night
To be determined when reservations are made.

Region: Aquitaine **City: Périgeux**

Meals
All meals can be provided on request.

Special rules
Times when silence is requested and times when showers cannot be used
are posted in the rooms.

Directions
By car: From Bordeaux take A89 to Périgeux. The center is in the heart
of town.
By train: Get off at Périgeux. It is a 15-minute walk from the train station.
Or take a taxi or bus.

Contact
Anyone who answers the phone
Centre d'Accueil Madeline Delbrel
Maison Diocésaine
38, avenue Georges Pompidou
24000 Périgeux, France
Tel: 0033 (0)5 53 35 70 70
Fax: 0033 (0)5 53 46 72 94
Email: camd24@wanadoo.fr

NOTES

AUVERGNE

MAISON ST-RAPHAEL
Diocese of Aurillac

The maison is well situated in the center of town. Offering a simple and friendly atmosphere, the maison is used as a retreat for French priests but also hosts guests who wish to visit the compelling landscapes of the region.

A small market town, Aurillac is a maze of old streets, now mostly pedestrianized. The provincial capital of the Cantal, it still bears the mark of its commercial and industrial past. Its markets and fairs are some of the most important in the region. On a steep bluff overlooking one end of town is the 11th century keep of the Château St-Etienne, locale of the fascinating Musée des Volcans. In addition to displays on volcanoes, there is a wonderful view over the mountains to the east. The focus of the Musée Rames is on local archeology and traditional Cantal country life.

Aurillac is within the Massif Central, a dense cluster of mountain ranges covering nearly 33,000 square miles and encompassing almost a sixth of France. It includes some of the least populated parts of Western Europe. A region where nature still reigns supreme, it is a place where rivers run through impressive gorges and forests range from dense woodland to spacious oak groves. France's most diverse geological region, the Massif Central is home to the Parc Naturel Régional des Volcans located northeast of the maison. Several hundred volcanoes are sited within the park. These magnificent geological features are linked by high plateaux, vast successive flows of lava eroded by glaciers dating back to the Quaternary period.

No two volcanoes are the same, a fact quickly revealed at the park. Among the different types, scoria cones are the most common. Also known as Strombolian cones after the active volcano Stromboli, they are easy to recognize. The crate sits atop a cone formed by a "scoria," the volcanic spray and pozzolan spray thrown out during the eruption. "Maars" are circular crates that can measure several hundred yards in diameter. The ash, blocks of earth and volcanic spray thrown out by the explosion are left around the crates in the shape of a ring or crescent and form the maar. Dome volcanoes are often formed following very violent

Maison St-Raphael

eruptions. After the initial eruption that opens the crater in the ground, the lava rises to the surface. Since it is too thick to flow, it accumulates to form a dome. Lastly, "Planezes" are very old lava flows transformed into low plateaux.

To the southeast of the maison are the attractive villages of Mur-de-Barrez and Brommat where a number of old houses and churches add to the ambience of these undiscovered gems. Southwest is the Châtaigneraie (chestnut grove), over a half million acres of chestnut trees crisscrossed by sunken paths broken up by small valleys. The area is perfect for walking and cycling.

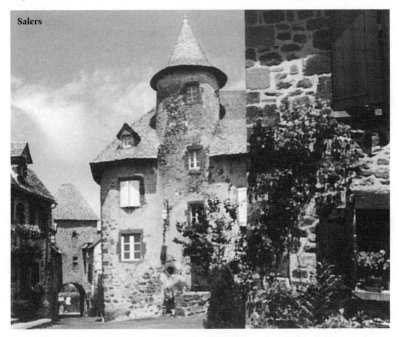

Salers

Due north of the maison, the 16th century town of Salers crowns a steep escarpment. Classed as one of "The Most Beautiful Villages in France," Salers reflects its 16th century heyday in cobblestone streets, 15th century ramparts and handsome Renaissance houses of gray volcanic stone, many with pepper-pot turrets, mullion windows, towers and carved lintels. The structures completely encircle Grande Place and remain as examples of the extraordinary architecture of that period.

Accommodations
Six beds in 4 single and 1 double room. Most have private baths.

Amenities
Towels and linens are supplied. Meeting room, parking and TV room.

Cost per person/per night
To be determined when reservations are made.

Meals
All meals are provided on request.

Special rules
Curfew to be arranged with the maison. Punctuality at meals is required.

Directions
By car: Exit at Massiac on A75 and take N122 to Aurillac.
By train: Get off at Aurillac. Take a bus or taxi to the maison or make prior arrangements and transportation can be provided.

Contact
Responsable pour l'hospitalité
Maison St-Raphael
40, avenue de la République
1500 Aurillac, France
Tel: 0033 (0)4 71 48 69 10

 NOTES

Region: Auvergne City: Le-Puy-en-Velay

ACCUEIL ST-GEORGES
Managed by the Catholic Association "Grand-Séminaire"

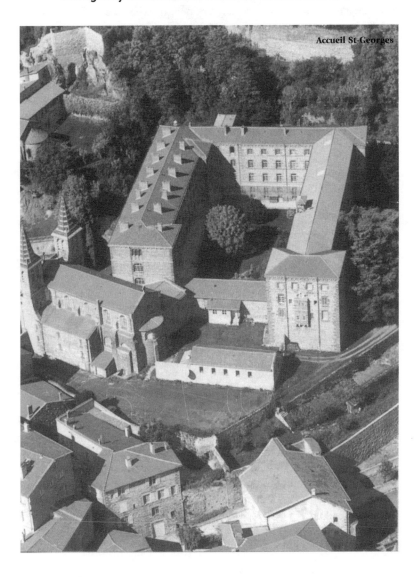
Accueil St-Georges

The old seminary of Le-Puy-en-Velay sits atop a volcanic thrust embraced by a park in the center of town. At one time, Accueil St-Georges housed young men studying to become priests. As vocations decreased, the accueil was converted into a guest house to host pilgrims. "We have about 200 beds but there are periods when we don't have even one bed available," said the man at the desk.

The sanctuary, dedicated to the Virgin Mary, was built in the early Middle Ages. Its popularity, both in France and throughout Europe, resulted in Le Puy becoming the starting point of the road to Santiago de Compostela. On August 15th, the Day of Assumption, the statue of the Black Virgin is carried in procession through the streets of the town. Throughout the centuries the veneration has aroused a great fervor, especially when the Feast of the Annunciation coincides with Good Friday. When that occurs, it is known as the Jubilee. The thirtieth occurrence of this event took place in 2005.

Le Puy ranks among the most remarkable towns in France. Slung between the higher mountains to the east and west, the landscape erupts in a chaos of volcanic stone, a confusion of abrupt conical hills top knotted with woodlands. The town enjoyed immense prosperity because of its medieval ecclesiastical institutions and it remains a center for pilgrims. Its most outstanding monument is the colossal, brick-red statue of the Virgin and Child that towers above the town on the Rocher Corneille. The Virgin is cast from 213 guns captured at Sebastopol and painted red to match the tiled roofs below. Views from the statue stretch over the singular volcanic countryside.

The town is the center of an old lace industry - most of which can be explored in a maze of steep cobbled streets that terrace the ancient town. The Cathédrale Notre-Dame de France dominates the old quarter. The exterior is one of the best examples of Auvergnat's Romanesque custom of decoration by using stone blocks with different shades of color in mosaic patterns. Begun in the 11th century, the cathedral is roofed with six domes. A long series of stairs leads from the Golden Gate and the streets, climbs under the cathedral and emerges in the center of the nave, directly in front of the altar and the Black Madonna. Another flight of stairs passes the miraculous *Fever Stone,* reputed to cure illnesses.

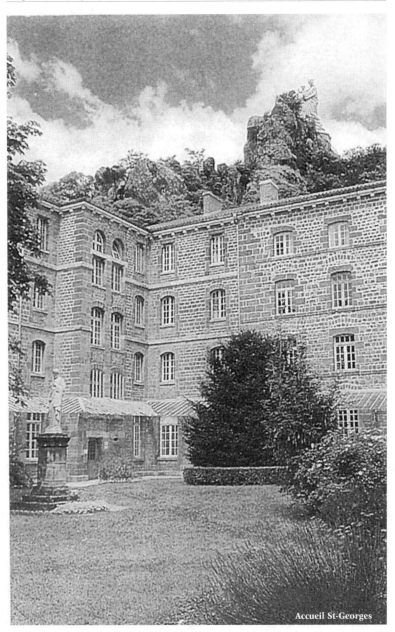

Accueil St-Georges

Almost Byzantine in inspiration and decoration, the Romanesque church of St-Michel d'Aiguilhe (literally, "of the needle") is a structure made all the more exotic by its site - perched atop a needle-pointed lava pinnacle with over 250 steps leading to the entrance.

St-Michel d'Aiguilhe

The new part of town is accented by the spacious Henri Vinay public gardens, locale of Musée Crozatier. The museum is known for its collections relating to the region's traditional lace-making activities.

Accommodations
Approximately 200 beds in single, double and triple rooms; baths are outside the rooms.

Amenities
Linens are supplied at an extra charge of 4.60€; towels are not supplied.

Cost per room/per night
Single room 12.00€, double 20.00€, triple 28.00€.

Meals
All meals can be provided on request.

Special rules
Punctuality at meals is required.

Directions
By car: Exit Le-Puy-en-Velay on A75 and reach the town with N102.
By train: Get off at Le-Puy-en-Velay and walk or take a taxi to the Grand Séminaire.

Contact
Responsable pour l'hospitalité
Association Grand Séminaire
Accueil St-Georges
4, rue Saint-Georges
43000 Le-Puy-en-Velay, France
Tel: 0033 (0)4 71 09 93 10
Fax: 0033 (0)4 71 09 93 17
Email: accueilstgeorges43@wanadoo.fr

DOMAINE DE CHADENAC
Managed by a Catholic association

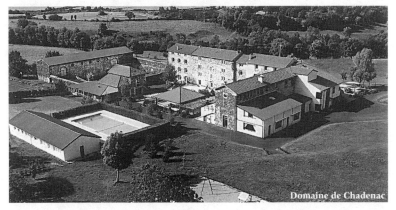

Domaine de Chadenac

Domaine de Chadenac enjoys a favorable position at 1,000' in the volcanic area of the Haute-Loire, a few miles from the town of Le-Puy-en-Velay. Once a fortified farm, the pretty 17th century stone building is nestled in a large parkland and sustains an ancient aura. Donated by a priest in 1935, the building dates to the 17th century. Some time ago it was completely restored. The diocese entrusted it to the Catholic association which now manages the facility. Many families come and stay for one or two week holidays but the domaine is open to individuals and groups as well.

Le-Puy-en-Velay had its beginnings on Mount Anis, just one of many volcanic peaks that rise precipitously above the fertile valley floor. The Romanesque Cathédrale Notre-Dame de France was begun in the 11th century. It has a checkerboard façade that reveals the influence of Moorish Spain. Most visitors come to see the Black Madonna. Standing upon the main altar, the Virgin is dressed in lace and golden robes. The passageway to the cloisters passes the so-called *Fever Stone* whose origins may have been as a prehistoric dolmen reputed to have the power of curing fevers. Ecclesiastical buildings comprise the medieval Holy City complex and distinguish the upper town. They all date from the same period and form a remarkable architectural pastiche.

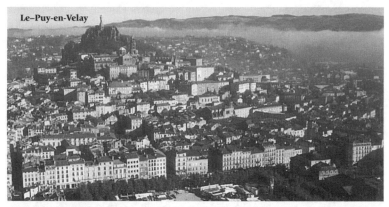

Le–Puy-en-Velay

The Domaine de Chadenac is in France's Massif Central, a region settled about 2,500 years ago by the Celtic Arverni. It is a landscape of rolling hills connected by pastureland and punctuated by thick forests. A rustic, rugged terrain, it is home to sheep, horses and cattle. It is also a land of extinct volcanoes; their symmetric cones dot the horizon in every direction.

Accommodations
Rooms with 1, 2, 3 and 4 beds. Rooms have private bathrooms accessible to the disabled.

Amenities
Linens are supplied; towels can be supplied for an additional fee of 3.5€.
Parking, swimming pool, tennis court, badminton and volleyball.
Accessible to the disabled, lift, indoor and outdoor dining rooms, chapel, terrace.

Cost per person/per week
Half board 259.00€, full board 294.00€.
Costs for fewer days to be determined when reservations are made.

Meals
All meals can be provided on request.

Special rules
Guests are required to leave the rooms clean, otherwise they will be charged an additional 20.00€ per week.

Directions
By car: Exit Le-Puy-en-Velay on A75 and take N102 to town.
By train: Get off at Le-Puy-en-Velay and take a taxi to the domaine.

Region: Auvergne **City: Le-Puy-en-Velay**

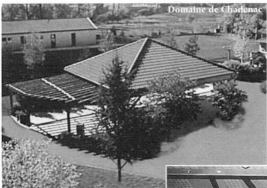

Contact
Anyone who
answers the phone
Domaine de
Chadenac
Ceyssac-La-Roche
43000 Le–Puy-en-
Velay, France

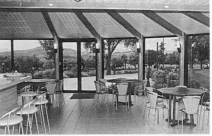

Tel: 0033 (0)4 71 09 27 62
Fax: 0033 (0)4 71 02 87 45
Email: chadenac@free.fr
Website: http://chadenac43.free.fr

 NOTES

LA MAISON DES PLANCHETTES

Property of the Diocese of St-Flour
managed by a lay association

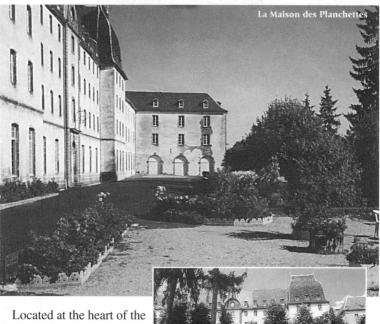

La Maison des Planchettes

Located at the heart of the medieval city of St-Flour in the Cantal, la Maison des Planchettes (House of the Small Planks) is installed in an 18th century building. Just a few minutes from the center of town, the maison overlooks the valley below. Founded in the 15th century, the institution was once the ancient seminary of St-Flour. It experienced various vicissitudes due to the French Revolution and the separation of power between state and church at the beginning of the 20th century. Despite these difficulties, the activity of the seminary continued until 1959. At that time it became a guest house for holidays, workshops and spiritual retreats.

St-Flour is the seat of a 14th century bishopric. Dramatically perched on a basalt promontory above the river Ander, the town was prosperous in the Middle Ages because of its strategic position on the main road from northern France to Languedoc. The medieval city conserves many architectural treasures.

Constructed of hard, black basalt chosen for its durability, the 14th century Cathédral St-Pierre is a structure of striking simplicity; its interior sheltering the only black Christ in France, a fine vaulted ceiling and several works of art, some dating to the 13th century. The church is enveloped in a jumble of old streets lined with 16th and 17th century houses. The entire area is quite appealing, particularly on Saturday mornings when it is filled with colorful market stalls. From the terrace of the cathedral, there are views over the countryside.

A number of attractive ancient buildings and two museums face the cathedral. Musée Alfred Douet displays a collection of furniture, tapestries and paintings. The more interesting Musée de la Haute-Auvergne is housed in the Hôtel de Ville, formerly the bishop's palace, a beautiful edifice dating from the 17th century.

East of St-Flour, the Margeride mountains stretch as far as neighboring Le Velay. These granite mountains are covered in open moorland and deep forest. The Margeride served as an entrenched camp for resistance fighters during WWII. Mount Mouchet holds particular importance for the movement and was the theater of some fierce battles. Today it pays tribute to the brave men and women in a national museum in Auvers. The Margeride is also crossed by dozens of streams that wind their way through dreamy landscapes.

South of St-Flour is the spa town of Chaudes-Aigues where thermal springs gush forth from the earth at over 179° F. They are the hottest in Europe and are used to heat part of the town. Sometimes called "Notre-Dame des eaux chaudes," the town is located at the southern tip of the region. As a result, there is a distinctly southern air to its architecture and spa atmosphere. The city lies at the gateway to Aubrac, a vast and imposing green plateau scattered with villages and "mazucs," mountain farms where cheese is made during the summer months.

Accommodations

The maison has 73 renovated rooms. The number of beds ranges from 1 to 5, some with private bath. Daily room cleaning can be arranged on request.

Amenities

Towels and linens are supplied. Accessible to the disabled. TV room, private parking, chapel. Various meeting rooms are fully equipped for workshops or conferences.

Cost per person/per night

Typical summer costs per person:
No meals, per person 25.80€.
Half board 29.75€ to 42.75€.
Full board 35.90€ to 55.15€.
Note: Rates vary according to the type of room and season. Contact the maison or visit the website for current rates.

Meals

All meals can be provided on request.

Special rules

Closed during the Christmas holiday.

Directions

By car: St-Flour is south of Clermont-Ferrand on N9.
By train: Get off at St-Flour and take a taxi to the maison.

Contact

Mr. Ferraton
La Maison des Planchettes
7, rue des Planchettes
BP 37
15102 St-Flour cedex, France
Tel: 0033 (0)4 71 60 10 08
Fax: 0033 (0)4 71 60 22 44
Email: info@maison-des-planchettes.com
Website: www.maison-des-planchettes.com/

MONASTÈRE DE LA VISITATION
Visitandine Sisters

From its hilltop position, the monastery offers a panorama of the valley below St-Flour, a charming small town of Auvergne. Founded in 1628, the monastery was closed during the French Revolution and reopened in 1928.

The first monastery (1628) was founded in another part of the town and was occupied by a large group of nuns until the French Revolution forced them to leave. Many returned to their homes, but they reunited when the suppression of religious orders ended. Since their numbers had decreased, they took up residence in a different building (also built in 1628) that was restored in 1928. "Our monastery is in a town that is very pretty," said Sœur Marie-Ange. The chapel of the monastery contains three retables; one represents the *Adoration of the Three Kings* and has been classified by "Beaux Arts."

The historic capital of the High Auvergne, St-Flour's history began at the first Christian era with the arrival of Florus. Alongside the cathedral, prestigious landmark of the upper town, many buildings bear witness to the Gothic style of the late Middle Ages as well as masterpieces of the Renaissance period. These structures include the work of sculptors who created art from the basalt stone.

Several inviting towns are in the vicinity. Just northwest of the monastery, Murat is on the eastern edge of Cantal at the foot of a basaltic crag topped by a giant white statue of the Virgin Mary. The closest town to the high peaks, Murat is the easiest to access. Part of the town's appeal lies in its ensemble of gray stone houses, many dating from the 15th and 16th centuries. Crowded together on medieval lanes, they are backdropped by steep basalt cliffs. An elegant 16th century house, Maison de la Faune, is open to the public. The Eglise de Bredons is a Romanesque structure containing 18th century altarpieces. Continuing further northwest, on the fringes of Cantal, Mauriac is small and pretty, with black lava houses and a Romanesque basilica, the Notre-Dame des Miracles.

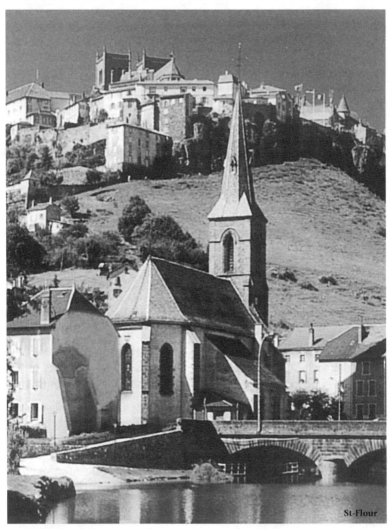

St-Flour

Accommodations

Women only: 18 single rooms with private bath.
Men and women: 20 single and double rooms. Some of the rooms have a
toilet and shower; all have a toilet and sink (shared showers on every
floor).

Region: Auvergne **City: St-Flour**

Amenities

Towels and linens are provided.

Cost per person/per night

Full board 34.00€, other rates depend on the number of meals, type of room, etc.

Meals

All meals can be provided on request.

Special rules

Punctuality at meals is required.

Directions

By car: St-Flour is south of Clermont-Ferrand on N9.

By train: Get off at St-Flour and take a taxi to the monastery.

Contact

Sœur Hôtelière

Monastère de la Visitation

7, avenue du Docteur-Mallet

15100 Saint-Flour, France

Tel: 0033 (0)4 71 60 07 82

Fax: : 0033 (0)4 71 60 43 97

Email: ma.visitation@wanadoo.fr

 NOTES

BRITTANY

MAISON SAINT-FRANÇOIS
Community of Consecrated Lays
Communauté du foyer de Charité de Tressaint

Sheltered within its own flower-filled park, the guest house lies in a peaceful residential area close to the shores of the river Rance, less than a mile from the center of Dinard. The handsome construction is an ancient convent of Capuchin friars presently occupied by a Catholic community of consecrated lays. The maison has been completely restored and offers hospitality to individuals, groups and families.

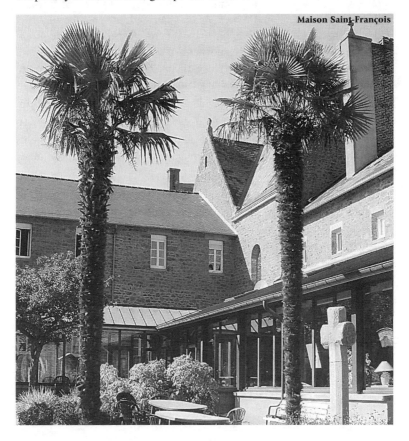
Maison Saint-François

A pretty English-flavored resort, Dinard has princely villas, gardens and parks. Once a fishing village, Dinard sprawls around the western approaches to the Rance estuary, just across from St-Malo (a twenty-minute car ride). Set in a hilly tableau, the town undulates over a succession of scenic coastal inlets with sandy beaches. Footpaths lead off in either direction from the principal beach which is enlivened by reproductions of paintings of the scene displayed at various points along the way including Pablo Picasso's *Deux Femmes Courants sur la Plage* and *Baigneuses sur la Plage*. Both works look quintessentially Mediterranean with their blue skies and golden sands but in actuality were painted in Dinard during Picasso's annual summer visits in the twenties.

One path heads east to the Pointe du Moullinet and views of St-Malo and then continues as the Promenade du Clair de Lune past the tiny port and down to the estuary beach, plage du Prieuré. A stroll along the promenade ambles amidst flowers and palm trees, pinnacled *belle époque* mansions and Mediterranean-style gardens. Hugging the coastline are numerous islands and islets, ideal day trips.

Nearby Dol de Bretagne became one of Brittany's first bishoprics in the 6th century. King Nomino I of Brittany was crowned there in 848 AD. The medieval town has one of Brittany's oldest houses, Maison des Petits Palets. It evokes the past and the Vikings who invaded the region many centuries ago.

Ancient Dol de Bretagne has its charms as characterized by rows of half-timbered houses and an imposing cathedral which owes its founding to St-Samson, one of the seven founding saints of Brittany who came

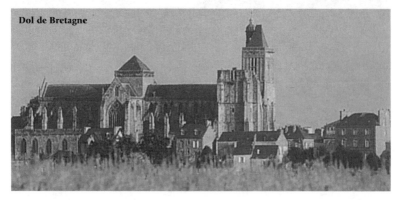

Dol de Bretagne

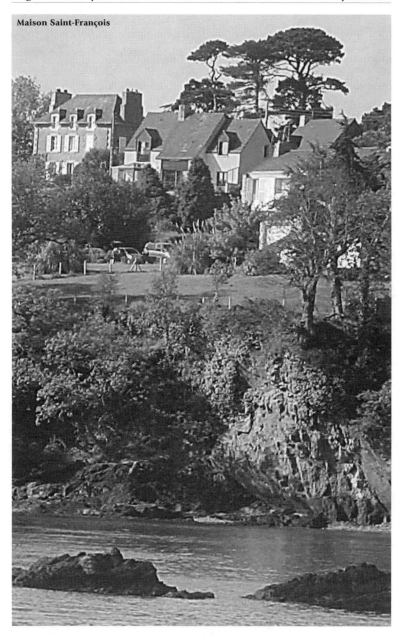

Maison Saint-François

from Britain in the 6th century. A prodigious structure, the cathedral is a gem of religious architecture. Standing on the edge of a marshland and partially built in the 13th century, it is flanked by twin towers, one higher than the other. The interior shelters eighty 15th century choir stalls carved with leaf motifs and human heads.

Situated in front of St-Samson is the "Cathedraloscope," a French national cathedral interpretive and discovery center. Three floors of museum displays and slide presentations explain the "Mystery of Cathedrals" to visitors. The innovative museum journeys through the history of cathedrals using a guided commentary to recreate this singular world.

As in other regions of France, food plays an important role in the character of Brittany. In Breton, a platter of fresh Breton seafood is considered an epicurean delight. *Cortiadea*, a Breton fish soup is a local specialty. Breton leg of lamb with white beans is another treat as are Morlaix ham and chitterlings from Quimperle. *Far Breton* is a cake whose recipe varies from region to region; *kouign amann*, literally butter cake, melts on the tongue.

Accommodations
80 rooms. The number of beds can vary depending on the level of comfort required. All have private baths, but some do not have showers.

Amenities
Linens are supplied; towels are not. There are two workshops, a private garden as well as bikes, books and games for rent. There is also a ping-pong table and TV room.

Cost per person/per night
Price to be determined when reservations are made.

Meals
Meals are always included with the lodging and cannot be reimbursed in case of absence. If a day trip is planned, picnic lunches can be provided.

Directions
By car: Take A11 and exit at Rennes. Follow the signs to Saint-Malò. From there follow the signs to Dinard. A detailed "Plan d'Accès" can be seen on the website.
By train: Get off at Saint-Malò and take a bus to Dinard. The bus terminal is 2 km from the maison. If arrangements are made in advance, transportation can be provided from the train station.

Contact

Write a letter, fax or email the Secretariat
Maison Saint-François
1, avenue des Acacias
La Vicomté – BP 80260
35802 Dinard cedex
France
Tel: 0033 (0)2 99 88 25 25
Fax: 0033 (0)2 99 88 24 15
Email: st.francois@wanadoo.fr
Website: maison-saint-francois.com

 NOTES

MONASTÈRE DES AUGUSTINES
Augustinian Sisters

Possessing the best of both worlds, the monastery is secluded in its own parkland less than a mile from the center of Morlaix. It faces the sea which is fed by the narrow strait of Morlaix. The complex was founded in the 16th century, however, the present order has only inhabited the institution for the past 150 years. The monastery sustains a small museum of sacred art.

During the Middle Ages, Morlaix was one of the great old Breton ports. Built on the slopes of a steep valley, the town was originally protected by an 11th century castle and a circuit of walls. Little is left of either but in the old part of town, the cobbled streets and half-timbered houses evoke the town's medieval past. In the Jacobin convent, Musée des Jacobins contains an interesting assortment of Roman wine jars and a few modern paintings.

Brittany's ancient Celtic name was *Armorica*, (land beside the sea). A landscape comprised of 750 miles of magnificent Atlantic coastline indented with hundreds of bays and inlets, the coast is rimmed by stunning high cliffs and fine sandy beaches. The region is dotted by small fishing ports where brightly painted boats nestle beneath half-timbered or stone houses. Like many a seafaring place, Brittany is a land of legends, from mysterious megaliths to Merlin the Magician, legends imparted in a tableau of forests and castles and elaborately carved stone churches.

Brittany is known for its *Enclos Paroissiaux*, literally "parish close." They represent some of the most spectacular yet common monuments in western France. Parish closes consist of a small monumental park such as a cemetery, around which are grouped a church, calvary and ossuary.

Bretons are known for their deeply religious and traditional culture and a visit to a parish close provides insight into that culture. One of the most beautiful is Lampaul-Guimiliau, an easy day trip from the monastery. There are two other closes in the nearby area: St-Thegonnec and Guimiliau.

On the northern coast of Brittany, not far from the monastery, is the resort town of Roscoff, departure point for ferries sailing to England and Ireland. Ranked as a "Small Town of Character," one of twenty in Brittany, Roscoff's stone heritage is exceptional, with winding stairs, sculpted dormers, finely carved cellar doorways and a church bell tower

Roscoff

topped with lantern turrets. The coastal town's finery is largely the result of its privateering and shipbuilding past. The remarkable uniformity of the old town's architecture (on the waterfront) is of particular interest. Primarily a fishing village, part of the medieval town wall survives beside the seafront. It was in Roscoff that Mary, Queen of Scots, landed in 1548 on her way to Paris to be engaged to François, the son and heir of Henri II of France. Roscoff's granite houses cluster around the 16th century Notre-Dame-de-Croas-Batz which showcases an ornate Renaissance belfry, complete with sculpted ships and protruding stone cannons. From the side, rows of bells can be seen hanging in galleries, one above the other like a wedding cake. *Le Grand Figuier* (giant fig tree) was planted in the early 17th century in the garden of the Capuchin convent. Its sprawling branches are supported on granite columns.

The waters of the English Channel around Roscoff experience a tidal phenomenon. Twice a day coastal landscapes change as the tide goes relentlessly in and out dictating the rhythm of life for marine creatures and flora. The tide is a result of the combined action of the moon and sun. The gravitational pull that these two heavenly bodies exert on the sea causes the tide to withdraw from the coast. The tide goes back in approximately six hours later, covering scenery that just a short time before had been left exposed. When the earth, moon and sun are in syzygy (lined up in a row), a maximum pull results in the extraordinary spring tides. The rise and fall during this time is a rare and magical sight. Nowhere is the landscape quite so varied, the view so changeable.

Heading northeast from the monastery, Lannion's alleyways reveal the town's historical and architectural treasures including 15th and 17th century wooden houses and 18th century mansions. The 20th century chapel of St-

Templar Church

Joseph by architect James Bouille is embellished with frescoes by Xavier de Langlais. The old town is quaintly alluring with its cobbled squares, timbered houses, churches, cloister and monastery. The Templar church of Brelevenez is accentuated by a flight of 142 steps. The Church of St-Jean-du-Baly dates to the 16th century. The Stanco valley runs directly through the town making it ideal for outdoor pursuits. Boat trips leave from the riverbank which is lined by a towpath.

Accommodations
Three small apartments inside the park of the monastery offer hospitality to families or small groups. Two of the rooms have 4 beds; one has 8. All have a bath and kitchen.

Amenities
Towels and linens can be provided on request.

Cost per person/per night
To be determined when reservations are made.

Meals
Not available.

Special rules
Pets are not allowed; guests are required to respect the silence. Open from May to September.

Directions
By car: From Paris take N12 to Morlaix.
By train: Get off at Morlaix and take a taxi to the monastery.

Contact
Sœur Hôtelière
Monastère des Augustines
St-Francis BP 47
29201 Morlaix cedex
France
Tel: 0033 (0)2 98 88 56 36
Fax: 0033 (0)2 98 63 92 55

NOTRE-DAME-DE-BEAUFORT
Dominican Sisters

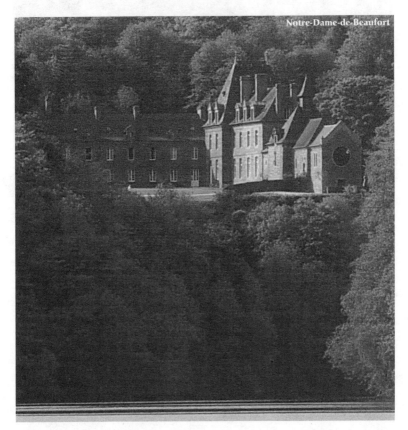
Notre-Dame-de-Beaufort

Dominating the pond of Beaufort, the monastery occupies a pictur-
esque site ensconced in a verdant woodland. The beautiful stone structure
became a monastery after the Dominican sisters took up residence in
1963. The complex was seriously damaged during the German occupa-
tion but over the last forty years, the sisters have managed to restore the
building and enlarge the chapel which has a vaulted beamed ceiling and
rustic stone walls.

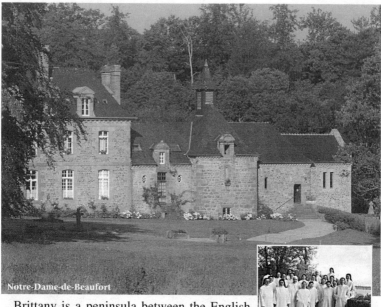

Notre-Dame-de-Beaufort

Brittany is a peninsula between the English
Channel on the north and the Bay of Biscay on
the south. The coast, particularly at the western tip, is irregular and rocky
with natural harbors (Brest, Lorient and St-Malo) and numerous islands.
A part of ancient *Armorica*, the area was conquered by Julius Caesar in
the Gallic Wars. It received its modern name when it was settled (c. 500)
by Britons driven from Britain by the Anglo-Saxons. Brittany and the
Breton people have retained many old customs and traditions. Breton,
their Celtic language, is spoken in Lower Brittany. Costumes featuring
high lace headdresses are distinctive in every community and are widely
worn on Sundays and holidays. Many megalithic monuments, attributed
to the Druids, dot the countryside.

Sitting in the heart of the Rance valley, nearby Dinan occupies a
plateau overlooking the valley and the ocean port below. The former seat
of the Dukes of Brittany, its rue du Jerzual was once the main street lead-
ing to the port. The town's medieval heritage is apparent in the ancient
houses and churches along its cobbled streets. The 14th century Château
de Dinan houses collections offering some insight into the history of the
Pays de Dinan; its dungeon includes a museum.

Nearby Lehon has recently been awarded "Small Town of Character" status. In the 9th century, King Nomino founded a Bénédictine abbey that houses the relics of St-Magloire. The Lords of Dinan built a fortress on the rocky spur to protect the richly endowed abbey and defend the passage of the river Rance. In later years, the craft industry contributed to the prosperity of this ancient castle town. It has retained an historic and religious heritage that recalls its importance in medieval times. Reminders of its significance can be seen in fine houses with molded cornices and sculpted lintels.

Once an important Gallo-Roman town, the regional capital of Rennes is a fairly large city with over a quarter million residents. It is a mixture of "new" 18th century royal architecture enveloped by an array of half-timbered houses from the 15th century. Its recent restoration project has blended medieval heritage with modern industry. Home to the Brittany Parliament, the city is also known for its museums, theaters and festivals. The restored 15th century Chapelle St-Yves shelters a permanent exhibition that relates the story of the city.

Palais des Musée contains the Musée des Beaux-Arts and the Musée de Bretagne. The former displays a collection of art from the 16th century to the present day including paintings by Veronese, Rubens, Corot, Sisley and Gauguin. The latter provides insight into Breton art, history and culture. The place du Palais and place de l'Hôtel-de-Ville form the heart of old Rennes; la place des Lices is a bustling meeting place on market days.

Becherel, a tiny town perched atop a hill, is also in the vicinity. A Celtic cross and Gallo-Roman ruins are testimony to the town's ancient background. The streets are lined with graceful 16th to 19th century houses. The imposing Romanesque church can be seen soaring upward from a small circular warren of streets filled with quaint squares. Although linen and hemp once made Becherel a prosperous town, today it is renowned for its bookbinding and calligraphy workshops. There are so many new and second-hand booksellers that the old fortified town has become the third largest book town in Europe.

Accommodations

30 beds in 13 single and 10 double rooms. Only 2 rooms have private bath. All rooms have a sink.

Amenities
Towels and linens are provided. Meeting
room available to guests.

Cost per person/per night
To be determined when reservations are
made. Rates will depend on the type of
hospitality (generally about 30.00€ for
half board).

Products of the institution
The sisters produce jam, honey, candles,
icons, religious garments and fabric with
batik decorations.

Meals
All meals are provided with the lodging.

Special rules
Full board for those coming for spiritual retreats; half board for other
guests. Punctuality at meals, no radio or noise inside the monastery.
Closed the last two weeks of June, the first two weeks of September and
the first two weeks of January.

Directions
By car: From St-Malo take N137 south to N176. Take N176 heading
towards Caen. Follow the signs to Plerguer. Take C201 from Plerguer to
Beaufort.
By train: Get off at Dol-de-Bretagne and take a taxi to the monastery.

Contact
Sœur de l'Accueil
Notre-Dame-de-Beaufort
35540 Plerguer
France
Tel: (Sœur de l'Accueil) 0033 (0)2 99 48 36 12
Tel: (Monastery) 0033 (0)2 99 48 07 57
Fax: 0033 (0)2 99 48 48 95
Website: http://ndbeaufort.free.fr

L'ABBAYE

Sisters of the Immaculate (Sœurs de l'Immaculée)

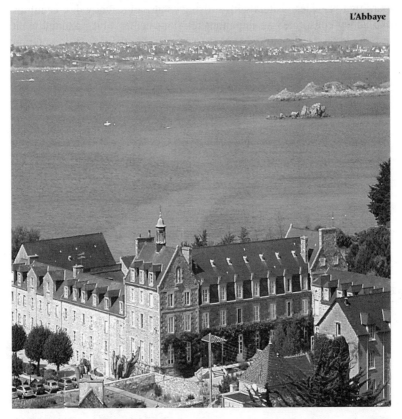

L'Abbaye

Brittany is defined by the sea and its coast which spans some 750 miles, sometimes jagged with treacherous cliffs, sometimes flat with long sandy beaches, and always, with palms, oleanders, figs and mimosas which thrive in the mild climate. For coastal Bretons, the sea means anything from raising oysters to deep-sea fishing. The area where the monastery is located is known as the Emerald Coast, named after the sparkling green color of the sea.

St-Jacut-de-la-Mer is almost an island, located between the bays of Lancieux and Arguenon and linked to the coast by a rocky isthmus. The abbey is a large complex quartered on this enchanting spot in the northernmost region of Brittany. Founded in 465 by St-Jacut it was originally a Bénédictine institution. The abbey is near the ocean and lodged in a park that provides visitors with a distinct sense of serenity. For centuries the abbey constituted an important religious center which exerted great influence on the development of the area. During the French Revolution the monks were forced to leave and the abbey was almost destroyed.

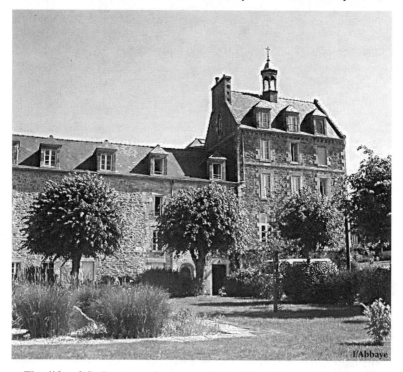

L'Abbaye

The life of St-Jacut revolves around the life of the monastery, which despite numerous vicissitudes, was a powerful institution until the 16th century. Beginning in 1875 the community of the Sœurs de l'Immaculee of St-Méen-le-Grand took up residence in the complex. During the summer months the abbey welcomes guests on holiday. At that time, the sisters organize numerous activities, excursions and workshops.

At the tip of the Arguenon area, at the heart of the Emerald Coast, St-Jacut is an attractive seaside resort and fishing village sited on a peninsula with a large natural bay lined with eleven beaches. Ebihens Island has a causeway that can be crossed at low tide. Most likely separated from the coast by an earthquake in the 6th century, traces of prehistoric settlements have been uncovered on Ebihens. A travel itinerary can include nearby St-Malo and Fort La Latte.

In the 9th century refugees fleeing Norman raids on St-Servan settled in St-Malo. The walled city is considered a Corsair City (corsairs were pirates). Renowned for its architecture and majestic site on a rocky promontory guarded by a reef of small islands, the bustling seaport was almost annihilated at the end of WWII. The city, however, was rebuilt with so much care for its original appearance that its narrow streets somehow retain a medieval milieu. A walk around the famous ramparts is the best way to view the sea and the town. St-Malo's castle was built by the Dukes of Brittany outside the walls of the town. Two of its towers are now museums; Grand Donjon illustrates the town's maritime history while the Quic-en-Groigne contains waxworks of the exploits of the corsairs.

Built in the middle of the 14th century by the Goyon-Matignon family, Fort La Latte was originally called Roche Goyon. It suffered two major sieges, the first in 1379, the second in 1597. An excellent example of medieval architecture, it was transformed under Louis XIV into a coastal defense fort. At that time its high walls were converted into cannon batteries. The pink sandstone watchtower protected St-Malo's ships from their enemies, the English and the Dutch. The military career of the fortress continued into the 19th century. Now listed as an historic monument, it is open to visitors.

Accommodations
95 rooms all with private bath. Rooms have 1, 2 or 3 beds.

Amenities
Towels and linens can be provided with the lodging (make arrangements when reservations are made). There are several meeting rooms that can accommodate up to 180 people, two TV rooms, a gallery for parlor games, reading room, library, tennis court and ping-pong table. There are four dining rooms.

Cost per person/per night

Approximately 40.00€ to 54.00€ per day (adults). Rates depend on the season, number of people, type of room, etc. For updated rates visit the website or inquire when reservations are made.

Meals

All meals can be provided with the lodging.

Special rules

Punctuality at meals. It is preferred that guests arrive in the afternoon on their first day. Closed the last week of June.

Directions

By car: From Paris take A81 or N12 to Rennes. From there follow the signs to St-Malo on N137. Exit at Dinan and take D794 west, past Dinan to Plancoët. Once there take D768 to St-Jacut-de-la-Mer.

By train: From Paris get off at St-Malo, Rennes (TGV) or Plancoët. Take a bus or a taxi to the abbey.

Contact

Directrice
L'Abbaye
BP 1
22750 St-Jacut-de-la-Mer
France
Tel: 0033 (0)2 96 27 71 19
Fax: 0033 (0)2 96 27 79 45
Email: abbaye.st.jacut@wanadoo.fr
Website: www.abbaye-st-jacut.com

NOTES

ABBAYE DE RHUYS
Sisters of the Charité de Saint-Louis

The spiritual center is an ancient abbey quartered in the middle of St-Gildas-de-Rhuys on the Golfe du Morbihan and the wild coast of Brittany. Founded in the 6th century by Saint-Gildas, an Irish monk, it was later occupied by a Bénédictine community. The church of the abbey has survived through the centuries and is a unique example of monastic Romanesque architecture blending elements of the 11th, 12th and 17th centuries. Today the former monastery of the abbey is inhabited by the Sisters of the Charité de Saint-Louis and managed by lay personnel.

The Golfe du Morbihan is only twelve miles wide and among the most provocative coastal settings in Brittany. Literally "little sea," Morbihan is sprinkled with tiny islands. It is a medley of picturesque villages, fishing boats, sea and migratory birds. The coastline also has several nature reserves and numerous walking paths. On either side of this virtual island/peninsula lie two very different views of the maritime world – the Atlantic and the Gulf. Composed of nine ports, the largest is at Port Crouesty. The smallest, Port aux Moines, is at St-Gildas. The best way to see the area is by boat; there are many rentals and tours available.

One of the foremost prehistoric centers is the seaside resort of Carnac, famed for its megalithic remains from the Neolithic period. In addition to almost 3,000 *menhirs*, (massive stones erected by tribes who inhabited the region before the arrival of the Gauls), the area is studded with burial places, semi-circles and *tumuli* (a pile of stones or earth placed over a grave). Carnac nestles in beautiful Quiberon Bay. Its Musée de la Préhistoire shelters a vast collection of artifacts.

Vannes

Located ten miles off the southern coast is Belle Ile, Brittany's largest island. Buffeted by storms and fringed by rocky cliffs, it is an isolated natural paradise. It is also home

to three different species of seagull. The medieval city of Vannes, at the head of the gulf, is a perfect base from which to experience the inland sea and its many islands. The city is enclosed by 13th century ramparts that recollect Brittany's medieval and Celtic past. It was in Vannes in 1532 that the province formally united with France. The old town and market-place are easy to explore. Points of interest include the 13th century ramparts, the Renaissance-style town hall, the Château du Plessis-Josso and the Cathédral St-Peter which shelters the tomb of St-Vincent Ferre. There is also an enchanting butterfly garden.

St-Corentin

Somewhat further afield but definitely worth a visit is the provocative town of Quimper. Inhabited since Roman times, it is the oldest Breton city and still reflects a Breton sensibility. The cobbled streets of Vieux Quimper are mostly pedestrianized and marked by half-timbered houses. The central part of the old town is surmounted by the extraordinary 13th century cathedral dedicated to St-Corentin, first bishop of the city. The church is remarkable for its noble twin spires, soaring vertical lines and 15th century stained glass windows. Between the spires is an equestrian statue of King Gradlon, the city's fabled founder.

The derivation of the city's name is found in the word kemper denoting the junction of two rivers, the Steir and the Odet. The city's origins date to Brittany's storied past when the good King Gradlon, fleeing the flooded city of Ys, founded a new city on the banks of the Odet. Tradition holds that the city of Ys was flooded because of the transgressions of Dahut, King Gradlon's corrupt daughter. Depicted by poets and painters, the dramatic legend remains popular today. In 1888 Edouard Lalo set the legend's story to music, causing audiences to shudder at this tale of chastised vice.

The verdant slopes of Mont Frugy form a green rampart overlooking the entire town. Below the mont, alleys of plane trees stretch alongside the river to Locmaria, the oldest part of Quimper. The Palais des Evêques is in the 16th century palace of the bishops of Quimper. It preserves rich collections of archeology, antiquities and the popular art of Finistere including precious metalwork, statues and stained glass. Two floors are devoted to Breton arts and traditions, such as costumes, furniture and Quimper pottery. Each July the week-long Fêtes de Cornouaille, Brittany's major festival of folk music and dance takes place.

Quimper

Nearby is the oldest Quimper pottery factory, Faïenceries HB-Henriot, where the characteristic wares have been made since the 17th century. The pottery depicts biblical scenes of Bretons in traditional dress. The studio/factory preserves the art of hand-painted pottery and continues Quimper's famous style of decoration. Since 1690 each piece has been individually hand-painted and signed by the artist. Guided tours allow visitors to witness every stage of pottery production from raw clay to final firing.

South of Quimper is picturesque Pont-Aven, an engaging market village defined by white houses and sloping riverbanks. Although the town's initial claim to fame was based on the saying, "Pont-Aven, town of renown, fourteen mills, fifteen houses," it was also home to the artists' colony known as the "School of Pont-Aven" led by painter Paul Gauguin. The style drew its influence from the Breton landscape and its inhabitants. Musée de Pont-Aven chronicles the achievements of the school. A pleasant walk above town leads to the Tremalo Chapel and the painted wooden figure of Christ on the Cross, inspiration for one of Gauguin's paintings, *Le Christ Jaune*. Visitors can explore the Lover's Wood and take the *Painters Route* from Pont-Aven to Pouldu. *Route des Phares* (The Lighthouse Route) provides a perspective of life in a lighthouse. To the west of Quimper is the Pointe du Raz, a protected nature enclave and one of the most beautiful spots from which to view the ocean.

Accommodations

140 beds in double rooms, most with private bath.

Amenities

Towels and linens are provided. Four meeting rooms, dining room, chapel, oratory, garden and access to the coast by a private path.

Cost per person/per night

Full board with private bath 44.00€, with shared bath 39.00€.

Meals

All meals are provided.

Special rules

Full board only. Punctuality at meals, silence in the rooms. Curfew is from 10:00 PM to 7:00 AM.

Directions

By car: From Paris reach Vannes via Rennes and take N165 and D780 to St-Gildas-de-Rhuys.

By train: Get off at Vannes (direct train from Paris) and take a taxi to St-Gildas. There are only a few buses available, ask once there.

Contact

Secretariat
Abbaye de Rhuys
Place Monseigneur Ropert
56370 St-Gildas-de-Rhuys
France
Tel: 0033 (0)2 97 45 23 10
Fax: 0033 (0)2 97 45 35 81
Email: abbaye.de.rhuys@wanadoo.fr
Website: http://catholique-vannes.cef.fr/site2/09-02i.html

CENTRE SAINT-AUGUSTIN
Property of the Diocese
Managed by "Foyer de la Charité" a religious association

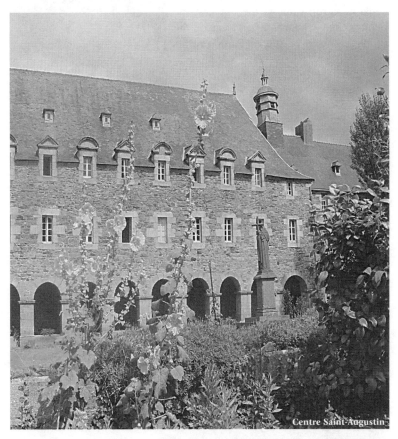
Centre Saint-Augustin

This former Augustinian convent is quartered in the center of Tréguier, less than two miles from the ocean. It was built in the 17th century over the ruins of Salles de passants, an ancient hospital where St-Ives once assisted the ill. The saint (1253-1303) is the main saint of Brittany. A native of Tréguier, during his early years he served as ecclesiastic judge but soon

abandoned this profession to care of the poor and ill. He was canonized in 1347 by Pope Clement VI who made him one of the few official Breton saints. His legacy was the cult of St-Ives which rapidly spread beyond the regional borders. He became patron saint of men of law, the poor, ill and orphans. Every year on the third Sunday in May, the "Pardon of St-Ives" (Pardon of Lawyers) takes place in Tréguier, a pilgrimage destination for lawyers from all over the world.

At a point in time, the convent was reconstructed and the hospital inhabited by a community of Augustinian friars and then by a group of priests. It is now a religious center managed by lay person-

Tréguier

nel. "The complex has been classified as an historical monument. We also have a Baroque retable... but it is the 'ensemble' that has a special atmosphere," said Catherine, the woman in charge of hospitality.

St-Tugdual

Founded in the 6th century by St-Tugdual, the once Episcopal town of Tréguier is very pretty and home to the graceful Cathédral St-Tugdual, constructed during the 11th to 13th century. The church conserves a handsome cloister and tower that dominate the town. In the town center, elegant half-timbered houses and façades edge the streets. Relaxing walks can be had in the *Bois du Poète* (Poet's Wood) and along the banks of the river Tréguier.

The nearby environs compose a rich mosaic of natural settings with over 900 miles of coastal footpaths. The area between Paimpol and Roscoff is known as the Pink Granite Coast because of the extraordinary rose-colored rock formations so different from the gray of the granite rocks found elsewhere in Brittany. The Sentier des Douaniers, a particularly interesting promenade leads from Perros-Guirec to the fishing port of Ploumanac'h whose oddly shaped giant granite boulders have been nicknamed: *The Whale, The Thimble, The Sea Tortoise* and *Napoleon's Hat*. Perros-Guirec abounds with vast beaches, marinas, a spa and casino. The Church of St-Jacques le Majeur was constructed of pink granite in the 12th century.

Off the coast, the Seven Islands archipelago's bird reserve can be reached by motorboat. The islands comprise a major bird sanctuary and are home to gannets, torda penguins, razorbills and puffins. On Ile aux Moines, 83 steps lead to the top of the lighthouse and outstanding views of the islands and coast.

To the south of Tréguier, Château de la Roche-Jagu is an inspirational and enchanting place to visit. Perched above the Trieux, the château overlooks the valley, its gardens gently sloping to the river. It is the last remaining building in a chain of fortifications started in the 11th century. The architecture reflects both defensive and civil purposes. The parapet walk and watchtowers were designed to defend the château against possible attack while the courtyard façade is one of elegance as manifested in large windows and Gothic adornment. Classified as an historic monument in 1930 the encompassing gardens reveal a contemporary landscape that is provocatively medieval. Water, a ubiquitous element, tumbles down slopes, spills out from a wall, feeds the pools and snakes its course down to the river. At the entrance to the grounds, edible and medicinal plants grow in small gardens enclosed by trellises of willow and chestnut. The garden also features numerous exotic species, palm trees and agaves.

Also south is the historical town of Guingamp. Situated between the sea and the woods, the town has preserved its original architecture of Renaissance houses. Reminders of the past can be seen in the 15th century castle, partly dismantled by Richelieu and in the Basilica of Notre-Dame of Bon-Secours, a splendidly designed church underscored by a stylistic architectural mix including Gothic and Renaissance. The north porch

contains a rare Black Madonna, carved from black stone. The place du Centre represents the heart of the town with its characteristic wooden houses, granite façades and sculpted portals. A beguiling ensemble, it is focused on the famous 15th century fountain of la Plomée, dedicated to the Celtic Goddess Ana. Guingamp is also renowned for the Festival of Breton Dance and the St-Loup festival.

Brittany is a land where traditions are strong and the region's Celtic origins are ever-present. Although Brittany has been a part of France since 1532, the Bretons are particularly proud of their language and heritage; Celtic words and expressions are often sprinkled in with French. All the villages of the region whose names start with "Plou" mean "the parish of" and a sign on a house that says "Ker Maria," means "the house of" Maria. Even the stories the Bretons tell hail from their Celtic roots, i.e., it was in the forest of Broceliande that Merlin, legendary magician, was imprisoned by Viviane.

Accommodations

During the academic year the center mainly hosts students but the remainder of the year it is open to all visitors for holidays or spiritual retreats. About 8 people can be hosted in "studios" provided with a small kitchen and a bath. The studios are located in the inner garden of the former convent. During the academic year only 2 beds are available.

Amenities

Towels and linens are provided on request.

Cost per person/per night

The rate depends on the season and the size of the studio.

Meals

Meals are not provided but there is a kitchen guests may use.

Directions

By car: From Paris reach Guingamp via Rennes and then N12. From
there follow the signs to Trèguier.
By train: Get off at Lannion or Guingamp and take a taxi to the center
(buses run infrequently).

Contact

Madame Catherine Droux
Centre Saint-Augustin
30, rue de la Chalotais
22220 Tréguier
France
Tel: 0033 (0)2 96 92 32 20
Fax: 0033 (0)2 96 92 13 90
Email: st-augustin@wanadoo.fr

 NOTES

BURGUNDY

CENTRE SOPHIE BARAT
Sacré-Cœur Sisters

The center is the birthplace of Sophie Barat, founder of the Order of Sacré-Cœur Sisters who was born here in 1779. In 1894 after her beatification, the house became a religious institution. In 1994 it became a center of hospitality for the devotees of Sophie Barat, for those seeking spiritual retreats or for tourists wishing to visit the town. "It does not contain works of art," said sister Marie-Therese, "but it is a très jolie maison." The house dates back to the 16th century and is nestled in a pretty garden that links the buildings of the complex. The river, tranquil woods and lush vineyards of Joigny are only a five-minute walk from the center.

Joigny is a city of great character stretched out on the shores of the river Yonne in the very heart of Burgundy. Its strategic position led to the construction in 996 of a fortified castle. The city was nearly destroyed by a fire in 1530 and most of the buildings were erected after that time. It is divided into several quarters that bear witness to the various stages of architectural development that occurred after the fire.

The narrow lanes of Joigny ascend steeply from the river. Ancient houses climb the slope while a 10th century fortress backdrops the evocative medieval scene. A tree-lined riverside path and 18th century bridge provide fine views of the old town. Rue Gabriel Cortel is lined with many buildings from the Middle Ages. These timbered structures are more than 700 years old; many were damaged during WWII but have been diligently restored. An interesting architectural assemblage distinguishes the town: the 12th century Porte du Bois, once the entryway of a castle; the 16th century Château des Gondi, built by the cardinal of the same name; the ancient convent of Notre-Dame; and the churches of St-Jean et St-Andres. The interior of the Gothic-Renaissance style St-Thibault harbors the *Smiling Virgin*, a 14th century statue.

Burgundy is especially famous for the wine produced in the Chablis region, the mountains of the Côte d'Or and the Saône and Rhône valleys.

During the Gallic Wars, the territory was conquered by Caesar and then conquered by the Gungundii (c. 480), a tribe from Savoy. The golden age of Burgundy began when John II of France bestowed the fief on his son, Philip the Bold, founding the line of Valois-Bourgogne.

South of the center, Auxerre inherited its name from the medieval county of Auxerrois. In 1435 it became part of Burgundy with the Treaty of Arras. One of the oldest and most alluring towns in the region, Auxerre is a composition of narrow, cobbled lanes and inviting squares including the pedestrianized place Charles-Surugue and rue de l'Horloge. Classified as a protected site, Auxerre's timbered houses and picturesque clock tower are attractively ensconced on a hill overlooking the river Yonne.

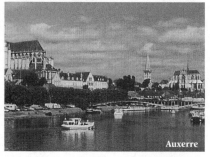
Auxerre

Gothic Cathédral St-Etienne was built over the course of three hundred years and wasn't completed until the mid-16th century. It is celebrated for its elaborate series of 13th century stained glass. The choir is defined by narrow columns and represents the best of Gothic elegance. The western portals are adorned with splendid Flamboyant sculpture while the Romanesque crypt displays 11th to 13th century frescoes including the famous *Christ on Horseback*.

St-Germain, 5th century bishop of Auxerre and founder of the first monastery in Auxerre, was buried in the abbey church of St-Germain. The crypt contains some of the only surviving examples of Carolingian architecture in France. Supported by thousand year old oak beams, the walls and vaulted ceiling are embellished with 9th century frescoes. The museum contains an exhibition of prehistoric artifacts and Gallo-Roman remains, testimony to Auxerre's illustrious past.

The Carolingians were a dynasty of Frankish rulers in the 7th century. Carolingian architecture reached its apex under Charlemagne. Inspired by the forms of antiquity, this style of architecture abandoned the small boxlike shapes of the Merovingian period and used spacious basilicas often intersected by vast transepts.

Once a Celtic and then a Roman settlement, nearby Tonnerre is revealed in its narrow streets and old quarter. The medieval town boasts the Fosse Dionne, a Vauclusian spring out of which an amazing amount of water bursts forth from the ground into an 18th century washing site. Considering its depth and strong currents, the

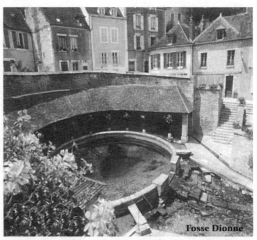

Fosse Dionne

somewhat cloudy green spring has never been completely explored. Legend holds that a serpent lives at the bottom. The town is also home to the Hôtel Dieu. Founded by St-Louis' sister-in-law, Marguerite de Bourgogne, it is one of the oldest and largest hospital monuments of medieval France. The impressive structure was finished in 1293; the ceiling and woodwork are in the form of an overturned ship. Its museum shelters seven hundred years of treasures.

South of Tonnerre, Noyers-sur-Serein is among the prettiest enclaves in France. A medieval village quartered at the gateway to the Chablis vineyards, it possesses some exceptionally charming features including cobbled squares and streets, half-timbered houses, lava and old tile roofs. In the Middle Ages, Tonnerre was best known for its castle. Begun at the end of the 12th century, vestiges of the immense structure remain. Triangular in shape, it was protected by two enormous ditches, still perfectly visible.

Nearby Avallon is a walled town on a granite spur between two ravines. The hilltop position overlooks the lush terraced slopes of the Cousin valley. A significant strategic site since Roman times, the ramparts date from the 15th and 16th centuries. Its main monument is the 12th century Romanesque Eglise St-Lazarus delineated by two carved doorways in Burgundian Romanesque style. The doors highlight the signs of the zodiac, labors of the months and the old musicians of the Apocalypse.

South of the church is the city's ancient portal, Bastion de la Petite Porte and a promenade of the same name. The promenade is a terrace of lime trees with wonderful views of the countryside. The spire of the 15th century Tour de l'Horloge looms over the town. Musée de l'Avallonnais displays a variety of collections including religious art, fossils and a Venus mosaic dating from the 2nd century AD. Musée du Costume has an array of regional clothing from the 18th to 20th centuries.

Accommodations
35 beds in single and double rooms and one 4-bed room. Some of the rooms have private baths.

Amenities
Towels and linens are supplied. There are two dining rooms, a conference hall, chapel and three private gardens.

Cost per person/per night
Provisional cost is 44.00€ for full board.

Meals
All meals can be provided with the lodging.

Directions
By car: From Paris take A6 and exit at Joigny. Take D943 to Joigny. A detailed map can be seen on the website.
By train: From Paris take a train of the Paris-Dijon-Lyon line and get off at Joigny: From there walk (10 minutes) or take a taxi to the center (taxis are not always available at the train station).

Contact
Anyone who answers the phone
Call in advance, the sisters will require a written confirmation.
Centre Sophie Barat
11, rue Davier
89300 Joigny
France
Tel: 0033 (0)3 86 92 16 40
Fax: 0033 (0)3 86 92 16 49
Email: centre-sophie-barat@wanadoo.fr
Website: http://centre.barat.free.fr

MONASTÈRE DE LA VISITATION
Visitandine Sisters

The monastery is nestled in Burgundy's pretty countryside along the banks of the Loire river, a short distance from the center of Nevers. The third French monastery of this order, it was founded in 1616 by Ste-Jeanne de Chantel, the same nun who established the Order of the Nuns of the Visitation.

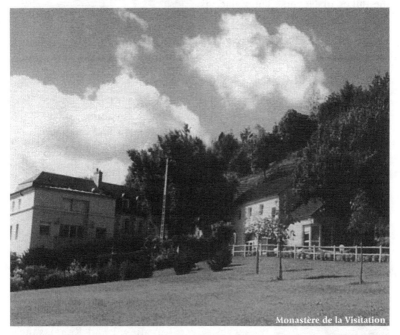

Monastère de la Visitation

The institution was closed during the French Revolution and the sisters didn't return to Nevers until 1854. During the second suppression of the religious orders (in 1908), the community once again had to leave, relocating to Belgium. In 1935 the order returned to France and in 1993 moved to the present complex. There are no works of art but there is a pretty chapel created by the restoration of a hayloft that exposes the natural rock of the hill. There is also a shop that sells souvenirs of Ste-Jeanne.

The history of Nevers began with Julius Caesar as *Noviodunum Aeduorum*. Gallo-Roman vestiges remain including the Porte du Croux, a 1393 fortified city gate with pepper-pot turrets astride a circular rampart walkway. The skyline of Nevers rises in tiers above the old town whose center is dominated by the 15th century Palais Ducal, former home of the dukes of Nevers. The palace is defined by octagonal turrets and a central tower adorned with sculptures illustrating the family history of the first duke. Nearby Cathédral St-Cyr

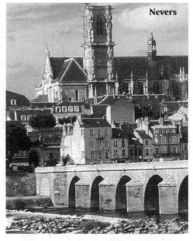

Nevers

reveals a wall display of French architectural styles from the 10th to 16th centuries. It also features two apses; one Gothic, the other Romanesque. The late 11th century Eglise St-Etienne is perhaps more interesting and aesthetically pleasing. A gem of Romanesque architecture, behind its plain façade lies one of the prototype pilgrim churches, with galleries above the aisles and three radiating chapels around the apse. The remains of Ste-Bernadette, who lived there from 1860 to 1879, are preserved in the Convent of St-Gilard. The town itself is a warren of narrow lanes and stepped alleys fronted by buildings dating from the 15th and 16th centuries.

Faïence pottery

Perched over a bend in the Loire on Burgundy's western border, Nevers has been famous for its faïence pottery since the 16th century; a fine collection is displayed in the Musée Frederic-Blandin. The museum also traces the pottery's development over the centuries. The old town preserves several medieval and Renaissance buildings.

East of Nevers is the intriguing town of Autun. During the 1st century BC, in order to diminish the importance of Bibracte, Roman Emperor Augustus founded *Augustodunum*, which as "Rome's sister city," quickly absorbed the elite

class of the Aedui population. The Gallic and Roman lifestyles fused and gave rise to a new society and to a Gallo-Roman people. From that golden age to the present, Autun has conserved an incredible list of historical vestiges. The city was built with a set of ramparts four miles long buttressed by fifty-four towers. Two-thirds of these ramparts still stand. Of the four monumental gates, two remain; the Arroux and the St-Andre. The amphitheater, Janus Temple and Couhard Stone are testimony to this era of splendor. The ancient theatre was the largest in all of Roman-held Gaul. It spread over a diameter of 485' and could hold 20,000 spectators on three levels, two of which are still in place. Each summer hundreds of local actors perform in a sound and light show.

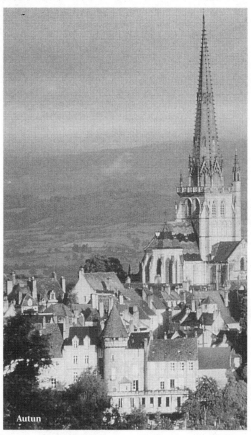

Autun

Although the spire of Autun's imposing St-Lazare Cathedral is distinctly Gothic in style, the 12th century church is primarily Romanesque. The façade depicts the *Last Judgement*, key theme of Romanesque sculpture. The celebrated sculptor Gislebertus deviated from Middle Age artistic practice by signing this work. The interior of the church represents the Burgundian School of Romanesque art. The columns are embellished with sixty sculpted capitals illustrating biblical scenes. On display in the Musée Rolin are archeological and medieval exhibits, statues and the *Nativity of Cardinal Rolin* by the Master of Moulins.

Accommodations
12 beds in single and double rooms, some with private bath.

Amenities
Towels and linens are offered.

Cost per person/per night
To be determined upon arrival.

Meals
All meals can be provided on request.

Special rules
Maximum stay 1 week. The community offers hospitality mainly for spiritual retreats, but according to the Sœur Hôtelière, "hospitality is also offered to those who travel and wish to stop here."

Directions
By car: From Paris take A77 and exit at Nevers center. Take N7 to the monastery.
By train: Get off at Nevers and walk or take a bus to the monastery.

Contact
Sœur Hôtelière
Monastère de la Visitation
49, rue des Saulaies
58000 Nevers
France
Tel: 0033 (0)3 86 57 37 40
Fax: 0033 (0)3 86 57 25 98

FOYER DU SACRÉ-CŒUR
Cor Christi religious association

Foyer du Sacré-Cœur

A former seminary converted into a guest house, the foyer is positioned in front of the Chapel of Apparitions in the center of its own garden. At one time it was inhabited by priests and then by a community of sisters. Today it is managed by the religious association Cor Christi, formed by consecrated lays.

According to tradition, between 1673-1675 Jesus' heart appeared in the chapel to Marguerite Marie Alacoque. The chapel soon became a popular pilgrimage site. Pope Pious IX eventually began the festivity of the Sacred Heart. During the past twenty years, the town has seen an increase in its popularity thanks to the visit of Pope John Paul II (1986). He stayed in the Foyer Sacré-Cœur in room number 4.

Paray, in the southern part of Burgundy, means "of the monks" and is among the most popular places of pilgrimage in France. The charming old town is enriched with half-timbered houses and other Renaissance structures. The Basilique de Sacre-Cœur, built in 1109 from blocks of pale stone, is a smaller version of the now lost abbey church at Cluny. Pure Romanesque, the

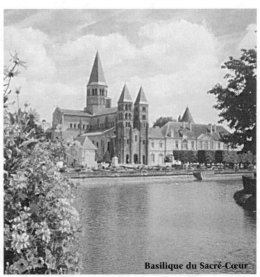

Basilique du Sacré-Cœur

architecture spotlights two square towers and an octagonal central spire. The slender columns of the interior mirror a classic influence.

At nearby Macon, the tree-lined Saône sweeps along beneath the windows of wine merchants' homes and warehouses to the city's port. The bustling pedestrianized section of the old town is a patchwork of shady squares and centuries-old buildings including the celebrated Maison de Bois, a half-timbered Renaissance townhouse carved with masks and curlicues. Musée Lamartine is housed in the aristocratic 18th century Hôtel Senece. Exhibitions depict the life and times of native son and poet Alphonse de Lamartine. Sheltered in a 17th century Ursuline convent, the Musée des Ursulines highlights local archeological finds in addition to 16th to 20th century paintings. Macon is the capital of the Maconnais, a small wine area west of the town that produces reds and highly acclaimed whites.

Close to Macon, the landscape is dominated by the huge monolithic rock of Solutre, a spectacular limestone cliff amidst the vineyards of the Maconnais region. Listed as one of France's prestige sites, the outcropping contains thousands of prehistoric horse fossils along with many artifacts, engraved silex and stones dating back thousands of years. It also preserves architecturally significant monuments such as stone walls, huts, washhouses and fountains. Solutre has been a pilgrimage destination

Rock of Solutre

from the time of the Celts to present day. French President Mitterrand has led groups on annual walks to the summit of the rock. Visitors can trace this trail and enjoy splendid views from the top.

St-Philibert Abbey is also in the vicinity of Macon. An exceptional specimen of the primitive Romanesque art movement, the abbey dates from the 11th and 12th centuries and is the oldest of Burgundy's major Romanesque churches. On the monument's majestic façade, the ornamentation is functional as well as decorative. Inside, the dimness of the penetrating light provides a stark contrast to the bright light streaming into the nave through the tall windows. The chapel safeguards the shrine to St-Philibert, patron saint of the order of monks who founded the monastery. The complex contains a cloister, chapter room, refectory and cellar.

In Burgundy, visitors are never far from a hospice, historic abbey or Bénédictine monastery, testimony to the importance of the monastic orders in the region's history. Among the most illustrious is the Bénédictine Ancienne Abbaye de Cluny, whose influence reverberated throughout Christendom. The ripple effect touched politics, religion, architecture and art. The Bénédictine Order was a keystone to the stability that European society achieved in the 11th century. The abbey of Cluny became the grandest, most prestigious and handsomely endowed monastic institution in Europe. The height of Cluniac influence started in the second half of the 10th century and continued through the early 12th. William I the Pious, Duke of Aquitaine and Count of Auvergne, founded the monastery. It differed in two ways from other Bénédictine houses—in its organizational structure and execution of the liturgy as its main form of work.

The abbey church was built in a distinctive Romanesque style and was the world's largest. After the French Revolution, it was demolished, leaving only the octagonal Clocher de l'Eau-Benite, two other towers and a part of the main abbey building. From these fragments, it is still possible to envision what once was. Sprinkled around the abbey, the small town of Cluny sustains several Romanesque structures.

Accommodations
54 rooms with 1 to 4 beds; some with private bath.
Amenities
Towels and linens are supplied. Private garden and parking.
Cost per person/ per night
Lodging only: 24.00€.
Half board 32.10€.
Full board 43.40€.

Meals
All meals can be provided with the lodging.

Special rules
Closed in January.

Directions
By car: Take A6 and exit at Châlon-sud or Macon and follow the signs to Montceau-les-Mines, Digoin and finally Paray-le-Monial on N79.

By train: Get off at Paray-le-Monial (SNCF) or Le Creusot (TGV). From Paray take a taxi or walk (twenty minutes) to the foyer. From Le Creusot take a bus to Paray and then follow the above instructions. Taxis must be booked in advance.

Contact
Anyone who answers the phone
Foyer du Sacré-Cœur
14, rue de la Visitation
71600 Paray-le-Monial
France
Tel: 0033 (0)3 85 81 11 01
Fax: 0033 (0)3 85 81 26 83
Email: foyersc@club-internet.fr
Website: www.chez.com/fsc

MAISON DU SACRÉ-CŒUR
Petites Servantes du Cœur de Jésus Sisters

The maison was founded in 1930 to host the pilgrims of the Chapelle des Apparitions. In 1998 it was enlarged; the new section designed with more comfortable rooms. The guest house is very close to the chapel, basilica and Museé Eucharistique.

In the 17th century Ste-Margaret Mary received revelations advocating the worship of the Sacred Heart. She founded the cult of the Sacred Heart of Jesus in Paray-le-Monial. The first pilgrimage took place in the late 19th century. Over the years the site rose to great eminence, second only to Lourdes. Built at the behest of the Abbot Hughes of Cluny during the 11th century, the Basilique du Sacré-Cœur is dedicated to the cult and is a small version of the lost abbey church of Cluny. It is an architectural blend of concordance and purity in Romanesque style. Two tall vertical towers serve to frame the main entrance. In harmonious contrast, the sequencing of the belfry, chancel and apse at the back of the edifice seem to cascade from one level to the next, presenting a memorable architectural montage. The adjacent 18th century cloister complements the entire ensemble. The Musée de la Faïence resides in the cloister and preserves a cache of 19th century porcelain.

To the east of the maison is the town of Châlon-sur-Saône. Of pre-Roman heritage, it was the capital of King Guntram of Burgundy's realm in the 6th century and the scene of ten church councils, most notably the one convoked by Charlemagne in 813. Work on the town's Cathédrale Saint Vincent commenced in the 12th century and was completed in the 15th. The quaint riverside quarter of town is an area of antique buildings centered around the Grande Rue. Nicephore (Joseph) Niépce, a native son, is credited with inventing photography in 1816. His namesake museum shelters a vast range of cameras as well as spy-type devices and a library of works on photography.

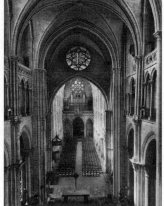

Cathédrale Saint-Vincent

The nearby market town of Charolles is lodged in lush, rolling coun-
tryside. The Arconce and Semence rivers meet in Charolles causing rise
to some thirty bridges in the petite town. The Charolles faïence work-
shops have become an international reference in culinary arts and interior
decoration.

Accommodations
68 beds in rooms with 1-3 beds. Some rooms have private baths.

Amenities
Towels and linens are supplied. Private patio. The institution does not
have private parking but free public parking is located nearby. Meeting
and conference rooms, TV room and chapel.

Cost per person/per night
19.00€ to 35.00€ depending on the type of room, number of meals, etc.

Meals
All meals can be provided with the lodging.

Special rules
Reservations should be made well in advance. To secure the reservation
it is necessary to send a 20.00€ deposit. Email is best from abroad.
Notify time of arrival if later than 8 PM. Pets are not permitted.

Directions
By car: Take A6 and exit at Châlon-sud or Macon and follow the signs to
Montceau-les-Mines, Digoin and finally Paray-le-Monial on N79.
By train: Get off at Paray-le-Monial (SNCF) or Le Creusot (TGV). From
Paray take a taxi or walk (twenty minutes) to the foyer. From Le Creusot
take a bus to Paray and then follow the above instructions. Taxis must be
booked in advance.

Contact
Anyone who answers the phone
Maison du Sacré-Cœur
3 ter, rue de la Paix
71600 Paray-le-Monial
France
Tel: 0033 (0)3 85 81 05 43
Fax: 0033 (0)3 85 81 68 08
Email: maison.sacrecoeur@wanadoo.fr
Website: http://perso.wanadoo.fr/maison.sacrecoeur

BASILIQUE SAINTE-MADELEINE
Fraternités Monastiques de Jerusalem (Friars and Sisters)

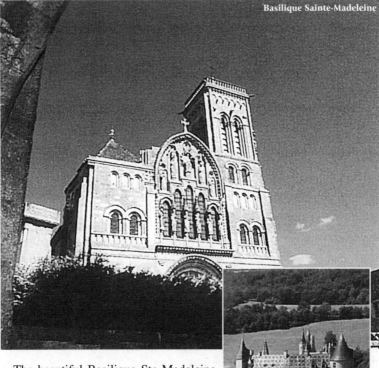

Basilique Sainte-Madeleine

The beautiful Basilique Ste-Madeleine crowns the top of the hill of Vézelay and can be seen from miles away. Its long and turbulent history hasn't kept it from becoming a resplendent church of truly imposing dimensions. Founded in the 10th century, it passed under the rule of Cluny in the 11th. Throughout the years the relics of Ste-Marie-Madeleine have attracted thousands of pilgrims.

The devotion of the pilgrims incurred the jealousy of other religious institutions which resented the independence and wealth of the church. Unfortunately fire destroyed the central nave in 1120 and the building could not be finished until 1215. The religious conflicts of the 16th century caused the church to decline. In 1840 architect Viollet-le-Duc began reconstruction of the church; work continued until completion in 1920.

In 1979 the church was recognized by UNESCO as a World Heritage Monument. A decade later the friars and sisters of the Fraternities Monastiques de Jerusalem assumed management of the basilica including the care of tourists and pilgrims. Considered one of the great pilgrimage churches of France, the façade and portals are richly adorned with bas-relief. Beyond the finely sculpted Romanesque interior portals, the columns of the nave are crowned with carved capitals that are considered masterpieces. The 13th century tower is a beautiful edifice as well. The friars and sisters conduct tours of the basilica for a charge of 3.00€. There are panoramic views from the top of the belfry that encompass a hamlet-dotted patchwork of pastures, woodlands and dense forest threaded by the Cure river.

The medieval village of Vézelay is marked by fortifications and dominated by the basilica. It possesses a definitive charm with wisteria-draped walls and stone houses. Gift shops and boutiques, cafes and restaurants line the steep streets that climb to the extraordinary basilica.

Vézelay is close to the Château de Bazoches. A medieval stronghold, the château was built in the 12th century. Beginning in 1675 it became the property of Vauban, famous military architect. His descendants are the present owners. Richly ornamented furniture and numerous mementos of their illustrious ancestor are carefully preserved.

The nearby city of Dijon is Burgundy's ancient capital as well as its commercial and cultural hub. As the Roman settlement of *Divio*, it was regularly pillaged and burnt. Since the Middle Ages it has remained untouched. The old quarter, protected by pedestrian-only zones, is a network of ancient alleys squeezed between well-restored medieval and Renaissance structures and small squares.

Seat of the flamboyant Dukes of Burgundy from the 9th to 17th centuries, Dijon is centered around the Palais des Ducs which faces the graceful semicircular place de la Libération. The cobbled courtyards, stone towers

Palais des Ducs

and sweeping staircases of the palace house the Musée des Beaux Arts, nicknamed "Le Petite Louvre" for its extraordinary wealth of French and Flemish art. The most impressive exhibits are an intricate gilded retable and the tombs of Philippe le Hardi and Jean sans Peur. The funeral statues were created by Claus Sluter and his disciples.

The Jewish community of Dijon dates back to the end of the 12th century when the Jewish quarter consisted of rue de la Petite Juiverie (site of the medieval synagogue, now rue Piron), rue de la Grande-Juiverie (now rue Charrue) and rue des Juifs (now rue Buffon). The cemetery was located on what is now rue Berlier, having been destroyed after the Jews were expelled from France in 1306. A new community was established after the French Revolution. The Musée d'Archeologie preserves an important collection of 12th and 13th century Jewish tombstones. It is located on 5, rue du Docteur-Maret. Dedicated in 1879 the synagogue was used as a warehouse during the German occupation. The lovely 19th century edifice was spared from destruction during WWII but the original pews were lost. The synagogue is located at 5, rue de la Synagogue.

In Dijon, mustard is a work of art. So too is cassis, a black currant liqueur that is the ingredient in a kir, the region's classic white wine cocktail. The cocktail is in honor of the prelate Canon Felix Kir, a WWII hero and Dijon's legendary mayor for nearly two decades. Atop the fountain in the handsome place Rude, the statue of a male nude treading grapes is a reminder that the surrounding countryside produces some of the finest wines in the world.

Hôtel-Dieu

From Dijon, the *Routes des Grands Crus* runs thirty miles in a nearly straight line through the storybook wine villages of the Côte d'Or. Waist-high vines line the edges of the road. The hub of this route is the ancient town of Beaune whose center is a medley of cobbled lanes and alluring squares. Once the region's main town, its medieval ramparts are still almost intact. Much of the central area is a pedestrian precinct. The town's most significant building is the 15th century Hôtel-Dieu. Now a museum, the multi-colored glazed tiles of its superb gabled roof add a spectacular splash of color to the skyline.

Accommodations

Accommodations are available in two separate guest houses.

1) Maison Saint-Bernard: Located near the basilica in the historic center of Vézelay. Open to men and women for retreats, visits to the basilica and pilgrims to Santiago de Compostela. Up to 38 beds in 13 rooms with 1, 2 or more beds, some with private bath.

2) Maison Bethanie: Located at the bottom of the hill of Vézelay. Open to men and women for retreats, visitors to the basilica and pilgrims to Santiago de Compostela. Up to 21 beds in 10 rooms with 1, 2 or more beds, some with private bath.

Amenities

Towels and linens are provided in both guest houses.

Cost per person/per night

To be determined when reservations are made.

Meals

Maison Saint-Bernard: Meals can be provided on request.
Bethanie: Meals are not provided but there is a kitchen that guests may use or meals may be taken at Maison Saint-Bernard.

Directions

By car: From Paris take A6 south and exit at Nitry. Take D 944 to Avallon and then D957 to Vézelay. A detailed plan of the city with the exact location of the guest houses is available on the website.
By train: Get off at Sermizelles or Montbard (with TGV) and take a bus to Vézelay. Sermizelles is connected to Vézelay via taxi, Montbard via bus.

Contact

Sœur Hôtelière
Basilique Sainte-Madeleine
Fraternités Monastiques de Jérusalem
1, place de la Republique
89450 Vézelay
France
Tel: 0033 (0)3 86 32 36 12
(Sœur Hôtelière) 0033 (0)3 86 33 39 50 or
(Friars) 0033 (0)3 86 32 33 61
Fax: 0033 (0)3 86 32 37 94
Email: hotellerie.monastique@vezelay.cef.fr

CENTER
(LOIRE VALLEY)

MAISON SAINT-IVES

Property of the Diocese of Chartres
Managed by lay personnel

A beautiful stone building, the maison is situated in the center of Chartres, a few steps from the famous cathedral. Constructed in the 16th century on the site of a medieval priory, the maison is where the monks of St-Jean en Vallée found shelter when their monastery was destroyed by fire. They remained until the French Revolution. Once a seminary, the diocese turned the building into a guest house to host pilgrims to the cathedral and tourists on holiday.

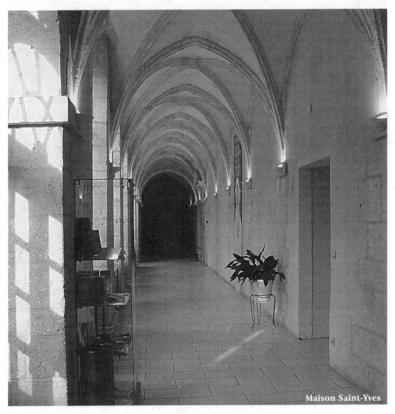

Maison Saint-Yves

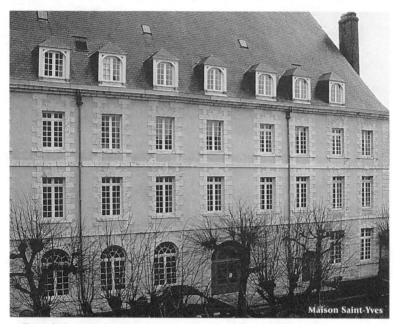

Maison Saint-Yves

Founded on the banks of the Autura (the Eure), Chartres became one of the capitals occupied by the Carnutes, hence the origin of the name Chartres. Towards the year 1000 the town became a center for intellectual and spiritual teaching. Its fame stretched across medieval Europe reaching its apogee in the 12th century.

More than just a cathedral town, Chartres is of great historic and artistic importance. It possesses numerous churches, towers, portals and fourteen ancient footbridges which cross the river Eure. Its picturesque districts, representative *tertres* (steep lanes and stairways), cobbled streets, gabled houses and museums contribute to the captivating appeal of the city.

Chartres is home to the world-famous Cathedral of Chartres. A UNESCO World Heritage Site, Rodin called the cathedral the "Acropolis of France." Its stunning rosette, spectacular 12th and 13th century stained glass windows and grand spires can be seen across the beauceronne countryside. The church also preserves a collection of ancient musical instruments. One peculiarity of the cathedral is its copper roof. In 1836 a fire destroyed the original wooden beams that were then replaced with iron ones covered with copper.

The present edifice was built between the 12th and the 13th centuries but its origins date back to a more ancient time having been built and destroyed at least five times before appearing as it does today. Only traces of the Romanesque period remain: in the crypt, stained glass windows and façade.

In the 13th century the new building was designed by an unknown architect and erected on the western wing of the previous cathedral. It is a three-story structure with a Latin cross plan. Its pointed (ogive) vaults are the most evident examples of true Gothic style. On the external walls, a system of large buttresses was built to counterbalance the push of the vaults. The two-sided porches are enriched by sculpted decorations.

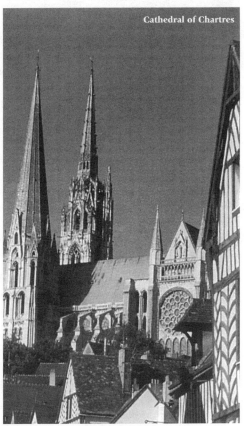

Cathedral of Chartres

Considered one of the most admired adornments of the cathedral are the stained glass windows in the nave. They represent the oldest collection preserved in France. Some, like the Notre-Dame-de-la-Belle-Verrière (1180) and those present on the west façade (1145 and 1155), were part of the previous Romanesque cathedral built by Fulbert during the 12th century. However, most of the stained glass belongs to the same period as the last cathedral. Two historic events took place in the cathedral: in 1146 St-Bernard of Clairvaux preached the Second Crusade and in 1594 Henry IV was crowned King of France.

Chenonceau Château

South of the maison are two evocative châteaux: Chenonceau Château is undoubtedly one of the highlights of Renaissance architecture. It is considered by many to be the most beautiful house in France. A grand avenue bordered by plane trees leads to symmetrical gardens. Stretching over the river Cher, the château's exquisite beauty is mirrored in the still waters and presents an altogether romantic and unforgettable vision.

The most visited château in France, Chenonceau's history is engrossing. In 1513 Thomas Bohier bought a manor dating from the Middle Ages from the Marques family. Since he was often away at war, it was his wife Catherine Briçonnet who oversaw construction of an extraordinary square turreted pavilion. She was one of five aristocratic women, who over the next 350 years, were responsible for the wealth of decoration both inside and out.

In 1547 the manor was given as a gift to Diane de Poitiers, lover of King Henry II. It was her idea to build a bridge over the Cher connecting the square pavilion to the opposite bank of the river. She also had the *parterres* (an ornamental flower garden having beds and paths arranged to form a pattern) laid out in Italian style.

Catherine de Medicis, wife of Henri II, took over the château in 1559 after she forced her rival, Diane de Poitiers, to leave. The architect Philibert Delorme built a two-level gallery on Diane's bridge and Bernard Palissy laid out the gardens.

In 1733 Chenonceau was purchased by Madame Dupin. Under her tutelage the château once again regained its former splendor and became an important venue of literary activity. The tutor of the Dupin boys was Jean-Jacques Rousseau and it was in the château that he wrote *L'Emile*.

The last woman to leave her mark on the château was Dame Pelouze. She bought the château in 1863 and spent ten years restoring it. Since 1913 the estate has belonged to the Menier family, famous chocolate makers. During WWII, the château helped lead many people to freedom. The demarcation line that cut France in two followed the Cher. The château was in the occupied zone but the end of its gallery was in the free zone.

The salamander, emblem of François I, can be seen above the main door of the château. The ground floor is centered around a gallery built over the five-arched bridge that crosses the Cher. The floor is covered with enamel tiles and leads to many of the larger rooms. The walls of Diane de Poitiers' bedroom are embellished with splendid tapestries from Flanders as is the room of her rival Catherine de Medicis.

Chambord Château

The other remarkable house, the vast fairy tale Chambord Château, was never a place for living. Its upkeep, especially heating, was so difficult that the kings of France came only in the summer. The pillages of the French Revolution and the long periods during which the château was abandoned explain why there is little furniture in it today. What makes the château significant is the flamboyance of its architecture. It is a combination of turrets, bells, cupolas, gables and pinnacles with hundreds of

sculpted chimneys. The château is the embodiment of grandiose; the interior contains over four hundred rooms and is defined by nearly a hundred stairways.

The stupendous size of the rooms and halls, the fittings and decoration are testament to the château's aristocratic roots. The wood floors, wainscoting and coffered ceilings are notable for their unequaled architectural and pictorial qualities. The only parts of the château that are furnished are the chambers of François I and Louis XIV and one room containing toys that once belonged to the noble children.

The grandest architectural highlight is the double spiral staircase that allows two people to go up or down without crossing each other. Purportedly it was designed by Leonardo da Vinci. *Son et lumière* (a show with music and drama) and night visits to the château are held from May through September. The park of the Chambord covers over 12,350 acres, the encompassing wall stretches for 20 miles. Heavily wooded, Chambord is Europe's largest park and a national nature preserve inhabited by deer, boar and many species of protected birds.

Continuing on a southward journey, the village of Montresor is among the most beautiful villages in France. Some Gallo-Roman vestiges and Roman steam baths have been found, attesting to the fact that Montresor has been inhabited for centuries. Records reveal that the town had its first feudal lord in 887. At the start of the 11th century, Foulques Nerra, an avid builder and conqueror, had a fortress erected atop a rocky promontory overlooking the Indrois valley. A double enclosure wall safeguarding the keep is still apparent. The massive corner towers and 12th century gate towers remain impressive due to their powerful feudal architecture.

In 1493 the Montresor "castellany" became the property of Diane de Poitiers' grandfather, counselor to four kings of France. He had a Renaissance castle built within the feudal enclosure of which only the main wing still stands. In 1849 a Polish aristocrat Xavier Branicki purchased the castle. He restored and redecorated it with many fine works of art. The castle remains in the hands of his descendants.

Montresor "castellany"

The Gothic church was built in the beginning of the 16th century and dedicated to St-John the Baptist. It is considered a Renaissance masterpiece because of the beautiful ornamentation on the façade, doors, capitals and vaulted ceiling. Also of interest and characteristic of the region, a covered washhouse is located at the end of a cul-de-sac.

Accommodations
80 beds in 50 rooms with one to three beds and private bath. There is a room accessible to the handicapped. All rooms have a telephone.

Amenities
Towels and linens are supplied. There are three small private gardens and conference rooms.

Cost per room/per night
Single room 35.00€, double room 47.00€, triple room 70.50€.

Meals
All meals are available.
Breakfast 6.60€.
Self-service lunch or dinner 10.00€ each.

Directions
By car: From Paris take A10 and exit at Thivars/Chartres nord and follow the signs to the center. A detailed map is available on the website.
By train: Get off at Chartres. Take a taxi or bus to the maison.

Contact
Anyone who answers the phone
Maison Saint-Yves
1, rue St-Eman
28000 Chartres
France
Tel: 0033 (0)2 37 88 37 40
Fax: 0033 (0)2 37 88 37 49
Email: hotellerie@maison-st-yves.com
Website: www.maison-st-yves.com
 www.diocesechartres.com/styves

PRIEURÉ SAINT-THOMAS
Sœurs du Christ

Prieuré Saint-Thomas

The prieuré is inhabited by a small community of sisters who actively organize spiritual retreats and sessions of study on religious subjects. They also welcome visitors on holiday. The institution is ensconced in its own park in the center of the city and provides a relaxing respite. Tall trees shade a trail through the maison grounds.

Epernon is a pretty little town situated at the end of the forest of Rambouillet, one of the remnants of the old forest of Yveline. Rambouillet is popular for hiking, biking, horseback riding and mushroom hunting. It is famous for its star-shaped crossroads and long, rectilinear paths, as well as its old-fashioned forestry houses built hundreds of years ago.

Trees shade a trail through the maison grounds

Founded during the Middle Ages, the church of Epernon is believed to haves Roman origins, although the facts are obscure. Restored in the 16th century, the church was recognized as an historical monument in 1942. The "Pressoir," a 12th century grape pressing cellar built of limestone, is sheltered within the church. It features three naves with seven rows of diagonal rib vaults.

The city of Orleans is an easy day trip. Once France's second largest city, Orleans is now the vinegar capital of France, a direct result of the region's wine industry. In the 15th century the city was liberated from the English by Joan of Arc who later returned to Orleans in triumph for her victory. Every May a celebration is held commemorating her exploits. Maison Jeanne d'Arc, where she stayed during the ten-day siege, can be visited. The Gothic Cathédrale Ste-Croix and the Hôtel Groslot, a brick and stone Renaissance mansion in the old town, are interesting sites to explore. Orleans' archeology museum conserves an exceptional collection of Gallo-Roman bronze statues. During the Middle Ages Orleans was an important center of Jewish scholarship. The synagogue is located at 14, rue Robert-de-Courtenay.

The castle and town of Sully-sur-Loire are in the vicinity of Orleans. The castle is composed of the original keep and a wing added in the 13th century. It is the setting for numerous performances that depict life in the Middle Ages. Sully-sur-Loire marks the start of the Val de Loire, a UNESCO World Heritage Region of the Loire Valley that stretches westward for nearly 200 miles. Often called the "Garden of France," the Loire Valley is an enchanted land of vineyards, flowers and rolling green hills dotted with more than a thousand medieval, Renaissance and classical castles. Many cities of the Val de Loire were built around these grand castles, each unique in their design, decor and flamboyance. Some are privately owned but most are open to the public and include visitor's centers, museums and fanciful gardens.

Nearby are a number of interesting towns and monuments including St-Benoît-sur-Loire and its Bénédictine abbey. A Roman masterpiece, Gregorian chant can still be heard in the abbey church. In Germigny-des-Pres, the Carolingian Oratory was the first monument of Christian art to be constructed in the western hemisphere. Built by Theodulf, a close advisor to Charlemagne, the interior shelters a surprising Byzantine dome covered in mosaics. The château in Meung-sur-Loire was the residence of the Bishops of Orleans for seven centuries, from the Middle Ages until the 17th century. A tour is offered which encompasses unusual surprises such as the bishop's bathroom, the underground passages and the *oubliettes* (dungeons that had their entrance in the roof). A walk along the little rivers, better known as the "Mauves," passes old mills used for tanning, flour and other grains.

Accommodations
Fifty beds in single, double and larger rooms (3/4 beds). Some rooms have a private bath.

Amenities
Towels and linens are provided on request. Meeting rooms and a park.

Cost per person/per night
Cost depends on the type of hospitality, length of stay and number of meals.

Meals
All meals can be provided on request.

Directions
By car: From Paris take A10 and exit at St-Arnoult-en-Ivelines. Take
N10 and then D906 to Epernon.
By train: Get off at Epernon and walk (10 minutes) or take a taxi to the
prieuré.

Contact
Sœur Hôtelière
Prieuré Saint-Thomas
29, rue du Prieuré
28230 Epernon
France
Tel: 0033 (0)2 37 83 60 01
Fax: 0033 (0)2 37 83 44 00
Email: prieure-epernon@wanadoo.fr

NOTES

CARMÉL DE BLOIS
Carmélite Nuns

The monastery is quartered in a wonderful spot far from the noise of the city. The carmél is actually an ancient farm dominating a forest and river from its hilltop perch. "We used to live in town but the monastery was at the intersection of four streets and it was too noisy," explained one of the sisters. The original monastery was founded in 1625 but the nuns were expelled in 1792. Although they returned a few years later, a fire forced them to leave once again. In 1977, they moved to their present location.

The town of Blois, the monastery's original site, is an historic city with intriguing medieval streets. Its famous castle has been linked throughout the centuries to the kings of France. Château de Blois is one of the most ornate castles in France. Its stunning architecture includes Gothic, Renaissance and classical influences. In the summer, visitors can see the *Son et Lumière*, a show that celebrates the history of Blois through music and drama. Within the town traditional blue-slated roofs and red chimneys dot the scenery between breathtaking cathedrals and lush gardens.

The innermost region of Western France is châteaux country, with scores of regal castles scattered throughout the lush countryside. France's medieval history comes alive among its châteaux and old cities. In 2000 the beauty of the area was recognized when Val de Loire was named as a UNESCO Heritage Region for its unequaled history and beauty.

Not far from Blois is Chambord Château, the largest of all the Loire valley castles. Its stunning architecture includes Gothic, Renaissance and classical influences; the grounds cover almost 3,000 acres. Built by François I, it is notable for its great staircase, roof terrace and lush wooded grounds where horse-drawn carriages escort visitors throughout the estate. Deer and wild boar roam freely in this very natural landscape.

The stunning 17th century Château de Cheverny presents an harmonious, symmetrical picture with a series of domes and parapets capping its white stone walls. Nestled in a verdant oasis, the château is home to fine tapestries and art. Outside the main building is the stately Orangery, a conference building where many famous works of art were hidden during WWII including the *Mona Lisa*.

Region: Center **City: Molineuf**

Sitting on the south bank of the Loire is the Château de Chaumont-sur-Loire, once the property of Catherine de Medicis. Although the façade presents a military appearance, the grounds are quite lovely. The stables

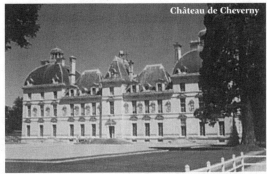
Château de Cheverny

offer horse-drawn carriage rides while the farmhouses host workshops on botany and landscaping. From June to October, the château comes alive during the International Garden Festival when landscape gardeners the world over come to create beautiful settings around a central theme that changes from year to year.

Accommodations
There are two types:
1) Inside the carmél: Hospitality is mainly for spiritual retreats. Men and women are welcome in 4 double and 4 single rooms. Baths are shared; each room has its own sink.
2) Annexed to the carmél: A guest house is available for men, women, families and groups. It can host 12 people in single and double rooms, plus a small dorm. Only one room has a private bath. There is a kitchen and dining room that guests may use.

Amenities
Towels and linens can be provided on request.

Cost per person/per night
The nuns request a basic price to cover expenses; the rest is a voluntary contribution.

Meals
Meals are only provided for those attending spiritual retreats. Guests staying in the guest house must provide their own meals.

Products of the institution
The nuns produce hosts and work as secretaries via computer.

Special rules
Punctuality at meals and respect of the silence.

Directions

By car: From Paris take A10 and exit at Blois. Take D766 in the direction of Angers to Molineuf.

By train: Get off at Blois. There are no buses. Take a taxi to the carmél.

Contact

Responsable pour l'hospitalité
Carmél de Blois
La Chambaudière
41190 Molineuf
France
Tel: 0033 (0)2 54 70 04 29
Fax: 0033 (0)2 54 70 05 76
Email: carmel.blois@wanadoo.fr
 carmel.molineuf@carmel.asso.fr
Website: http://www.carmel.asso.fr/famille/moniale/molineuf/41190.shtml

 NOTES

Sanctuaire Notre-Dame de Miséricorde

Saint-Jean Sisters and Friars

The heart of the complex of the shrine of Notre-Dame de Miséricorde is the chapel built in the bedroom where, in 1876, Mary appeared to Estelle Faguette. A young women dying of tuberculosis, Estelle was the sole support of her aged parents. Knowing she was ill, she wrote a letter to Mary asking the Virgin to keep her alive so she could care for her parents. According to tradition, on the day of her final agony, Our Lady appeared and told Estelle that in five days she would completely recover. After five apparitions she was cured. The pilgrimage was officially authorized in 1877 and the bedroom converted into a chapel. A monastery was built around the room and was home to an order of Dominican nuns until a few years ago. At that time they were replaced by the sisters and friars of St-Jean. The "Great Pilgrimage" takes place every year on the last Sunday of August.

Pellevoisin is a small village of 900 inhabitants in the hilly countryside separating the basins of the rivers Indre and Cher. The name of the town derives from the Latin *Belle-Vici* (village of the war). One of the distinguishing characteristics of Pellevoisin is the *tumulus*, a 32-foot high tomb that most likely dates back to the Gallo-Roman period. The town also preserves a handsome 12th century Romanesque church. Nearby are the 14th century Château du Mée and 17th century Château de Montbel. The writer George Bernanos (1888-1948), often called the Catholic Dostoyevsky, was buried in Pellevoisin.

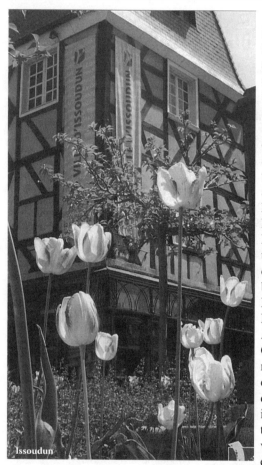

Issoudun

Due east and quite close to the sanctuary is Issoudun. The city's name comes from the Celtic *Exoldunum*. As the capital of the Lower Berry and a royal city since 1240, its prosperity can be traced to the fairs and markets that have taken place for centuries and to the quality of its handicrafts, particularly leather goods. La Tour Blanche has dominated the city since the 12th century. A beautiful building, it evokes the Middle Ages of Richard Lion-Heart, Phillippe Auguste and Blanche of Castille. On summer nights a walking tour called "Les Legendaires d'Issoudun," escorts visitors to the top of the tower and stunning views of the city and environs. The Museum of the St-Roche Hospice is housed in an architectural complex with a 12th century chapel. The exhibitions provide insight into the history of the city.

Continuing eastward is the town Bourges. At the geographical heart of France and part of the Berry Region, the Gallo-Roman town retains its ancient walls and rich historical foundation. The past is evident in the town's maze of paved stone streets, medieval and Renaissance architecture and vestiges of ancient ramparts. Bourges is also home to the extraordinary French Gothic masterpiece, the Cathédral of St-Etienne, a UNESCO World Heritage Site. It is remarkable in that it has no transept.

A handsome edifice, it is replete with five sculpted portals on the west façade. The interior features a soaring nave, an unbroken line of columns and medieval stained glass windows. There is also a 15th century astronomical clock, a wedding present to Charles VII and Marie d'Anjou. Jacques Coeur's Palace is a Gothic work of art reminiscent of the splendors of bygone times.

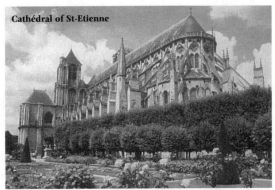
Cathédral of St-Etienne

West of the sanctuary, Tours is the chief town of the Loire valley and capital of the Touraine region. The original home of the French language, the capital is rich with history and a well-preserved heritage. A Gallo-Roman city named *Caesarodonum*, the hill of Caesar, it is mentioned in the first century AD. A few remains from the period can be seen near the cathedral. Below the royal château, traces of the baths of a private dwelling still survive.

It was in Tours in 732 that Charles Martel halted the Moorish conquest of Europe when his Frankish army defeated the Arab army, which had crushed all resistance before it. Although it took another two generations for the Franks to drive all the Arab garrisons back across the Pyrénées,

Battle of Tours

Charles Martel's halt of the invasion of French soil turned the tide of Islamic advances. The Battle of Tours earned Charles the nickname "The Hammer," for the merciless way he hammered his enemies. Most historians believe that had he failed at Tours, Islam would probably have overrun Gaul and perhaps the remainder of Catholic Europe.

Tours was also the cradle of the first French Renaissance. Signs of this artistic development include masterpieces such as the tomb of Charles VIII's sons, the top sections of the cathedral towers, the remains of St-Martin cloister and several mansions. In the atmospheric old quarter, around the pedestrianized place Plumereau, the medieval lanes are fronted by an array of 12th to 15th century half-timbered houses, stairway towers, bustling cafes, boutiques and galleries. Quite close to the square the Hôtel Gouin is an exemplary specimen of Renaissance domestic architecture. Musée des Beaux Arts is in the former archbishop's palace. It preserves a collection of paintings from the Middle Ages to the 20th century including Mantegna, Rubens, Rembrandt, Boucher, Delacroix and Degas. In a vaulted 12th century cellar, the Touraine Wine Museum details the history, guilds and feasts of wine growing and production.

Historians have evidence of Jewish life in Tours as far back as the late 6th century. In the Middle Ages Jews lived in an area near the rue de la Caserne. They had a synagogue and leased cemetery land from the archbishop. The Jewish community still maintains a synagogue and community center.

West of Tours is the beguiling town of Saumur. Among the most beautiful in the Loire valley, the town supplies France with 65% of its mushrooms. Beneath the city, mushrooms grow in the caves carved out of the limestone rock. Guided tours of the underground caves are available. Saumur is also France's military and equestrian center. For nearly two centuries the cavaliers of the Cadre Noir have been the pride of the city which is also home to the Ecole Nationale d'Equitation, stabled in St-Hilaire-St-Florent.

Fashioned out of the chalky tufa stone typical of the Loire, Saumur's fairy tale white limestone castle perches atop the town and is home to a famous miniature, the *Book of Hours*, painted for the Duke of Berry. Once a luxurious residence for the Dukes of Anjou in the Middle Ages and a bastion of Protestantism in the 17th, the turreted Château de Saumur overlooks the river and seems to watch over the old town.

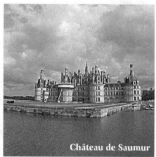
Château de Saumur

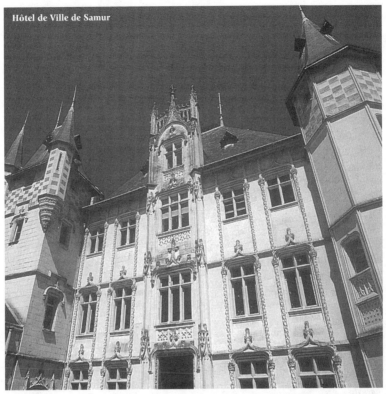

Hôtel de Ville de Samur

Nicknamed the "white town" most of Saumur's architecture reflects its stone foundations but there are a number of restored half-timbered houses as well. Among its outstanding monuments is the 12th century Romanesque Church of Notre-Dame de Nantilly .

Renowned for its sparkling white wines, Saumur's wine cellars provide tastings of the famous Saumur Champigny, Crémant de Loire and the regal dry Saumur Brut. It has also achieved prominence for its religious-medal industry, in existence since the 17th century.

Within close proximity to the maison are several small towns, each with something special to recommend it. The pretty town of Valençay is neatly perched on a sloping hillside, its 16th century château a gift from Napoleon to Talleyrand. The ancient Cordeller's Convent in Châteauroux oversees the Indre valley and is the site of various exhibitions of contem-

porary art. Bertrand Mansion takes its name from one of Napoleon's loy-
alists, its museum is set in a 17th century hall. It recalls epic tales from
the Napoleonic era and houses an aviary made for Napoleon by eighteen
Chinese workers during their incarceration at Ste-Hélène.

Loches is an unspoiled medieval gem on the banks of the Indre. A
walled town about halfway between Pellevoisin and Tours. Loches offers
a slice of history combined with artistic and architectural charm; a place
of narrow cobbled lanes and inviting ramparts,
13th century Gothic gateways and sculpted
façades. History, however, also reveals a some-
what sinister side. Political prisoners were kept in
the notorious Round Tower and Martelet of the
Château de Loches. For betraying Louis XI,

Château de Loches

Cardinal La Balue was imprisoned for eleven years in an iron cage that
he himself invented. At the foot of the dungeon lies a secret garden with
aromatic plants and vegetable patches.

Accommodations
50 beds in double rooms, baths are shared. There is also a house where
guests may stay with sleeping bags.

Amenities
Towels and linens are supplied on request.

Cost per person/per night
Lodging 11.00€.

Meals
All meals can be provided with lodging.
Breakfast 2.00€.
Lunch/Dinner 8.00€ each.

Special rules
Curfew at 9 PM.

Directions
By car: From Paris take A20 and reach Châteauroux and take N143
towards Tours to Buzançais. From there follow the signs to Pellevoisin
on D11 (11 km).
By train: Get off at Tours (TGV) and take a bus to Buzançais or get off at
Buzançais (SNCF) and take a bus to Pellevoisin. With advance arrange-
ments, the friars can provide transportation from Buzançais.

Contact

Write a letter, fax or email: To the Recteur
Sanctuaire Notre-Dame de Miséricorde
3B, rue Notre-Dame
36180 Pellevoisin
France
Tel: 0033 (0)2 54 39 06 49
Fax: 0033 (0)2 54 39 04 66
Email: sanctuaire@pellevoisin.net
Website: www.pellevoisin.net

NOTES

CHAMPAGNE-
ARDENNE

LYCÉÈ PRIVÉ SAINTE-MAURE
Marianist Congregation

Nestled within its own spacious park, the maison is a private boarding school in an idyllic countryside setting near the river Seine. The Marianist congregation manages the institution and offers hospitality to groups during weekends and school holidays. The small village lays claims to a score of handsome monuments including a 16th century castle; the Château de Vermoise, distinguished by a Renaissance façade; and a 16th century church whose interior is accented by wooden altar panels.

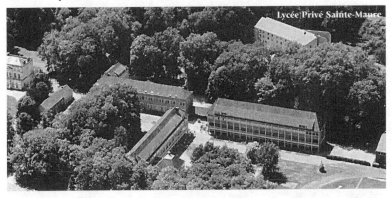
Lycée Privé Sainte-Maure

Troyes is less than a mile from the maison. City of art, medieval Troyes is the jewel in the area's historic crown. It is underscored by a striking assemblage of medieval and Renaissance houses, all lovingly protected and restored. The ring of boulevards defining the historic center is shaped like a champagne cork. Because of this, locals say that some of the residents live in the body of the cork, others in the head. Troyes is renowned as the city of nine churches, (each in a different style); and famous for its heritage of stained glass. Created by the Troyes School, the glass is made using a technique that produces a milky finish. The origins of stained glass can be traced to the Middle Ages. In France the craft reached its peak in the Aube region where there are more stained glass windows than anywhere else in the country; 1,160 examples with more than a thousand dating from the 16th century.

The eglise of Ste-Madeleine is the oldest in the city, dating from the mid-12ᵗʰ century. It was rebuilt between 1498 and 1501 and has many outstanding features including a fine Renaissance bell tower, a Gothic nave and a stone-carved chancel screen in Flamboyant style. Executed by Jean Gailde, the screen is considered one of the finest in France. Basilique St-Urbain was begun by Pope Urban on the site of the shop where his father plied the cobbler's trade. Although the church was

Virgin With Grapes

built in the 13ᵗʰ century, the upper part of the nave was not finished until the 19ᵗʰ. The structure is an agreeable Gothic masterpiece enriched by 13ᵗʰ century stained glass windows. The interior shelters several 16ᵗʰ century statues including the *Virgin with Grapes*.

The Visit

St-Jean-au-Marche stands in the ancient quarter where Louis le Begue was crowned in 878 and where Catherine of France wed Henry V of England in 1420. The nave is divided into eight bays with a high standing chancel. The altar has an exquisite retable attributed to Julyot. The south chapel reveals a group of stone figures dating from the early 16ᵗʰ century known as *The Visit* .

The heart of the pedestrianized old city is filled with 16th century houses with wooden corbelled balconies built in a timbered style typical of the Bocage Champenois. The corbelled first floor was a means of acquiring more space; the design was also a method of tax avoidance since taxes at that time were calculated on the basis of the ground area covered by the construction. The Maison du Boulanger is another fine example of this unique style of archi-
tecture. The "ruelle des Chats" (Cats' Alley) in the St-Jean quarter is so named because the roofs are so close together that cats can leap from one grain loft to another to hunt for mice. Tourelle de l'Orfèvre (Goldsmith's Turret) was built in the 16th century; its turret decorated in a

Basilique St-Urbain

checkerboard pattern and embellished with stained glass windows. Housed in the former episcopal palace, the Musée d'Art Moderne displays a collection of 2,000 paintings created between 1850 and 1950 including work by Dufy, Degas, Rodin, Picasso and Renoir. The Maison de l'Outil showcases an unusual exhibition of 20,000 tools and implements representing the ancient guild of the Compagnons du Devoir. The tools were used in wood, metal and leather work as well as stone carving.

In ancient times Troyes commercial importance was reflected in annual fairs that attracted merchants from throughout the world. The fairs set standards of weights and measures for the continent of Europe and the troy weight survives to this day. Troyes was also the first town taken by Joan of Arc on her march to Reims.

South and east of Troyes are half a dozen small towns and villages easily visited in a day. The area is known as Côte des Bar and owes its reputation to the champagne produced in the vineyards that blanket the sloping hillsides. *The Champagne Trail* winds its way through flower-bedecked towns that embody the sum and substance of the Champagne region passing twenty-six champagne producers along the way.

In Chaource, the Church of St-Jean-Baptiste houses a 16th century entombment with large polychrome characters and a gilded and painted wooden creche with moving figures. The town is also noted for its cheese. Bar-sur-Seine is an inviting little town at the foot of a picturesque vineyard crossed by the Seine. Defined by 15th century half-timbered houses, it is the locale of an apothecary's house, the Eglise St-Etienne, vestiges of the castle of the Counts of Bar and the Châtillon Gate. Essoyes was once the home of August Renoir and is now the burial site of his two sons, Pierre and Jean. Many of the artist's paintings portray the picturesque village. Renoir's studio and the cemetery where he is buried are open to visitors.

Bar-sur-Aube was home to philosopher Gaston Bachelard. A comely little town built on the right bank of the Aube, it is overseen by verdant, wooded hills. The halloy of the 12th century Eglise St-Pierre is a wooden gallery that sheltered tradesmen during the famous champagne fairs. The small town of Bayel is acclaimed for its crystal works, in continuous operation since 1666. The choir of St-Martin was built in the 12th century, the nave in the 18th. The church preserves a *Madonna with Child* from the 14th century and a superb Pietà of the Troyes School.

Epernay, capital of Champagne, is situated in the heart of the vineyards and makes an ideal departure point for trips into the Marne valley and environs to the north. The main reason to visit Epernay are the "caves,"

Epernay

where millions of bottles of champagne are stored and the place to sample the bubbly. Near Epernay and set among the vineyards of the Montagne de Reims is the village of Hautvillers earmarked by its quintessential wrought iron signs. Legend holds that it was in the Bénédictine Abbey (ca. 660) of Hautvillers that Dom Perignon, a monk of the order, developed the champagnisation techniques in the 18th century.

Two canals run through Châlons-en-Champagne, the Mau and the Nau. Châlons is the main town in Champagne-Ardennes and throughout the summer months, the tourist office organizes boat trips on the canals. These excursions provide visitors with a different perspective of Châlons including its old bridges and charming English-style gardens. Since the Middle Ages the town has conserved a distinguished architectural heritage that reflects a pairing of Romanesque and Gothic styles. The 13th century Notre-Dame-en-Vaux is a fine example of the Romanesque-Gothic transitory period. The cloister of the church was only discovered forty years ago during an archeological dig on the site. At that time more than 3,000 items were uncovered, most of them columns from the cloister. They can be seen in the Musée du Cloitrede Notre-Dame-en-Vaux. Châlons has preserved its bourgeois character as epitomized by large residences built of chalk and red brick and its restored timbered houses. The architectural elements showcase stone work, sculpture, classic façades and stained glass windows. The winsome picture is further enhanced by the reflection of the ancient houses in the canals.

Further north, Reims is one of the most important cities of art and history in the region. Kings and champagne both reigned upon Reims. The baptism of Clovis, King of the Franks, in 496 AD marked the start of a long series of coronations culminating in the last, that of Charles X. One look at the majestic Gothic Cathédrale Notre-Dame and the reason it was chosen becomes obvious. The cathedral is a jewel of religious architecture, one of balanced proportions and rich sculptures including the

Smiling Angel

famous *Smiling Angel*. Its clerestory and rose windows are ornamented with resplendent stained glass. Artifacts of the historic coronations are housed in the Palais du Tau, which, along with the Cathédrale Notre-Dame and Basilique St-Remi, are UNESCO World Heritage Sites.

Accommodations
300 beds in various configurations. Rooms have 1-10 beds, baths are mostly shared.

Amenities
Towels and linens are supplied only on request and only at an extra charge.

Cost per person/per night
To be determined when reservations are made.

Meals
All meals can be provided with the lodging.

Special rules
Hospitality is offered to large groups (80 and up). It is possible to be hosted in smaller groups if a large group is already present.

Directions
By car: Reach Troyes with A5 or A26 and then take D78 to Sainte-Maure.

By train: Get off in Troyes and take a taxi or bus to Sainte-Maure.

Contact
Anyone who answers the phone
Lycée Privé Sainte-Maure
10150 Sainte-Maure
France
Tel: 0033 (0)3 25 70 46 80
Fax: 0033 (0)3 25 70 46 81
Email: ste-maure@cneap.scolanet.org
Website: http://perso.wanadoo.fr/lycee.ste.maure

 NOTES

CORSICA

PRIEURÉ DU SAINT-ESPRIT

Bénédictine Monks

Prieuré du Saint-Esprit

The Bénédictine monastery overlooks a verdant valley and the sea from the foothills of the mountains. The 17th century complex once belonged to the Franciscan Order. It is built in a very simple manner, typical of Franciscan constructions and has been preserved for four centuries without ever being remodeled. "The church is extremely poor," said Pere Federico, "and it would be too complicated to restore it. Even the floor is made of the original stone." Including a cloister and terraced garden, almost every part of the monastery is accessible to guests who are hosted inside the original cells of the friars.

The third largest island in the Mediterranean after Sicily and Sardinia, Corsica has all the qualities of a mini-continent. Its main appeal is its scenery, a composition of majestic mountain peaks, forest-filled valleys, olive, fig and citrus groves and countless miles of sandy beaches bathed in brilliant sunlight. Much of the island is wild and covered by maquis, the flowers of which produce a fragrance that carries far out to sea and has earned Corsica the name "scented isle." A strong traditional island culture exists and flavors the cities and countryside.

Cateri is inland about halfway between Calvi and L'Ile Rousse. Near the monastery are a handful of towns including Balagne (an amphitheater of hills and plains) and Calvi, which according to legend, is the birthplace of Christopher Columbus.

Calvi is overshadowed by the 15th century Chapelle de Notre-Dame de la Serra, a Genoese-built citadel sited high on a windswept rock. Three enormous bastions are topped by a crest of ochre-colored buildings, sharply defined against a hazy backdrop of the snowcapped peaks of Monte Cinto. Within the old town, ancient houses are tightly packed along stairways and narrow lanes that converge on the tiny place d'Armes. Dominating the square is the Cathédral St-Jean-Baptiste. The structure was founded in the 13th century and suffered extensive damage in the 16th. It was rebuilt in the form of a Greek cross.

Haute-Balagne

The region between L'Ile Rousse and Calvi (a dozen or so miles) is called Haute-Balagne. Dotted with fine sand beaches and rimmed by high mountains, the Balagne is one of rugged Corsica's few rich farmland areas. Known as the "Garden of Corsica" the farms produce fruit, honey and wine. Ile Rousse is a pretty port founded by Pascal Paoli to counterbalance Calvi which he considered too Genoese. Its name comes

from the red granite of Ile de la Pietra, a rocky island now connected to the mainland. The view of L'Ile Rousse from the island is particularly dramatic at sunset when the full effect of the red glow boldly tints the horizon. The core of the town is the plane-shaded place Paoli, home to the popular covered market. Beyond the square is the old town.

To the south of Calvi lies some of Corsica's most memorable coastal scenery. It extends from the Scandola Cliffs, a UNESCO World Heritage Site famous for rare wildlife, to the white sand beaches of the Bay of Vallinco. Further south, granite hills, their lower slopes covered by pine forests, impart an unforgettable beauty to the Bay of Porto. The bay is edged by the spectacular red granite cliffs, rocks and pinnacles of Les Calanches. The sight of the 1,000' cliffs plummeting to the sea is not easily forgotten. The cliffs are accessible on foot or by boat.

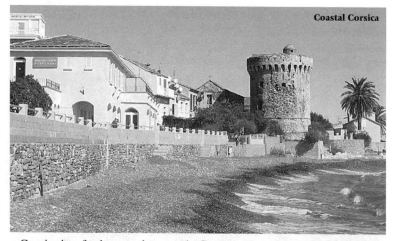
Coastal Corsica

Continuing further south towards Cargese, the coast is punctuated by small towns and villages fronted by beautiful golden beaches. Cargese sits high above a deep blue bay on a cliff scattered with olive trees. Half the residents are descendants of Greek refugees who fled the Turkish occupation of the Peloponnese in the 17th century. Two churches are at the heart of the village, one Baroque and Roman Catholic, the other a large granite neo-Gothic (Greek) edifice built in 1852. Icons of the Virgin and Child brought from Greece with the original settlers are believed to date back to the 12th century.

Accommodations
There are 15 cells, 5 of which are double. Baths are shared.

Amenities
Towels and linens are provided.

Cost per person/per night
Half board 30.00€.
Full board 35.00€.

Meals
All meals are offered with the lodging. Lunch and dinner are spent with the monks; breakfast can be taken with other guests or alone.

Special rules
Minimum stay 3 days. Lodging with either half or full board is required. Silence must be respected in the evening. For that reason, families with small children (under ten) are not admitted.

Directions
By car only. There is no public transportation. From Calvi take N197 and then D71 to Cateri and then follow the signs to San Antonino.

Contact
Anyone who answers the phone
Prieuré du Saint-Esprit
Marcassu
20225 Cateri
Corsica, France
Tel: 0033 (0)4 95 61 70 21
Fax: 0033 (0)4 95 61 71 15
Email: marcassu@wanadoo.fr

 NOTES

MAISON SAINT-HYACINTHE
Marie-Immaculée Sisters

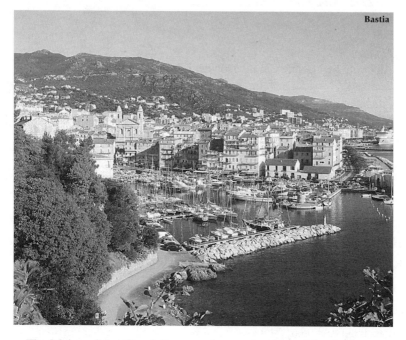

Bastia

The Maison Saint-Hyacinthe occupies a splendid position halfway up the mountain above the coast north of Bastia, five miles from the city and a little over a mile from the sea. It is nestled in its own park of olive and palm trees. On the maison's mountain setting, nature and faith commingle in harmony. "People appreciate very much the peacefulness and they feel at their ease," said father Stanislaw who collaborates with the nuns. In the 11th century the institution was a Dominican convent. It was destroyed during the French Revolution and the friars were forced to leave. The Dominican Order was replaced by a community of Franciscan sisters who built an orphanage over the ruins and preserved the original 11th century portal. The chapel houses a 14th century statue of the *Holy Virgin of the Travelers* and a 17th century retable of St-Hyacinthe.

In 1999 a Polish community of nuns bought the complex and then restored and converted it into a large and very active guest house. During the summer months there are concerts and dances and the maison is filled with families and groups of young people.

Santa Maria de Lota is the gateway to the Cap Corse, the narrow peninsula at Corsica's upper northern tip. It is composed of little villages including Miomo, a small hamlet on the hills above the valley accented by a Genovese tower. Sited on the Tyrrhenian Sea, nearby Bastia is the island's largest city. Founded in the 14th century as a fort by the Genoese, it remained the capital of Corsica until 1791.

The allure of Bastia lies in its atmospheric old port and citadel. The city exudes an earthy Mediterranean vitality. Colorful seven-story Italianate-style houses crowd the port, the crumbling walls backdropped by maquis-covered hillsides. The historic neighborhood of Terra Vecchia (old land, from Italian) reveals a warren of tightly packed streets, tree-lined squares and Flamboyant Baroque churches. The heart of the city is place St-Nicolas, a vast seafront plaza shaded by trees and enlivened with outdoor cafes. It is the central hub with ferries coming and going to France and Italy. At l'Hôtel de Ville, a daily morning market attracts locals and visitors alike.

Bastia

Eglise St-Jean-Baptiste

The 16th century Oratoire de l'Immaculée preserves an intricate 18th century interior behind a very sober façade. Walls covered with paneling and scarlet velvet damask adorn the nave. The vault fresco, representative of Baroque styling, depicts the Immaculate Conception, the Apostles and the Evangelists. Looming over the old port, Eglise St-Jean-Baptiste is a high Baroque affair flanked by two campanile towers. The nave and two aisles are distinguished by a texture of architectural details including rare marbles, gold and stucco effects, trompe l'œil paintings and gold and silver pieces.

Built by the Genovese between the 15th and 17th centuries, the bastiglia or citadel in Terra Nova (new town) is Bastia's most historic quarter. The buildings were the main residence of the Governors of Corsica from the end of the 15th century until the end of the Genovese domination in the 18th. The ramparts around Terra Nova were completed in 1480; the Palais des Gouverneurs, symbol of power of the Genovese Republic, was finished in 1530.

Inside the citadel. winding streets lead to the striking Chapelle Ste-Croix. A Baroque jewel, it preserves the city's famous Black Christ, a mysterious crucifix that, according to legend, was discovered (in 1428) floating in the sea by anchovy fishermen. Constructed on the land of the Basilica St-Jean de Latran, the property actually belongs to the Vatican. The papal coat of arms that surmount the 18th century altar ciborium are a reminder of that ownership. The chapel that conserves the Black Christ is adorned with a Renaissance period coffered ceiling. Beyond the church in the center of the citadel is the diminutive but inviting place Guasco.

The citadel's Cathédrale Ste-Marie de L'Assomption was built between 1604 and 1619. The church has a façade with three pediments. The nave

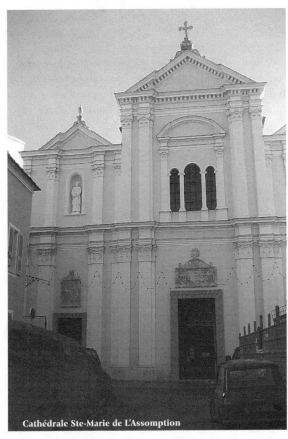

is bordered by two aisles and is lavishly embellished with stuccos, marble and wonderful trompe l'œil paintings.

Over the centuries the church has accumulated numerous works of art. Sheltered within a glass alcove, the Virgin in solid silver was engraved by Gaetano Macchi in the 19th century. The organ, built by the Serassi brothers, is the only Italian-built instrument classified as an historical monument in France.

Cathédrale Ste-Marie de L'Assomption

Accommodations

100 beds in single, double, family rooms (3/4 beds) and dorms (large rooms with bunk beds). Some have private baths.

Amenities

Towels and linens are supplied. Private parking, private park, meeting halls and the possibility of shuttle transportation to the beach.

Cost per person/per night

To be determined when reservations are made; prices vary depending on the season, type of room, number of meals. Provisional price range for high season 23.00€ (lodging only without a private bath) to 53.00€ (full board with a private bath).

Meals

All meals can be provided with the lodging.

Directions

By car: From Bastia take D80 north towards Cap Corse. Proceed for 4 km to Miomo-Figarella and follow signs to Santa Maria di Lota and Maison Saint-Hyacinthe.

By ferry to Bastia: From Nice, Marseille, Genoa or Livorno. Take a taxi or a bus to Miomo. For an extra charge, the sisters can arrange transportation.

By plane: From Poretta Airport take a taxi. Or call the sisters and for an extra charge, the sisters can arrange transportation.

Contact

Sœur Hôtelière
Maison Saint-Hyacinthe
Lieu-dit Miomo Bastia
20200 Santa Maria di Lota
France
Tel/fax: 0033 (0)4 95 33 28 29
Email: mshcorse@aol.com
Website: http://www.mission-catholique-polonaise.net/korsFR.htm

COUVENT SAINT-FRANÇOIS
Oblat Friars

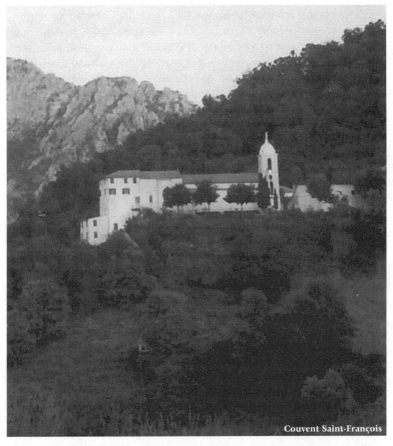

Couvent Saint-François

The convent is in Vico, less than ten miles by mountain road from the sea. Built in 1481 by the Franciscan Order, it was completely rebuilt in 1627 and enlarged in 1700. During the French Revolution the friars left the convent and returned after it had been bought by a priest. Since that time it has been inhabited by a community of Oblat friars.

In the winter months hospitality is mainly for spiritual retreats. In the summer the convent is open to anyone wishing to visit this part of Corsica. Vico is in Ajaccio province, a landscape of lakes and forests and the natural reserve of Porto-Scandola. There are also several intriguing archeological sites in the vicinity such as Sagone, Castiglione and Arbori.

Corsica is a place unto itself. The history of the Corsican language is obscure. Written, it looks like Italian but spoken, it sounds quite different. Corsica has all the attributes of a mini-continent with tropical palm trees, vineyards, olive and orange groves, forests of chestnut and pine, alpine lakes and unending beaches. Most distinctive of its flora is the maquis, a shrub heavy with the scent of myrtle which Napoleon swore he could smell from the sea.

Ajaccio

A day trip away is Ajaccio, Corsica's cosmopolitan capital. A fortified seaport, it is an important harbor town established by Genoese colonists in 1492. The old streets twist away and open onto boulevards and squares. Many sites commemorate the birth of native son Napoleon Bonaparte including the Maison Bonaparte where he was born and the cathedral where he was baptized. On the first floor of the maison is the furniture of Madame Laetitia, Napoleon's mother. On the second floor the collections cover Napoleon's ancestors and Corsica at the time of his birth.

The Chapelle Impériale was built in the late 19th century for Napoleon III. A Renaissance-style edifice in the shape of a Latin cross, it was executed in St-Florent stone. Members of the imperial family of Napoleon I are laid to rest in the round-shaped crypt. On Ste-Helena, as Napoleon lay dying, he remembered La Cathédrale D'Ajaccio, the church of his childhood. "If they forbid my corpse, as they have forbidden my body, a small piece of land in which to be laid, I desire to be buried with my ancestors in Ajaccio cathedral in Corsica." This quotation is engraved on a red marble plaque at the entrance to the cathedral. It shows how important the church was to Napoleon during his life. The Latin cross layout has seven side chapels, an imposing dome and a fine Baroque ochre façade; architectural details that imbue the building with an indefinable charm.

The Musée Fesch harbors a fine collection of Italian primitive art. Among its masterpieces are works by Botticelli, Titian and Veronese. Another highlight is a display of Neapolitan Baroque painting, a school of painting that combines impressive realism with a very marked dramatic sense. The school is represented by Luca Giordano, Francesco Solimena and Corrado Giaquinto.

Heading south around the bay is the town of Porticcio. Headlands of weirdly weathered granite separate long stretches of sand from intimate coves. Filitosa, further south of Ajaccio, is Corsica's most important prehistoric site. In the 2nd century BC, stone carvers and megalithic sculptors made Filitosa the largest Corsican and Mediterranean center for statuary art. With 8,000 years of history and mystery, Filitosa stands guard over its statues, circular

Granite menhirs

monuments and secrets. The granite menhirs, with their enigmatic sculptured faces, have intrigued visitors since their discovery in 1946. The hilltop site is shaded by a thousand-year old olive tree. There's also a small museum that displays some interesting artifacts.

Accommodations
60 beds in single, double and family rooms (5/6 beds). Baths are shared.

Amenities
Linens are provided, towels are not.

Cost per person/per night
Depending on the type of room, length of stay, number of meals, etc. Minimum cost for full board 36.00€.

Meals
Meals are provided only to groups. Families and individuals can prepare their own meals in a kitchen at their disposal.

Special rules
Proper garments inside the convent, silence between 11 PM and 7 AM.

Directions
By car: From Ajaccio take D81 north to Sagone. From there take D70 to Vico.

By bus: From Ajaccio take a bus to Vico (a bus leaves Ajaccio in the morning).

Contact
Anyone who answers the phone
Couvent Saint-François
20160 Vico
France
Tel: 0033 (0)4 95 26 83 83
Fax: 0033 (0)4 95 26 64 09

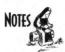 **NOTES**

FRANCHE-COMTÉ

SANCTUAIRE DE NOTRE-DAME DE MONT ROLAND
Diocese of Dole
Managed by lay personnel

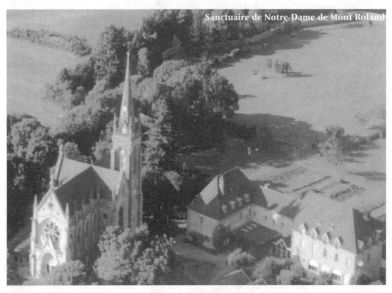

Sanctuaire de Notre-Dame de Mont Roland

The shrine, one of the most ancient in the region, is less than a mile from the small town of Dole. Enclosed by its own park with a forest nearby, the sanctuary is the epitome of a relaxing locale. Built in 1089 by the Bénédictine Order, the complex was destroyed in 1636 by the Swedish army. At that time the statue of the Virgin Mary was taken to the convent of the Capuchin Friars of Auxonne before being returned to the church in 1650.

At the beginning of the 18th century, the church was demolished and then reconstructed. In 1850 the Jesuit Fathers who had purchased the property decided to remodel the church once again. Designed by the architect Ducat, it was completed in 1859 and is highlighted by a rose window. During the 20th century the shrine became more and more popular with thousands visiting each year.

Dole is a port city where the Doubs meets the Rhine-Rhône canal. Once the capital of the Comté, Dole retains a somewhat regal air. The attractive town is characterized by old, leaning houses topped with rust-red roofs. Eglise Notre-Dame is at the center of the medieval section, a pastiche of narrow, cobbled streets.

Nearby is the picturesque town of Arbois. Considered the capital of the wine-producing heart of the Jura, it is completely enveloped by vineyards. The old town retains a medieval flavor and traces of its ancient fortifications remain. Wine shops and wine tasting are very much a part of the town's allure. The 13th century Pont des Capucins offers good views of the antique houses that edge the river. Louis Pasteur was born in Arbois. Maison de Pasteur is his preserved home and laboratory.

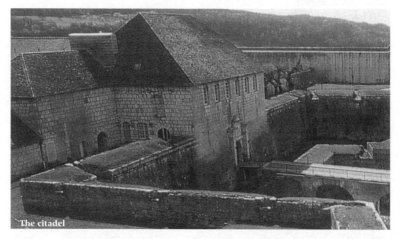
The citadel

The region's capital of Besançon is one of the finest provincial cities in France. Of Gallo-Roman origin it was an archiepiscopal see from the 5th century. Enclosed in a horseshoe bend of the river Doubs, it is a site so striking that Julius Caesar described it in *The Gallic War*. The town is full of fine houses representing all periods including structures in Spanish Renaissance style, notably the Palais Granvelle and the striking town hall. The fortifications and citadel were designed by the famous military architect Sébastien Vauban. The citadel houses the Musée de la Résistance et de la Déportation which relates the compelling account of the civilian struggle against Nazi occupation and the mass transportation of French Jews and others to concentration and labor camps.

The entire Franche-Comté region is known for clock and watchmaking and Besançon is no exception. One marvelous example is the Horloge Astronomique, an ingenious astrological clock in the 12th century Cathédral St-Jean. It features sixty-two dials and 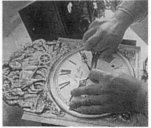 numerous animated figures. The 16th century Palais Granvelle houses the city's Musée des Beaux-Arts et d'Archeologie. Exhibits comprise a rich collection of art and artifacts once the property of the family of Chancellor Nicolas Perrenot de Granvelle including a selection of works by Fragonard, Courbet and Boucher.

Accommodations
150 beds in 28 single, 32 double and 5 family rooms (5/6 beds) and a dorm. All rooms have a private bath.

Amenities
Towels and linens are provided. Meeting rooms, private park.

Cost per person/per night
To be determined when reservations are made.

Meals
All meals can be provided with the lodging.

Directions
By car: From Paris take A6 south to A36. Exit at Dole but before entering the city, take N5 north and then follow signs to the Sanctuaire de Mont-Roland.
By train: Take the train or the TGV to Dole. Take a taxi or bus to the sanctuary.

Contact
Accueil
Sanctuaire de Notre-Dame de Mont Roland
BP 246
39103 Dole cedex
France
Tel: 0033 (0)3 84 79 88 00
Fax: 0033 (0)3 84 79 88 25
Email: accueil.mont.roland.wanadoo.fr
Website: http://eglise.eglisejura.com/index.php?p=19

MONASTÈRE SAINTE-CLAIRE
Clarice Nuns

A stone archway leads to the monastery

The monastery is primarily famous for having been founded by Ste-Colette de Corbie in 1415. The saint, charmed by the small fortified town, asked Jean-Sans-Peur, Duke of Burgundy, to finance her project. She lived in the monastery about a dozen years and then traveled and established seventeen other monasteries, all inhabited by the nuns of the Order of Sainte-Claire of Assisi. Founder of the Order of Poor Clares, she was born on January 13, 1381 at Corbie in Picardy and died in Ghent (Belgium) on March 6, 1447. Her father, Robert Boellet, was the carpenter of the famous Bénédictine Abbey of Corbie. In 1783 her relics were brought to the monastery.

Sainte-Claire

The chapel, dedicated to Notre-Dame des Sept Douleurs, preserves the relics of the saint in a gold case adorned by precious stones. A 16th century deposition represents the main participants in the founding of the monastery. Within the chapel is an important Byzantine icon of the 12th century depicting the Christ of St-Damien; a Flemish painting of the saint by Melchior Wirsch (1774); various wooden statues; and above the main portal, a Pietà of the 18th century.

Close to the monastery and set at the confluence of the rivers Cusancin and Doubs are Baume-les-Dames, Baume-les-Messieurs and Château-Chalon. The name Baume is derived from an old Celtic word for grotto and the dames were the nuns of the village's historic 7th century convent.

Messieurs is cradled in a hollow surmounted by high rock cliffs and waterfalls; the name comes from the Bénédictine monks of the ancient abbey. From Messieurs it's a short climb to Château-Chalon, a fortified village clinging to the edge of a cliff. The village is noted for its wines, one of several produced in the Jura where the grapes grow at altitudes as high as 800' above sea level, the highest in France.

Accommodations

The monastery offers hospitality mainly for spiritual retreats and pilgrims to the Chapel of Ste-Colette but visitors on holiday are welcome when rooms are available. There are 9 rooms; 2 doubles and 7 singles. Baths are shared except in 1 room.

Amenities

Towels and linens are provided. Meeting room.

Cost per person/per night

To be determined upon arrival.

Meals

All meals can be provided with the lodging.

Directions

By car: From Besançon take N83 south to Poligny.

By train: Get off in Poligny and take a taxi or walk (20 minutes) to the monastery.

Contact

Sœur Hôtelière
Monastère Sainte-Claire
13, rue Sainte-Colette
39800 Poligny
France
Tel: 0033 (0)3 84 37 11 40
Fax: 0033 (0)3 84 37 07 53
Email: monastere.claire.poligny@wanadoo.fr
 clarisses.poligny@free.fr
Website: http://eglise.eglisejura.com/index.php?p=16
 (not their own site but the site of the diocese)

NOTES

LANGUEDOC-
ROUSSILLON

NOTRE-DAME DE L'ABBAYE
Property of the Bishopric of Carcassonne

Notre-Dame de l'Abbaye

Notre-Dame de l'Abbaye occupies a wonderful position at the foot of the medieval city of Carcassonne. Once the ancient seminary of the town, it was converted into a guest house to host tourists, conferences and groups of young people. The complex is enveloped in a lovely garden and sustains a crypt and 13th century chapel. There is also a museum with a display of medieval relics of saints.

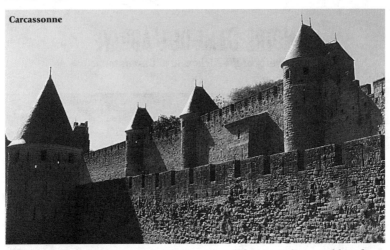
Carcassonne

Carcassonne is Europe's largest medieval fortress. Approaching from nearly every direction, the citadel shimmers in the distance. With its turrets, towers and honey-colored walls, it looks like a mythical fairy tale castle and appears to float on its lofty setting, a steep bank above the river Aude. The Romans fortified the hilltop site in the 1st century BC and towers built by the Visigoths in the 6th century are still intact. The viscounts of Carcassonne added to the fortifications in the 12th century. Visiting Carcassonne is like traveling back a thousand years in time. Intact and crenelated, from the outside, La Cité, as the walled city is known, is the most perfectly restored medieval town in Europe.

At the crossroads of two major traffic routes used since antiquity, Carcassonne began as a Gaul settlement and later became a Roman town. The ramparts were added in the 3rd and 4th centuries while the castle dates from the 12th century. Work on the fortifications continued throughout the 13th century until the fortress was impregnable. It is delineated by fifty-two towers and two rings of town walls (the walls total two miles of battlements). After the signing of the Pyrénées Treaty in 1659, the Cité lost its strategic importance. In the second half of the 19th century it was completely restored. The project was supervised by famous architect Viollet-le-Duc and despite the ongoing controversy that the restoration detracted from its authenticity, the citadel has been listed as a UNESCO World Heritage Site.

Carcassonne is divided into two, quite separate parts. The Cité occupies a plateau on the right bank of the Aude. The Bastide St-Louis lies on the left. For centuries the old district of la Trivalle and its famous bridge have linked the two. (The stone bridge replaced the original Roman one and features twelve, full-center arches.)

Built in 1262, the bastide is the "new" part of the town. It developed under the successive reigns of Louis IX, Philippe Le Hardi and Philippe Le Bel. Set on fire by the Black Prince in 1355, it was immediately rebuilt. Hemmed by boulevards built in the 18th and 19th centuries over the old, once fortified town ditches, the Bastide was constructed in a checkerboard pattern around the central place Carnot. A popular market takes place in the square Tuesday, Thursday and Saturday mornings at the 18th century Fountain Neptune and in the grain exchange.

Finished in the first part of the 12th century, La Basilique St-Nazaire is a prime example of Norman and Gothic architecture; the transept's rose window and stained glass windows of the chancel are the most beautiful in the area.

St-Michel became a cathedral in 1803. A Languedocian Gothic-style church, it is distinguished by a square bell tower that becomes octagonal. It preserves stained glass, statuary, gardens and the remains of the ramparts. St-Vincent, also Languedocian Gothic, dates to the 13th century. The 175' tower houses forty-seven bells and was used by Delambre and Méchain to calculate the length of the Meridian line. For seven years the pair traveled the meridian to create a single measurement, "the meter," from the curved surface of the planet. They began their journey by travelling in opposite directions. When they reached the extremities of their arc, they measured their way back toward one another. Their mission took them to the tops of filigree cathedral spires, to the summits of domed volcanoes and very nearly to the guillotine. At last, their seven years of travel done, the astronomers converged on the southern fortress town of Carcassonne. From there they returned to Paris to present their data to the world's first international scientific conference. The results of their labors were then enshrined in a meter bar of pure platinum. Accepting the fruit of their labor, Napoleon Bonaparte, France's new supreme ruler was noted to say, "Conquests will come and go, but this work will endure."

Canal du Midi

Opened in 1681 the 127-mile Canal du Midi was diverted through Carcassonne in the late 18th century. A notable engineering challenge and the oldest functioning canal in Europe, it was created by Pierre-Paul Riquet. The canal links Toulouse to the Mediterranean and contains many original features. A UNESCO World Heritage Site, the magnitude of the project is inspiring, particularly considering that construction took place centuries ago. To this day the canal remains an object of wonder. As an aside: Thomas Jefferson (before he became president) took a cruise on this mythical canal.

The area around Carcassonne is filled with an array of towns and monuments. Nestled in a secluded valley of limestone hills and protected by fortified pinnacles of rock, Abbaye de Fontfroide was founded in the 11th century. Occupied first by the Bénédictines and then by the Order of Cîteaux, the abbey was a bastion of active orthodoxy during the Albigensian Crusades. It declined from the 15th century onwards until its rebirth at the end of the 19th. One of the jewels of Languedoc-Roussillon's religious architectural heritage, its church possesses cathedral-like proportions and with the abbey as a whole, represents the transition from Romanesque to Gothic style. Surrounded by cypress trees and gardens, it is embellished with sumptuous stained glass windows.

Nearby Lagrasse is a particularly picturesque fortified village with narrow cobbled streets, a 14th century market hall and 15th century houses. Its abbey was founded in the 8th century by Charlemagne and was most prosperous during the Middle Ages.

Traces of Neolithic occupation have been found in riverside Limoux. The city's eventful history entails being taken by Simon de Montfort during the crusade against the Albigeois; becoming a crown possession in 1296; being razed by the Black Prince in the 14th century; and in the 16th, a battlefield for Protestants and Catholics. In the 14th century Limoux was enclosed within walls with seven gates and twenty towers and protected by moats. Only traces of the ramparts and one tower remain. Belying its name, the Pont Neuf is the oldest of the city's three bridges. Originally constructed of wood, it was rebuilt in stone in the 14th century. From the bridge there is a view over the apse of St-Martin Church, an early Roman edifice. Restorations in the 14th and 15th centuries account for its Gothic style. The half-Roman, half-Gothic tower was built over an ancient 11th century tower. Despite much of the restoration, the church retains a distinct southern Gothic appearance.

Somewhat further afield but certainly worth the detour is the medieval town of Pézenas. Like a trip back in time, reminders of its past are at every turn. One of the first cities in France to be protected by the state historic monument department, it is rich with *hôtels particuliers* – period mansions with wonderful wrought iron balconies, stone sculptures and ornate entryways. Hôtel de Lacoste boasts a Renaissance staircase; Hôtel d'Alfonse is highlighted by striking arches and columns. It was in Hôtel d'Alfonse in 1655 that Molière presented his first performance of *Le Médecin Volant* to the court of Prince de Conti.

Traces of Pézenas' Jewish presence can be seen below the walls of the castle in the 14th century ghetto that is still mostly intact (between the Faugeres and Biaise gates). Entry is through a low archway that leads to rue Juiverie and travels to rue des Litanies. Stones from an ancient synagogue are revealed in the cloister of Cathédral St-Nazaire .

The annual trade fairs that began in the 13th century brought fame and wealth to Pézenas. In concert with nearby Montagnac, the fairs continued for nearly six centuries and brought wool merchants from the hills to meet buyers. Eventually other merchandise and crafts were added.

Development of trade was facilitated, when in 1261, Pézenas became part of the royal estate. A royal order stipulated that during the fairs, goods were tax-free for thirty days. Merchants could not be arrested for debt and were assured protection on their travels to and from the fairs by the neighboring aristocracy.

Accommodations
140 beds in single, double, family rooms and a dorm, each with a private bath.

Amenities
Linens are supplied; towels are not. There is private parking, meeting rooms.

Cost per person/per night
Lodging and breakfast 27.00€ (single room), 24.00€ (double room). Full board 34.00€ (single room), 31.00€ (double room).

Meals
All meals can be provided with the lodging.

Directions
By car: From A61 exit at Carcassonne est and follow the signs to the Cité. The center is located below the medieval Cité and the bus parking. A detailed map of the city of Carcassonne is available on the website www.carcassonne.org. Instructions are in English.
By train: Get off at Carcassonne and take a taxi or bus to the Centre Diocésain of the Notre-Dame de l'Abbaye.

Contact
Anyone who answers the phone
Centre Diocésain
Notre-Dame de l'Abbaye
103, rue Trivalle
11000 Carcassonne
France
Tel: 0033 (0)4 68 25 16 65
Fax: 0033 (0)4 68 11 47 01
Email: ndaa@wanadoo.fr

MONASTÈRE DE CLARISSES
Clarice Nuns

The monastery was established in 1854 in the town of Troyes and transferred to its present site years later. The building inhabited by the nuns was built in the 18th century whereas the guest house is of modern vintage. The monastery is in the center of the city at the foot of a mountain. "It is very pretty," said the sister "and the surroundings offer a lot of interesting places to visit." Apart from the 11th century statue of the Virgin Mary, the institution does not contain any works of art. "The statue is not on display but can be shown to those who come to visit," the sister added.

Castelnaudary was founded in the 12th century by Arius. It was a castle that took the Latin name *Castrum Novum Arii*. In modern French became Castelnaudary. Over the years the castle evolved into a city and was the focal point of various battles, mainly during the Hundred Year War (1350-1450). It also gained importance in later years when Pierre Paul Riquet made it the heart of the construction of the Canal du Midi, a waterway that

Castelnaudary

192

links this part of the region to the city of Sète on the Mediterranean. The canal is now a popular tourist attraction. In addition to canal trips, there are lovely canal-side walks. For many years, Castelnaudary has been known as the city of windmills. It also lays claim to some fine old mansions and an 18th century tower.

Sitting beside the monastery is the most famous monument of the town, the Collégiale of St-Michel (1240-1270). The church was originally built in Romanesque style. Since it suffered many religious vicissitudes, it has been restored throughout the years. The interiors are decorated with marble and conserve a beautiful 18th century

altar, precious paintings and an important 18th century organ.

Collégiale of St-Michel

The city is also famous for being the "Capital of the Cassoulet," a special recipe which tradition claims was created during the Hundred Year War. The people of Castelnaudary and the soldiers protecting them were under siege and hungry. The townspeople pooled their foodstuffs (beans, sausages, lard, etc.) and cooked it in the oven of a bakery. The result was the cassoulet, a hearty dish that gave the soldiers the strength to drive the English enemy from their town. As an aside: an authentic cassoulet must be made in an earthenware pot from Issel, with beans grown in Pamiers or Lavelanet and cooked in a baker's oven fired with rushes from the Montagne Noire.

Castelnaudary is in the heart of Cathar country, a scenic realm of verdant hills and valleys. In this region of southwest France during the 13th century, the Cathars, a separate religious sect at odds with the king and church, built a world of their own. Throughout the years the Cathars exercised a strong influence in the Languedoc as the messengers of a new faith. Their faith rejected the material world, regarded women as the equal of men and did not recognize church marriages. They believed there were two gods, an evil one ruling the physical world and a greater, good god ruling the spiritual world. Considered heretics, attacked by king and church, they were massacred and burnt at the stake. In actuality they were not Christian heretics but rather "Cathari," Provençal adherents of the Manichaen dualistic system popular in the Mediterranean basin for centuries.

Not far from the monastery is Cordes-sur-Ciel, a citadel built in 1222 by Raymond of Toulouse and one of the fortresses in which the Cathars sought refuge. A significant number of the town's medieval buildings have survived intact. As a result, it is popularly known as "the town with five walls and one hundred Gothic arches." Mountaintop Cordes-sur-Ciel is a gem of a village with cobbled streets and graceful Gothic houses. The grand manors and palaces were built by prosperous merchants and noble families between 1280 and 1350 and are resplendent with Gothic-inspired sculpted façades. Honoring centuries of tradition, the locals turn out in full medieval costume for the Grand Falconer's Festival on Bastille Day.

In nearby Albi, the ancient part of the city is known as the Ville Rouge because of its red brick buildings. A marvel of medieval architecture, the skyline is dominated by the massive Gothic Cathédrale de Ste-Cécile. Begun in 1282 it resembles a fortress rather than a church and took two centuries to complete (1282 to 1480). The cathedral is one of the most visited in France and among the largest brick structures in the world. Built by Christian loyalists as a defense against the Cathars, the vast structure is a masterpiece of "meridional" (southern) Gothic architecture. The contrast between the sober simplicity of the exterior and the sumptuous decoration and detail of the interior is remarkable. The interior is so gloriously painted it might be the vortex of a kaleidoscope. The most impressive among its many noteworthy features is the gigantic mural of the *Last Judgement* painted by unknown Flemish artists in the mid-15th century. During that same period, French sculptors completed the *Jube*

and Choir, an ensemble that includes a set of polychrome statues. The frescoes on the arched ceiling form the largest work of Italian Renaissance painting to be found in France. The classical French organ, by Christophe Moucherel in 1736, is considered one of the three finest in the country.

The Palais de la Berbie was constructed during the Middle Ages. The oldest sections of the monument date back to the 13th century. Along with the Palais des Papes in Avignon, the Berbie is one of the most completely restored fortresses in France. The 13-foot thick walls, Magne Tower, dungeons and enclosed fortified courtyard illustrate what the word fortress truly means. In the 17th century when the need for defenses gradually diminished, the massive ramparts were turned into walking paths that today permit visitors to enjoy the gardens of the Berbie along with wonderful views of the Tarn.

Quartered within the palace is the Musée Toulouse-Lautrec. It showcases more than 1,000 paintings, drawings and the thirty-one cabaret posters that made the native born artist famous during his lifetime.

The nearby town of Narbonne recently celebrated its 2,100[th] anniversary. It has preserved intact its rich cultural and architectural heritage. Established in 118 BC, it was the first Roman colony in Gaul. Testimony of its prosperity throughout that period can be seen in the "Horreum" (underground granaries and grain chutes), the bridge and amphitheater. Narbonne's Cathédral St-Just is one of the tallest Gothic cathedrals in France. Begun in 1272 it replaced three churches on the same site. The interior harbors fine 15th to 17th century tapestries. The cloister leads to the massive fortified Palace of the Archbishops flanked by three square towers.

Jewish history in the region is long and distinguished, especially in the cities of Béziers, Montpellier, Narbonne and Perpignan. The 1306 order that expelled Jews from France brought them south to Provence, Catalonia and Roussillon. At the end of the 14th century, with the French annexation of Languedoc, more Jews were expelled and did not return to Languedoc until the end of the 18th century. The expulsion of the Jews and the Black Death in 1310 were severe blows to the city's prosperity.

Accommodations
20 beds in single and double rooms. All rooms have a sink and toilet; showers are shared and located in the corridors. Open from Easter to November 1st.

Amenities
Towels and linens are provided.

Cost per person/per night
Half board 20.00€.
Full board 30.00€.

Meals
All meals are provided with the lodging.

Special rules
The monastery closes at 8 PM. If guests plan to spend the evening out and return later than 8 PM, a key will be provided.

Directions
By car: From Toulouse take N113 or A61 and exit at Castelnaudary.
By train: Get off at Castelnaudary and walk (5 minutes) or take a taxi to the monastery.

Contact
Sœur Hôtelière
Monastère des Clarisses
10, rue Pasteur
11400 Castelnaudary
France
Tel: 0033 (0)4 68 23 12 92
Fax: 0033 (0)4 68 23 69 46

Notre-Dame de la Gardiole
Missionaries of Montfortains

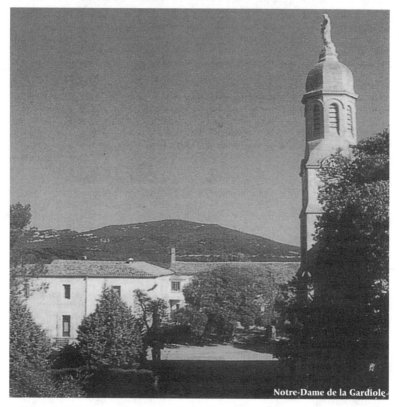

Notre-Dame de la Gardiole

The Sanctuary of Notre-Dame de la Gardiole is quartered in Conqueyrac, in the countryside between the sea and the mountains of the Cevennes chain. The sanctuary was once an orphanage that closed in 1932. The interiors have been completely restored. The exterior stone structure has been preserved in its ancient state. Today it is inhabited by a community of missionary friars, who, with the lay association, manage the guest house. Conqueyrac is an ideal setting for exploring the intriguing and historic environs.

Languedoc-Roussillon is a multi-faceted region rich in its powerful Roman past. It is the locale of the Camargue, half water, half land, a refuge of salt and untouched, unending beaches that provide a unique and protected environment for fauna. Salt production in the Camargue began in antiquity, by both the Greeks and the Romans and continued through the Middle Ages. The colors of nature blend harmoniously in this area: pink spots of flamingos, black of the bulls and white of the horses.

Camargue horses

The Camargue is like a country unto itself. Eagles, hawks and harriers soar in the blue skies and muskrats swim along the meandering canals. Black bulls and white horses graze in the fields. Cyclists peddle against the wind along roads or lanes closed to motor vehicles. The Camargue was designated a botanical and zoological nature reserve in 1927 and 1970. Spring and fall are the best times to see the birds, bulls and horses of this singular region. The white horses of the Camargue are small sturdy animals and one of the oldest breeds in the world. Strictly protected, it is often called "the horse of the sea." The animals run wild in the marshlands and the breed has existed in this region since prehistoric times. Some believe it is descended from the now extinct Soutre horse.

Nestled in the Celette mountains, St-Guilhem-le-Desert is well worth the journey. A medieval settlement on the famous Santiago de Compostela, it is a UNESCO World Heritage Site. The ancient village is remote and extraordinarily picturesque. At the confluence of the Verdus and Herault gorge, it is built around an abbey founded by St-Guilhem in 804. A trusted lieutenant of Charlemagne, Guilhem built the abbey to house a relic of the True Cross given to him by his leader. Traces of the 10th century church remain but most of the building exemplifies the best of 11th to 12th century Romanesque architecture. Its chapels command the heights of the village, a composition of two parallel streets linked by passageways.

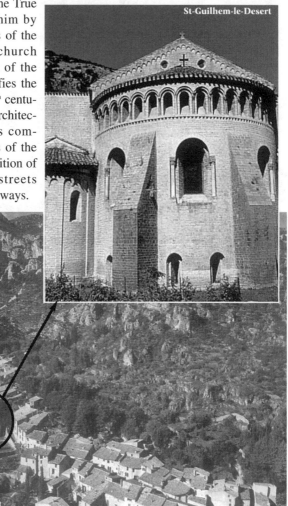

St-Guilhem-le-Desert

St-Guilhem-le-Desert

In nearby Uzès, the first traces of occupation were found on the banks of the river Alzon, close to the source of the Eure. An oppidum was built at the top of the hill and in the 5th century the town was known as *Ucetia*. In 50 AD the Romans decided to tap the source of the Eure to provide water for Nîmes. They built a 31-mile-long aqueduct, the main part being the Pont du Gard. The remains of the aqueduct are just a short distance from the town center. In the mid-16th century many citizens of Uzès were Calvinists; the town had the fifth largest Protestant sect community in the kingdom. Religious wars resulted in the destruction of the temple and all the churches.

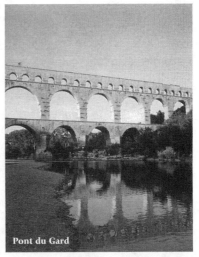
Pont du Gard

An aristocratic hill town, Uzès is a place of medieval towers and narrow lanes fronted by gracious Renaissance and neoclassical houses and is among the most charming and historic enclaves in the region. A delightful synthesis of arcaded streets and handsome structures, its history is closely tied to that of its great ducal family, the House of Uzès. The Duchy of Uzès is a well-preserved feudal complex that has been occupied the by ducal family for more than a thousand years. An eclectic mix of architectural styles, it is defined by a Renaissance façade, Gothic chapel, 11th century donjon and the 14th century Tour de la Vicomté.

The warmth and welcoming essence of the town is reflected in place aux Herbes, the town's main square. Tree-shaded and framed by arcaded houses, it is the center of the very popular, lively market held Wednesday mornings and all day Saturday. The most unusual structure in town is the 12th century Tour Fenestrelle, a round six-story campanile that is more classically Italian than French. The tower is marked by a profusion of windows and is the only one of its kind in France. Cathédrale St-Theodorit was completed in 1090 but destroyed during the wars against the Albigensians. Rebuilt, it was destroyed again during the wars of religion. There are traces of wall and ceiling frescoes.in the chapels.

Accommodations
80 beds in single, double, triple and quadruple rooms and small apart-
ments. Baths are private or shared depending on the room.

Amenities
Towels and linens are provided. If guests provide their own supplies, a
reduction will be given on the price of the room.

Cost per person/per night
Cost is dependent on the type of room, length of stay, number of meals.
Prices can be determined when reservations are made.

Meals
All meals are provided with the lodging.

Special rules
Punctuality at meals and minimum noise inside the facilities.

Directions
By car: From Nîmes take D999 to Conqueyrac.
By train: Get off in Nîmes and take a bus which stops in front of Notre-
Dame de la Gardiole.

Contact
Accueil Montfortain
Notre-Dame de la Gardiole
30170 Conqueyrac
France
Tel: 0033 (0)4 66 77 20 95
Fax: 0033 (0)4 66 77 29 40
Email: lagardiole@wanadoo.fr

NOTES

MAISON DIOCÉSAINE
Property of the Diocese of Nîmes

Maison Diocésaine de Nîmes

A fifteen-minute walk from the center of Nîmes, the Maison Diocesaine is a peaceful, verdant oasis far from the noise of the city yet conveniently close to all that Nîmes has to offer. Quartered at the center of a large wooded park, the maison was built a century ago and for a few years served as the seminary of Nîmes. After that time it was occupied by a community of nuns. In 2000 the nuns left and the diocese decided to convert the facility into a guest house.

Maison Diocésaine de Nîmes

Each bedroom overlooks the park. The chapel has also been restored and is open to guests. The premises have been completely renovated and are handicap-accessible. The maison frequently hosts art expositions.

Nîmes, an old Gallic town, was the Roman town of *Nemausus* in 120 BC. It was an important city and the link between the road to Rome and Spain. United to the French crown in 1258, it later became a stronghold of the Huguenots but suffered greatly from the revocation of the Edict of Nantes. The history of Nîmes is definitively

Roman 1ˢᵗ century AD amphitheater

engraved in the grandeur of its Roman monuments. From the imperial, oval-shaped amphitheater to the famous Pont du Gard, Rome's presence cannot be denied. The magnificent 1ˢᵗ century AD arena is one of the best preserved from Roman times. Seating up to 24,000 spectators, it was used for chariot races and battles between Caen gladiators and wild animals. A system of stairways and passages allowed spectators to reach their seats that were positioned according to social status. They were shaded from the sun by a canopy supported by ropes attached to poles. Today the arena hosts bullfights.

The Pont du Gard was built by Agrippa in 19 BC to supply Nîmes with water. It consists of three tiers of arches and is 900' long and 160' high. With its blocks of stone weighing up to six tons each, the structure continues to amaze engineers. After some 19ᵗʰ century restoration, it is in near perfect condition, its arches of golden stone harmonizing with the landscape. A contemporary museum details the exceptional story of Nîmes' aqueduct. Agrippa also built the Maison Carrée (square house) in Hellenic style. Constructed in the 1ˢᵗ century AD, it has had its name since the 16ᵗʰ century. In ancient French any rectangle with four right angles was described as a *carré* or square. Raised up on its high podium, the temple would have dominated the forum of the ancient city. The spacious square, once the center of public life, was surrounded by a portico, traces of which can still be seen. With its finely fluted Corinthian columns and harmonious proportions, it remains one of the loveliest examples of Roman antiquities.

Other Roman relics include the
Temple of Diana from the 2nd century
AD, the ruins of a watchtower and
the Tour Magne. Visible from a dis-
tance, the tower was the highest and
most prestigious of the Roman town.
Octagonal in form, it was composed
of three levels on top of a pedestal.
Today the upper story has vanished.
From atop the tower the view over
Nîmes is memorable.

Temple of Diana

The city of Nîmes is sprawled on
seven hills. Its picturesque historic
quarter contains many beautiful Renaissance mansions. The elegant 18th
century Jardins de la Fontaine is a formal public garden laced with canals
highlighted by stone terraces, paths lined with statuary and enormous
shade trees. Keeping to the plan of the ancient shrine, it was designed in
the French style and is ornamented with statues and vases in marble or in
white *pierre de Lens*. The top part of the garden, Mont Cavalier, was
planted in the 19th century. Mediterranean species are predominant includ-
ing pine, cypress, ilex, boxwood and bay, providing green foliage
throughout the year. The Musée Archéologique maintains a collection of
Roman statues, ceramics, ancient coins and mosaics. Musée des Beaux-
Arts showcases French, Italian, Dutch and Flemish works. Featured on
the main floor is a wonderfully preserved Gallo-Roman mosaic, *The
Marriage of Admetus*.

Cathédrale Notre-Dame was built in the Romanesque period and was
destroyed and rebuilt several times, notably during the wars of religion
when only the bell tower remained to serve as a lookout. On the façade
is a long sculpted frieze, one of the most beautiful examples of
Romanesque art in lower Languedoc.

The contemporary Carré d'Art opened in 1993. Designed by British
architect Sir Norman Foster, the striking edifice was built in tribute to the
Maison Carrée. The complex includes a library, roof terrace restaurant
and the Musée d'Art Contemporain with vast, airy galleries that present
work by contemporary artists.

Nîmes lies in a multi-faceted region. It weds the riches of its powerful Roman past with the shifting expanses of the Camargue, a milieu of salt marshes, protected reserves and bird refuges. A land of lagoons, wild horses and vineyards, it is indelibly stamped by strong local traditions and customs. Nîmes is also known for its "ferias." The Feria de Pentecôte is a great French festival that has been staged for more than half a century. The five-day extravaganza takes place in June and is complete with bullfights, concerts and dancing in the streets.

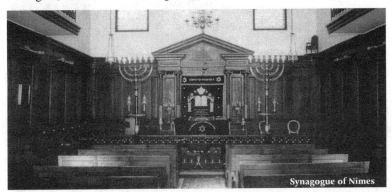
Synagogue of Nimes

Jewish history in the region is long and distinguished. Although the earliest evidence of an established settlement dates to the 10th century when the town had a synagogue, the Jewish community has probably come and gone from Nîmes as far back as the 7th century. In the 11th century, Mont Duplain, one of the hills within the city walls, was called *Poium Judaicum* and was the site of a Jewish cemetery. The synagogue at 40 rue Roussy was built in 1793 and contains a *mikvah* (ritual bath) and matzo bakery.

Nearby Montpellier is the capital of the Languedoc-Roussillon region. Situated on hilly ground six miles inland from the Mediterranean coast, the name of the city was originally Monspessulanus, which supposedly stood for mont pele (the naked hill). One of the few cities in France that does not have a Roman background, it was founded by a local feudal dynasty, the Guillem Counts of Toulouse who joined two hamlets, built a castle and surrounded the complex with walls. Two towers survive from that period, Tour des Pins and Tour de la Babotte. Montpellier came to prominence in the 10th century as a trading center with links across the Mediterranean. The city's university was established in 1220 and was the first medical school in France.

Cathédral de St-Pierre is noteworthy for its impressive porch supported by two soaring rocket-like towers. The interior houses six chapels that open onto a unique nave with a ribbed vault. As a sign of the wealth and prosperity of the city, *Follies* (grand châteaux) had their heyday in the 18th century and were inspired by Italian villas built around Venice. Château de Flaugergues is the oldest. Entirely furnished, it exhibits a number of collections including five Belgian tap-

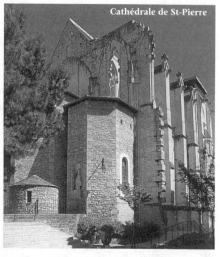

Cathédrale de St-Pierre

estries. A monumental staircase, formal French gardens and English-style botanical gardens complete the ensemble. Château de la Mogere has had the same family in residence since 1715. It preserves a variety of furniture and paintings from the 17th and 18th centuries.

The Ecusson district of the ancient quarter is also rich in *hôtels particuliers*, 17th and 18th century private mansions with spacious inner courtyards, stone staircases and balconies. Fine examples include the grand Hôtel de Varennes, a blend of Romanesque and Gothic; the elegant Hôtel St-Come; and the Hôtel des Tresoriers de France. The wide central square, place de la Comédie with its paved piazza, is the social hub of the city and the link between the new and old towns. The square is filled with cafes and defined by the delightful Fontaine des Three Graces which sits in front of the 19th century opera house.

From the moment it was established and despite the obstacles, the Jewish community of Montpellier played an essential role in the city's economic development and intellectual influence. The names of great Jewish lawyers, doctors, poets and philosophers are inscribed in letters of gold on the pediment of the university. The medieval Jewish quarter was located around the present rue de la Barralerie. Under the city walls is a restored 13th century *mikvah* (ritual bath). A series of vaulted rooms, a staircase, disrobing room and bath are open to visitors.

Accommodations
28 double, 4 single, 1 triple and 1 family room (5 beds) with private bath; 20 doubles with bunk beds and shared bath; 4 mini-apartments with 2-8 beds, private bath and kitchenette.

Amenities
Towels and linens are supplied. Private parking, TV room, dining rooms, meeting and conference halls, chapel and oratory.

Cost per person/per night
Lodging only: single 25€, double 35€.
Up-to-date prices are available on the website (click on "Télcharger") or they will be communicated when reservations are made.

Meals
All meals can be provided with the lodging.
Breakfast 2.00€, lunch and dinner are 11.00€ each.

Special rules
Reservations must be made in advance. Maximum stay is one month. Hospitality is offered to guests on holiday and groups seeking spiritual retreats.

Directions
By car: From either A9 or A 54 exit at Nîmes (a detailed map to reach the maison is on the website).
By train: Get off at Nîmes (TGV line, 3 hrs from Paris) and take a taxi, bus (Ligne F et G - stop Charles Gide) or walk (15 minutes) to the Maison Diocésaine.

Contact
Monsieur Humann
Maison Diocésaine de Nîmes
6, rue Salomon Reinach
30000 Nîmes
France
Tel: 0033 (0)4 66 84 95 11
Fax: 0033 (0)4 66 84 27 68:
Email: contact@maison-diocesaine-nimes.org
Website: www.maison-diocesaine-Nimes.org

MAISON DIOCÉSAINE
Property of the Diocese of Perpignan
Managed by the association Mont Thabor

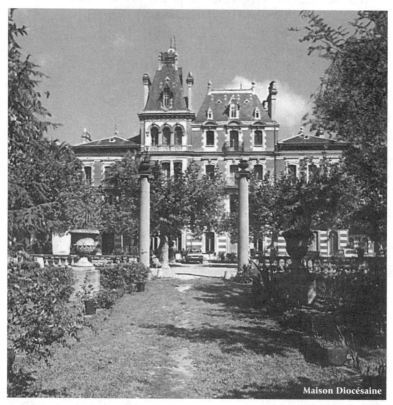

Maison Diocésaine

 This splendid villa-castle was built at the end of the 19th century. It is immersed in its own park, two miles from Perpignan and ten miles from the sea and the Spanish border. The villa belonged to a local nobleman before becoming the seminary of the Bishopric of Perpignan. In the 1960s it was converted into a guest house. The original interiors and stuccos have been preserved, although the house has been restored and is accessible to the handicapped.

Once the Roman city of *Ruscino*, Perpignan was the fortified capital of French Catalonia from the middle of the 10th century to the 17th. It occupies a privileged position; on one side, the Mediterranean coast with its beaches and rocks, on the other, the Canigou, one of the highest mountains in the French Pyrénées. Perpignan has a definitive southern feel with palm trees fringing the river promenade. The houses and shops are painted in vibrant colors, a reflection of its Catalan heritage. The ancient quarter still maintains its urban layout.

Among the town's notable buildings is the handsome 14th century Loge de Mer. Built to house the merchants' exchange, the structure reflects a Moorish aspect. Despite the fact that it is now used as a restaurant complex, its gracious beauty is undisguised. The 14th century Gothic Cathédral St-Jean is an impressive church enhanced with fine wood and marble carvings including a massive marble font. It was constructed in typical Roussillon style from river pebbles layered with brick. Perpignan sustains its original ancestry, a cultural inheritance from the Kings of Majorca (1276-1344) who built the vast fortified Palais des Rois de Majorque. On the top of a hill named Puig del Rei, the palace gazes down upon 700 years of Roussillon's history. A Gothic castle surrounded by ramparts, it is underscored by a central arcaded courtyard and flanked

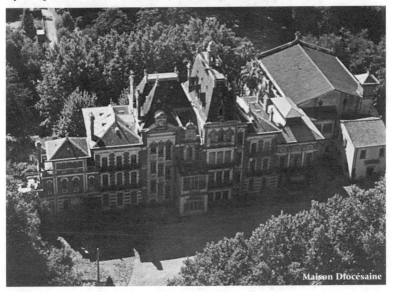

Maison Diocésaine

by the Salle de Majorque. Two royal chapels represent southern Gothic style with pointed arches, patterned frescoes and Moorish tile work. The 14th century red brick Le Castillet was the main gate of the city and formed a part of the old citadel. It houses the Casa Pairal Museum where local arts and traditions offer an introduction to Catalan culture.

Perpignan became the literary cradle of famous troubadours like Pons D'Ortaffa, the stop of traveling philosophers like Ramon Rull and the headquarters of a great Jewish philosophy school. From its train station, baptized "the center of the world" by Salvador Dali, many major painters of the 20th century including Picasso, Miro, Matisse, Derain and Chagall, headed out to the little ports of the Côte Vermeille. The Roussillon beaches form a perfectly straight coastline all the way to Collioure, where the steep, rocky, cove-filled Côte Vermeille (Ruby Coast) begins.

Château Royal de Collioure

Only miles from Spain, sits the glittering jewel of Collioure. Fortified during the Carolingian period, this picture-perfect Mediterranean port features brightly painted houses sheltered by cypress trees; its harbor filled with colorful fishing boats. The town is dominated by the Château Royal de Collioure. Originally a prehistoric oppidum (town) used by Phoenicians as far back as the 6th century BC, in 1207 the Order of

Knights Templars established a fortress on the site. Once the residence of the Kings of Aragon and Majorca, renowned architect Vauban added the defensive walls in the 17th century. The château houses exhibitions of modern art.

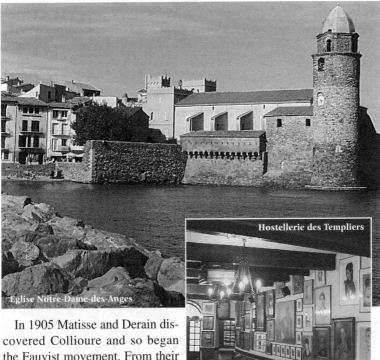
Hostellerie des Templiers

Église Notre-Dame-des-Anges

In 1905 Matisse and Derain discovered Collioure and so began the Fauvist movement. From their walks, the two painters recorded on canvas, images of the village such as the belltower, castle, fishing nets hung to dry, boats leaving the port, women mending nets, windows and more windows. It wasn't long before Picasso, Dufy and other artists arrived, drawn by the unique setting. Today, all along the "Fauvism footpath," a living museum based on nearly two dozen reproductions, are displayed where the original works were painted. In front of the harbor is the Hostellerie des Templiers, an inn that houses a cache of paintings including many of the lighthouse, a favored setting.

Behind the harbor, the cobbled old quarter of Moure is an inviting pastiche of boutiques and restaurants. At the northern end of the harbor is the 17th Eglise Notre-Dame-des-Anges. The church shelters an altarpiece considered a gem of Catalan Baroque.

Several other cities and sites warrant a day trip. Castelnous is a beautiful village. Its 10th century medieval castle overlooks the picturesque Aspres region. Built as a military and administrative center for the viscounty of Vallespir, the castle typifies one of the most archaic examples of a medieval fortress existing in Roussillon. From its terrace are breathtaking views over the entire plain.

Abbey St-Michel de Cuxa

In close-by Prades, the Abbey St-Michel de Cuxa is in a valley at the heart of the Romanesque Conflent region. A Bénédictine residence since 878, the abbey is an outstanding architectural monument with a large 10th century pre-Romanesque church, Lombard steeple, 11th century crypt and the ruins of a 12th century Romanesque cloister. The complex has inspired the architecture of many other convents.

Since the 1950s when renowned cellist Pablo Casals created his famous music festival, Prades has earned itself a reputation as a center of culture. The town's most important structure is the 17th century church; it shelters some outstanding examples of Baroque art including a large wooden altarpiece by Joseph Sunyer.

Accommodations
100 beds in single, double and family rooms (3/4 beds). There are also some studios with 2 beds and a kitchenette. All rooms have private baths.

Amenities
Towels and linens are supplied. Private parking, private park, TV room and meeting rooms.

Cost per person/per night
To be determined when reservations are made.

Meals
All meals can be provided with the lodging.

Special rules
On day of check-in, arrival must be before 6 PM.

Directions
By car. Take A9 and exit at Perpignan nord. Follow the signs to "Centre ville." Along the road there will be signs to Parc Ducup.
By train: Get off at Perpignan and take a taxi to the Maison Diocésaine.

Contact
Anyone who answers the phone
Maison Diocésaine
Château du Parc Ducup
Allée des Chenes
66000 Perpignan
France
Tel: 0033 (0)4 68 68 32 40
Fax: 0033 (0)4 68 85 44 85
Email: parcducup@wanadoo.fr
Website: www.parcducup.com

LIMOUSIN

MONASTÈRE DE LA THÉOPHANIE
Greek-Catholic Nuns of Oriental Rite

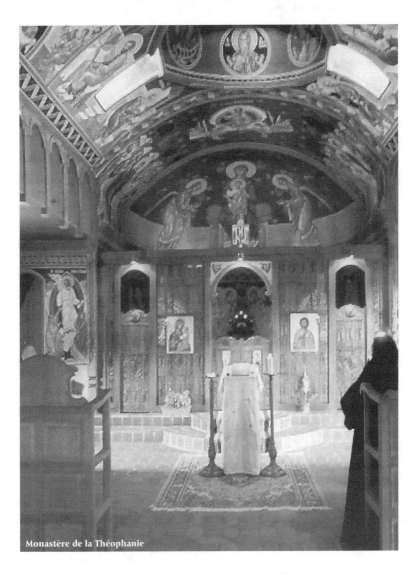

Monastère de la Théophanie

Forty years ago a small community of nuns came from the Middle East and lived in a convent of Aubazine for twenty years. In 1985 they moved to the present complex, a former farm in the countryside. Occupying a wooded site near the Massif Central, the monastery is very close to the quaint village of Aubazine.

The nuns built a Byzantine-style chapel that is covered with frescoes. Quite close to the monastery, the 12th century church also belongs to the community. Constructed by the Cistercian monks who arrived in Aubazine in the Middle Ages, it is highlighted by a carved tomb of St-Etienne. Famous for their ability in hydraulic engineering, the monks built the Canal des Moins to bring water to the village. The ancient waterway remains visible and every year attracts thousands of visitors. During that same period the industrious monks also erected a female monastery.

An easy day trip can be made to Limoges and Brive La-Gaillarde. Long before it became synonymous with porcelain, the city of Limoges was famous as an enamel center. Musée Municipal de l'Evêché shelters a treasure trove of brilliantly colored enamelware. The porcelain craft of Limoges is well represented in the Musée Adrien-Dubouche. The collection exhibits samples of the locally produced porcelain as well as ceramic displays from around the world.

Every morning, from Tuesday through Saturday, a colorful farmers market overflows historic place des Bancs. Another market takes place Tuesday through Sunday mornings at which time stalls laden with fruit, vegetables and traditional delicacies fill the 19th century covered market on place de la Motte. The medieval half-timbered houses on rue de la Boucherie, once the domain of the butchers' guild, are now ateliers for contemporary artisans.

Cathédral St-Etienne, a landmark for miles around, was begun in 1273 and modeled after the cathedral of Amiens, although in St-Etienne, only the choir is pure Gothic. The most striking external feature is the 16th century façade of the north transept, built in Flamboyant style with elongated arches and clusters of pinnacles. The soaring quality of the structure is accentuated by the upward reaching lines of the pillars, the net of vaulting ribs and the flame-like lines in the side chapels and rose window.

Brive La-Gaillarde's open-air market is held under huge plane trees. An ancient city, it is underlined by turreted houses (some dating to the

13th century), the 12th century Eglise St-Martin and Hôtel de Labenche, a fine Renaissance structure.

During WW II the Limousin region's département of La Creuse was the first place in France to establish safe homes for Jewish children rescued in Germany and hidden by the Oeuvre de Secours aux Enfants which also created the Garel Network that evacuated many children to the United States. *The Children of Chabannes*, a film produced and directed by Lisa Gossels, daughter of one of the children hidden at the Château de Chabannes, recounts the story. Many of the safe homes still exist, especially in La Creuse and in the département of Haute-Vienne. Château de Chabannes is now a private home near the village of St-Pierre-de-Fursac (35 km west of Guéret). The château took in 400 children between 1939 and 1944.

Accommodations
Guests on holiday are welcome (no groups).
19 beds in single and double rooms. All baths are shared.

Amenities
Towels and linens are provided.

Cost per person/per night
To be determined when reservations are made.

Meals
All meals can be provided with the lodging.

Special rules
Minimum noise inside the monastery.

Directions
By car: From Limoges take N20 south to Brive La-Gaillarde and then take N89 about 10 km, turn right on D130 and follow the signs to Aubazine.
By train: Get off at Aubazine. The station is 4 km from the monastery. Taxis must be reserved in advance.

Contact
Anyone who answers the phone
Monastère de la Théophanie
Le Ladeix
19190 Aubazine
France
Tel/Fax: 0033 (0)5 55 25 75 67

LORRAINE

ERMITAGE SAINT-JEAN
Property of the Diocese of Metz

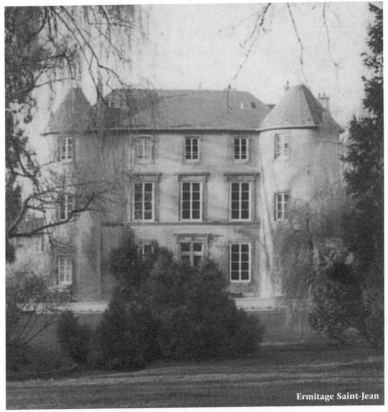

Ermitage Saint-Jean

The guest house is a beautiful stone structure flanked by two rounded towers. The rays of the sun stream through the large windows and bathe the spacious interiors with diffused light. The ermitage occupies a peaceful spot enveloped by a tree-shaded, green oasis in Moulins-les-Metz, a tiny village on the outskirts of Metz. The house was an ancient castle that once belonged to the Bishopric of Metz. In 1923 it became a Maison d'Accueil (guest house) offering hospitality to guests and religious orders.

Ermitage Saint-Jean

The castle's history began in the Middle Ages when the city of Moulins-les-Metz was divided into three *seignories* (medieval dominions). There is evidence that in 1368 a tower stood where the guest house now stands. In the early 1400s the structure was fashioned into a fortified castle. The owners were part of the De Laitre family. Having no heirs the family left the castle to the daughters of a local family. At a later date it was sold to Nicole Grognat. As with other properties, the castle suffered the wars and devastations that took place in France between 1400 and 1700. Over the course of time, ownership of the property changed hands many times. In 1789 during the French Revolution the owners were expelled and the castle sold as national patrimony. In 1923 the Bishopric of Metz bought the castle and converted it into the guest house it is today. At that time responsibility for hospitality was given to lay personnel who continue to manage the facility.

Of pre-Roman origin, Metz was once the capital of a Gallic people. One of the most significant cities of Roman Gaul, it was invaded and destroyed by the Vandals and then the Huns. It was a major cultural center of the 8th century Carolingian Renaissance. Records document that in the 10th century, Metz was a prosperous city with an important Jewish community and home to France's first state-sanctioned rabbinical seminary (which was relocated to Paris in 1859). The synagogue is now a French historic monument at 39 rue du Rabbin-Elie-Bloch.

Synagogue

A stone's throw from Belgium, Luxembourg and Germany and built on several islands, Metz is surrounded by a moat formed by the rivers Moselle and Seille. Funeral urns found by archeologists testify that people of the late Bronze Age settled here. Rising above the upper city, cathédral St-Etienne is a Gothic masterpiece built between 1220 and 1520. Known for its golden stonework, dramatic Gothic spires and flying buttresses, the cathedral is most celebrated for its stained glass windows,

some more than 100' tall. Referred to as the "Good Lord's Lantern," the nave's heights are painted by sunlight that sifts through panes hand-colored centuries ago by great artists such as Hermann de Munster, Valentin Bousch and, more recently, Marc Chagall.

Metz is considered a stained glass city. The art was first practiced here in the 12th century and the traditional craft is widespread today. Stained glass by Marechal can be seen in the choir of St-Martin; the windows in St-Maximin were by Jean Cocteau who succeeded in creating an unusually delicate and poetically colored work. The oldest example of stained glass in Lorraine is in the tiny 12th century Crucifixion in Ste-Ségolène.

The dignified city boasts stately public squares and twenty miles of landscaped walks along rivers, canals and ramparts. Metz was the winner of the first European Prize for "Flowered Cities." With its Mediterranean-style ambience and ochre buildings, the capital of Lorraine is imbued with a softness more typical of towns in the south. Many of the façades are executed in Jaumont, a stone whose warm pink and yellow hues are pleasing to the eye. Nicknamed the "City of Light," Metz has made the most of its magnificent buildings, enhancing them with a program of illuminations that literally makes the city sparkle at night.

Metz lays claim to dozens of historic landmarks including the Gallo-Roman ruins that encompass an aqueduct, thermal baths and part of an amphitheater. Much has also been preserved from the medieval period including the ancient arcades and merchants' houses in place St-Lôuis that date from the 14th to 16th centuries and the beautiful mansions fringing place Ste-Croix. Numerous promenades round out the town's architectural ensemble.

Chapelle des Templiers was built by the Knights Templar in the 13th century. Its handsome interior is enriched with frescos. Eglise St-Pierre-aux-Nonnains is reputed to be one of the oldest churches in France. Part of the façade dates from Roman times; the remainder belongs to the 7th century Bénédictine abbey church that once occupied the site.

The Franco-Prussian War of 1870 added new architectural sensibilities to the city. From that period, many large urban structures were built in quintessential Germanic styling such as the railway station, central post office and many grand buildings and town houses. Ironically, during WWII the city suffered greatly under German occupation.

A few miles west of Metz, Scy-Chazelles is a tiny pair of villages built into the ledge of Mont St-Quentin. The steep narrow streets of the villages are crowded with homes built by weathy vintners. Many are adorned with 18th and 19th century decorative elements evoking the wine trade. Two fortified churches dominate diminutive villages; one, the church of Chazelles, contains the remains of Robert Schuman, father of the European Union.

Accommodations
55 rooms with single, double and twin beds. Some with private bath.

Amenities
Towels and linens are supplied. Parking, private park, TV and meeting room.

Cost per person/per night
Half board 32.00€ to 54.00€.
Full board 40.00€ to 68.00€.
Note: Rates depend on the room and size of the group. Costs to be determined when reservations are made.

Meals
All meals can be provided with the lodging.

Special rules
The guest house is closed July 10th to August 7th and December 25th to 31st.

Directions
By car: Take A31 and exit at Moulins-les-Metz. Follow the signs to Moulins Centre. From there follow the signs on the four-lane road to Verdun to a small road on the left between the Pâtisserie Kuntzmann and the bar P.M.U. From there follow the signs to Ermitage St-Jean.
By train: Get off at Metz and take a taxi to the ermitage.

Contact
Anyone who answers the phone
Ermitage Saint-Jean
7, rue des Moulins
57160 Moulins-les-Metz
France
Tel: 0033 (0)3 87 60 62 78
Fax: 0033 (0)3 87 60 06 33
Email: ermitage.saintjean@wanadoo.fr

SANCTUAIRE NOTRE-DAME
Saint-Joseph Sisters

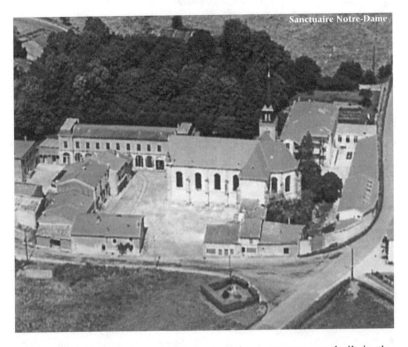
Sanctuaire Notre-Dame

Situated in a verdant area of Lorraine, the sanctuary was built in the 17th century and is one of the oldest pilgrimage sites in Lorraine. The origins of the sanctuary date to 1180. At that time the site was called Martin-Han. According to legend, some woodsmen heard celestial voices coming from a fallen oak tree under which they discovered a statue of the Virgin Mary. They erected a chapel on the same site and entrusted the care of the site to the Hermit Martin. After a number of years, visiting pilgrims arranged for a group of Prémontré Friars from the Abbey of Etanche to look after the shrine. In 1331 a fire destroyed the area and reduced the statue to ashes. It was replaced with a wooden image that remains today and is displayed in the Chapel of the Relics. In the 17th century a new church replaced the one built after the fire.

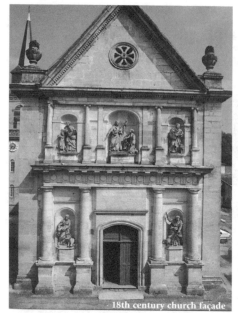

18th century church façade

Under the care of the friars, the pilgrimage developed and important religious and political dignitaries visited the site; the sovereigns of Lorraine became faithful devotees. Benoîte-Vaux survived untouched by the Hundred Year War, the plague and other wars and remained a place of devotion. The French Revolution brought the pilgrimage site to a temporary but brutal halt. The contents of the library were confiscated, the property sold, the friars dispersed and the building ransacked.

In 1838 the Bishop of Verdun re-established the pilgrimage. A new monastery was edified, ancient fountains rebuilt, a tower bell erected and a monumental *Via Crucis* created. The shrine was preserved during both world wars. Afterwards it was entrusted to the Oblats of Marie Immaculée. The church was restored in the 19th century and shelters wooden engravings of the 18th century and a 17th century statue over the fountain. Two sisters of the Order of St-Joseph now reside in the sanctuary. The large guest house is managed by lay personnel.

Lorraine is a border region that has been contested for centuries. Its heritage survives in medieval fortresses, 17th century bastions and countless battlefield memorials. A beautiful blending of forests, mountains, cornfields and vine-covered slopes, the countryside is laced with rivers and canals. It is also a region that cherishes good food and superb wines.

To the west of the sanctuary, in the Côtes de Meuse area, is the outstanding village of Hattonchatel. The reredos in the church's chapel are reputed to have been carved by Ligier Richier, one of the most prestigious sculptors of the Renaissance; the extraordinary stained glass windows

were fashioned by Gruber. Musée Louis-Cottin was named after the artist who won the Grand Prix de Rome in 1934. The museum is housed in the Romanesque-style town hall. The castle, restored in the fashion of the 15th century, overlooks the plain and offers breathtaking panoramic views.

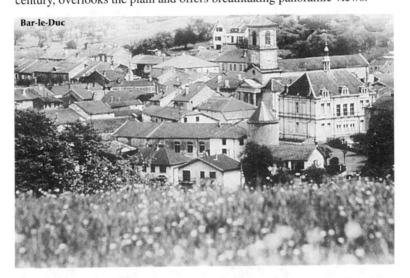

Bar-le-Duc

Heading southeast from the sanctuary, the quaint town of Bar-le-Duc is officially recognized as a "Ville d'Art et d'Histoire." The Ville Haute, a Renaissance district perched on a promontory, is an appealing mix of quaint streets and alleyways. At the foot of the upper town stands the Renaissance-style College Gilles de Trèves. Eglise St-Etienne, heralded as a jewel of Flamboyant Gothic style, houses the *Transi*, masterpiece of 16th century sculptor Ligier Richier. The artist worked with highly prized, fine-grained limestone from nearby quarries. To imitate marble, he created sculptures in stone and then covered them with a type of wax polish which produced a smooth and shiny appearance. The *Transi* depicts the skeleton of Rene de Chalon standing in a triumphant pose.

Between Rambluzin-et-Benoîte-Vaux and Bar-le-Duc is an area of rich architectural heritage and natural beauty. It is a setting of old bridges and graceful buildings constructed from honey-colored stone, and here and there an occasional half-timbered house typical of the neighboring Champagne region. To the north the steeper hills of the Argonne valley

are covered with woodlands while the landscapes to the south represent the essence of the nearby Vosges. The romantic valley of the Saulx and Ornain rivers are scattered with villages replete with stately buildings including the majestic Château de Jeand'Heurs, an abbey from the 18th century and Château Gilles de Trèves, a typical 16th century residence.

 Verdun is an easy day trip from the sanctuary. A prosperous community in Roman times and during the Carolingian period in the 800s, it was fortified by the famous military architect Vauban during the reign of Louis XIV. After 1871 it became the principal French fortress facing Germany and was surrounded by a ring of impressive defenses comprised of thirty-eight forts and buildings and four miles of tunnels carved in the rock. But, perhaps more than anything, Verdun's name is synonymous with WWI. The longest battle of that war was fought at Verdun in 1916. Almost totally destroyed, Verdun was rebuilt after

the conflict. Its meadows contain rows of white crosses and former villages remain as shell-pocked memorials to the war. Fort de Douaumont still crowns the hilltop where the bones of unknown soldiers lie in a vast, cathedral-like ossuary. The huge necropolis pays final emotional homage to the 130,000 soldiers who laid down their lives on the battlefields of Verdun. The military cemeteries and staggering monuments form a national sanctuary. The 18th century Palais Episcopal now houses the Centre Mondial de la Paix (World Center for Peace), an education and interactive venue whose message is peace, freedom and human rights.

Jewish settlement in this former duchy is believed to date back to the 4th century. In the mid-15th century, Duke John II granted Jews the right to live in cities such as Nancy and Lunéville. Only twenty years later, his successor, Duke René II, appropriated their property and expelled them. Life improved somewhat when Lorraine became part of France in 1766. On the eve of the French Revolution, about 500 Jewish families lived in the region.

In the 9th century Verdun became a center for *Tosaphists* (rabbinical scholars who wrote commentaries and analyses of the *Torah* and *Talmud*). Most noted among these were the followers of Rabbenu Tam. Verdun's synagogue was built in 1805 on the site of a Dominican monastery. It was destroyed during the Franco-Prussian War in 1870 but reconstructed in 1872. Its Moorish style reflects 10th, 11th and 12th century Byzantine influences. In WWII the Nazis gutted the synagogue. It was restored with the aid of Jewish members of the American army and placed on the Register of Historic Monuments in 1984.

North of Verdun the town of Marville presents an architecturally abundant tableau. First occupied by the Romans, the town developed a prosperous leather and cloth trade and over the years transformed itself into a wealthy Renaissance village. Iberian troops occupied the town from the mid-16th to mid-17th century and left behind tall, chalky-yellow houses with sculptures inspired by classical myths. The main square is framed by 16th and 17th century structures. The simple 14th century church is highlighted by a Flamboyant balustraded organ loft.

To the south of the sanctuary, tiny Domremy-la-Pucelle is the birthplace of Lorraine's most famous figure, Joan of Arc, patron saint of France. The young woman who emerged in the 15th century to lead the French to victory against the English was born in a bunker-like, four-room dwelling with only one window (for centuries there was a window tax in France). The plain house has no furniture and its walls are bare. Now an interpretive center, the saint's birthplace bears witness to the diversity of old buildings in rural Lorraine. It was in nearby Vaucouleurs in Meuse, that the heroine first took up arms in 1429. The town has a memorial museum in her honor.

Southwest of Domremy are the ruins of a Roman amphitheater that could seat 17,000. The Romans were the first to express their architectur-

al talents here, on sites previously venerated by the Celts. The extraordinary shrine in Grand was dedicated to Apollo and preserves mosaics and a network of underground pipes and ducts.

Accommodations

There are three buildings and three types of accommodations for a total of 110 beds.
1) A dorm with 40 beds and shared baths.
2) Rooms with shared baths.
3) Rooms with private bath.

Amenities

Towels and linens are provided in the single and double rooms but not in the dorm.

Cost per person/per night

Lodging only 14.50€ to 31.00€.
Half board 21.00€ to 41.00€.
Full board 23.00€ to 72.00€.
Note: Minimum and maximum rates depend on the type of accommodation.

Meals

All meals can be provided with the lodging.

Directions

By car only: There is no public transportation. Take A4 and exit at Les Souhesmes. From there take N35 south about 10 km and then D124. Follow the signs to Rambluzin-et-Benoîte-Vaux.

Contact

Anyone who answers the phone
Sanctuaire Notre-Dame
55220 Rambluzin-et-Benoîte-Vaux
France
Tel: 0033 (0)3 29 80 52 35
Fax: 0033 (0)3 29 80 59 00
Email: bv.accueil@wanadoo.fr

COUVENT DE LA DIVINE PROVIDENCE
Sisters of Divine Providence

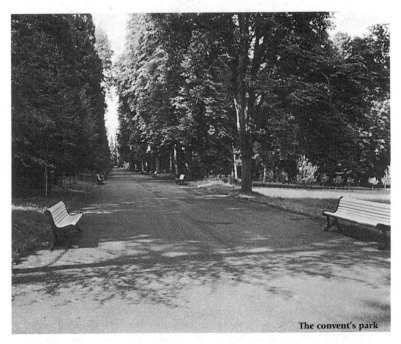

The convent's park

The convent is an ancient structure of grand proportions. At the center of the complex is a high steepled church characterized by a rose window. The surrounding countryside is one of lush fields and swaths of farmland. Sheltered in the small town of St-Jean-de-Bassel, the convent is enveloped by its own park at the border of the Parc Natural Regional de Lorraine. Naturalists who visit Tarquimpol (in the regional park) in spring or autumn will be able to observe some of the 270 types of migratory birds, (some from as far away as the Ukraine), in its marshes and woodlands. Couvent de la Divine Providence is the mother-house of the Order of the Sisters of the Divine Providence who took up residence in 1927. Less than ten miles from the convent is Sarrebourg, an ancient city inhabited for more than 2,000 years; it sustains several historic and artistic sites.

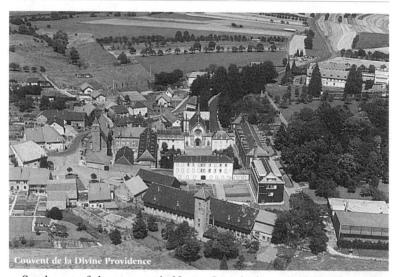
Couvent de la Divine Providence

Southwest of the convent is Nancy, Lorraine's capital city. Founded a thousand years ago by the Dukes of Lorraine, the city grew around a castle and became the duchy capital in the 12th century. The city center with its gracious streets, parks and promenades is a model of urban planning and a gem of 18th century architecture. Built during the reign of Stanislas I, Duke of Lorraine and former King of Poland, it passed to the French crown in 1766 and in 1848 was one of the cities to proclaim the republic. Nancy's outstanding architecture has received worldwide acclaim and owes much to Stanislas. The elegantly proportioned place Stanislas is now a UNESCO World Heritage Site, its neoclassic stone pavilions linked by elaborate gilded grillwork and sculpted fountains, a hallmark of the city. The 15th century Eglise des Cordeliers, a former Franciscan monastery, houses the grand tombs of the princes of Lorraine and the Musée Regional des Arts et Traditions Populaires. Exhibits focus on folklore, furniture, crafts and costumes.

Undoubtedly the arabesque ironwork in place Stanislas was inspiration to cabinetmaker, ceramist and glassmaker Emile Galle who originated his sinuous art nouveau creations in Nancy around 1900. His artistic endeavors were just the beginning of the distinctive style and were soon followed by the Daum brothers and Louis Majorelle, renowned glass artisans. The Musée de l'Ecole de Nancy is dedicated to the art nouveau

movement. Installed in a house that is itself an art nouveau monument, the museum is filled with fanciful furniture, glass and objets d'art by Louis Majorelle, Emile Galle, Jacques Gruber, Eugene Vallin, Antonin Daum and others. Galle's *Dawn and Dusk* is a highlight of the museum. Nancy is also home to the famous workshops at Baccarat, producers of fine crystal since 1764. Exquisite examples can be seen at both the Musée du Cristal and in the multicolored windows of St-Remy.

Following Jewish emancipation, the vast majority of Lorraine's Jews (nearly 11,000 by 1808) lived in and around Nancy. They established synagogues, schools and other community organizations. After France's defeat in the Franco-Prussian War, Jewish refugees from Alsace and the parts of Lorraine annexed by Germany moved to French Lorraine. The Treaty of Versailles (1919) which returned Alsace and Lorraine to France resulted in an increase in the Jewish population. The main synagogue of Nancy was built in 1788, restored and enlarged in 1841. It is one of the oldest in Lorraine and listed as a French historical monument. Musée Lorrain has the second most important collection of *Torahs*, prayer books and other Jewish objects in France. It is located in the medieval section of town at 64, Grand' rue. Unfortunately, WWII took a great toll on the Jews of Lorraine.

South of Nancy, Château d'Haroue is one of several in Lorraine still in the hands of its original owners. A classic early 18th century structure, it incorporates the four round towers and moat of an earlier castle and contains nearly 90 rooms, 365 windows and 52 fireplaces. Fine tapestries, paintings and gilded furniture add luster to the superbly adorned section that is open to visitors. The music room preserves the original chinoiserie wallpaper. The first floor bedroom contains a monumental four-poster bed.

Accommodations
55 single and double rooms. Only 5 have toilet and showers, some have toilet and no shower and 22 have only a sink. There are shared showers and toilets for those in rooms that are not so equipped.

Amenities
Towels and linens can be provided at an extra charge of 4.50€.

Cost per person/per night
Lodging and breakfast in a room with a full bath 39.50€.

Meals

All meals can be provided with the lodging.

Special rules

Punctuality at meals, 8:00 AM, noon and 6:45 PM.

Curfew is 9 PM in winter and 10 PM in summer.

Closed September 1-15 and January 1-15.

Directions

By Car: Exit at Phalsbourg on A4 and take N4 to Sarrebourg. From there take D43 to D95 and follow the signs to St-Jean-de-Bassel.

By train: Get off at Sarrebourg and take a taxi to St-Jean-de-Bassel.

Contact

Sœur Hôtelière

Couvent de la Divine Providence

BP 2

57930 St-Jean-de-Bassel

France

Tel: 0033 (0)3 87 03 00 50

Fax: 0033 (0)3 87 03 02 20

 NOTES

LOWER-
NORMANDY

ABBAYE NOTRE-DAME
Bénédictine Nuns

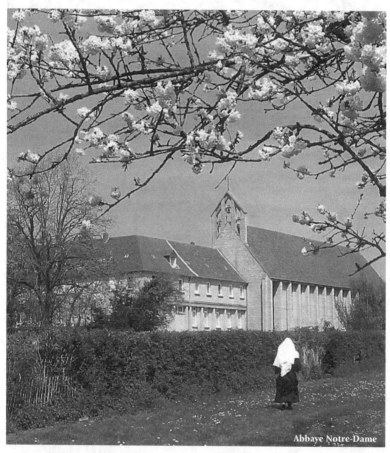

Abbaye Notre-Dame

A very active monastery in Argentan, a small town of the Norman countryside, it was originally founded in the 6th century in Almenesches, a mile or so from Argentan. The monastery was destroyed during the Norman invasions of the 9th century and then restored in 1060. In 1736 King Louis XV ordered that the abbey be moved to Argentan.

The abbey is very proud of its verdant setting. In springtime the trees come alive with beautiful white flowers. The complex is embraced by the pretty countryside and offers a peaceful alternative to the hustle and bustle of city life. The church is a stark, contemporary-like stone structure with clean, spare lines. Its interior reflects the simplicity of the construction with stone walls, a domed wood ceiling and other interesting wood touches. Sunlight streaming through the slender stained glass windows adds a touch of color to the monochromatic value.

During the French Revolution the monastery was confiscated but the nuns were able to return in 1822. They continued in residence until bombing in 1944 destroyed the complex. In 1958 the new abbey was built at the present location. The church conserves a 15th century stone sculpture of the Virgin Mary and a relic of Ste-Opportune (8th century). The relic is worshiped by the nuns and by the faithful who wish to conceive a child and come to pray to the saint.

The nuns of Argentan are famous for Gregorian chant and have recorded compact discs and tapes. They are equally renowned for the art of embroidery, a skill they have preserved through the ages. Around the end of the 17th century, Argentan became the unofficial capital of the lace industry and by 1671 was home to many lace factories including four royal ones. During the French Revolution the production and tradition was interrupted and didn't resume again until 1874. The rebirth of *tatting* (lace working) is attributed to the abbey. The sisters opened the Ecole Dentellière des Bénédictines and over the years the school has presented pieces to the Universal Exposition, winning the gold medal in 1900.

Abbaye Notre-Dame

Argentan is an attractive town stretching along the shores of the river Orne. Thanks to its strategic position on a small hill protected by the river and a marshland, it became an important fortress of the Middle Ages. Built at the start of the 12th century by the Duke of Normandy, it was soon protected by walls and towers. Over the years numerous castles and towers were constructed within the walls. Many monuments have survived including the 12th century donjon, the Tour Marguerite, the 14th century castle and chapel of St-Nicholas and a beautiful 15th century home.

The city boasts an abundance of monuments and churches although many were partly destroyed during WWII. Eglise St-Germain is an eclectic mix of Gothic, Renaissance and classic style; the church of St-Martin has preserved part of the original glass windows; and the 10th century St-Martin-des-Champs is one of the city's most ancient structures.

Many years before Viking longboats landed permanently on its shores in the 10th century, Normandy had claimed its place in European history. The Celts were the first to settle but were later conquered by the Romans and then ruled by Franks. An early bastion of Christianity, the local abbeys date back as far as the 6th century. Normandy is a region of flat farmland, forests and gentle hills. The region prides itself on its outstanding beach resorts notably Deauville, Granville and Etretat. It is also known for its centuries-old fairs and festivals.

Caen

Not far from the abbey, the town of Falaise was the birthplace of William the Conqueror who became King of England in 1066. Falaise's cream-colored castle sprawls on the massive rocks of the *falaise* (cliff) that gave the town its name. The huge structure is an evocative sight. The Romanesque-Gothic St-Germain preserves a 12th century lantern tower while La Trinité is defined by a triangular Gothic porch.

Caen

Capital and largest city of Lower-Normandy, Caen was devastated during the battles of 1944. Despite the destruction, there are parts of town still worth exploring including a ring of ramparts that allows a fine overview of the city. The Abbaye aux Hommes was founded by William the Conqueror. Designed to hold his tomb within the austere Romanesque church of St-Etienne, the abbey is delineated by four impressive buttresses and two intricately adorned towers. The Romanesque Abbaye aux Dames was built by William's wife, Mathilda, and is dedicated to the Sacred Trinity. The interior reveals stained glass behind the altar.

The Caen Memorial is positioned on a plateau named after General Eisenhower. It is the quintessential starting place for an understanding of the events that took place leading up to D-Day. The museum covers the rise of fascism in Germany, the resistance and collaboration in France and the major battles of WWII. Three separate film documentaries are part of the museum's offerings.

South of the abbey and situated at the heart of France's largest nature preserve is the small town of Carrouges. Its elaborate fairy tale château was built from the 13th to the 17th century. The structure is protected by a moat and highlighted by gardens. Composed of rose-red brick, the castle features four circular towers, each topped with pepper-pot roofs. As befitting the castle's genre, the entranceway is via a drawbridge. Ornate furnishings and tapestries reflect the grandiose royal era.

Accommodations

There are two types:

1) Inside the abbey: 4 to 5 beds for guests seeking spiritual retreats.

2) Next to the abbey: A house that can host 10 to 15 guests in 4 rooms with shared baths. The guest house also contains a dining room and kitchen. Guests are completely independent.

Amenities

Towels and linens are available upon request.

Cost per person/per night

Rates to be determined when reservations are made.

Meals

Meals are offered only to guests staying inside the abbey.

Products of the institution

The nuns sell their products and show a video of the origins of the lace industry and of *point-d'Argentan*, a style unique to their work. The shop is open every day from 2:30 to 4:30 (except Sundays and holidays).

Special rules

Visitors staying in the guest house must arrive before 7.30 PM on day of arrival. Closed during Advent and Lent (except the week before Easter).

Directions

By car: From Paris take N12 and N26 to Argentan.

By train: Get off at Argentan. The train station is not far from the abbey.

Contact

There is a Sœur Hôtelière for each type of accommodation.

Abbaye Notre-Dame

2, rue de l'Abbaye

61201 Argentan cedex (France)

Tel: 0033 (0)2 33 67 12 01

Fax: 0033 (0)2 33 35 67 55

MONASTÈRE DEL LA SAINTE-TRINITÉ
Bénédictine Sisters

The monastery is centrally situated in Bayeux but enjoys the tranquility of the park that engulfs it. An enormous ancient tree stands in the center of the monastery's court-yard. The story of the nuns began in 1066 when Queen Mathilda and William the Conqueror founded

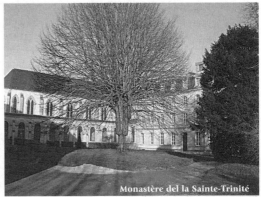

Monastère del la Sainte-Trinité

the Abbey of Sainte-Trinite in Caen. From there, two nuns traveled to Bayeux in 1648 to start a second monastery.

The first structure was built in what is now called place Charles de Gaulle. It prospered there until the French Revolution. At that time the nuns were forced to leave and were deprived of all their possessions. In 1806 they were able to return to their life but not their monastery. Since they needed a new home, they took up residence in a former 13th century Franciscan convent that they restored.

The interior of the monastery harbors the ancient pavilion St-Michel that dates from the 13th and 16th centuries. The pavilion housed the nuns when they first arrived in 1806. It was partly demolished and remodeled between 1880 and 1895 when the sisters built the new monastery. Today it serves as a guest house and is all that remains of the ancient Franciscan edifice. The church also shelters a wooden statue of the Virgin Mary by Yves Le Pape.

Bayeux is a Gallo-Roman town that has preserved many enduring works of art and architecture. Known by the Romans as *Augustodorum,* the history of this former regional capital is reflected in a perfectly pre-served medieval ensemble of 15th to 18th century houses that borders the cobbled streets of the old town.

"Bayeux Tapestry" sections

Throughout the centuries the history and landscape of Normandy have inspired countless writers and artists including the anonymous creators of the *Bayeux Tapestry* for which the town is most famous. An exquisite 11th century scroll, the huge embroidered tapestry is made from wool on linen canvas. It is 230' long and 20" high and recounts the story of the Norman conquest of England in 1066. The artwork consists of fifty-eight scenes, which, in addition to relating the conquest, details medieval life, popular fables and mythical beasts.

Built on the site of a Roman temple, the Gothic Cathédrale Notre-Dame maintains its original Romanesque design. The 11th century crypt is stunning, its columns graced with frescoes of angels. Beside the cathedral is the Musée Baron Gérard, named for its generous patron. The museum displays a collection of porcelain and lace donated by local families. Musée de la Bataille de Normandie is a war museum. Still another museum honors General de Gaulle.

Not far from the monastery, Balleroy is a grand village lodged in a valley at the eastern edge of the Forêt de Cerisy, a landscape of rolling hills and lush green meadows. On the tree-lined main street of the village is the stately Château de Balleroy, first masterpiece of Louis XIII's celebrated architect François Mansart. His work is noted as being an outstanding expression of French classical design. Built in 1631 the castle was one of the first in France to inspire Versailles. In 1975 industrialist Malcomb Forbes created a museum on hot-air balloons in one of the castle's outbuildings.

A pleasant excursion can be made to Honfleur, best preserved of the old ports of Normandy. It is a near perfect seaside town lacking only a beach. The Sainte-Catherine district is a charming maritime section whose narrow streets are home to a number of churches, museums and cafes. The old center, around the Vieux Bassin, is lined with slate-fronted houses, each one or two stories tall. Although their composition seems a jumble, they somehow come together to present an harmonious picture. Honfleur's artistic past can be credited to Eugène Boudin, forerunner of Impressionism. A native son, he worked in the town and trained the 15-year old Monet. Musée Eugène Boudin contains some of Boudin's crayon seascapes although the Dufys, Marquets and Monets are the most significant works on display. Over the years, artwork by Pissarro, Renoir and Cézanne have been added to the museum's collection. Just down the hill from the museum is Les Maisons Satie, the red-timbered house of Eric Satie, another native son. From the outside it looks unchanged since 1866 when the composer was born there but the interior conceals one of Normandy's most unusual and enjoyable museums.

Honfleur

Normandy is known for the serenity of its countryside and the architecture of its surviving structures. But perhaps more than anything else, Normandy is forever linked with one of the most important military events of the 20th century when Allied troops stormed the beaches in 1944 and began the final stages of WWII. Memorials at Omaha Beach, Caen, Bayeux and Arromanches are reminders of the gallant and heroic efforts that brought an end to the war. Commemorative centers and military cemeteries throughout the area serve to honor those who gave their lives in the name of freedom. Undeniably, the region has preserved its place in history at its beaches and in its villages.

The city of St-Lô is about 25 miles from Bayeux. A Gallo-Roman town, St-Lô was a medieval fortress and the scene of a massacre of Huguenots in the 16th century. Today it is known as the "Capital of the Ruins," a memorial to the destruction wrought during WWII. In the main square, the gate of the old prison commemorates resistance members executed by the Nazis, those deported to the concentration camps and soldiers killed fighting for freedom. It is a compelling sight and one that will not soon be forgotten. The trees throughout the city remain as visible testimony to WWII as well. After the war they were all planted at the same time to replace those destroyed during the battles and now are all the same height, creating an evocative illusionary effect.

Cathédrale de Notre-Dame

Cathédrale de Notre-Dame is yet another significant memorial. Deeply scarred following heavy bombardments in June 1944, for the most part, the Flamboyant Gothic church has been left as it was to demonstrate the ferocity of the war.

Rather than being restored, its façade was replaced by a green shale wall covering the nave. The church still preserves a decorative throne on the north wall of the choir, a WWII shell embedded in the stone and 15th to 16th century stained glass windows that miraculously survived the devastation.

Accommodations
35 rooms with 1, 2 or 3 beds; 24 of the rooms have private baths, the others have shared.

Amenities
Towels and linens can be provided at a charge of 5.00€ per day.
There are two meeting rooms, a large dining room and a park.

Cost per person/per night
Price depends on the length of stay, number of meals, type of room, etc.

Meals
All meals can be provided with lodging.

Products of the institution
The nuns operate a book/gift shop and do bookbinding.

Special rules

Silence must be respected inside the hôtellerie; no music, no television.
Punctuality at meals is required and clean up after meals is requested.

Directions

By car: From Paris take A13 towards Cherbourg and exit at Bayeux (exit 37).
By train: Get off at Bayeux and take a taxi or bus to the monastery.
By plane: Airport of Caen Carpiquet, then take a taxi or a bus to Bayeux.

Contact

Sœur Hôtelière
Monastère del la Sainte-Trinité
48, rue Saint-Loup
14400 Bayeux
France
Tel: 0033 (0)2 31 92 85 74
Fax: 0033 (0)2 31 92 82 52
Email: hôtellerie@lajoiesaintbenoit.com
 benedictines.bayeux@wanadoo.fr
Website: www.lajoiesaintbenoit.com

NOTES

CHÂTEAU DES FORGES
Property of the Salesian Order (Don Bosco's Priests)
Managed by a lay association

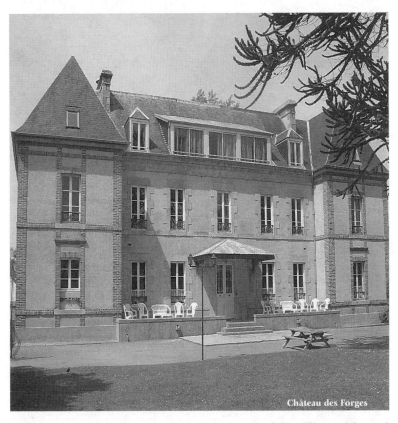

Château des Forges

Château des Forges is very close to the center of Gouville-sur-Mer and the sea. Set in its own verdant park the château faces the Anglo-Norman Channel Islands. A 19th century castle converted into a guest house by the Don Bosco's Salesian Priests, it is managed by a lay association. The château is an excellent base from which to explore the Manche département of Normandy as well as the coastline cities.

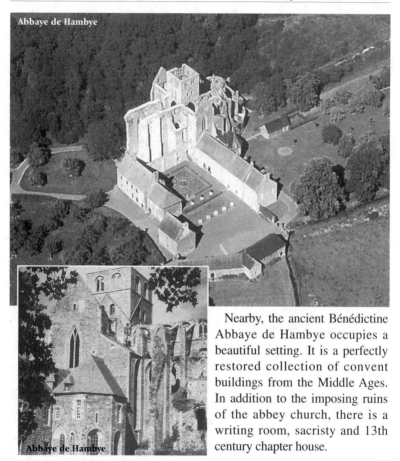

Abbaye de Hambye

Abbaye de Hambye

Nearby, the ancient Bénédictine Abbaye de Hambye occupies a beautiful setting. It is a perfectly restored collection of convent buildings from the Middle Ages. In addition to the imposing ruins of the abbey church, there is a writing room, sacristy and 13th century chapter house.

Just north of Gouville, the Château in Pirou was built in the 12th century on an artificial island protected by three moats and five fortified gates. Endowed with high ramparts, it is the oldest Norman château. Legend holds that when the occupants of the castle were faced with Norman assailants, they transformed themselves into wild geese, only to find that they could never regain their human form; the magic formulas had been destroyed. The château preserves a bakery, cider press, chapel and a room exhibiting the Pirou tapestry. Summer is the best time to visit the old lodge with its covered walkway and beautiful shale roof.

Close to Gouville is the lively and popular resort of Granville, its water-front more commercial than picturesque. Once a corsair town built on a rocky spur, the upper city possesses an architectural melangé of notewor-thy 17th and 18th century houses and the Eglise de Notre-Dame with a win-dow depicting the procession of the *Grand Pardon*. The old town is entire-ly enclosed by ramparts built by the English in 1439. At that time, the English planned to use the citadel as a base from which to attack Mont-St-Michel, however, their power was short-lived.

Anacreon

Granville is home to two museums. The Musée d'art Moderne Richard Anacreon houses a collection of contemporary art. Musée de Vieux Granville showcases local art; its exhibits focus on the city's heritage and the seafaring traditions of its inhabitants. Granville is a sea connection to Iles Chausey, a smattering of granite islands approximately 9 miles from the port city. Only a handful of fishermen inhabit Le Grande island. The other islands are deserted places of natural isolation. The entire archipela-go is granite. It was from these quarries that the stones to build Mont-St-Michel were cut, as well as the cobblestones of Paris. The combination of immense tides, brisk currents, ever changing light and varied flora and fauna create an exceptional natural spectacle. The islands have been offi-cially tied to Granville since 1802. They are preserved and protected by the local residents. Chausey is a classified reserve and refuge for sea birds.

Jersey can also be reached via Granville. Only 12 miles from the French coast, it communicates a very definitive British flavor. A jewel of natural beauty, its white sand beaches, dunes and spectacular cliffs can be easily explored by car, bicycle or on foot. The peaceful country lanes are bright with daffodils in the spring and the locals take great pride in their picturesque cottages and roses. Many varieties of flowers bloom year-round, so the island is constantly ablaze with color.

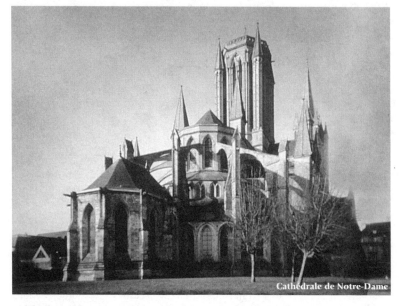
Cathédrale de Notre-Dame

Medieval Coutances is less than ten miles from the Château des Forges. An ancient hill town, it owes its founding in the 1st century BC to its elevated position. The city lays claim to the beautiful Norman Gothic Cathédrale de Notre-Dame, its towers and turrets soaring above the medieval town. Built of light colored limestone, the interior of the cathedral is highlighted by the purity of Romanesque relics as well as several frescoes. The bold and turreted lantern tower and double flying buttresses were added in the 13th century. The stained glass windows from the Middle Ages comprise the largest collection of 13th century stained glass windows in Normandy. Jardin des Plantes, a landscape garden of rare plants, was created between 1852 and 1855. The garden is a compatible marriage of French symmetry, English copsing and Italianate terracing.

The Church of St-Nicholas dates from the 16th and 17th centuries and personifies late Gothic style. St-Peter's was rebuilt after the Hundred Year War. It merges Flamboyant Gothic with Renaissance as illustrated by the lantern tower.

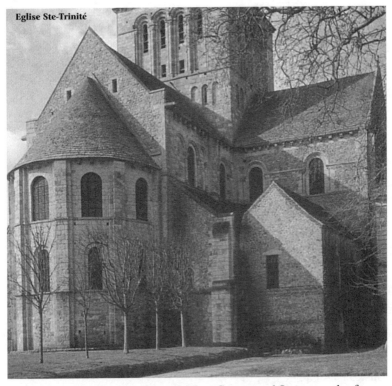

Eglise Ste-Trinité

In the vicinity of Gouville-sur-Mer, Genets and Lessay make for an easy day trip. The former is a pleasant seaside resort of narrow streets and medieval houses. Its diminutive 12th century church was the final stop on the pilgrim route to Mont-St-Michel. Lessay resides in the inlet of the estuary of the river Ay. The town's most famous monument is the 11th century abbey church of Ste-Trinité. Founded during the reign of William the Conqueror, it was constructed of a mellow golden stone, the first Norman Romanesque building to be entirely vaulted with diagonal ribs. Decimated during the bombing of WWII, the church has been diligently and carefully restored to its former glory; the restorers replicating

tools like those used in medieval times when the structure was first built. The result is extraordinary and the structure is regarded as one of the most perfect Romanesque churches in France. Lessay is also famous for its thousand-year old Fair of the Holy Cross. It takes place during the second weekend of September.

Accommodations
93 beds in rooms with 2-8 beds. Baths are shared. There is a campsite available.

Amenities
Towels are not supplied; linens can be supplied at an extra charge. There is a large park with a playground. Horse and pony rentals are available.

Cost per person/per night
To be determined when reservations are made. Depending on the size of the group, provisional cost is 24.00€ to 28.00€ full board.

Meals
By request, all meals can be provided. Guests can also cook their own meals in a kitchen at their disposal.

Special rules
Only groups of 15 and more are accepted. Silence is required after midnight.

Directions
By car: Reach Coutances and follow the signs to Gouville-sur-Mer on D244 and D268.
By train: Get off at Coutances and take a taxi to the château.

Contact
Anyone who answers the phone
Château des Forges
121, rue du Littoral
50560 Gouville-sur-Mer
Tel: 0033 (0)2 33 47 85 68
Fax: 0033 (0)2 33 45 16 17
Email: c.j.heribel@wanadoo.fr

ABBAYE SAINT-MARTIN-DE-MONDAYE
Prémontré Friars

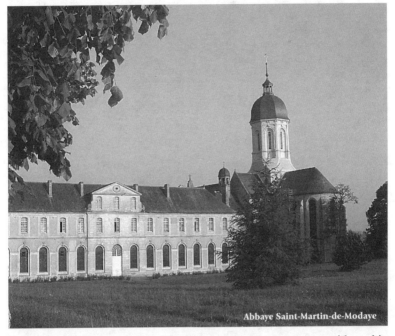
Abbaye Saint-Martin-de-Modaye

The abbey occupies a peaceful setting in the Norman countryside and is encircled by its own parkland. On a hill overlooking the plain of Bessin and the distant contour of the Cathedral of Bayeux, the abbey began in the 12th century, founded by the Hermit Turstin and a handful of disciples. It suffered various vicissitudes due to the Protestant-Catholic conflicts. Since its inception the abbey has been renowned for its hospitality and generosity although it remained a modest complex throughout the Middle Ages.

During the French Revolution it was confiscated and remained empty for a period of time. It then became a boarding school and continued as such until 1858 when it was returned to the Prémontré Friars.

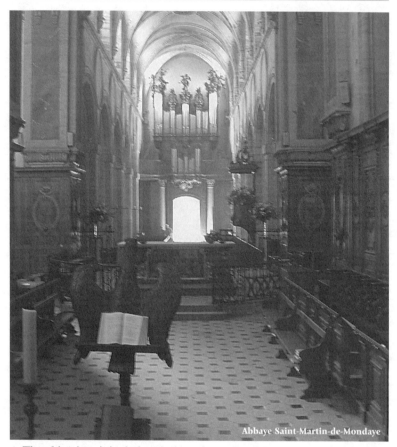

Abbaye Saint-Martin-de-Mondaye

The abbey's original church dates from the 13th century while the second was started in 1706 and completed some fifty years later. The church and monastic buildings, constructed under the Abbot Philippe L'Hermite, were designed by one of his priors, painter/architect frère Eustache Restout (1655-1743). The buildings are comprised of stone and remarkable for their sobriety, harmony and balance, a very unusual combination when compared to the contemporary Louis XIV style of that time. The chapels are enriched with paintings and statues representing episodes of the Gospel, Testament and tradition. Guided by a monk, there is a one-hour tour of the church, vestry and main monastery rooms including the library which preserves a collection of 50,000 volumes.

Château de Fontaine Henry

Southeast of the abbey are two interesting châteaux. Château de Creully is in the tranquil enclave of Cruelly in the Seulles valley. The château was built between the 11th and 15th centuries. Once a powerful medieval fort, it has been municipal property since 1946. An exhibition of equipment and photographs belonging to English, Canadian and French journalists recalls how the BBC studios were housed in the castle in 1944. There is a guided tour that lasts 45 minutes. Open Tuesday to Friday from July until September.

Château de Fontaine Henry overlooks the verdant Mue valley. Its soaring rooftops sit upon a façade that has been lavishly sculpted in a succession of 15th and 16th century styles. Guides provide tours of the castle and its collection of furniture, paintings and antiques. Contemporary art exhibitions take place in the summer months.

Another excursion can include Lisieux, home to the monastery of Ste-Thérèse, patron saint of all missionaries. Ste-Thérèse received the title "Doctor of the Church," an honor only received by Ste-Thérèse of Avila and Ste-Catherine of Siena.

Ste-Thérèse

Ste-Thérèse entered the monastery at the age of fifteen and lived an ordinary, almost unnoticed existence. During those years she wrote the story of her life. The book, published in 1898, one year after her death, was extremely successful and with its success, the pilgrimages began. And with the pilgrimages, it is said, came the miracles. In 1925 Thérèse was canonized and an immense basilica was built in her honor. Its interior conserves stained glass windows and mosaics by Pierre Gaudin, an artist who reproduced the message of Thérèse through his work. The bell tower houses fifty-one bells and forty-five chimes. Their lilting sounds are among the most beautiful in Europe. The monastery embodies the main building and a chapel where the saint is displayed in a glass case.

One of the oldest towns in Normandy, Lisieux is an important commer-
cial and tourist center that retains some of its old streets still fronted by
half-timbered houses. The city is steeped in religion, a vibrant city with
festivals and outdoor markets year-round. Although a majority of the
town was destroyed during WWII, several beautiful old churches remain.
The concept and construction of the Norman-Gothic cathedral in 1149 is
credited to Bishop Arnoult. Although it sustained damage during the
French Revolution, the structure was returned to its former splendor in
1802. The land around Lisieux forms the famous Auge valley, an area of
characteristic Norman beauty, a diorama of lush fields, dairy farms,
orchards and manor houses.

Accommodations
40 to 45 beds. Rooms have 1, 2 or 3 beds, each with private bath.

Amenities
Towels and linens are provided. Meeting room is available to guests.

Cost per person/per night
Minimum contribution 19.00€ for a single and 26.00€ for a double room.

Meals
All meals can be provided with the lodging.

Products of the institution
Monastic products such as liqueurs and pastries made by other monaster-
ies as well as a choice of music and religious publications are sold.

Directions
By car: From Paris take A13 to Caen and then take N13 towards
Cherbourg to Bayeux. From the Bayeux train station (gare SNCF) take
D6 south towards Tilly-sur-Seulles for 7 km. Once in Douet-de-Chouain
turn right towards the abbey and follow the signs.
By train: From Paris Saint-Lazare get off at Bayeux (ligne Paris-
Cherbourg). There is no bus. Take a taxi or call the abbey in advance and
they will try to arrange transportation.

Contact
Frère Hôtelier
Abbaye Saint-Martin-de-Mondaye
14250 Juaye-Mondaye - France
Tel: 0033 (0)2 31 92 58 11; Fax: 0033 (0)2 31 92 08 05
Email: hotelier@mondaye.com
Website: www.mondaye.com

SANCTUAIRE NOTRE-DAME DE MONTLIGEON

Property of the Shrine of Notre-Dame de Montligeon
Managed by priests, sisters and lay personnel

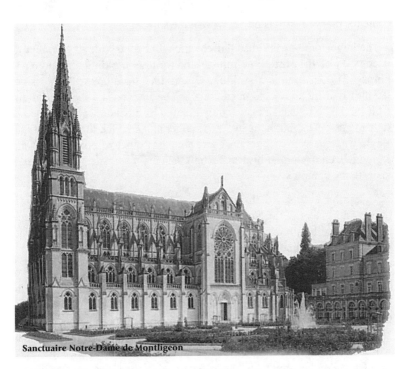

Sanctuaire Notre-Dame de Montligeon

La Chapelle-Montligeon lies in the Orne département and represents Normandy in its most natural state. Green fields, deep river valleys and forests abound, punctuated by fine manor houses and estates. Sprawled on a hillside, its houses are clustered around a Renaissance church. The focal point of town is the Basilica and Shrine of Notre-Dame-de-Montligeon built at the turn of the 19th century. The shrine is an internationally known sanctuary and the center of prayer for souls in purgatory. It was established by Father Paul Buguet, a cleric deeply affected by the death of his brother and two nieces. In their honor he founded the shrine to create a link between people and "the neglected souls of purgatory."

In 1884 Father Paul Buguet obtained approval for the statute of the "Association for the deliverance of the souls in purgatory" and at the same time created a printing works to spread his ideas. In 1894 the shrine was conceived and completed twelve years later. The association continues to gather followers worldwide. Many pilgrims come for prayer sessions or just to visit the shrine.

The large complex is situated in the tranquil countryside of Normandy. It consists of the shrine, hermitage and various buildings including a library. The basilica is a striking, Gothic-like structure with two side steeples soaring above the main church. The interior is a glorious affair with carved columns, an exuberantly colored rose window and handsome stained glass. The mosaic is by Lechevallier and Barillet, the statue of the Virgin by Italian artist Tadolini. There are many other works of art and an early 20th century organ by Rual. The sanctuary's website allows virtual visits to the complex.

Reception is ensured throughout the year by a team composed of priests and sisters of the Nouvelle Alliance and lay people who provide a simple, friendly atmosphere. The hermitage offers the opportunity for creating relationships with other people, by sharing in meals and leisure time.

Nearby Mortagne-au-Perche is home to the Abbaye de la Trappe (in La Trappe forest) where, in 1664, the first Trappist vows of silence were taken. The Trappist Order surpasses both St-Benedict and St-Bernard in austerity. The life of a Trappist monk is one of strict seclusion from the world. Mortagne-au-Perche is an ancient country town and once the capital of the Perche region. It has a wealth of history and many antique buildings including a house once owned by King Henry IV. The town museum is near the 13th century St-Denis and contains artifacts depicting life in the region over the last six hundred years.

The Percheron horse originated in this part of France and the dappled draught equine can be seen on many of the studs and farms that dot the countryside. Montagne is highly regarded for its cider, pommeau, calvados and its own *boudin noir* (black sausage). As an aside: in the 18th and 19th centuries, many Frenchmen emigrated from this region to establish the new colonies of Quebec and Ontario.

To the west of the sanctuary is Alençon, city of lace and birthplace of Ste-Thérèse. Sited on the edge of the Ecouves forest, it was once known as the "Cité des Ducs." Alençon boasts a fine old town hall and 15th century church as well as the Dukes' Palace dating from the 14th and 15th centuries. The art of *point Alençon*, a well known lace technique, has been preserved as a living tradition. The intricate method can be seen in the Musée des Beaux Arts.

Although Alençon was heavily damaged during WWII, a number of structures have survived including the Eglise Notre-Dame. The structure is detailed by stained glass windows, a Gothic Flamboyant carved balustrade and a 17th century organ-chest. Mirroring the town's famous lace products, the porch, with three arcades, showcases finely pierced stone gables suggestive of lacework. The *halle au blé* (corn market) is an imposing circular edifice begun in 1806 on the site of the Notre-Dame Convent. In the mid-19th century it was fitted with a remarkable metal dome. The structure has recently been restored to its original grandeur. The architecture of the town presents distinctive wrought iron balconies, another art form inspired by the centuries-old lace tradition.

South of La-Chapelle-Montligeon, in the heart of Normandy, is the ancient town of Bellême. A fortified town perched on a promontory overlooking a vast landscape of hills and valleys, it is very near the forest of the same name. The walled city is a patchwork of narrow lanes lined with 17th and 18th century houses.

Accommodations

180 beds in single, double and family rooms, each with private bath. Visitors have the opportunity to interact with the priests and sisters present at the shrine during meals and leisure time.

Amenities

Towels and linens are provided. Three large meeting rooms, bookshop and souvenir shop.

Cost per person/per night

Rates to be determined when reservations are made.

Meals

All meals are provided with the lodging.

Directions

By car: From Paris take A11 and exit at Chartres. Follow the signs to Nogent le Rotrou, Condé sur Huisne and la Chapelle-Montligeon.
By train: From Paris take the Paris-Le Mans line. Get off at Nogent le Rotrou or Condé sur Huisne and take a bus to the shrine. An updated train schedule to La Chapelle is available on the website.

Contact

Accueil
Ermitage de la Basilique
Sanctuaire Notre-Dame de Montligeon
61400 La Chapelle-Montligeon
France
Tel: 0033 (0)2 33 85 17 00 or 0033 (0)2 33 85 17 02
Fax: 0033 (0)2 33 85 17 15
Email: infos@sanctuaire-montligeon.com
Website: www.sanctuaire-montligeon.com

 NOTES

L'ÉTOILE DE LA MER
Notre-Dame-du-Mont-Carmél-d'Avranches Sisters

Backdropped by a woodland, L'Etoile de la Mer is quartered in the center of St-Jean-le-Thomas on the Atlantic coast of Normandy. Situated on the plateau Champeaux, it offers a unique panorama of Mont-St-Michel Abbey. The small village enjoys a special micro-climate which accounts for its nickname, "petit-nice." The sea is less than a mile from the center. Numerous "randonneurs" walk the paths that separate l'Etoile de la Mer from the Mont-St-Michel.

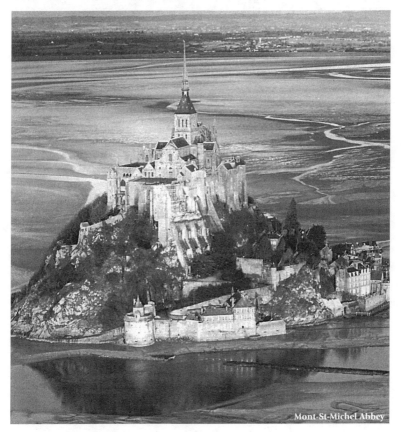

Mont-St-Michel Abbey

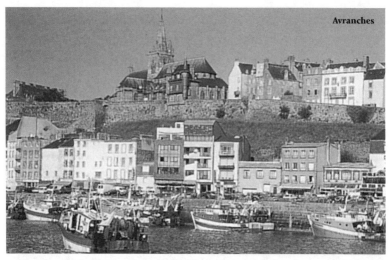

Avranches

Nearby Avranches was a Gallo-Roman capital for three centuries. It has been a religious center since the 6th century. For over a thousand years bishops were the most important figures of the town. One of them, St-Aubert, founded a sanctuary in 708 that became the west's most famous place of pilgrimage, Mont-St-Michel. As the last stop for visitors to St-Michel, Avranches has always had close ties with the abbey. The Church of St-Gervais is an imposing building that dates from the second half of the 19th century. Legend holds that one night in 708 the Archangel Michael touched the head of Aubert and instructed him to build a church on the nearby island. Known as the *Treasure*, the scull with the finger-hole, is sheltered within St-Gervais. After the French Revolution, two hundred and three illuminated manuscripts were rescued from Mont-St-Michel. Some are on view at Musée Hôtel de Ville.

Musée Municipal showcases the rich past of the area from the Middle Ages to more recent times. The collection comprises examples of local art and traditions as well as a replica of a rural family home, old cos-tumes and workshops of local craftsmen. A monastic scriptorium has been established with tools, inks and pigments to recreate the ambi-ence of medieval book production. This exhi-bition is a useful prelude to a visit to the Mont-St-Michel manuscripts.

History and legend meet in the timeless Bénédictine Abbey of Mont-St-Michel. A UNESCO World Heritage Site, construction began in the 8th century after the Bishop of Avranches had a vision of its creation. The stunning architecture stands out from the serenity of the coastal site; its soaring spires can be seen for miles. A famous pilgrimage point between the 8th and 18th centuries, the abbey is a noted example of both religious and military architecture from the Middle Ages. The legendary

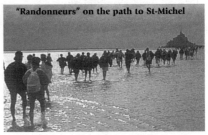
"Randonneurs" on the path to St-Michel

"sacred mount" is one of the most famous abbeys in all of Christendom and certainly one of the most visited monuments of France. The indisputable symbol of Normandy, the abbey is gloriously perched atop a windswept granite islet, isolated in the middle of an immense bay whose tide is among the strongest in the world. St-Michel's history museum traces its thousand-year history with particular emphasis on the architecture, master builders and 19th century periscope overlooking the bay.

In 1204 a part of the monastery was destroyed by a fire but later in the century, King Philippe Auguste restored it and built *La Merveille* (the wonder), the monastic structure that exists today. The Gothic masterpiece has three levels, the upper is occupied by the marble cloisters and refectory with a terrace overlooking the bay. The second floor was reserved for the abbot, knights and noble guests. The pilgrims were welcomed at the lowest level, after having risked the dangers of quicksand caused by the sudden arrival of the high tide.

Mont-St-Michel Bay is also a UNESCO World Heritage Site. The huge bay occupies an area of 310 miles from Cancale to Granville. The most dramatic tides of continental Europe occur at Mont-St-Michel. There is up to a 50' difference between low and high tide and the tidal withdrawal reaches a distance of 9.5 miles from the shoreline. An unforgettable spectacle is the arrival of the late tide that returns with a speed that increases during the last hours of the flow. To catch sight of this tidal wonder, plan to be on Mont-St-Michel approximately two hours before full tide. Even during the strongest tides, however, the sea wall that connects Mont-St-Michel to the continent is never submerged.

In 1874 thanks to the appeal of writer Victor Hugo, Napoleon declared the mont a National Monument. As part of the restoration, a golden statue of St-Michel was added on the tower bell. As an aside: the architect who directed the restoration moved to the island and brought a maid with him. The woman eventually married and remained on the island where she opened a hotel. She was known as Mère Poulard. The restaurant she established still exists at the foot of the rock.

Accommodations
130 beds in rooms with 1-8 beds.

Amenities
Towels are supplied; linens can be supplied at an extra charge of 5.00€. Three dining halls, a TV room, playground and private park.

Cost per person/per night
Provisional cost only.
Lodging only 18.00€.
Half board 26.00€.
Full board 36.00€.

Meals
All meals can be provided with the lodging.

Special rules
Advance reservations are required.

Directions
By car: From Paris take A13 to Caen and then take A84 to Caen-Rennes. Exit at Avranches-Granville. Follow the signs to St-Jean-le-Thomas on D911(8 km).
By train: Get off at Granville and take a bus (they run infrequently in winter) or a taxi to St-Jean-le-Thomas.

Contact
Anyone who answers the phone
L'Etoile de la Mère
50530 St-Jean-le-Thomas
France
Tel: 0033 (0)2 33 48 84 24
Fax: 0033 (0)2 33 48 99 80
Email: etoiledelamer@free.fr
Website: www.etoiledelamer.fr.st

ABBAYE NOTRE-DAME DE PROTECTION
Bénédictine Sisters

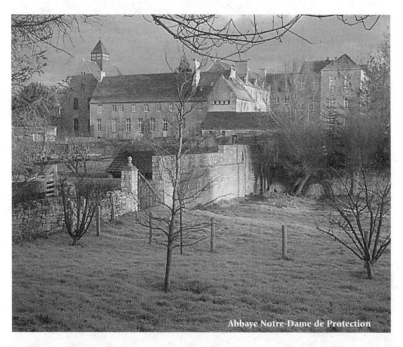
Abbaye Notre-Dame de Protection

The small town of Valognes is home to the abbey, an ancient structure enhanced by the beauty of its own park. "The countryside is very near... we are surrounded by the enchantment of Normandy!" said the Sœur Hôteliere. From nearly every window are views of the serene setting. The abbey was originally founded in Cherbourg in 1623 but the order moved to its present location a few years later. The abbey prospered until the French Revolution instituted the suppression of monastic orders. At that time the complex was seized and became the hospital of Valognes. In 1811 the nuns took up residence in a former Capuchin convent which remains their home. The simple cloister has an arched ceiling enhanced by stone work and rounded windows through which sunlight streams down on the handset paved stone floor.

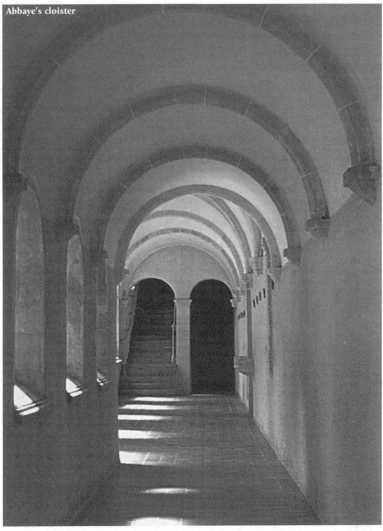
Abbaye's cloister

The church of the monastery suffered during the bombing in 1944 and was restored in 1956. It is a synthesis of ancient and modern style. Apart from the stained glass windows by Leon Zack, the church contains a sculpture of the Virgin Mary by H. Rey and a 17ᵗʰ century retable. The abbey is open to visitors. "It is not big, but ancient," concluded the Sœur Hôteliere.

Valognes, former aristocratic capital of the northern Côtentin, is a small center of art and history. The region was initially subjected to Roman occupation during the 1ˢᵗ century BC and subsequently to the Germanic and Saxon invasions before finally being conquered by the Vikings (literally the "Men from the North," a derivation of the name Normandy). From the Roman period, the compelling *Alauna Gallo* (Roman thermal baths) remain as testimony to this occupation. The sophisticated methods used in the construction and stone work indicate the importance the Romans attributed to their architecture. The layout of the rooms remains visible in the foundation.

Hôtel de Beaumont is a remarkable residence that was spared the ravages of the June 1944 bombings and is a symbolic reminder of the aristocracy that once lived in the area. The structure is an unusual blend of lavish and classic architecture. A monumental stairway leads to the first floor and divides the building into two symmetrical parts. One side is open to visitors and showcases a collection of Louis XV and Louis XVI period furniture. The bedrooms, baths and servants quarters retrace the changes in lifestyle up to the end of the 19ᵗʰ century. There are also French-style gardens that add to the lavishness of the setting.

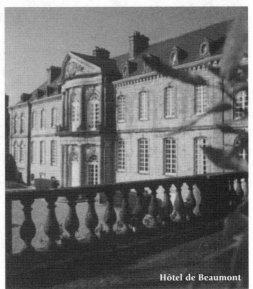

Hôtel de Beaumont

Cherbourg is an easy day trip from the abbey. A sailing port with over a thousand moorings, its history dates to Napoleon when its main purpose was a naval base. A pedestrian-friendly city, it hosts a delightful open-air market three times a week. The flower-filled market square, place General de Gaulle, is at the heart of the town. Many historic footpaths meander through the city.

Three miles west of Cherbourg is Nacqueville Château and Park. Construction of the château began in 1510 as a fortified manor. Partly remodeled during the 18th and 19th centuries, it reveals granite walls, stone roofs and pepper-pot towers characteristic of the finest Côtentin manors. The alluring park was created in the 1830s by an English landscape architect. A stream runs down to a lake that mirrors the château in its still waters. The grounds are composed of a profusion of rhododendrons, azaleas, hydrangeas and ornamental trees that impart a gracious beauty to the site.

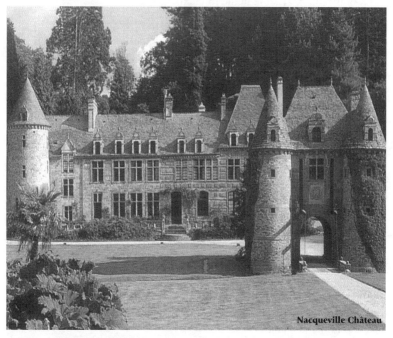

Nacqueville Château

Also in the vicinity is the Abbaye du Vœu. Founded in 1145 it is the most important medieval monument in the Cherbourg area. It has served many purposes over the centuries; the residence of the governor of Normandy, a maritime hospital and a garrison. Bought by the town of Cherbourg-Octeville in 1961, the convent buildings, cloisters and nave have been restored. The Abbey Residence has been converted into an exhibition hall and shelters the tomb of the priest Guillaume.

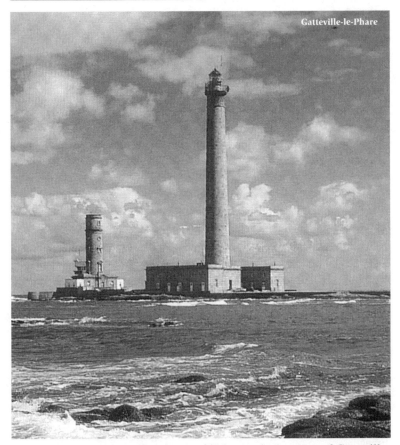
Gatteville-le-Phare

East of Cherbourg and northeast of Valognes is the town of Gatteville. Accentuated by handsome granite houses, the village boasts a spacious square and miniscule 11th century Chapelle des Marins. The main church dates from the 15th century and is underscored by a Romanesque bell tower. The tallest lighthouse in France, Gatteville-le-Phare, was built between 1829 and 1834 to illuminate one of the most treacherous coasts in France. The structure is composed of 11,000 blocks of granite; with a height of 250 feet, it is the second highest lighthouse in France. Twelve stories high, it has fifty-two windows and three hundred and sixty-five steps leading to the top and views over the Val de Saire and the Channel. A small exhibition room at the foot of the lighthouse retraces its history.

Accommodations

The nuns offer hospitality to men and women.

There are two types of accommodations:

1) 20 rooms with 1 or 2 beds, some with a sink and toilet, some with only a sink; all have access to toilets and showers on each floor.

2) A large dorm with 30 beds and shared baths for young guests.

Note: The hôtellerie is closed in January.

Amenities

Towels and linens are provided with the lodging. A meeting room is available to guests.

Cost per person/per night

The nuns request a minimum contribution to cover the cost of each stay, the rest of the contribution is voluntary.

Meals

All meals can be provided on request.

Directions

By car: From Paris take A13 to Caen, then N13 towards Cherbourg and exit at Valognes (20 km before Cherbourg). A detailed local map is available on the website.

By train: From the Paris Saint-Lazare station take the train to Cherbourg. Get off at Valognes. Walk or take a taxi to the monastery.

Contact

Sœur Hôtelière

Abbaye Notre-Dame de Protection

8, rue des Capucins

50700 Valognes

France

Tel: 0033 (0)2 33 21 62 82 (Abbey)

0033 (0)2 33 21 62 88 (Sœur Hôtelière)

Fax: 0033 (0)2 33 21 62 83

Email: accueil.valognes@wanadoo.com

Website: perso.wanadoo.fr/abbaye.valognes/

MIDI-PYRÉNÉES

ABBAYE SAINTE-FOY
Prémontrés Fathers

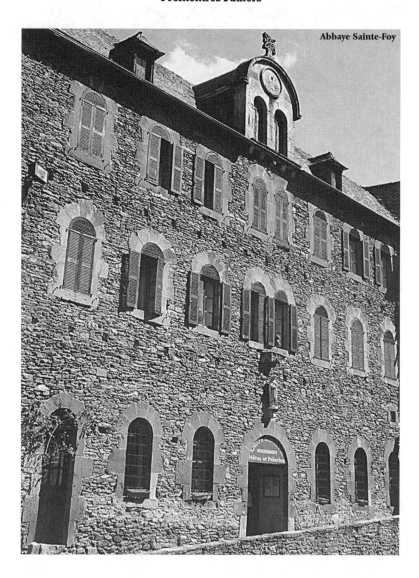

Abbaye Sainte-Foy

A UNESCO World Heritage Site, Conques has existed since the Middle Ages. A jewel of a town, it has been preserved intact throughout the centuries and is one of the main stops along the French pilgrimage route to Santiago de Compostela. Set in the hollow of a luxuriant valley, Conques is marked by ancient slate-roofed, half-timbered houses. One of the major sites of France, Romanesque art expresses itself here as nowhere else, in a concordance of reddish-brown schist (metamorphic rock), silvery stone roof slabs, roses and wisteria.

Conques' most outstanding monument is the vast but harmoniously proportioned Abbaye Sainte-Foy, considered one of the most beautiful Romanesque structures in France. The abbey's story begins with Foy (derived from the Latin *Fides*, which means faith), a young martyr who died in 303 under the persecutions by Diocletian. Foy's relics were brought to Conques in 866, and as typical of the Middle Ages, were worshiped by a large number of pilgrims. This devotion provided the impetus for the construction of a church and a new shrine in 1050. In 1060 the *Chanson de Sainte-Foy*, one of the first works in *Langue d'Oc** made the abbey famous throughout the Western World.

In 1107 the Abbot Boniface built the tympanum of the façade. A recognized masterpiece of the Romanesque period, it is embellished with 124 carved figures representing the *Last Judgment*. The Treasure of Sainte-Foy is found in two exhibition rooms open to visitors and sustains the most important collection of medieval and Renaissance gold work in western Europe. The *Majesté de Sainte-Foy* is a gilded wood reliquary studded with precious stones donated by pilgrims, with parts dating from the 4^{th} and 5^{th} centuries, it is one of the oldest statues of the Christian era. There is a lapidary museum in the only remaining cloister gallery. The stained glass windows of the church were created in 1987 by Pierre Soulages, an abstract artist born near Conques in 1919. In the summer months concerts are held within the abbey church

After the Middle Ages the abbey suffered the vicissitudes that afflicted the French: the Hundred Year War, the conflicts between Catholics and Protestants and finally, the French Revolution. During the revolution the abbey's works of art were confiscated and the abbey closed. With the arrival in 1873 of the Prémontré Friars of Mondaye, religious life resumed. Since that time the friars have maintained their community and

continued the tradition of offering hospitality to pilgrims and to all those who "knock on our door," added the woman in charge of hospitality. In addition to the enchantment within its own boundaries Conques is well located for exploring the region.

Château de Montségur

As in neighboring Languedoc-Roussillon, the Midi-Pyrénées was also home to the Cathars, a religious sect that believed the world was too awful to be the work of God. During the first part of the 13th century, the Cathar religion spread throughout the south of France. The pope became furious and set his military might against the "heretics."

The crusade quickly turned into a war of conquest that enabled the small kingdom of France to annex the great Occitania. The bloody crusades against the Cathars annihilated the ancient civilization of Occitanie. Once a world of troubadours and courtly love, of tolerance and true democracy, ruins and legends are all that survive. The area is filled with châteaux shrouded in mystery. The most notable Cathar ruins can be found in the Ariège département.

For visitors interested in the Cathars, the following towns all have a tale to tell: Albi, Cordes-sur-Ciel, Castres, Mazamet, Toulouse and Montségur. Albi's Gothic Ste-Cécile was built as a reminder of the Catholic triumph over the Cathars. The great vault is a divine vision hung with gold and sky blue. Its paintings, reminiscent of the Sistine Chapel, are the work of 15th century Italian artists. The Gothic façades of Cordes-sur-Ciel are built of sandstone in shades of ochre, reddish-purple and gray and are ornamented with elegant windows. The ruined Cathar houses in Castres and the archives in Mazamet are testaments to this period. The Counts of Toulouse, protectors of the Cathars, were buried in the Basilique de St-Sernin in Toulouse, the once powerful capital of Languedoc. Their tombs are still there. As an aside: Castres is also home to the Musée Goya. Sheltered within the former bishop's palace is the most significant collection of 14th century Spanish art after the Louvre including three Goya masterpieces.

The Counts of Foix were also faithful defenders of Catharism. The Château de Foix in the Ariège managed to withstand the horrific attacks by Simon de Montfort. The handsome structure now houses a museum recounting the people and history of Ariège. But perhaps the most famous of the Cathar ruins is the Château de Montségur. Positioned on a 3,960' rocky peak, it is only accessible on foot. Montségur was one of the most important spiritual retreats for the Cathars and the last they would inhabit. The last two hundred plus Cathar "heretics" were burnt at the base of the château at the spot now known as the *Prat das Cremats*, the Field of the Cremated. Within the château walls are traces of the keep, outbuildings and large hall in which the Cathars met. There is a tiny museum in the village of Montségur that preserves a variety of objects and documents related to the château.

* Langue d'Oc and Langue d'Oïl are the names of the two principal groups of medieval French dialects. Langue d'Oc was spoken south of a line running roughly from Bordeaux to Grenoble, whereas Langue d'Oïl was prevalent in central and northern France. The two dialect groups were named after their respective words for "yes," oc having been the form of "yes" in the south and oïl (now oui) having been used for "yes" in the north. Of the langue d'oïl dialects, that of the Paris region gradually supplanted all others as the standard idiom and developed into modern French.

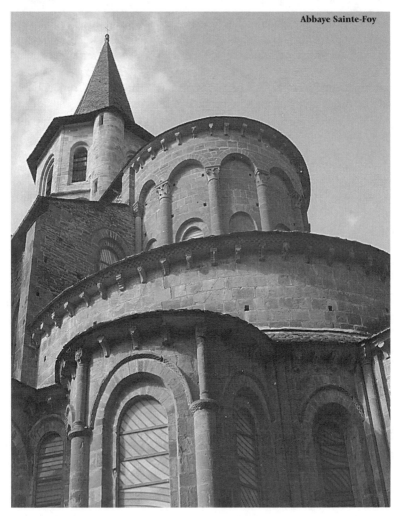

Abbaye Sainte-Foy

Accommodations
95 beds in single, double, triple and quadruple rooms and a dorm. Baths can be shared or private depending on the room.

Amenities
Towels and linens are provided on request at an extra charge of 3.00€.

Cost per person/per night
Lodging only 8.00€ to 25.00€.
Full board 29.00€ to 44.00€.

Meals
Only breakfast and dinner are available.
Dinner 10.00€.

Special rules
Guests must arrive at the abbey before 6 PM on day of arrival.

Directions
By car: Exit at Séverac-le-Château on A75 and take N88 to Rodez. From Rodez take D901 to Conques.
By train: Get off at Rodez and take a bus to Conques or get off at Saint-Christophe and take a taxi to Conques. (Taxi service: 0039 (0)8 10 11 17 55.)

Contact
Accueil
Abbaye Sainte-Foy
12320 Conques
France
Tel: 0033 (0)5 65 69 85 12
Fax: 0033 (0)5 65 72 81 01
Email: sainte-foy.de.conques@mondaye.com, or
 accueil-conques@mondaye.com
Website: www.mondaye.com and
www.conques.com (for general information in English about Conques and the abbey).

MAISON FAMILIAL DE VACANCE SAINTE-FOY

Property of the Abbey of Saint-Michel de Frigolet of Tarascon (Provence),
managed by lay personnel

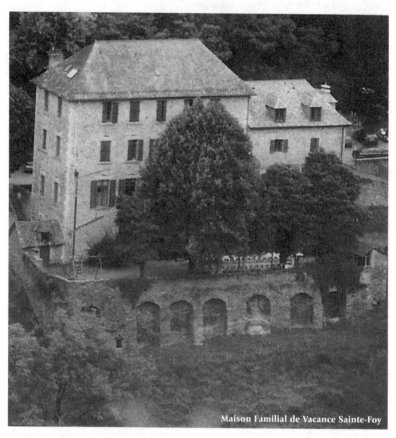

Maison Familial de Vacance Sainte-Foy

The 1897 complex is located very close to the Abbaye Sainte-Foy. It belongs to the monks of the Abbey of Saint-Michel de Frigolet of Tarascon who have turned a former Catholic school into a guest house to host individuals, families and groups. The house has a very pleasant terrace used for outdoor dining in the summer months.

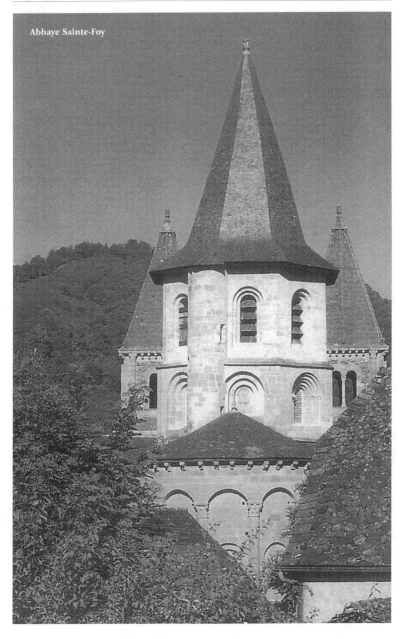

Abbaye Sainte-Foy

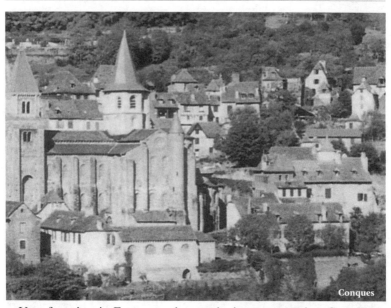

Conques

Very few sites in France can boast a heritage as grand as Conques, a place that seems to have traveled through time unchanged. A stop on one of the four routes to Santiago de Compostela, the allure of the village lies in its Romanesque-style abbey church encompassed by slate-roofed, half-timbered houses. The church is celebrated for its tympanum depicting the *Last Judgement*.

Within the vicinity of Conques is the town of Rodez, capital of the Aveyron département. It lies on a hill with wide horizons and is dominated by the late 13th century red sandstone Cathédrale Notre-Dame, an outstanding edifice of northern Gothic style crowned by a 240' tower. A finely worked 15th century screen, a 16th century "Entombment" in polychrome stone and a double row of sculpted stalls accentuate the interior. The ancient quarter of Rodez, now a pedestrian zone, retains its old world-charm.

This is bastide country. Bastides were "new" towns built by feudal lords to attract settlers and soldiers. They are defined by a central marketplace bordered by arcaded houses, an adjacent church and checkerboard streets. More than three hundred bastides are strewn in an enchanting

galaxy across the entire southwestern part of France. No two are alike, yet all share the same basic grid design: a central market and market square with a network of streets and lanes radiating out in perfect symmetry. At the time they represented the latest advance in civil construction techniques due to the combined use of stone, brick and wood.

The bastide of Villefrance-de-Rouergue is a landscape of architectural charm. A regimented alignment of roofs, narrow lanes arranged in a grid pattern, a central arcaded square and a church form the heart of the bastide. A fortified town, it was founded in 1252 by Alphonse de Poitiers, brother of King Louis IX. The ancient core is overshadowed by the stalwart bulk of Cathédrale Notre-Dame. Built in southern Gothic style, the church is marked by a massive 15th century belfry. The 17th century Penitents Noirs Chapel has a gilded wooden altarpiece and 15th century choir stalls. The former 15th century charterhouse of St-Sauveur is a singular Gothic structure and the only complete charterhouse open to the public in France.

Quite close to Villefranche-de-Rouergue are two other bastides. In 12th century Martel, time seems to have stopped. The pedestrian-only streets showcase attractive buildings and an 18th century covered market. The town was named after Charles Martel who built an abbey in 732. Martel later became the capital of the Viscounts of Turenne and was known locally as the "Town of Seven Towers." Evidence of its violent past can be seen in the fortified church of St-Maur, characterized by buttresses and battlements.

Set in an ocean of orchards, Montauban was one of the finest and earliest bastides. Built of pink bricks by the Count of Toulouse, it can trace its founding to 1144. A fortified village on the river Tarn, excellent examples of the golden age of the 13th century are obvious in its place Nationale and bishop's palace, now the Musée Ingres. Jean-Dominque Ingres was born in Montauban in 1780.

The monks at nearby Moissac were also architects of faith who were as powerful as they were inventive. The abbey they built was consecrated in 1100. An architectural masterpiece, the cloister of the abbey church of St-Peter stands clothed in incomparable grace at the heart of a huge complex of buildings including a museum of decorative and Romanesque art. The cloister is embellished with seventy-six capitals.

Region: Midi-Pyrénées City: Conques

Accommodations

90 beds in 28 rooms (1-4 beds) some with private bath. In July and August the house hosts individuals, families and groups but only for a minimum one-week stay. The remainder of the year it hosts only groups of 20 or more for stays of any length.

Amenities

Towels and linens can be provided on request. Public parking, TV room, meeting rooms and terrace.

Cost per person/per week

July and August prices per week: 240.00€ for a room with a shared bath and 282.00€ for a private bath. Other prices to be determined when reservations are made.

Meals

All meals can be provided on request.

Special rules

Minimum stay one week in July and August.
September-June; only groups of 20 or more are hosted.

Directions

By car: Exit at Séverac-le-Château on A75 and take N88 to Rodez. From Rodez take D901 to Conques.
By train: Get off at Saint-Christophe and take a taxi to Conques. Taxi service: 0033 (0)8 10 11 17 55.

Contact

Mr. Bernard Burguière
Maison Familial de Vacance Sainte-Foy
12320 Conques
France
Tel: 0033 (0)5 65 69 86 18
Fax: 0033 (0)5 65 69 86 18

CARMÉL DE FIGEAC
Carmélite Nuns

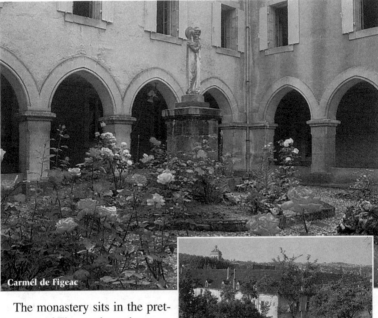

Carmél de Figeac

The monastery sits in the pretty town of Figeac along the route to Santiago de Compostela. The building was erected in 1833 and a community of Carmélite Nuns has inhabited the structure since that time. The chapel shelters a 16th century wooden statue of Christ.

Figeac lies between Rocamadour and the Tarn Gorges. The deep chasms of the Tarn were formed thousands of years ago when the vast chalk plateau of the "Grands Causses" (limestone uplands) were split during an intense geological upheaval. The area is worth visiting for the landscapes alone. The beautiful countryside contrasts the rugged Jurassic limestone plateau of the Causses with the lush green hills of the appropriately named "Garden of Segala."

Figeac's medieval core is an a medley of pale amber stone buildings with Gothic arches fronting narrow streets that rise to reveal open-lofted roof areas called *soleilhos*. This unique architectural feature imparts a particular southern nature to the town. The balconied houses date to the 14th and 15th centuries. Some are adorned with coats of arms, others with forged ironwork and mullion windows. In the later Renaissance period, wealthy merchants built their turreted stone mansions around an open interior courtyard with finely carved balustraded stone staircases leading to the upper floors. The entire town has been exceptionally well-preserved, particularly the *Aiguilles* (needles), two monumental stone obelisks on the heights above town.

The ancient core of Figeac with its winding alleys, churches, palaces and museums attracts thousands of tourists each year. Birthplace of Jean-François Champollion there is a namesake museum in honor of the man who deciphered Egypt's *Rosetta Stone*. The museum contains mysterious documents, sarcophagi and portraits of the scientist in Oriental dress. Close-by is the magnificent place des Ecritures with its enigmatic slab of black granite covered in hieroglyphics, an enormous version of the *Rosetta Stone,* created by American sculptor Joseph Kosuth in homage to Champollion.

Halfway between Figeac and Rocamadour is the village of Lacapelle-Marival. The history of the village is linked to that of its château. The keep was begun at the end of the 13th century while the main part of the living quarters dates to the 15th and 16th centuries. The village developed around the château's landmark presence. Due to its geographical position, Lacapelle-Marival became a center of economic activity with trade, crafts and markets of renown. Nestled between foothills, the monumental 15th century church is highlighted by ten small chapels.

Nearby Cardaillac is firmly anchored onto a rocky spur in the Haut Quercy area. Set in a wooded milieu punctuated by secret dales, crossing over the threshold that leads to the plateau is like stepping back into the Middle Ages. Within the village, alleyways snake between ochre-colored sandstone houses, many with architectural details such as Gothic arches and carved signs.

West of the monastery, Cahors was an important town in Roman times. In the 13th century it became one of the most important financial centers of Europe and the Cahorsin money lenders were among the most well-

known. Surrounded on three sides by the looping river Lot, Cahors preserves many reminders of its golden age, in particular, the early 14th century triple-towered Pont Valentré, one of the few enduring fortified towered bridges in Europe. It took seventy years to complete this 14th century military architectural feat.

Cathédral St-Etienne is graced with Byzantine cupolas and the tower of native son Pope John XXII. The old city treasures its ancient houses, mansions, gates, narrow lanes and the Maison de Roaldès where King Henri IV spent one night. On the banks of the river, the Chartreux fountain, Cahors' pre-Roman water supply, is fed by an underground spring some twelve miles away. The Arc de Diane is all that remains of a once vast Gallo-Roman thermal spa. A lively Saturday morning market is held in place Chapou, in front of St-Etienne and place Galdemar.

St-Cirq Lapopie

Between Figeac and Cahors are several perched villages somewhat off the beaten track but well worth the detour. From Figeac a sinuous drive through the Lot valley leads to picture-perfect St-Cirq Lapopie. Classified as an historical monument, it is dramatically sited on a cliff overlooking the river. The streets and their stall archways bear witness to the crafts that made the village wealthy: leather works of the rue de la Pelissaria, pot-makers of the rue Peyrolerie and above all the boxwood

turners, their workshops producing button molds, bowls, goblets and cooperage taps. Quaint cobbled lanes twist up a steep hill crowned by a 13th century castle. Rows of striking timber-framed manor houses with idiosyncratic tiled roofs fringe the ascent. From the top of the hill, views stretch across the river.

Nearby Cabrerets is eclipsed by the 14th century Château Gontaut-Biron. The small village is marked by stone houses with multicolored shutters. Less than a mile up the hill via a footpath from Cabrerets is the Pech-Merle cave. Discovered in 1922 the cave contains paintings of mammoths, bison, horses, female bodies and human hands. Connected by passageways and galleries, the seven "rooms" of the caverns are covered with cave art in red and black pigments. The average width of the galleries is over 30' with the ceilings often 15' to 30' high. There are about 700 depictions on the cave walls and all may be dated to the Upper Paleolithic era. A section of the galleries is lit and open to the public.

Accommodations
Hospitality is offered in July and August. There are 8 beds in 2 quadruple rooms. Baths are shared.

Amenities
Towels and linens are not provided.

Cost per person/per night
Voluntary contribution.

Meals
There is a kitchen that guests may use.

Special rules
Guests may only stay for one night.

Directions
By car: From Rodez take N140 north to Figeac.
By train: Get off at Figeac and walk to the carmél (10 minutes).

Contact
Sœur Hôtelière
Carmél de Figeac
7, allée Jean-Jaures
46100 Figeac - France
Tel: 0033 (0)5 65 34 27 53
Website: http://www.carmel.asso.fr/famille/moniale/figeac/46100.shtml

L'ISARD

Property of the Etablissement Scolaire Catholique
Immaculé Conception et Beau-Frêne (ICBF)

L'Isard is a guest house property of the Catholique Institution Immaculé Conception et Beau-Frêne. Once a private home, it was donated to the ICBF and then partially renovated. Guests must be independent since there is no one on the premises to provide services. However, there is a guardian who will provide keys to the house upon arrival.

Pyrénées

The Midi-Pyrénées includes the highest part of the mountain chain where several summits top 10,000'. In addition to these peaks, there are many breathtaking cirques sculpted by enormous ancient glaciers. The cirques are among the outstanding characteristic features of the Pyrénées. Just a stone's throw from Spain, Gavarnie is at the heart of this region. The village was a former stop on the Santiago de Compostela and is classified by UNESCO for its exceptional beauty. Set in a realm of snow-capped mountains, wildflowers, rocks and waterfalls, from its heights there is a panorama of the famous Cirque de Gavarnie, an awe-inspiring amphitheater of glacial mountains soaring high above the valley.

The famous Brèche de Roland gorge is a cleft in one of the crests. A popular tourist sight in the Pyrénéan mountain range, its colossal size is more than two miles in circumference at its base and nearly nine miles at its highest point. Looking as if it is suspended in mid-air, the Grande Cascade, Europe's longest waterfall, completes the extraordinary picture.

Not far from Gavarnie is the town of Argelès-Gazost. Standing at the crossroads of the Lavedan valley, the old districts rise in terraces above the stream. Like other Pyrénéan spa towns it was most popular in the late 19th century. There are still many large, beautiful homes, a casino and an English-style park. The Lavedan valley stretches from the Lourdes area to the Spanish border. Of the seven valleys, three are most interesting: the wild, luminous Val d'Azun is home to numerous windmills; the gentle St-Savin is famous for its Bénédictine abbey; and the steep-sided Barèges leads up to Tourmalet Pass.

Cauterets is in the general vicinity. It lies in the verdant valley of the Gave de Cauterets and is well known for its copious thermal springs. The spas are chiefly characterized by the presence of sulphur and silicate of soda. Pont d'Espagne is near Cauterets. It is a place of waterfalls that alternate between rushing water and calmer terraced pools. Mountain lakes are prevalent throughout the area. In the Néouvielle Nature Reserve, there are seventy such lakes, their sparkling colors - deep blue, sky blue and jade - leave a lasting impression.

Accommodations
24 beds in single, double and small dorms with bunk beds. Baths are shared. The house can only be rented in its entirety, whether to groups or individuals.

Amenities
Towels and linens are not provided. There is a private garden and common room. It is possible to receive calls at 0033 (0)5 62 92 41 43.

Cost per person/per night
Minimum of 60.00€ per night for up to 10 guests; additional guests are 6.00€ each per night.
Weekend rates: Flat rate - no limit on guests.
Summer rates: May 1st – September 30th 80.00.€ per night.
Winter rates: October 1st – April 30th 120.00€ per night.
There is a 35.00€ cleaning fee in addition to lodging cost.

Meals

Meals are not provided. There is large kitchen that guests may use.

Directions

By car: Take A64 and exit at Lourdes. From there take N21 and then D921 to Gavarnie. Once in Gavarnie leave the national road in front of the "Chambres d'hôtes" Coumély, turn right and cross the stream. The house is 250m further. The parking lot is 15 m from the house.
By train: Get off at Lourdes and take a bus to Gavarnie.

Contact

Make advance reservations with Madame Lagleyse. She will provide pertinent information on how to reach Gavarnie and obtain keys to the guest house. The arrangements for obtaining keys are somewhat casual. Keys are available either in Pau at Immaculée, boulevard Edouard Herriot (see below) or from Mr. Lartigues, a neighbor.

Guest house
L'Isard
65120 Gavarnie
France

ICBF:
Bd Edouard Herriot - BP 9068
64051 Pau cedex 9
Tel: 0033 (0)5 59 72 07 72
Fax: 0033 (0)5 59 32 80 57
Email: icbf@wanadoo.fr
Website: www.icbf.net

NOTES

FOYER FAMILIAL
Order Dominican Sisters of Presentation

The guest house is near the train station and a fifteen-minute walk from the shrines of Lourdes. The house with its private garden has always been inhabited by the Dominican Sisters and has always hosted guests visiting Lourdes.

Situated in the foothills of the Pyrénées, Lourdes is the largest Catholic pilgrimage site in France. According to tradition, in February 1858, the

Bernadette

Virgin Mary appeared to Bernadette Soubirous (a fourteen-year old girl) on eighteen occasions. (Bernadette entered the Monastery of Nevers in 1866 and was canonized in 1933.) A statue of the Madonna of Lourdes was erected at the site in 1864. Soon thereafter the chapel structure was replaced with a pilgrimage basilica. Each year millions are drawn by their faith in the miraculous cures attributed to the waters of the shrine. Especially impressive are the candlelight and sacrament processions. The underground basilica of St-Pius X is one of the largest holy sanctuaries in the world. Another place of worship is the Stations of the Cross, delineated by fourteen monumental bronze figures.

The Basilica of the Rosary is part and parcel of the vast architectural synthesis of the sanctuaries of Lourdes. Representing a vast Greek cross, the composition echoes the biblical gesture of open arms and as such is a world symbol of fraternity between men. Arcades in Lourdes' stone complement the façade and support the stairways and ramps leading to the terraces and upper basilica. The arcades and enormous terraces embrace a grand square where almost 80,000 people can gather.

The dominant features of the monument are Romanesque, with the stones cut in Roman bossage style. The domes and chapels are adorned with Venetian mosaics and reflect the tradition of Byzantine architecture. Like a prodigious mantle spread over a total area of some 2,000 square meters, the mosaics were completed during a twelve-year period by G.D. Faccina, a master mosaicist of the 19th century. The artist was also responsible for the frescoes of the Opera Garnier in Paris, those of the Kyoto Imperial Palace and the Basilica of Our Lady of Sion in Jerusalem.

Fifteen chapels radiate out by groups of five around the apse and the transept. Each chapel symbolizes a scene of the mysteries of the rosary. Although the paintings were the work of several artists, the fifteen chapels form a compatible entity. The first five chapels represent the joyous mysteries. Their paintings were executed by two Parisian artists. In the five chapels of sorrowful mysteries, the *Bearing of the Cross* fresco sets itself apart from the others. The work of Aragonest artist Felipe Maso, it is the most intricate.

Chapel 13 of Pentecost is regarded as housing the finest of the five frescoes of the glorious mysteries. It is a remarkable work of art, both in the manner that the mystery is presented and in the finish of the drawing. The chapel features a texture of architectural details including marble altars enriched with bronze, copper, enamel and gemstones.

East of Lourdes and resting against the shoulder of the Pyrénées is St-Bertrand-de-Comminges. The fortified village is built on a slope, its medieval ramparts dominate the remains of a huge town founded by Pompey. Backdropped by verdant mountains, Cathédrale Ste-Marie is shaped like a ship and towers above steep streets crammed with red roofed, half-timbered houses from the 15th and 16th centuries. The cathedral preserves sculpted woodwork on the rood screen and choir. The Romanesque cloisters offer a tranquil respite and are enriched with carved capitals and statues of the four Evangelists. Built in 1550 the cathedral houses an historical organ, one of France's finest classical instruments. The international music academy performs concerts during July and August.

Accommodations
100 beds in single, double and family rooms with private bath. The guest house can also host groups of young people in large dorms with shared baths.

Amenities
Bed linens are supplied by the sisters. Guests must provide their own towels. Private garden, private parking, TV and meeting rooms.

Cost per person/per night
Full board 29.00€ in single, double and family rooms, 27.00€ in dorms.

Meals
All meals can be provided with the lodging.

Directions
By car: Take A64, exit at Tarbes ouest and take N21 to Lourdes.
By train: Get off at Lourdes and walk to the Foyer Familial.

Contact
Anyone who answers the phone
Foyer Familial
2, avenue Saint-Joseph
65100 Lourdes
France
Tel: 0033 (0)5 62 94 07 51
Fax: 0033 (0)5 62 94 57 14
Email: foyerfamilial.domenicaines@wanadoo.fr

NOTES

MAISON BELLEVUE
Association Concorde – Mission Catholique Polonaise

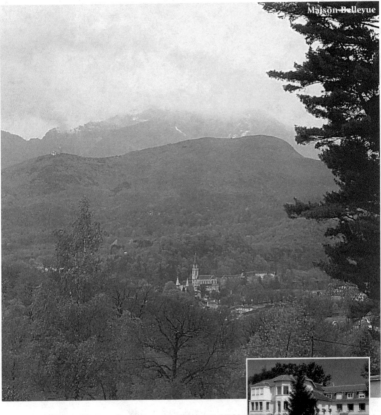

The maison is perched on a hilltop 1,970' above sea level overlooking the shrine, the town of Lourdes and the Pyrénéan peaks. The vista is illuminated by the intermittent lights of the cable cars and presents an altogether lovely picture. "The view is outstanding, absolutely exceptional," said Sœur Francesca. "I really think it is the best view of Lourdes. I haven't been here for long, but I have already taken many photographs,"she added.

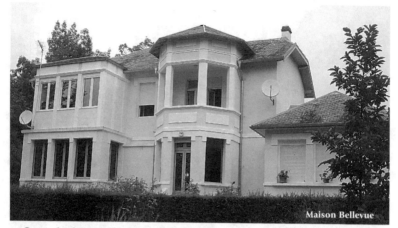

Maison Bellevue

Once the home of a British lord, the maison is a large villa built at the beginning of the 20th century. The property was eventually sold to a community of Franciscan Sisters who enlarged the structure and remained in residence until 1986. At that time the sisters of the Polish Catholic Mission bought and restored the house.

Lourdes is famous for its Roman Catholic shrine. Each year millions of people make the pilgrimage to Lourdes, drawn by their faith in the miraculous cures attributed to the waters of the shrine. It is said that to under-

Bernadette

stand what "brother" really means, come to Lourdes, one of the greatest pilgrimage destinations in the world. Each day a fervent crowd gathers to pray in front of the grotto where the Virgin Mary appeared to Bernadette Soubirous. According to belief the fourteen pools cut into the rock at the edge of the river Gave de Pau have performed miraculous cures. The so-called Ste-Bernadette path is near the maison. It is the path from Lourdes to Barters that the saint followed to work every day.

The ancient castle in Lourdes has an interesting history. The area was inhabited very early on as demonstrated by flint axes, cut stones and bones found in the area. The Gauls, Romans, barbarians and Moors successively fortified the rock on which the castle still stands. Legend holds that in 778 Charlemagne lay siege to the castle that was occupied by the Saracen Mirât and his Moors. Despite the assaults and the ensuing famine,

the château fort remained impregnable. In the course of the battle, an eagle appeared overhead and dropped an enormous trout at Mirat's feet. The Moor took the fish and presented it to Charlemagne, wanting his enemy to believe that the holdouts still had provisions. Charlemagne was about to continue the siege when one of his trusted companions suggested that he speak with Mirat and ask him to surrender, not to the sovereign, but to Notre-Dame, the queen of the sky. Mirat followed Charlemagne's suggestion and was baptized. On the day of his baptism he took the name of Lorus, which was then given to the town and later became Lourdes.

The Musée Pyrénéan exhibits the popular arts and traditions of the region in a setting symbolic of the history of Lourdes. Created in 1921, it is a compliation of eighteen rooms and outdoor areas which present the main elements of the culture of the mountain dwellers: a typical Bigourdane room, Béarnaise kitchen, traditional costumes, models of characteristic houses as well as furniture of the old church of St-Pierre de Lourdes.

South of Lourdes is the Abbey of St-Savin. Now a parish church, the Romanesque edifice was part of a Bénédictine monastery that was once very influential in Bigorre. An important sanctuary of the Pyrénées, it houses the relics of St-Savin, a hermit monk of Spanish descent. The abbey preserves the largest Romanesque frescoes in Europe and is renowned for its incomparable Byzantine mosaics. The history of St-Savin is sketchy but through various historians some information has emerged. The abbey was sheltered by a castle and so escaped pillage from the Viking raids. In the course of the 11th century, the abbey was completely rebuilt. In 1368 during the Hundred Year War, English troops took refuge in the church. In the mid-16th century the church and monastery suffered, many possessions were lost and buildings destroyed. It wasn't until the 19th century that the church regained its benefactors and restoration was begun.

Accommodations
100 beds in rooms with 1 to 4 beds, most with private bath. There is also a chalet available in the summer months with 8 dorms and shared baths.

Amenities
Towels and linens are supplied. Private parking, private park, TV room, chapel and library. There is the possibility of shuttle transportation to and from the train station and the shrine as well as transportation to the ski slopes.

Special rules

Curfew 11:30 PM – 7:00 AM. Exceptions are made for early departures or visits to the shrine.

Cost per person/per night

Prices are to be considered provisional. Up-to-date prices are provided on the web page.

Lodging only with breakfast 15.00€ to 16.00€.

Half board 22.00€ to 26.00€.

Full board 28.00€ to 31.00€.

Meals

Lunch 9.00€, dinner 10.00€.

Directions

By car: From A64 exit at Tarbes ouest and take N21 to Lourdes. Once in Lourdes take the Route de Bartres (D3) to the maison.

By train: Get off at Lourdes and take a taxi; or provide notice of arrival time to the nuns. They will arrange shuttle transportation. Transportation can also be provided to the shrine.

Contact

Anyone who answers the phone

Maison Bellevue – Association Concorde

Route de Bartres

65100 Lourdes

France

Tel: 0033 (0)5 62 94 91 82

Fax: 0033 (0)5 62 42 08 75

Email: pmk-lourdes@club-internet.fr

Website: www.mission-catholique-polonaise.net

NOTES

MONASTÈRE SAINTE-CLAIRE
Clarice Nuns

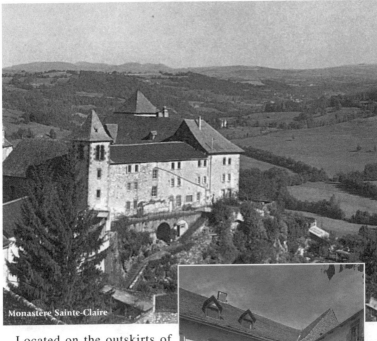

Monastère Sainte-Claire

Located on the outskirts of Mur-de-Barrez, the monastery enjoys a splendid vista of the Monts du Canal on the Massif Central. It was founded in 1653 by a group of nuns of the Clarice Order. Due to the suppression of the religious orders during the French Revolution, the sisters were forced to leave the complex in 1790 and didn't return until 1868.

Mur-de-Barrez is a pastiche of medieval architecture replete with the ruins of a castle. Founded in 1200 by the Counts of Rodez, the town became English property during the Hundred Year War and was devastated during the religious conflicts of the 16th century. In 1643 it passed to the Grimaldi family

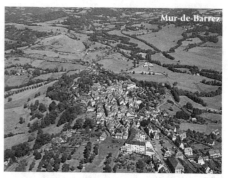

Mur-de-Barrez

ly (Principate de Monaco). Today it is the capital of the Carledez, an area abundant in natural sites that attracts thousands of visitors every year.

Easy day trips can encompass a number of quaint villages. Medieval Estaing is at the entrance of the gorge of the Lot. Its architectural heritage can be admired in a Gothic bridge and château built by successive generations of the Counts of Estaing.

St-Côme-d'Olt is a medieval market town with an old quarter that has remained intact for six hundred years. The porte Théron is one of the town's three fortified gates. Within the maze of streets and alleyways are squares lined with 15th and 16th century houses. The Point de Caylus has retained its *dovecot* (small compartmented raised boxes for domestic pigeons) once used as a watchtower. The Gothic-inspired town church was built between 1522 and 1532 and harbors a wooden Christ. The 16th century church doors are made of carved oak, each one studded with 365 wrought iron nails.

Ste-Eulalie-d'Olt is lodged at the foot of the mounts of Aubrac in the Lot valley. The town has a medieval structure organized around the church square in a series of alleyways and small squares. Handsome 15th and 16th century residences bear witness to the town's heritage. Architectural details feature pebbles from the river. The 8th century church has a Romanesque-style chancel surrounded by cylindrical columns; the ambulatory leads to three apsidal chapels and a bust reliquary in which two thorns are believed to be from Christ's crown. The village also celebrates its 15th century château and a 16th century Renaissance corbelled townhouse.

Mur-de-Barrez is not far from the small towns of Entraygues and Espalion. The former sits at the confluence of the rivers Truyère and Lot and preserves a 13th century bridge and attractive old quarter. The latter stretches out along both sides of the river Lot. The older part of town lays claim to a 13th century sandstone bridge. A number of sites can be visited including the hilltop ruins of a feudal castle. Hanging over the river, the balconies of the riverside houses, many punctuated by steep stone roofs and outside stairways, compose a memorable picture. .

Called Midi after the noonday sun, Midi-Pyrénées is the largest and one of the most varied regions in France, ranging from warm limestone plateaux in the north to snowy peaks 170 miles south in the Pyrénées. Dozens of medieval towns and fortified villages pepper the hilltops and valleys. Many are bastides from the 12th and 13th centuries; fortified towns built on a grid layout with a central market square. The bastides began to appear as feudalism declined in medieval France and represented an attempt by landowners to generate revenues from taxes on trade rather than tithes (taxes on production). Farmers who elected to move their families to bastides were no longer vassals of the local lord, they became free men and were encouraged to work the land around the bastide which, in turn, attracted trade in the form of merchants and markets.

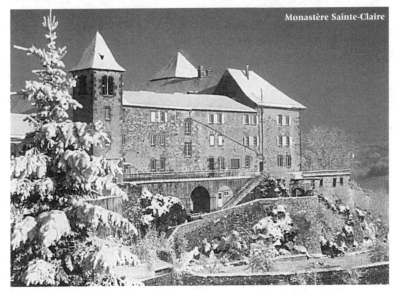

Monastère Sainte-Claire

Accommodations

9 single, 10 double and 11 rooms with 3 or more beds. Most rooms have private bath, although many single rooms have shared ones.

Amenities

Towels and linens are provided.

Cost per person/per night

A minimum contribution is required; additional contributions are voluntary.

Meals

All meals can be provided on request.

Special rules

Silence after 10 PM.

Directions

By car: Take A75 and exit at St-Flour. From there take D990 to Raulhac and then D600 to Mur-de-Barrez.

By train: Get off at Aurillac and take a bus to the monastery (buses do not run during festivals).

Contact

Sœur Hôtelière
Monastère Sainte-Claire
2, rue de la Berque
12600 Mur-de-Barrez
France
Tel: 0033 (0)5 65 66 00 46
Fax: 0033 (0)5 65 66 00 90
Email: steclaire.mur@wanadoo.fr

NOTES

LES RELAIS DES REMPARTS

Property of the Diocese of Cahors and managed by lay personnel

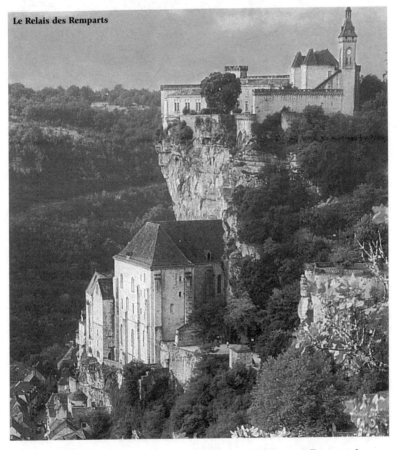

Le Relais des Remparts

The guest house occupies an astonishing position atop Rocamadour, a sacred town of Midi-Pyrénées and the site of a millenarian pilgrimage to worship a black statue of the Virgin Mary. Les Relais was built specifically to host the pilgrims who number more than a million every year. It is annexed to the 19th century castle that crowns the cliff of Rocamadour.

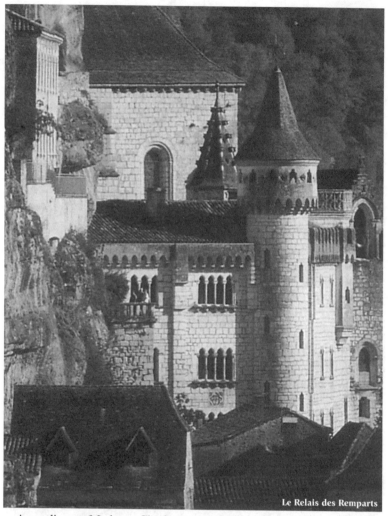

Le Relais des Remparts

According to Madame Charlotte, the guest house boasts a view over the city and surroundings that is "Unique!" The fortified castle is partly inhabited by the priests and partly occupied by the restaurant of the Relais, (only this last part can be visited by guests). The remainder of the complex is of recent vintage and equipped with all the amenities guests may require.

Rocamadour means Amadour's Rock. The rock has numerous caves that, in the early Middle Ages, were occupied by hermits, also called *Amoreux-Amadour* (lovers of the rock). According to tradition, in 1166 a local man on the point of death asked to be buried in front of the oratory where a black statue of Mary was sheltered. While trying to fulfill the wish of the man, his family found the body of a hermit completely intact under the soil of the chapel. From that time the hermit was called Amadour. Over the ensuing years, many miracles were attributed to the sacred site and Rocamadour became a Cité Religieuse.

Founded in the 12th century, Rocamadour is one of the most amazing sites in France. Halfway up a cliff, in the hollow of the rock, the city is formed around seven churches and chapels. From the remains of an ancient castle, the city descends among a jumble of stone-built medieval houses that hang from a near-vertical cliff. Throughout the old town are towers and churches dating from the 12th to the 15th centuries.

A popular local nursery rhyme describes the surprising and alluring architecture of the town.

> *The houses on the rock*
> *The churches on the houses*
> *The rock on the churches*
> *The castle on the rock*

At the Grotte des Merveilles, beautiful crystalline concretions enhance wall paintings depicting hands, horses and stags that date back some 20,000 years. Rocher des Aigles is both a habitat for birds such as eagles, falcons and vultures and a showplace in which birds of prey are released.

To the north of Rocamadour are three inviting villages. Loubressac is an ancient village hanging on a breathtaking promontory that dominates three valleys including that of the Dordogne. The flowered streets of Loubressac converge on a shady square that shelters an ancient church. Capped with old tiles, the limestone houses of the village reflect the sunlight and present a distinctive image. Many hiking trails leave the village and connect with neighboring hamlets passing fountains and dolmens and ending on a nearby limestone plateau.

Nearby Autoire is a hamlet in a marvelous landscape on the edge of the Périgord area. A Quercy village, it has been preserved intact for eight cen-

turies. A patchwork of alleyways, some lined by elegantly crooked half-timbered houses while others are characterized by white corbelled structures with brown tiled roofs, one prettier than the one before.

Situated on the banks of the river Dordogne, the picturesque market town of Carennac is an architectural delight. The charm of its golden stone houses is enhanced by brown tiled roofs with turrets and high chimneys, wooden balconies, carved window frames and Renaissance period ogives clustered around an ancient priory. Attached to the priory are a lovely 11th century Romanesque-style church and the Château des Doyens.

Accommodations
75 beds in single and double rooms each with a private bath.

Amenities
Towels and linens are supplied. Private parking, private park, conference and meeting rooms, TV and dining room in the castle halls.

Cost per person/per night
Single, lodging only 30.00€, full board 63.70€, half board 50.00€.
Double, lodging only 44.80€, full board 56.10€, half board 42.50€.

Meals
All meals can be provided with the lodging.
Breakfast 5.70€, lunch and dinner 13.50€.

Directions
By car: From Toulouse take A20 and exit at Labastide-Murat (#56) and take N20 and D673 to Rocamadour.
By train: Get off Rocamadour and take a taxi to the guest house (5 km). There is no other public transportation.

Contact
Anyone who answers the phone
Le Relais des Remparts
Le Château
46500 Rocamadour
France
Tel: 0033 (0)5 65 33 23 23
Fax: 0033 (0)5 65 33 23 24
Email: relais.des.ramparts@wanadoo.fr
Website: http://pro.wanadoo.fr/relaisdesremparts

PRIEURÉ NOTRE-DAME DES NEIGES
Premontré Friars

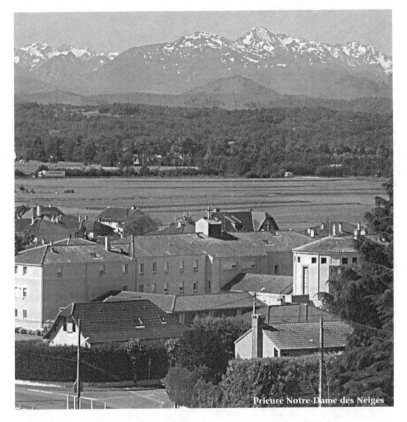
Prieuré Notre-Dame des Neiges

The prieuré is a new construction on the outskirts of Tarbes, a pretty
town at the foot of the Pyrénéan chain. At one time a community of
Carmélite Sisters inhabited the complex. The present community of friars
took up residence in 1998. The city of Tarbes is an ancient one, ideally
located near the mountains, Lourdes, the Spanish border and a multitude
of castles and abbeys. There is a wonderful view of the Pyrénéan moun-
tains from the guest quarters.

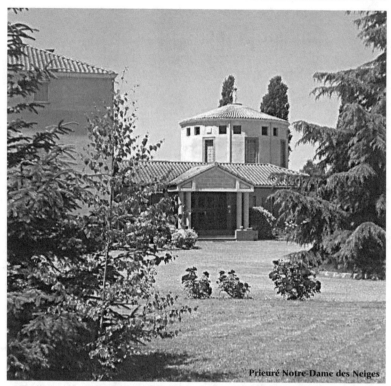

Prieuré Notre-Dame des Neiges

Tarbes was called *Bigorra* in Roman times and was later the capital of the earldom of Bigorre. Invaded and destroyed many times in the course of history, it became part of the French Crown in the 16th century. Among its monuments are the Cathédrale de Notre-Dame-de-la-Sede, the 13th century churches of St-Jean and Ste-Thérèse and the base of a castle tower built by the Counts of Bigorre.

A day trip to Toulouse has its rewards. Two thousand years ago Toulouse was built on the banks of the Garonne river. It was an artistic and literary center of medieval Europe. In the late 12th century, the powerful Counts of Toulouse controlled most of the Languedoc region. Ruling with great tolerance, particularly toward their Jewish constituency, the counts held a brilliant court that attracted the best troubadours. In the 13th century, under the guise of eradicating the heresy of the Albigensian (Cathars of Albi), the northern lords plundered Toulouse.

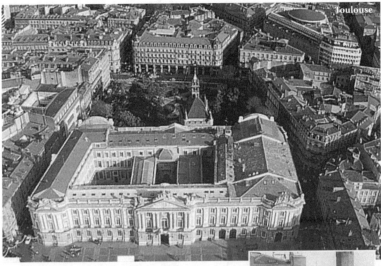

The city's pedestrian friendly historic center is anchored by lively cafe terraces, museums, monuments and riverside walks. Adding to the city's overall appeal is the characteristic russet hue of its buildings. The brick that gave Toulouse its nickname "the pink city" is everywhere. As the sun moves during the day, the pink changes color, ranging from coral to purple to fiery red. Old Toulouse has been left almost intact since the 18th century and is quartered by two 19th century streets: rue d'Alsace-Lorraine/rue du Languedoc and rue de Metz (which runs onto the Pont Neuf and across the Garonne). Contrary to its name, the Pont Neuf is the oldest bridge in the city. Toulouse is also home to a large university, second only in size to Paris.

The place du Capitole is the hub of the city's social life. Three of its sides are lined with outdoor cafes, the fourth closed by the pillared façade of the mid-18th century capitole or town hall. The capitole is an eminent structure reflecting the superb use of brick and stone, hallmark of Toulouse's architectural personality. The south wing houses the theater that helped Toulouse sustain its long-established reputation as a European

capital for operetta. The square's centerpiece is a huge bronze Occitan Cross set into the pink and gray granite paving slabs. Opposite the town hall, the Gallery of Arcades celebrates paintings by Raymond Moretti that narrate the history of Toulouse and its inhabitants. The square is also the scene of a vast Wednesday market. A labyrinth of narrow medieval streets radiates out from the core to the town's other squares.

Two churches rank among the town's important artistic and architectural treasures. Basilique de St-Sernin is a masterpiece of Romanesque art. In southern hues of purplish pink, it is the emblematic monarch of Toulouse. With its three doorways, narthex, nave with double aisles, enormous transept and apse, it is the largest and most complete Romanesque church in France. Designed to cater to pilgrims on the Santiago de Compostela, the spire of the octagonal Romanesque and Gothic bell tower is five stories high. The belfry served as a model for dozens of smaller churches in the area. Founded by St-Dominic in 1215 to expunge the Cathar heresy, the Gothic brick Les Jacobins was the mother church of the Dominican Order. It has a "palm tree" vaulted ceiling - a score of arches radiating from the chancel pillar. The church is the repository of the relics of St. Thomas Aquinas.

The *hôtels particuliers* that give the town so much of its intrinsic charm remain as a legacy from Toulouse's golden age. At that time the city had a flourishing woad trade. (Woad is a European herb of the mustard family grown for the blue dyestuff yielded by its leaves.) In order to leave the stamp of their prosperity, the pastel traders created regal mansions and adjacent towers, the height of which testified to their riches. More than seventy private mansions are open to visitors.

Hôtel d'Assézat, a brick and stone jewel of Renaissance architecture, illustrates classical elegance to perfection. It was built in 1555 by Pierre d'Assezat, a rich woad merchant. It harbors the Foundation Bemberg, a collection of paintings and objets d'art from the Renaissance to the 20th century. Two other fine examples are the Hôtel du Bernuy with its octagonal stair tower and the early Renaissance Hôtel Beringuer-Maynier.

The city also prides itself on several worthwhile museums. Located in a 14th century monastery, the Musée des Augustins exhibits an array of medieval sculptures and paintings of the 17th, 18th and 19th centuries including work by Rubens, Perugino, Murillo and Delacroix. Musée St-

Raymond is lodged in a Renaissance building and preserves remnants of the Roman occupation including mosaics and a stately gallery of portraits of Roman emperors. Musée Georges Labit contains a definitive collection of Asian and Coptic works representing Egyptian and Asian art.

Centuries ago, Toulouse had a thriving Jewish community but numerous expulsions resulted in its demise. Today, thanks to the immigration of Jews from North Africa, Toulouse once again has a vibrant Jewish community, the third largest in France.

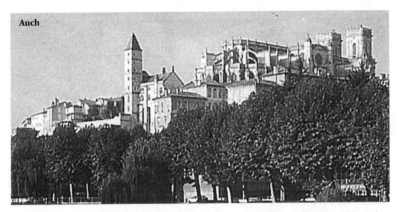
Auch

North of the prieuré, the city of Auch makes for a pleasant day trip. One of the chief towns of Roman Gaul, it is a gleaming white stoned and red tiled southern city. The lower city was founded upon the 1st century BC *August Auscorum*; the upper upon the Roman imperial settlement of *Elimberris*. During medieval times the town was an important stop on the Santiago de Compostela. A place of narrow medieval streets, monuments and buildings, Auch represents the quintessential spirit of Gascony.

The ancient quarter, steep and hilly, is topped by the Flamboyant-style Cathédrale de Ste-Marie. Begun in 1489 it was completed two centuries later. From the river the church is reached via 232 stone steps. The pale gold structure conserves twin bell towers and an elegant Renaissance façade. Its vast choir features 113 hand-carved oak stalls executed over a fifty-year period. The carvings resemble extravagant lace and depict more than 1,500 characters drawn from religious, historical and mythological sources.

Accommodations
8 singles with sink; 6 doubles, some with sink; 1 apartment with 4 beds and no sink. Baths are shared.

Amenities
Towels and linens are provided on request at an extra charge of 4.00€ per person.

Cost per person/per night
Full board 29.00€. Other rates to be determined according to the number of meals included with lodging.

Meals
All meals can be provided with the lodging.

Special rules
Silence after 10 PM.

Directions
By car: Exit at Tarbes on A64 and follow the signs to the "Centre Hospitalier" and Bagnères-de-Bigorre. After a McDonald's restaurant (c'est bien dommage!), take the second right to the Prieuré Notre-Dame de Neiges.

By car: Get off at Tarbes and take a taxi or bus to the prieuré.

Contact
Frère Hôtelier
Prieuré Notre-Dame des Neiges
12, rue de la Châtaigneraie
65310 Tarbes-Laloubère
France
Tel: 0033 (0)5 62 51 80 60
Fax: 0033 (0)5 62 93 28 63
Email: fr.pierre-marie@wannadoo.fr
 nd.des.neiges@mondaye.com
Website: www.mondaye.com/

NORTH-CALAIS

MAISON SAINT-VAAST
Property of the Diocese of Arras

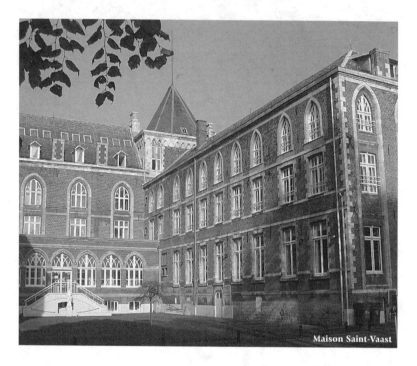

Maison Saint-Vaast

Surrounded by its own private park, the ancient seminary of Arras is in a peaceful quarter of the city. Built in 1698 by a community of Trinitarian friars, nearly a century later the structure was sold and its chapel destroyed. In 1814 a group of Bénédictine monks took up residence in the complex and built a new chapel and bell tower. Sixty years later they were forced to leave as a result of anticlerical laws. In 1914 the Bishop of Arras bought the complex and converted it into a seminary.

During WWI the town was near the front of a long series of battles known as the Battle of Arras in which the *boves* (twisting medieval tunnels carved into the limestone rock beneath the city), unknown to the Germans, became a decisive factor in the French holding the city.

The bombing of 1915 destroyed the chapel and part of the cloister. After the war it once again became a seminary, the new chapel enhanced with stained glass windows. The windows are divided into two parts; one represents the patron saints of the seminary, the other, scenes from the ordination of a priest.

In 1990 the Sisters of the Ste-Union replaced the previous order and the center became a guest house for holidays, spiritual retreats and cultural sessions. In mid-1995 renovation of the complex was begun and completed in 2003. The original architecture has been preserved including the chapel and oratory. "The maison is beautiful," said Madame Veronique. "Visitors find it a relaxing place to stay since it is located in such a tranquil, verdant spot," she added.

Originally settled by the Celtic tribe of the *Altrebates*, Arras became a Roman garrison town known as *Atrebatum*. By the 14th century the town had become a center of wealth and culture renowned for its tapestry interwoven with gold and silver threads. At that time the city was governed by the Dukes of Burgundy and the tapestries were fashionable in

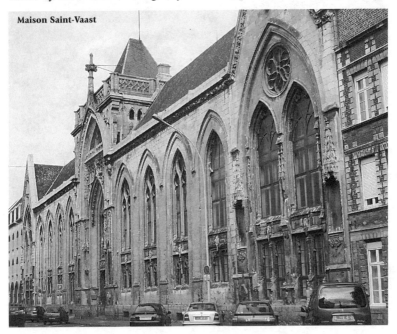

Maison Saint-Vaast

the lavish Burgundian court. As an aside: In Shakespeare's *Hamlet*, characters "hid behind the arras" to eavesdrop on others. Unfortunately only a few examples of the tapestry work have survived.

la Grande Place

Although much of the town was destroyed during the world wars, Arras retains an age-old Spanish-Flemish flavor. Two picturesque squares form the heart of the town; la Grande Place and place des Héros. At one end of the latter, the epic Hôtel de Ville was rebuilt in Flamboyant Gothic style. Both squares are lined with stone-pillared arcades and tall stone and brick gabled mansions. The squares come to life on Saturday mornings when the weekly market takes place. The town's appealing architectural lineage is reflected in an ensemble of 155 Flemish-style residences dating from the 17th and 18th centuries. The house where Robespierre was born still stands. Musée des Beaux-Arts is in the 18th century St-Vaast Bénédictine Abbey. It harbors an assortment of medieval sculptures, paintings, collections of decorative art and a relief map of the town.

Several nearby towns offer interesting diversions. Douai is officially recognized as a "Town of Art and History" and has preserved the quaint charm of its 18th century architecture. Two old city gates and a number of Flemish buildings also remain. In Cambrai, one of the oldest towns in the region, Spanish and Flemish-style houses coexist in perfect concordance. Occupying an 18th century town-house, Musée des Beaux Arts is characterized by its originality, in its exhibits, as well as its internal architectural style. The heritage section contains fragments from local churches and monasteries, 17th to 19th century sculptures and paintings by Ingres, Rodin and Van Dongen.

The little town of Le Quesnoy, characteristic of northern France, has sustained the entire two miles of the ramparts constructed by the military engineer Vauban. An hstorical walk leads from the fortifications to the foot of the belfry and its carillon. St-Riquier traces its founding to a 7th century Bénédictine abbey. Its church dates from the 15th century although the interior reflects a 17th century restoration.

North of the maison is the Canadian War Memorial of Vimy. The massive site is the work of Seymour Allward. A poignant symbol of the courage displayed by Canadian troops against the German invader, it was erected in homage to the soldiers who lost their lives on Vimy ridge during WWI.

Canadian War Memorial

The region of Picardy is not far from the maison. A cradle of Gothic art with six splendid cathedrals and numerous churches and abbeys, the diversity of its architectural ancestry is everywhere. In the very heart of Picardy, the city of Amiens is renowned for its cathedral, a UNESCO World Heritage Site. A Gothic masterpiece of the 13th century, it is notable for the coherence of its plan, the beauty of its three-tier interior elevation and for the particularly fine display of sculptures on the principal façade and the south transept. It is tallest of the large classic Gothic churches and the largest of its kind in France.

Picardy architecture

Accommodations

The house is managed by lay personnel and offers two types of accommodations; one for visitors on holiday, the other for spiritual/group meetings. 130 beds in single, double and family rooms (4 beds.) Only 10 have private bath.

Amenities

Linens can be supplied at an extra charge of 4.50€ per stay. Guests must supply their own towels. There is private parking, eleven meeting rooms and a private park.

Cost per person/per night

Lodging only 12.50€ to 15.50€.
Half board 24.00€ to 27.00€.
Full board 31.00€ to 34.00€.

Meals

All meals can be provided with the lodging, however, there are times when the personnel are on holiday. When reservations are made, inquire if meals will be available.

Special rules
Closed during the Christmas holidays and the end of August (times vary).

Directions
By car: From either A1 or A26 exit at Arras and follow the signs to the center. A detailed map of the town is available on the website.
By train: Get off at Arras (train or TGV) and walk (1/2 hr) or take a bus or taxi to the maison.

Contact
Anyone who answers the phone
Maison Saint-Vaast
103, rue d'Amiens – BP 1016
62008 Arras cedex
France
Tel: 0033 (0)3 21 21 40 00
Fax: 0033 (0)3 21 21 40 09
The maison prefers to be contacted via fax.
Website: www.maisondiocesainearras.asso.fr

 NOTES

ABBAYE SAINTE-MARIE DU MONT-DES-CATS
Trappist Monks

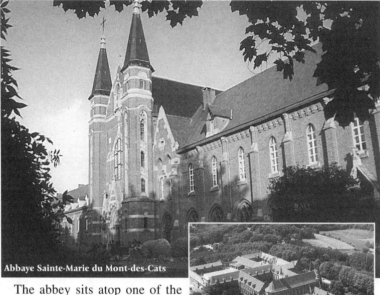

Abbaye Sainte-Marie du Mont-des-Cats

The abbey sits atop one of the few hills of the region and features views of the surroundings. An idyllic setting, it is encompassed by spacious lawns and hundreds of trees. The complex is in the Parc Naturel Regional des Monts de Flandre, an arena for naturalists who can explore the park on foot, bicycle or horseback. At the time the monastery was founded in 1690 (by the friars of St-Anthony), it was only a hermitage. The complex was closed in 1792 and then reopened in 1826 by the monks of the Trappist Order who erected the present building in 1847. In 1880 and 1901 the monks were forced to leave due to the temporary suppression of all religious orders, however, they never completely abandoned the abbey. A handsome stone structure defined by scores of Gothic-style windows, the church has a fine vaulted nave and apse.

During WWI the monastery was used as a hospital and occupied by the army. The complex was finally restored in 1950. The main activity of the friars is the production of cheese. It is sold in their shop along with several other monastic products, books and CDs. The Centre Charles Grimmick, located inside the complex, displays videos and books on the life of the monks.

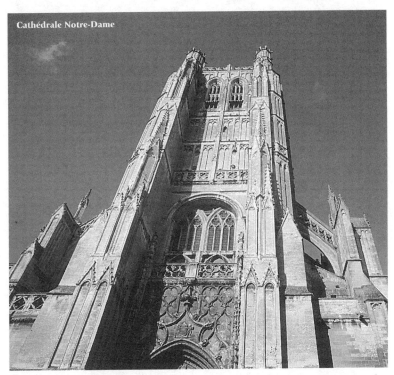

Cathédrale Notre-Dame

Just west of the abbey is the town of St-Omer. The city grew around a monastery founded in the 7th century by the namesake saint, (the ruins of the monastery can still be seen). Following a rich medieval period St-Omer became part of France in 1678 and is enclosed by robust fortifications constructed by the military engineer Vauban. Its heritage is reflected in houses and façades dating from the 18th century. A stroll through the narrow streets yields unexpected surprises including the Cathédrale Notre-Dame. Musée Henri Dupuis houses an original assemblage of

25,000 minerals and shells as well as a Flemish kitchen featuring kitchen furniture and objects from the 17th and 18th centuries. Additionally, there are hundreds of ceramic pieces and paintings that formerly belonged to Monsieur Dupuis.

Côte d'Opale

North of the abbey is the Côte d'Opale with over a hundred miles of fine sandy beaches rimmed with dunes, forests and vertiginous cliffs. There are two cape sites with views over the Channel and the North Sea to the chalk-clad cliffs of Great Britain. Numerous towns and villages dot the coastline.

Malo-les-Bains is a seaside resort characterized by an unusual blend of styles including Swiss chalets, Chinese pagodas, Norman-style thatched cottages and Gothic mansions. Nearby Gravelines is a small seaside town that also boasts fortifications by Vauban. The small village of Wissant has managed to retain its archetypical fishing village personality. Fishermen are proud of their flotilla of fishing boats known as flobarts. A festival involving the boats is held every year in August. Continuing along the coast, Boulogne-sur-Mer prides itself on art, history and the sea. A lively town, its pedestrian precincts are lined with shops and cafes.

Cobbled streets meander through the old quarter that is partly enclosed by ancient ramparts. Château Musée presents a rich collection that includes the finest Eskimo masks in Europe in addition to ancient Greek vases and many works from Egyptian antiquity and Gallo-Roman times.

East and south of the monastery, the interior part of the region is home to a smattering of towns and villages including Lille. Chief city of the département of Flanders, Lille was one of the residences of the 16th century dukes of Burgundy and the capital of French Flanders. Among its principal buildings are the huge citadel, one of Vauban's finest works, the ancient stock exchange and several churches. In the restored Vieux Lille, cobblestone streets beckon visitors to stroll past Flemish façades and admire shop windows topped with traditional shop signs.

Lille's Musée de Beaux Arts maintains a fine art collection, second only to Paris. The superb assemblage includes many of the best works of the Flemish, Dutch, French and Spanish masters. Displays are presented in sections: scale models of towns, French sculpture, Middle Ages and Renaissance. An interesting event is the Braderie de Lille that takes place the first Saturday and Sunday in September. During the event amateur vendors known as bradeux set up their stands over several kilometers of the city's streets.

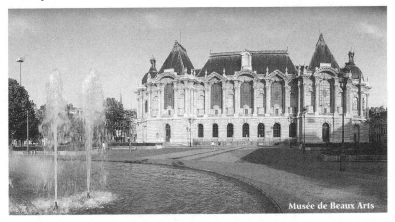

Musée de Beaux Arts

320

Region: North-Calais City: Godewaersvelde

Accommodations
40 beds in single and double rooms, baths are shared.

Amenities
Towels and linens are provided on request.

Cost per person/per night
To be determined when reservations are made.

Meals
All meals are provided with the lodging.

Products of the institution
The main activity of the friars is the production of cheese which is sold in their shop along with several other monastic products, books and CDs.

Special rules
Curfew at 8 PM. Closed in January. Guests are usually required to help with clean up after meals.

Directions
By car: From Lille take A25 north, exit at #10 "Météren" and take D18 to Godewaersvelde.
By train: Get off at Hazebrouck and take a bus to Godewaersvelde (two departures a day).

Contact
Frère Hôtelier
Abbaye Sainte-Marie du Mont-des-Cats
2470 Route du Mont-des-Cats
59270 Godewaersvelde
France
Tel: 0033 (0)3 28 43 83 63 (Hôtellerie 9-12 AM and 3-5 PM)
Tel: 0033 (0)3 28 43 83 60 (Abbey)
Fax: 0033 (0)3 28 43 83 64 (Hôtellerie)
Fax: 0033 (0)3 28 43 83 61 (Abbey)
Email: econome@abbaye-montdescats.com or hotellerie@abbaye-mont-descats.com
Website: www.abbaye-montdescats.com

PARIS
ISLE-OF-FRANCE

FOYER SAINT-JEAN EUDES
Eudistes Fathers

Built in 1968 the guest house is quartered on the left bank in a peaceful section of Paris and surrounded by its own garden. It is a lovely place to stay for a relaxing holiday and is easily accessed by the Metro and the RER.

Very close to the foyer, Jardin du Luxembourg is a composition of sixty acres of chestnut groves, formal terraces, fountains, flower beds, sculptures, apiaries, cafes, carousels, concert pavilions and chess tables. The Palais du Luxembourg and the gardens are the crown jewels of St-Germain-des-Prés. The historic abbey and church of St-Germain-des-Prés was founded in the 6th century by Childebert I. Several Merovingian kings were buried there. The present church is Romanesque in style and dates from the 11th century.

Capital of France, the name of the city comes from a Gallic tribe, the Parisis, who inhabited the region at the time of the Roman conquest in 52 BC. Considered one of the most romantic cities in the world, Paris' parks and gardens serve as emerald links stringing together the city's mystic charms. The 17th century Jardin des Tuileries was the first park to make outdoor strolling fashionable. Geometric in form, few other public gardens offer as much.

George Eugène Haussmann, Paris' foremost city planner, was distinguished by his bold alterations under Napoleon III and is largely responsible for the city's present appearance. Under his direction many civil engineering projects were instituted; existing boulevards were widened and new ones cut; railroad stations were placed in a circle outside the old city and provided with broad approaches; open spaces and vistas were conceived enhancing monuments such as the place de l'Opéra, place de l'Etoile and place de la Nation. During Haussmann's tenure, the famous Bois de Boulogne was also laid out.

Paris is an artistic city filled with churches, museums and monuments. Neatly divided by the Seine, the following overviews the highlights of the right bank.

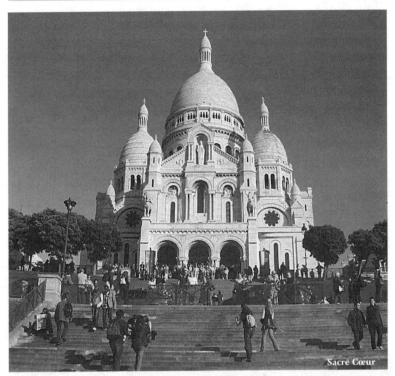

Sacré Cœur

Montmartre (hill of the martyrs) is the highest point in Paris and is crowned by the neo-Romanesque Sacré Cœur. Legend holds that St-Denis, first bishop of Paris, was martyred on Montmartre and it was on the hill in 1534, that Ignatius Loyola and seven companions took the vows that led to the creation of the Jesuit Order. Parts of the ancient quarter were long a favorite residence of the bohemian world. Until the 20th century Montmartre retained an almost rural quality that attracted painters like Van Gogh, Pissarro and Utrillo.

One of the largest and most famous museums in the world, the vast Palais du Louvre was founded by Phillippe II in 1190 as a fortress to defend Paris against Viking attacks. The most recent significant modification of the Louvre was the "Grand Louvre" project under President Francois Mitterrand. At that time the metal and glass pyramid, designed by architect I.M. Pei, was erected at the center of the palace. Among its thousands of priceless paintings, the *Mona Lisa* is perhaps the most

famous. The Louvre is renowned for its enormous collection of Greek, Roman and Egyptian antiquities and for its exquisite old masters, a collection particularly rich in works by Rembrandt, Rubens, Titian, Poussin and da Vinci. Among the well-known sculptures are the *Winged Victory* and *Venus de Milo*. The collection of Baron Edmond de Rothschild, given to the Louvre in 1935, fills an entire exhibition room and contains more than 40,000 engravings, nearly 3,000 drawings and 500 illustrated books. Besides art, the museum sustains exhibits encompassing archeology, history and architecture.

On an elevation at the end of the Champs Elysées, the imposing Arc de Triomphe stands over 165' tall and is 150' wide. It was commissioned in 1806 after the victory at Austerlitz by Napoleon Bonaparte and was finally completed in the reign of King Louis-Philippe in 1833-36. In the attic above the sculptured frieze of soldiers are thirty shields engraved with the names of major revolutionary and Napoleonic military victories. Place de l'Etoile, extensively redesigned by Baron Haussmann, increased

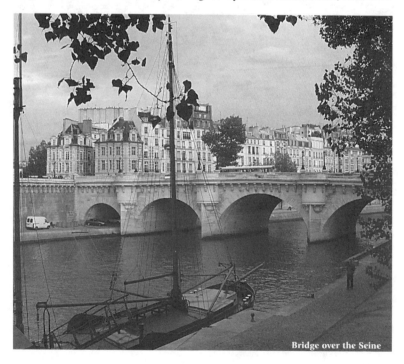

Bridge over the Seine

the number of avenues radiating from the star to twelve. Surrounding the Arc, Haussmann imposed a uniform design on the house facades and added small gardens at the rear. The uniformity complements the Arc's monumental presence. Beneath the Arc is the Tomb of the Unknown Soldier from WWI. It has the first eternal flame lit since the Vestal Virgins' fire was extinguished in the year 391 AD. It continues to burn in memory of the dead who were never identified during both world wars.

Opera Garnier roof

Often likened to a giant wedding cake, the Opera Garnier was built on orders of Napoleon III as part of the great Parisian reconstruction project. Work began in 1857 and was finished in 1874. One of the largest and most sumptuous theaters in the world, the undertaking was decided by a competition won by Charles Garnier, a then unknown 35-year old architect. The landmark building is renowned for its grand staircase, constructed of white Carrara marble and dominated by an immense chandelier. On its façade is *The Dance*, by sculptor J.B. Carpeaux. Work was interrupted by numerous incidents including the Franco-Prussian War, the fall of the Empire and the Paris Commune. Another problem was the discovery of an underground lake beneath the site. The lake later inspired the lair in *Phantom of the Opera.*

In the Marais, place des Vosges is Paris' oldest square. Built by Henry IV in 1612, it is a true square and was the prototype for all the residential squares of European cities that were to follow. Defined by its symmetrical structures, the house fronts were all built to the same design: red brick and gray slate with strips of stone quoins over vaulted arcades that stand on square pillars. It remains a perfect ensemble of 17th century architecture. Many of the Marais' private mansions have been restored including the Hôtel Sale, home to the Musée Picasso. Displayed in chronological order, the museum traces Picasso's work from his earliest years. The unique collection contains examples from his Blue, Pink and Cubist Periods. The new Musée d'Art et d'Histoire du Judaisme is in the Hôtel de St-Aignan. Within the space, architects have managed to integrate 21st

century dynamics into the 17th century mansion which displays art and artifacts dating back to the Middle Ages. Hôtel de Rohan-Guemenée is where Victor Hugo lived from 1832 to 1848. The museum covers the three major stages of the writer's life.

Paris' most famous Jewish neighborhood is in the Marais and is known as the *Pletzl* – Yiddish for "little place." A fashionable quarter, visitors will find Jewish restaurants, bookshops, boulangeries and charcuteries, along with synagogues and *shtiebels*, small prayer rooms. Throughout the area commemorative plaques on buildings serve as reminders of darker times, particularly those of WWII, when people were deported and never returned. The Agudath Ha Kehilot, an orthodox synagogue, is the largest in the Pletzl. Opened in 1914 it was designed by Hector Guimard, the art nouveau architect famous for the green archways of the Paris Metro. Guimard's American wife was Jewish so with the rise of Nazism they left France for the United States. On Yom Kippur 1940 the Germans dynamited the synagogue. It has since been restored and is now a national monument. On the wall of the Jewish boys school at 6, rue des Hospitalieres-St-Gervais is a plaque commemorating the teachers and students deported to Auschwitz and killed in the transit camp at Drancy.

The following covers a sampling of the left bank:

Constructed for the Universal Exhibition of 1899 the Eiffel Tower is a metallic edifice built on the Champ de Mars. Symbol of Paris, it is the city's most famous landmark. At the time it was built it was the tallest construction in the world and it remained so until 1930 when the Chrysler Building in New York was completed. Named after its designer, engineer Gustave Eiffel, the tower was initially met with resistance from the public but today it is widely considered to be one of the most

Eiffel Tower

striking pieces of architectural art in the world. When Adolf Hitler visited occupied Paris in 1940 the French cut the lift cables so that Hitler would have to climb the 1,665 steps to the summit (he chose not to). The part needed to repair the cables was allegedly impossible to obtain because of the war, however, within hours of the Nazi departure it was working once again.

Representing the finest early neoclassical design, the domed Panthéon was built as a church dedicated to Ste-Geneviève. King Louis XV vowed that if he recovered from an illness he would replace the ruined church with an edifice worthy of the patron saint of Paris. It was secularized under the French Revolution and became the Panthéon; its façade modeled on the Pantheon in Rome. The overall design is a Greek cross with a massive portico of Corinthian columns. The vast building is 360' long by 275' wide and 275' high. Over the years it served many purposes but today it is a temple to the great men of France, from Voltaire to Dumas.

Montparnasse is still haunted by the spirit of the Expressionists – Modigliani, Picasso, Stravinsky and Cocteau. Along the wide boulevard du Montparnasse, the cafes favored by this group in the 1930s have passed into permanent folklore of the city. The quarter contains the Pasteur Institute, the ancient catacombs and the Montparnasse cemetery. In the 3rd century it was the center of a Gallo-Roman town of 6,000. The vast catacombs and baths remain from the Roman period. There is even a Roman arena, Arènes de Lucece, partially destroyed by barbarians in 280 AD and now used for picnics and pageants.

The historical heart of Paris is the Ile de la Cité, a small island largely occupied by the grand Palais de Justice, Ste-Chapelle and the Cathédrale de Notre-Dame. It's connected with the smaller Ile St-Louis, a residential tree-lined quay that showcases elegant 17th and 18th century houses.

Ste-Chapelle is a Gothic masterpiece completed in 1246. Louis IX was its patron and the structure served as a chapel for the royal palace. The palace itself has since disappeared leaving Ste-Chapelle almost entirely surrounded by the Palais de Justice. The chapel shelters precious relics including Christ's Crown of Thorns and fragments of the True Cross. The most visually beautiful aspects of the structure are the stained glass and rose windows. The windows depict more than 1,000 biblical scenes in a spectrum of colors.

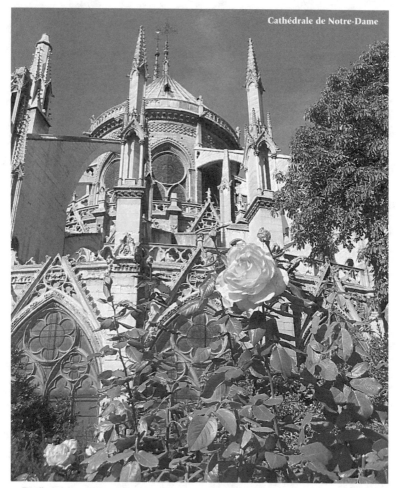

Cathédrale de Notre-Dame

Defined by flying buttresses, the Cathédrale de Notre-Dame is widely considered the finest example of French Gothic architecture. Built on the site of a Roman temple, the western façade is the church's single most recognizable feature. The south tower houses the cathedral's famous bell, "Emmanuel," Notre-Dame's oldest bell recast in 1631. The grand gallery connects the two towers and is where the legendary gargoyles can be seen. Many elements of the stained glass windows date back to the 13th century construction of the cathedral.

Surprisingly, the cathedral, a singular embodiment of French Catholicism also holds some interest for Jews. In tall niches on either side of the central portal are two female figures: Ecclesia and Synagoga. Ecclesia, wearing a crown, represents the Roman Catholic Church; while Synagoga with a bowed head, shattered staff, the broken tablets of the *Ten Commandments* at her feet and a serpent around her eyes, represents Judaism. Variations of these two figures are common in church architecture throughout Europe.

The King's Gallery is a line of statues of the twenty-eight Kings of Judah and Israel which was reassigned by the famous architect Viollet-le-Duc to replace the statues destroyed during the French Revolution. The revolutionaries believed the statues represented the French kings and decapitated them. The rose windows are notable for being among the few stained glass windows in the cathedral that sustain their original glasswork. The design of the pulpit and placement of the original central spire were also the work of Viollet-le-Duc. He was the most prominent exponent of Gothic revival in France and was celebrated for his restoration of historic French monuments.

The exhibits of the Musée d'Orsay represent mainly French art from 1848 to 1914: paintings, sculptures, furniture, objets d'art and photography. Originally a railway station built in 1900 by Victor Laloux, it was known as Gare d'Orsay. The building was listed as a historic monument in 1978 and re-opened as a museum in December 1986. Included among its masters are Cézanne, Courbet, Degas, Monet, Whistler, Manet, Renoir, Rodin and Van Gogh.

Tying it all together, old sights and new, is the Seine. The tree-lined quays along the river are an integral part of Paris. They are famous for their open-air bookstalls and for the historic boulevards that replaced the ancient city walls. To Parisians the river is a leading character in their daily lives. The average Parisian probably crosses one of its thirty-six bridges at least once a day. Over the centuries Paris has been shaped around the 7.6 mile crescent of the Seine. The Pont-Neuf, contrary to its literal definition, is actually the oldest bridge in Paris. Built in 1578 its graceful stone arches cross Ile de la Cité, the island where the city was founded. The new Passerelle Solferino footbridge provides a pedestrian link between Jardins des Tuileries and Musée d'Orsay.

Region: Paris-Isle-of-France **City: Paris**

Paris

Accommodations

In July and August: 42 single and double rooms with sink and shower; toilets are outside the room on each floor. During the academic season, priority is given to students and only some of the rooms are available for other guests.

Amenities

Towels and linens are supplied. Private garden, meeting rooms, parking space available.

Cost per person/per night

Provisional cost is 31.00€ including breakfast.

Meals

Only breakfast is provided with the lodging and it is always included.

Special rules

Silence is required from 10.30 PM to 7:00 AM. Guests can come and go as they please. A key is provided.

Directions

By train: Take Metro ligne 6 and get off at Glacière or St-Jacques.
By plane: From Orly take the Orly bus and get off at St-Jacques; from Charles de Gaulle take the RER B direction Antony and get off at Denfert-Rocherau.

Contact

Anyone who answers the phone
Foyer Saint-Jean Eudes
1, rue Jean Dolent
75014 Paris
France
Tel: 0033 (0)1 44 08 70 00
Fax: 0033 (0)1 43 36 72 03
Email: foyer-saint-jean-eudes@wanadoo.fr

CENTRE DU DIALOGUE
Pallottin Fathers

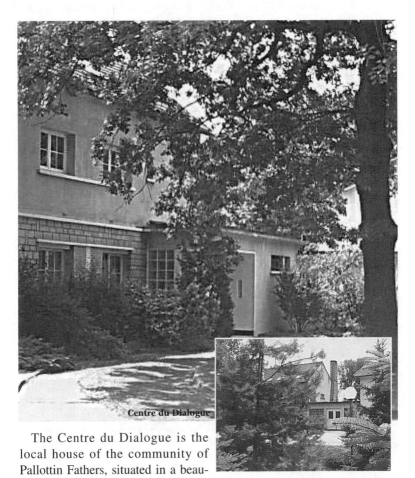

Centre du Dialogue

The Centre du Dialogue is the local house of the community of Pallottin Fathers, situated in a beautiful position amidst a verdant forest. At an altitude of 675', the center is blessed with a magnificent panorama of Paris, twelve miles away. The house was once a private villa that was bought in 1985 and converted into a guest house and conference center.

The Pallottin Fathers belong to the Italian order founded by St-Vincent Pallotti. Born in Rome in 1795 he established the Union of the Catholic Apostolate in 1835. He believed that every Christian had a mission for the church and the world and that the bishops, priests and the devout could not assume sole responsibility for evangelization. He believed that lay people had the obligation and the right to actively participate in the mission of the church. His concept and philosophy were new at the time. In order to implement his beliefs, Pallotti founded the Union of Catholic Apostolate. He died in January 1850 but his communities are now located worldwide.

Montmorency, a small market town once enclosed by walls, was a desirable holiday destination as early as the 15th century. Capital of the Duchy of Montmorency, one of its most impressive sights is the Collégiale St-Martin. Constructed in four stages that stretched over five centuries, the structure preserves lovely stained glass windows. Château de Dino, an unusual Renaissance-inspired edifice, was built at the end of the 19th century. Musée Jean-Jacques Rousseau is in the house where the philosopher lived from 1756 until his exile to Switzerland in 1762. The estate belonged to his friend, Mme d'Epinay and was where he wrote some of his major works.

Quite close to Montmorency is Enghien-les-Bains, inherited by Marie of Luxembourg in 1526. The water's sulphurous healing properties gave rise to its popularity, the only thermal spa town in Ile-de-France. The center is huddled around the lake, the shore of which is home to a theater and casino. Place de Verdun is the site of the bustling covered market that takes place every Tuesday, Thursday and Saturday morning. The Villa Ste-Jeanne was the first example of what was to become the Enghien-style of architecture, it highlights a pinnacled roof showcased by pedimented skylights.

The wide ring around Paris was once a greenbelt of farms and forests that fed the crowded, walled city and provided diversions for its wealthiest and most regal inhabitants. In the not too distant past, carriages clattered along the spoke-roads leading through the gates of Paris and into Ile-de-France, a landscape of chalky plains and wheat fields, of centuries-old châteaux, walled gardens, swan-flecked ponds and twisting country roads. Synonymous with escape from the stress of court or city life, the pastoral countryside was a magnet luring kings to their hunting lodges,

writers to peaceful retreats and artists to sources of inspiration. Gardens became representative of the essence of country life, especially those designed by André Le Notre, France's most esteemed garden architect. His designs featured embroidered *parterres* (ornamental gardens in which the flowerbeds and paths form a pattern), precisely clipped topiary and mirror-like reflecting pools.

The rivers and canals were once France's main trade routes and nearby Conflans-Ste-Honorine, was perfectly positioned to take advantage of the shipping boom of the 19th century. The lively town is still a riverboat center with barges moored along its quays. In the former Château Gevelot, the Musée de la Batellerie commemorates centuries of boats, builders and boatmen.

Auvers-sur-Oise was a favorite destination of many 19th century painters, among them Camille, Pissarro and Cézanne. Auvers is best explored on foot. From the house and garden of Charles-Francois Daubigny, the first painter to settle in Auvers, it's an easy walk to the Musée de l'absinthe. The small space is dedicated to the potent and often deadly drink that became a symbol of the era before it was outlawed in the early 20th century.

Van Gogh

Auvers is best known as the last home of Vincent Van Gogh. The Maison du docteur Gachet is where he stayed for the ten weeks prior to his death and is a place of great importance in the history of art. The town hall, church and wheat fields remain much as Van Gogh painted them. The artist and his brother are buried in the town's small cemetery. Château d'Auvers has an interactive exhibition where visitors can journey back to the time of the Impressionists. This famous artistic movement and the great painters who espoused it come to life in historical and artistic presentations.

The Cistercian Abbaye Notre-Dame du Val is in nearby Mériel. Built around 1220, it is possible to visit the sacristy, chapter room, parlor and monk's wing. Musée Jean Gabin relates the public and personal life of the most famous resident of Mériel. (Gabin's 40-year career as a leading star has made him a national institution in France.)

Asnières-sur-Oise is home to the Cistercian Abbaye de Royaumont, sister abbey of Notre-Dame du Val and an important cultural center. Founded by King Louis IX in 1228, and in whose church he was married in 1234, the abbey is nestled in a woodsy setting. The cloisters, kitchens, refectory and lay brothers' wing remain as testimony to the architectural mastery of that time. The double nave of the church is divided by a line of pillars. The ruins of the imposing church provide insight into its once grand proportions.

Montmorency is close to a number of royal towns. To escape the court at Versailles, Louis XIV would often set out on weekends to Marly-le-Roi, one of the seven royal cities of Ile-de-France. The town has existed since the 7th century although it didn't become a royal favorite until Louis XIV built a country retreat in the small village. Once a popular hunting preserve, the royal park is complete with ponds and statuary. Musée Promenade houses a collection of paintings, sculptures and models. One room contains a replica of a legendary machine comprised of thirteen huge wheels that pumped water uphill from the Seine to the Cascade and later to Versailles. In Port Marly, the Château de Monte-

Marly-le-Roi

Cristo is surrounded by gardens executed in the English style. After the huge success of *The Count of Monte Cristo,* Alexandre Dumas had the château built. The neo-Gothic tower, dubbed Château d'If after Monte Cristo's prison, is a fairy tale fantasy.

Birthplace of King Louis XVI, St-Germain-en-Laye was a favorite of countless French kings. The town cherishes the ancient heritage of its royal families as represented by the 17th and 18th century mansions that line the streets and the Renaissance château built by Francois I. Louis VI erected the first castle on the site of a convent dedicated to St-Germain. It was Louis XIV, however, who left behind the greatest legacy - the gardens and magnificent Grande Terrasse. The gardens are enhanced by a mile and a half promenade fringed with lime trees and a panorama of distant Paris and the valley of the Seine. The château is now the Musée des

Antiquités Nationales and was established by Napoleon III during his restoration of the château. Its seventeen rooms contain important archeological collections including the earliest known carving of a human face, the 20,000-year old, thumb-sized *Dame de Brassempouy*.

Versailles

Versailles is the most extravagant of the royal towns. Three centuries ago, the Palace of Versailles was created in its entirety by the express will of Louis XIV. It remains an historical and artistic treasure representing French classical style at its zenith. The famous château is encompassed by luxurious gardens covering over 1,976 acres designed by André Le Notre. Le Notre was considered a master gardener for his classically formal designs and his influence on European horticulture. His artful orchestration of nature can be seen in the garden's play of light and shadow. The woodsy groves, called bosques, were used for flirtation and game playing during the time of royalty.

Versailles

The Palace of Versailles was created by the combined genius of architect Louis Le Vau, J.H. Mansart and Charles Le Brun. Le Vau opened up the interior court to create the expansive entrance *cour d'honneur*, an architectural element later copied throughout Europe. The Petit Trianon dates from the time of Louis XV and was his gift to Marie-Antoinette. The hamlet, a group of thatched houses, was created by the queen's favorite architect, Richard Mique. The pastoral setting promoted and gave countenance to the simple lifestyle that Marie-Antoinette tried to share with her children and friends. The Grand Trianon is a single story palace of stone and pink marble built in 1687.

The Hall of Mirrors is an immense room generally considered one of the major attractions of the palace. Begun in 1678 at the time it was the official residence of Louis XIV, many references to the gallery can be found in Marie Antoinette's diary.

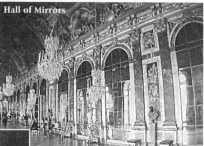
Hall of Mirrors

At the high point of his reign, Louis ordered Le Brun to paint the benefits of his government on the ceiling.

The painter conceived thirty scenes framed with stucco: the king appears as a Roman Emperor, as great administrator of his kingdom and as victorious over foreign powers. The gallery contains nearly six hundred mirrors. Seventeen high-arched windows, opening onto the gardens, face seventeen arcades lined with mirrors. The mirrors were of an exceptional size for the time and cost an exorbitant amount of money. They were created to compete with the products of Venice. The hall is lavishly embellished with crystal chandeliers. It was in this hall that the German Empire was proclaimed following the defeat of France in the Franco-Prussian War. Ironically, it was also where Germany signed the Treaty of Versailles in 1919 accepting responsibility for WWI.

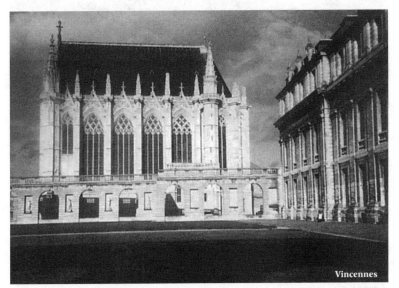

Vincennes

On the eastern edge of Paris, Vincennes is another royal town that has maintained a countryside charm and a remarkable quality of life. For six centuries the Château de Vincennes was the very embodiment of royal power and in that regard has preserved many reminders of France's heritage. The medieval complex remains one of the greatest fortresses in Europe and the only surviving residence of a medieval monarch in France. It claims a 14th century tower keep and a 13th century chapel with a mammoth bell cast for Charles V in 1369. A walk along its ramparts or in the former moat conveys a vivid sense of medieval life.

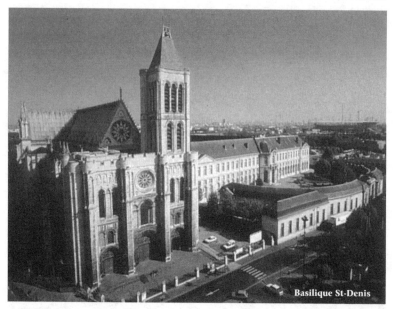

Basilique St-Denis

St-Denis is a city of art on the northern outskirts of Paris. Its history can be traced back 2,000 years. Begun in 1136 the majestic Basilique St-Denis was the precursor of the great cathedrals of Notre-Dame and Chartres and is one of the most important Gothic basilicas in France. It contains the tombs of Henri II and Catherine de Medicis, Louis XVI and Marie Antoinette and nearly seventy tombs and funerary statues from Dagobert to Louis XVIII.

Accommodations
45 beds in rooms with 2 to 4 beds; all rooms have a private bath.

Amenities
Towels and linens are supplied. Meeting rooms are available at an extra charge.

Cost per person/per night
Lodging only 16.00€.

Meals
All meals can be provided with the lodging.
Breakfast 5.00€, lunch/dinner 10.00€.
There is also a kitchen that guests may use for a daily charge of 50.00€.

Special rules
Only groups of 25 are hosted in the house. It is sometimes possible to arrange accommodations for a smaller group if the guest house is not entirely occupied.

Directions
By car: Take N311 to Montmorency or take A1 and exit at "Gonesse-Sarcelles." From there take D125 and then N1 to Montmorency. Once in Montmorency take D144 towards Domont. The center is near the church of St-François d'Assise (detailed map on the website).
By train: Get off at Enghien-les-Bains and take bus #13 or 15M to the stop "Les Champeaux," a short walk from the center.

Contact
Père Hôtelier
Centre du Dialogue
34, Chemin de Bois Briffaults
95160 Montmorency
France
Tel: 0033 (0)1 39 89 32 96
Fax: 0033 (0)1 34 12 02 08
Email: centredialogue@libertysurf.fr
Website: www.centrumdialogu.org

NOTES

PAYS-DE-LA-LOIRE

MAISON DIOCÉSAINE
Property of the Diocese of Angers

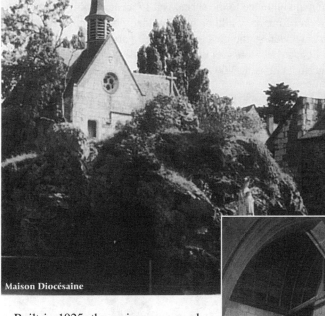

Maison Diocésaine

Built in 1925, the maison was used as a school for a number of years until it was converted into a guest house. It offers hospitality to individuals, groups and families visiting the area, to those seeking spiritual retreats or pilgrims visiting the 15th century Marian Shrine of Notre-Dame de Béhuard.

The tiny picturesque village of Béhuard sits mid-stream on a rock cluster of an island. The village traces its origins to the 5th century and is tied to the story of the shrine. At that time the bishop of Angers erected a statue of the Virgin Mary to honor the nativity. Built on the island's volcanic rock in the 11th century, it became the property of the knight Béhuard who had received it from the Count of Anjou as a token for his services. Béhuard erected his own residence there with a mill, oratory and several other buildings. In the 15th century King Louis XI fulfilled his vow and had a shrine built on the rock.

Inside the main entrance to the shrine is a 15th century polychrome statue of the Virgin lifting the Child on her shoulder. The church also shelters a 16th century wooden statue covered with rich garments. The Cloche de la Paix was donated by Louis XI in 1472 with the proviso that the bell be rung for peace every day at 8:00 AM.

Château d'Angers

Nearby Angers became the seat of the powerful Counts of Anjou and the historic capital of the province. One of the counts, Henri Plantagenêt, married Eleanor of Aquitaine and later became King of England. The 13th century castle with its stout stone walls looks as formidable today as it did when it was built in the Middle Ages. The walls are over half a mile long and studded with seventeen black shist turrets. Among the best defended fortresses of St-Louis' kingdom, the massive dark stone castle imprints the town and offers stunning views over the river Maine. One of the finest

examples of feudal architecture of the Loire valley, it was a key defense in 1230. The interior gardens are a reminder that the castle is in the Loire valley where the traditional French garden was born. A treasure of Renaissance dwellings lie within the interior courtyard where a special room has been reserved for the *Apocalypse Tapestry*, a work of biblical proportions and the jewel of the fortress-like château. Woven in 1375 the medieval masterpiece features seventy-five scenes from the Apocalypse and is the largest medieval tapestry in the world, measuring 351' in length by 14.75' high. Before it was restored, pieces of it were actually used as cleaning rags. During the 14th and 15th centuries the castle held the court of the powerful Dukes of Anjou including the brilliant court of King René.

Ancient Angers abounds in lovely houses. In the center of the historic quarter, not far from the castle, is the Cathédral St-Maurice, a unique configuration of Gothic-Renaissance design. The stained glass windows date from the 12th to 16th century. In the nearby Musée David d'Angers are

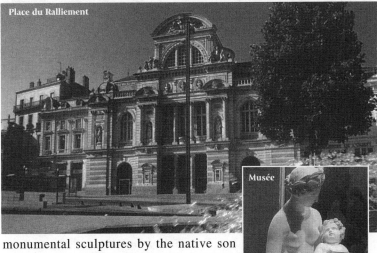
Place du Ralliement

Musée

monumental sculptures by the native son sculptor. Place du Ralliement is home to many outdoor cafes as well as the Musée Cointreau where the famous orange liqueur is distilled in huge copper vats, its aroma permeating the air. Angers also has a great number of wineries where tastings are offered.

Main town of the Gallic tribe of the Namnettes, Nantes became an important center under the Romans. Capital of the region, the city is famous for its maritime traditions, fine homes, museums and chic shopping. The medieval Juiverie and Bouffay districts around the 15th century

Nantes

cathedral and castle of the Dukes of Brittany are inviting, pedestrian-only lanes and alleys fringed with ancient structures. Today Nantes is a lively university town of immense variety with new buildings overlooking the port, canals and art nouveau squares.

Cathédral St-Pierre was founded in 1434 but took centuries to complete. It is notable for its sculpted Gothic portals and Renaissance tomb of Francois II, last duke of Brittany. It houses the Renaissance tomb of Francois II and his wife, Marguerite de Foix. In ancient times, the Loire lapped at the walls of the Château des Ducs de Bretagne. Chosen as the seat of the Breton court in the 15th century, the building is a place of historic significance. Anne, Duchess of Brittany, was born in the château; it is also where Henry IV signed the Edict of Nantes in 1598 granting freedom of worship throughout France. With its granite towers and walls, the castle remains an impressive monument. Musée des Salorges resides within one wing and overviews the city's colonial links in the 18th and 19th centuries and provides insight into Nantes' slave trading practices.

Musée des Beaux Arts is renowned for its fine French collection of paintings. Artists include Rubens, Tintoretto, Georges de la Tour, Monet and Ingres as well Picasso and Kandinsky. Native son Jules Verne is represented in a namesake museum that preserves documents, posters and first editions connected with the science fiction novelist.

The Jewish community of Nantes traces its history to the middle of the 13th century and the rue des Juifs. Portuguese Conversos, Jews who had converted outwardly to Christianity but who practiced Judaism in secret, settled in Nantes in the mid-16th century. The synagogue was built in 1870; visits can be arranged by appointment.

About ten miles from Nantes is the small town of Clisson. Devastated during the Vendée Wars, it was rebuilt in Italian style and its red-tiled roofs, brick bell towers, arches and umbrella pines resemble Tuscany more than the Loire valley. A romantic ruined castle sits on a rocky point overlooking the town and the Sèvre river. The covered market and the Italianate gardens enhance the setting.

Between Angers and Nantes is the delightful town of Ancenis where ancient houses rise in tiers above the river. There are relics of a castle including a Renaissance wing with an overhanging tower.

Clisson

A worthwhile excursion can be made from Béhuard to the Vendée coast and the island of Noirmoutier. A long peninsula jutting out into the Atlantic, the island's coastline is partly rocky and partly sandy with thirty miles of beaches. It is sometimes called "Little Holland" because much of the island is below sea level. Since 1971 it has been linked via a bridge to the mainland. Before that, the 17th century Gois causeway, exposed at low tide, was the only way reach Noirmoutier. About 2.5 miles long, the passage du Gois is definitely a curiosity to be experienced when the tide is out. The landscape of the island is an attractive mix of dykes and wind-mills, woods and mimosa, fishing villages and bobbing boats.

Southeast of the maison is the beguiling town of Saumur. Among the most beautiful in the Loire valley, it is fashioned out of the chalky tufa stone typical of the region. Saumur's fairy tale white limestone castle perches atop the town and houses one of the famous miniatures in the *Book of Hours* (painted for the Duke of Berry). Once a luxurious resi-dence of the Dukes of Anjou in the Middle Ages and a bastion of Protestantism in the 17th century, the turreted castle overlooks the river and seems to stand guard over the old town.

Nicknamed the "white town," most of Saumur's architecture reflects its stone foundations but there are a number of restored half-timbered houses as well. An outstanding monument is the Romanesque Church of Notre-Dame de Nantilly, ca. 12th century. The city is also France's mili-tary and equestrian center. For nearly two centuries the cavaliers of the Cadre Noir have been the pride of the city which is also home to the Ecole Nationale d'Equitation, stabled in nearby St-Hilaire-St-Florent.

Saumur supplies France with 65% of its mushrooms. Beneath the city mushrooms grow in caves carved out of the limestone rock. Tours of the underground caves are available. Renowned for its sparkling, Champagne-style white wines, even the underlying *tuffeau* (limestone) is similar to the Champagne area. For nearly two centuries winemakers have used traditional natural methods to make their wines which are matured in the network of cool cellars deep in the limestone cliffs. The wine cellars provide tastings of the famous Saumur Champigny, Crémant de Loire and the regal dry Saumur Brut. The town has also achieved prominence for its religious-medal industry, in existence since the 17th century.

Just south of Saumur and extending over nearly thirty-seven acres, the Royal Abbey of Fontevraud is the largest surviving complex of monastic architecture in Europe and once a key spiritual and cultural center of the western world. A mixed order headed by an abbess, the complex is the best-preserved medieval abbey in France. Founded by Robert d'Arbrissel in 1101 the abbey's protectors were the Counts of Anjou, followed by their descendants, the Plantagenêt Kings of

Abbaye de Fontevraud

England. Of the five abbeys, three still exist. The English Plantagenêt Kings chose Fontevraud as their burial sites. Polychrome recumbent effigies of Henry II of England, Eleanor of Aquitaine, their son Richard Lion-Heart and Isabel of Angoulême are preserved in the abbey church. Especially interesting are the large Renaissance cloisters, the Romanesque abbey church and the peculiar medieval kitchens whose towers are topped by pepper-pot chimneys.

A little further south, the town of Montreuil-Bellay was built by warlord Foulques Nerra. Set high on a rock in a terraced milieu, it is one of the last enclosed medieval villages in the Anjou region and is symbolized by a mighty turreted château. More fortress than castle, the edifice is complete with interlocking towers and ramparts and is reached by a bridge over a moat. In town there's a restaurant in a thousand-year old building that serves medieval cuisine based on Anjou *fouée* - warm bread pockets filled with meat and cheese.

Accommodations

10 rooms; 2 doubles and 8 singles. All rooms have a private bath.

Amenities

Towels and linens can be provided at an extra charge of 4.00€ per day.
There is parking, meeting rooms and halls, a TV room, garden and dining
room.

Meals

All meals can be provided with the lodging.
Breakfast 3.00€, lunch 9.00€, dinner 7.00€.

Cost per person/per night

Single room 19.50€ (1 night) to 15.50€ (2 nights or more).
Double room/per person 17.00€ (1 night) to 13.00€ (2 nights or more).

Directions

By car: Take A11 and exit at Angers. From there take N23 and at St-
Georges take the first road on the left at the Chalonnes intersection and
follow the signs to Savennières and the bridge to the island.
By train: 1) Get off at Savennières (SNCF) and walk (1.5 km) or take a
taxi to the maison. Or 2) Get off at Angers (TGV) and take a taxi or bus.
TER stops at Savennières.

Contact

Accueil
Maison Diocésaine
1, rue Notre-Dame
49170 Béhuard
France
Tel: 0033 (0)2 41 72 21 15
Email / Website: http://catholique-angers.cef.fr
(Search for Béhuard and its Maison Diocesaine and click on "contact" to
send a message.)

CENTRE DE L'ETOILE

**Property of the Diocese, managed by Marianistes Sisters
of Sainte-Croix and lay personnel**

Nestled in its own park, the house is a ten-minute walk from the center of Le Mans. A former 19th century monastery, it was converted into a guest house in 1981. The story of the monastery began when an ancient monastery of the Visitation Order was closed and turned into a prison during the French Revolution. Afterwards (in 1820) the sisters were able to rebuild a new monastery on the present location. Theirs was a very active order and more than one hundred sisters inhabited the premises in the ensuing years. In 1979, their declining numbers forced them to leave. The house was then restored and opened to guests for holidays, work-shops, spiritual retreats and meetings.

The chapel of the center preserves two precious paintings: a 17th century retable from the ancient monastery that represents St-Francis of Sales and a painting of the 19th century that depicts a miracle performed by St-Julian, patron saint of Le Mans.

In Le Mans the famous twenty-four hour Grand Prix car race and *rillettes*, a local gastronomic specialty, have made the town famous. Le Mans, however, has managed to preserve its traditions and has one of the loveliest and intact old quarters in France. The city's Gallo-Roman ram-parts, with their striking geo-metric designs, tower over the Sarthe river. Poised gracefully above the ancient ramparts, the medieval town is a favorite with filmmakers. Several movies, including *Cyrano de Bergerac* with Gérard Depardieu, have been filmed in Le Mans.

Rillettes

The atmospheric core of the city is sheltered within the Roman walls. In the shadow of the old cathedral are twisting, cobbled lanes lined with tilting half-timbered houses, ancient mansions with intricate Renaissance stonework, arcaded alleys and tiny courtyards. A wonder of Gothic architecture, the Cathédral St-Julien, tribute to the memory of the Plantagenêt Kings of England, boasts flying buttresses and a Romanesque portal as elegant as that of Chartres. The interior harbors a nave and choir enriched by sculpted capitals and a 12th century stained glass window. Le Mans' synagogue contains a memorial to the deportation of Jewish victims of the Holocaust.

In 2000, the Loire Valley was named as a UNESCO World Heritage Site in recognition of the region's 2,000 years of history. Its pedigree comprises Roman remains, châteaux and manor houses, abbeys and churches, formal gardens and spacious parks. Many of the châteaux are still inhabited, often by families whose ancestors built the structures centuries ago.

One of France's loveliest rivers is the Sarthe. Rising in the hills of the Perche, it weaves its way past the historic city of Le Mans and then meanders through sleepy meadows on its route to Angers. Along the way are some very special places. Malicorne-sur-Sarthe was once a busy river port. For over two centuries it has been famous for its faïence. The town's château has hosted many famous people including Louis XIII, Marie de Medicis and Mme de Sévigné. Asnières-sur-Vegre ranks among the loveliest villages in the Sarthe valley. The village is a beguiling place of shaded banks and 15th and 16th century cottages. Reminders of its illustrious history include a medieval bridge that spans the Vegre and a Norman church with ancient murals dating to the 13th century.

Sable-sur-Sarthe sits on a rock where three rivers meet. Dominated by its 18th century château, a classic example of Louis XIV architecture, the small town seems unchanged since medieval times.

Sable-sur-Sarthe

Bénédictine monks still inhabit the medieval St-Pierre, considered one of the most important in the Christian faith. The interior of the abbey church sustains fine 15th and 16th century sculptures. The abbey is also a major center for Gregorian chant. Visitors are welcome to attend the daily sung mass or vespers at the ritual hours of the day; 10 AM for mass, 5 PM for vespers.

The origins of Gregorian chant can be traced to early Christian times and seem to have derived from musical practice in the Jewish synagogue and Greek musical theory. During the late Middle Ages and the Renaissance, the chant melodies were used as the basis for polyphonic composition. In the 19th century the Bénédictine monks of Solesmes sought to restore the Gregorian chant to its original form and their published editions from 1889 onward became the official music of the Catholic Church. The texts of plainsong are the words of the Mass, the Psalms, canticles and certain verse hymns.

Château Le Lude

Nearby Château Le Lude is a fine example of early French Renaissance architecture. Once a medieval fortress, it was later converted into a comfortable country house. The terrace that runs along the south side overlooks a classic French garden and English-style park.

Accommodations
60 beds in single, double and 6-bed rooms. Baths are shared. The center is open year-round except from mid-July to mid-August.

Amenities
Bed linens are supplied; guests must provide their own towels. Meeting room, private parking, private park, TV and reading room, all accessible to the handicapped. Chapel and oratory are available to guests. There is also a music room with a piano and an outdoor terrace/dining room.

Cost per room/per night

Single 23.00€, double 31.00€, six-bed room: 60.00€.

Meals

All meals can be provided with the lodging except on Friday and
Saturday evenings and all day Sunday. At those times, meals are avail-
able only to groups with advanced reservations.

There are two types of restaurants:

Self-service breakfast 4.20€, lunch/dinner 9.80€.

Restaurant with served meals, for buffets and cocktails by reservation.
Provisional cost per meal 15.00€ to 18.50€.

Directions

By car: Take A11 or A81 and exit at Le Mans center (on the website,
click on "plan d'accès for detailed map).

By train: Get off at Le Mans (SNCF or TGV). From the station take a
taxi or bus #5 to the house and get off at the stop "Etoile."

Contact

Anyone who answers the phone
Centre de l'Etoile
26, rue Albert Maignan
72000 Le Mans
France
Tel: 0033 (0)2 43 54 50 02 (for reservations)
0033 (0)2 43 54 50 00 (for general information)
Fax: 0033 (0)2 43 76 46 31
Email: centre@centre-etoile.com
Website: www.centre-etoile.com

NOTES

CENTRE PASTORAL DU SANCTUAIRE
Property of the Sanctuaire Diocesain de Pontmain

The Centre Pastoral is a guest house annexed to the Sanctuary of Pontmain. The sanctuary and town have a fabled history. In January 1871 the conquering Prussian army was at the gates of Laval, not far from the town of Pontmain. That evening a young boy, Eugène Barbedette, was helping his father crush *gorse* (winter food for horses) in the barn. According to legend, when he went outside to check on the weather he saw a beautiful lady wearing a star-spangled dress. She was looking at him and smiling, arms outstretched and surrounded by a blue oval with four candles. After research and a canonical investigation, the Bishop of Laval deemed that the Virgin Mary had indeed appeared in the hamlet of Pontmain.

At the central crossroads of the present town, the farm buildings where the Barbedette family lived can be seen. The interior of the barn preserves a painting and five statues depicting the various stages of the apparition. Traces of the past include the granite trough and pestles used to crush the gorse.

The parish church has been modified several times and was restored in 1984. Although it does not have any particular style, it reveals a certain charm and its interior imparts an expression of harmony and intimacy. In the 14th century, the church was dedicated to St-Simon and St-Jude whose statues are preserved in the choir.

Founded at the turn of the first millennium, nearby Laval lies at the crossroads of four provinces. This privileged position has encouraged a varied architectural heritage and has earned Laval the title of "Ville d'Art et d'Histoire." Built of dark granite and pale limestone, Laval's medieval streets are contained within fortified walls. Set on the banks of the Mayenne, it was the birthplace of Rousseau and has been noted for its linen products since the 14th century. Grande rue, the town's main thoroughfare, is bordered with Renaissance and half-timbered houses.

Monumental highlights include the churches of Notre-Dame des Cordelliers and Notre-Dame de Pritz. The Pritz Chapel was established in

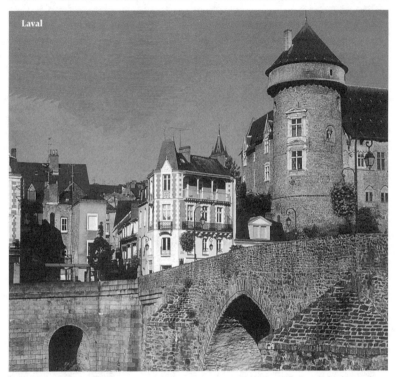

Laval

the 8th century and was the first parish church in Laval. Its paintings date from the 12th century. The medieval castle is now a fine arts museum surrounded by steep, narrow streets that descend abruptly towards the river and the ramparts. Running along the banks of the Mayenne and dominating the cityscape, the Perrine Gardens were created in 1885 and blend French and English garden traditions. Musée d'Art Naif conserves a collection of the greatest international masters of Art Naif painting.

South of Laval are the Gallo-Roman thermal baths at Entrammes. The recently discovered baths owe their astonishing state of conservation to the fact that for centuries the site was concealed by a church. This protection enabled the preservation of some extremely rare vestiges including Roman walls and a row of four linked baths, brick arcades and windows. Also in Entrammes is the Cistercian Abbey of Port-du-Salut. Founded in 1233 it was the first monastery in France to be re-established after the vicissitudes of the French Revolution.

Characteristic of the Cistercian Order, the abbey's design is quite simple. Cistercian ideology places a good deal of emphasis upon water and its relevance in determining placement of a Cistercian structure. As with other monasteries of the order, Port-du-Salut was built near a river with the church facing east.

Not far from Pontmain, the Mayenne is one of the most attractive rivers in the west of France. Wild and unspoiled in its northern stretches, the Mayenne softens when it reaches Laval. The area between Laval and Angers passes through a number of ports and villages. In tiny Grez Neuville, the ambience of a bygone era has been perpetuated in lovingly restored stone houses.

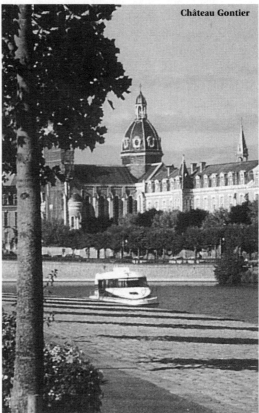

Château Gontier

The village of Segré is defined by pretty lanes, with houses reflecting the legacy of wealth from past iron and slate mining. Chenille-Change is among the most attractive villages on the Mayenne. Its church and some of its houses date to the 11th century. Perhaps, though, the village's most interesting treasure is the 400-year old working water mill. Château Gontier is also a lovely place to explore. The old town is a synthesis of splendid houses and elegant mansions. In the summer months, the former 17th century Ursuline convent is brought to life with music performances.

Accommodations

77 beds in double rooms with shared baths. There are also 20 beds in mini-apartments with bedroom, living room and kitchen available year-round to all guests. Groups are hosted year-round except for one month when the center is closed (the month varies - either November or February). Individuals are hosted from June 15th to September 15th. Reservations must be made well in advance.

Amenities

Towels and linens can be supplied on request at an extra charge of 4.00€. There is parking, a garden, TV and meeting rooms.

Cost per person/per night

Voluntary contribution.

Meals

All meals can be provided on request.

Special rules

Visitors are asked to participate in daily tasks such as setting and clearing the tables.

Directions

By car: Take A84 and exit at Fougères. Take D806 to St-Ellier-du-Maine. From there take D224 to Pontmain.

By train: Get off at Fougères and take a bus or a taxi to Pontmain.

Contact

Anyone who answers the phone
Centre Pastoral du Sanctuaire
3, rue Notre-Dame
53220 Pontmain
France
Tel: 0033 (0)2 43 05 07 26
Fax: 0033 (0)2 43 05 08 25
Email: contact@sanctuaire-pontmain.com
Website: www.sanctuaire-pontmain.com

POITOU-CHARENTES

ABBAYE DE BASSAC
Missionary Friars of Sainte-Thérèse

Tucked away in its own spacious park the thousand-year old abbey is immersed in the countryside and vineyards of cognac country. Founded in 1009 by Wardrade, a wealthy nobleman of nearby Jarnac, it flourished during the Middle Ages. Not much is left from that period since the abbey was almost destroyed during the Hundred Year War and the religious conflicts of the 16th century. Its Romanesque façade was altered in the 15th century; the interior harbors a 13th century statue of St-Nicholas. The Congregation of St-Maur restored the complex between 1666 and 1715. During that time they remodeled the building and church and enriched the monastery

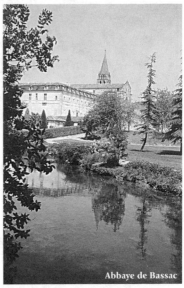
Abbaye de Bassac

with precious furniture. Today those furnishings represent the most important works of art of the complex. Most exceptional are the engraved figures on the bookstand and the seats of the choir. In 1947 the friars of Ste-Thérèse took up residence in the complex and began the tradition of hospitality. The tiny village of Bassac is just outside the park.

West of the abbey is a twenty-mile area called the "golden circle" of cognac production including the distilling towns of Cognac and Jarnac. Cognac has been the main source of wealth for the Poitou-Charentes region for more than four hundred years. The "liquor of the gods" as Victor Hugo called it, owes its outstanding character to the area's warm, humid climate. The fabled nectar of cognac has been created in town since the 17th century. The very air is permeated by the heavy scent of spirits evaporating from oak casks, an aroma referred to as the "angel's

share." Musée des Arts du Cognac is, as the name implies, all about cognac and displays an impressive collection of 25,000 labels, posters and other items linked to the brandy.

A medieval setting of narrow cobbled streets, Cognac's old quarter shelters many regal 16th and 17th century houses with elegant Renaissance façades and a Romanesque fountain. The castle was once the home of the Valois family and birthplace to François I in 1494. In the 16th century it was a Huguenot stronghold.

Northwest of the abbey, St-Jean d'Angely is a small attractive town in the Charente-Maritime. Lying on the banks of the river Boutonne, the town is surrounded by beautiful countryside. Built on the site of a Roman villa, it was a major stop on the pilgrimage route to Santiago de Compostela. St-Jean d'Angely's historic center is composed of cobbled alleys, timber-framed houses, leafy squares and fountains. There are some some striking features like the gateway and the Tour de l'Horloge, erected at the beginning of the 15th century on the site of an old door of the 12th century ramparts. The tower shelters a large bell symbolic of the communal freedoms granted to the city. The town's royal Bénédictine abbey is a handsome structure built in the 9th century by the Duke of Aquitaine. According to legend it was built to house the head of John the Baptist and became one of the most powerful abbeys in the west of France. The abbey was destroyed in 1568 and the relic disappeared. The abbey has since been rebuilt and is the arts center of the city. It shelters a library, a center of European culture and a school of music.

In summer the town's markets and shops are open by day; at nightfall, an interesting tradition takes place. A "medieval" pilgrim escorts visitors into the past on an animated tour of the town. A bustling street market takes place on Wednesday and Saturday mornings.

Accommodations
42 single and double rooms, each with a sink. Bathrooms are shared.
Note: Cultural associations and groups are hosted for holidays and conferences. Individuals are only hosted for spiritual retreats.

Amenities
Towels and linens can be supplied at an extra charge of 5.20€. Fully equipped conference halls, smaller meeting rooms and a TV room are available to guests.

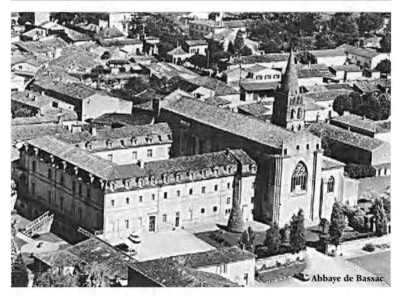

Abbaye de Bassac

Cost per person/per night
Spiritual retreats
Lodging only 10.90€, full board 29.80€.
Other groups and associations
Lodging only 13.30€, full board 36.10€.

Meals
All meals can be provided with the lodging.

Special rules
Punctuality at meals is required. Arrival before 6 PM on check-in day is requested.

Directions
By car: Take highway A10 to the exit at Saintes. Take N141 past Cognac and Jarnac and D22 to the abbey.
By train: Get off at Jarnac and take a taxi to the abbey.

Contact
Responsable pour l'hospitalité
Abbaye de Bassac
Frères Missionaires de Ste-Thérèse
16120 Bassac

France
Tel: 0033 (0)5 45 81 94 22
Fax: 0033 (0)5 45 81 98 41
Email: abbayedebassac@aol.com
Website: www.abbayebassac.com

 NOTES

ABBAYE NOTRE-DAME DU PIN
Property of the Parish Vienne of Asnières,
Managed by the Association USSAC

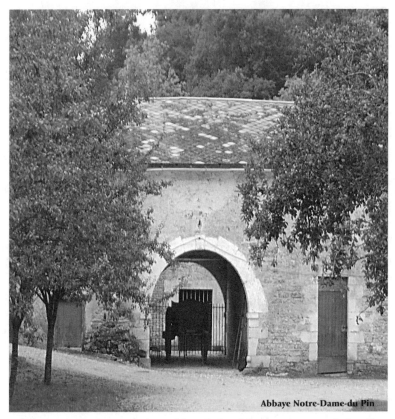

Abbaye Notre-Dame-du Pin

The complex is an ancient abbey lodged in a pretty wooded valley formed by the river Boivre in the département of Poitou-Charentes. "Like any other Cistercian institution, we are in a beautiful spot near the water," said the man at the desk. The abbey is ideally located for relaxing excursions in nature and cultural itineraries in the environs of cognac country, a region known for its Romanesque architecture.

Founded in 1120, the domination of the Cistercian Order is evident not only in the siting of the complex but in the sobriety of its style and harmony of its proportions. Unfortunately, the Hundred Year War, as well as the religious conflicts of the 16th century, brought the abbey to ruins at various times. The architecture visible today belongs to the 17th century.

In 1792 the property was confiscated as national patrimony, sold and the monks expelled. In 1947 the Parish of Asnières, near Paris, bought the property. Over the past few years, the association which runs the complex has begun a total restoration. Ruins of a Romanesque church and buildings are still visible. The association operates a farm that may be visited by guests. Horse rides are also available.

Southwest of the abbey is the town of Niort. Originally a Gallo-Roman town called *Novioritum,* during the 16th and 17th centuries it was a Huguenot bastion. Its most interesting area is the mainly pedestrian section around rue Victor-Hugo and rue St-Jean where stone-fronted and half-timbered medieval houses edge the streets. In the heart of the city sit four bronze dragons recalling the Niortais legend of a chivalrous knight who slew the dragons that haunted the marshes. Two immense towers and ramparts, relics from a castle built by Henry II and Richard Lion-Heart, house a museum of Poitou costumes.

The abbey is close to the Marais Poitevin. Called the "Green Venice," this part of Poitou-Charentes is often likened to the bayous of Cajun country. The canals date from the Middle Ages when a group of monks started a project to drain the Golfe du Poitou, a vast bay that nearly reached Niort. The contours of its cliffs can still be traced on a map. Since roads are scarce and waterways plentiful, a boat or bicycle is the best way to explore the area. At the gateway to the Marais, the village of Coulon is underscored by rows of low whitewashed cottages with brightly colored shutters.

Medieval Parthenay is in the vicinity of the abbey. A town of architectural, artistic and historic interest, it was a stop on the route to Santiago. Monuments and sites include the St-Jacques district with its timbered houses on rue de la Vau St-Jacques; the ornately carved Romanesque churches of St-Peter and Notre-Dame-de-la-Couldre; and the Georges-Turpin museum with its collection of archeological artifacts and 19th century tin-glazed pottery.

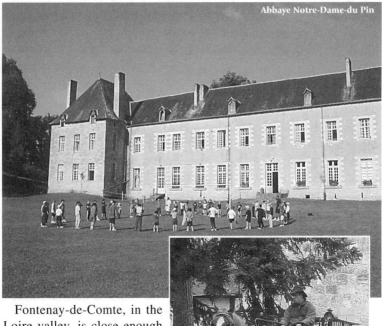
Abbaye Notre-Dame-du Pin

Abbaye Notre-Dame-du-Pin

Fontenay-de-Comte, in the Loire valley, is close enough to Béruges to warrant a day trip. Classified as a "Village of Art and History" for its cultural wealth, Fontenay is over a thousand years old. The former capital of Bas-Poitou, the town has a wonderful architectural birthright including the Eglise Notre-Dame and the Quatre-Tias fountain.

At nearby Nieul-sur-l'Autise, the 800-year old royal abbey of St-Vincent is a rare surviving example of a classic Poitou monastery complete with its own church, cloisters and dorms. The town itself is a "Petite Cité de Caractère" with an excellent museum, a working water mill, bread oven and country crafts. Although the buildings at nearby Maillezais are in ruins, they are still impressive. Sound and light shows take place in the summer.

Region: Poitou Charentes City: Béruges

Accommodations

80 beds in 16 rooms with 3 to 6 beds. Each room has a sink and shower; toilets are shared. Only groups of 15 and more are accepted.

Abbaye Notre-Dame-du-Pin

Amenities

Linens are supplied; towels are not. There is a large dining room, two meeting rooms and an outdoor dining space. Volleyball, soccer and a swimming pool are on the premises.

Cost per person/per night

Lodging and breakfast 15.60€.
Lodging and half board 22.60€.
Lodging and full board 27.50€.

Meals

All meals can be provided with the lodging.

Directions

By car: Take A10, exit at Poitiers and take D6 to Béruges. From there follow the signs to the abbey.
By train: Get off at Poitiers and take a taxi to the abbey.

Contact

Anyone at the desk
Abbaye Notre-Dame-du Pin
Le Pin
86190 Béruges
France
Tel: 0033 (0)5 49 53 32 23
Fax: 0033 (0)5 49 36 00 12
Email: abbayedupin@wanadoo.fr
Website: http://abbayedupin.free.fr/

MONASTÈRE DES AUGUSTINES
Augustine Sisters

Monastère des Augustines

This recently built monastery is lodged in a peaceful forest. It is less than a mile from the sleepy village of Bonneuil-Matours in the Vienne département of Poitou-Charentes, an area extremely rich in artistic and natural attractions. "We are in a very pleasant spot and above all a very calm and quiet situation," said Sister Monique. The original community of nuns was founded in Poitiers in 1644 but moved to their present location in 1963. Unfortunately they built above clay soil and after a few years almost all the buildings had to be demolished and rebuilt. The chapel was not rebuilt and is original. It was constructed of ties from the Chemin de fer – train tracks. Large glass windows dominate the structure imparting an al fresco sensibility. "We can see everything from the interiors, it is like being outdoors," the sister continued.

The guest house was rebuilt in 2000 and hospitality is the main activity of the order, whose mission is to pray, live together and attend to others. Guests are welcome to participate in the daily liturgy. The town's Romanesque church is highlighted by ornate choir stalls.

Directly east of the monastery, the ruins of a fortress overlook Angles-sur-L'Anglin, an evocative medley of old streets and ancient houses. The "Jour d'Angles" workshop produces drawn threadwork on silk, cotton or linen that is both a craft and an art form. In days gone by, the workshop supplied the trousseaux for royal families and the linens for the most luxurious ocean liners.

Northwest of the monastery is the town of Châtellerault, home to numerous monuments. Established by the Count of Poitiers to secure his borders in the early 10th century, the town sits at the confluence of four rivers. The grand Pont Henry IV is flanked by twin towers and joins the two halves of the town across the river Vienne.

Picturesque Chauvigny is south of the monastery and is the only village in Poitou-Charentes to be listed as one of the most beautiful byways in France. A major center of Romanesque architecture, the town preserves several medieval fortresses whose ruins stand atop a precipitous rock spur and provide vistas of the river Vienne. The 11th and 12th century donjon de Gouzon houses an unusual display representing the local economy through the ages - stone quarries, porcelain, mills and lime kilns. Chauvigny limestone is ideal for carving and was the stone used for the base of the Statue of Liberty. Dragons, monsters, human and biblical faces and scenes are illustrated on the outstanding capitals in the choir of Romanesque Eglise St-Pierre. Market days are Saturday, Tuesday and Thursday mornings and are held between the Cathédrale de Notre-Dame and the river.

Southeast of Chauvigny the 11th century murals in St-Savin-sur-Gartempe are considered landmarks of Romanesque art. The murals have been recognized by UNESCO and are listed as World Heritage Masterpieces. The paintings on the vaulting in the nave illustrate scenes from the Old and New Testaments, Genesis and Exodus. The Galilée porch contains depictions of episodes from the Apocalypse.

Poitiers

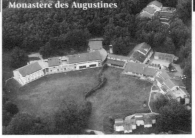

Monastère des Augustines

The town of Poitiers is quite close to the monastery. Often referred to as the town of a hundred bell towers, Poitiers is almost completely encircled by the twin rivers Clain and Boivre. It is a place of timbered houses, Renaissance residences and private mansions. Among the country's oldest cities, it is considered one of France's most outstanding centers of Romanesque architecture. A view of the city from Les Dunes reveals the church of Notre-Dame-la-Grande; its west front decorated with carvings that present the Old and New Testaments. In addition to the Romanesque structures, there are vestiges dating from the Gallo-Roman era including amphitheaters and baths. Poitiers was a monastic and religious center as early as the 4th century - the polygonal Baptistére St-Jean is one of the oldest Christian edifices in France and dates from the 4th century. The interior contains a very fine set of 12th to 13th century murals. Musée Ste-Croix covers the history of the Poitou area from prehistoric times to the present day.

Accommodations
45 singles and 34 beds in rooms with 4 or 5 beds. All rooms have a private bath.

Amenities
Towels and linens are supplied. Meeting rooms, TV room and private park.

Cost per person/per night
34.20€ per person, full board.

Meals
All meals are provided with the lodging.

Directions
By car: From A10 exit at Poitiers-Nord or Châtellerault. From Châtellerault take D749 south. The monastery is 1 km before Bonneuil-Matours. From Poitiers take N151 to Chauvigny and then D749 north. The monastery is 1 km after Bonneuil-Matours.
By train: Get off at Poitiers or Châtellerault (trains run less frequently to Châtellerault). There is no public transportation to Bonneuil-Matours. From Châtellerault the nuns might be able to arrange transportation if advance notice is provided.

Contact
Sœur Hôtelière
Monastère des Augustines
Le Val de la Source
86210 Bonneuil-Matours
Tel: 0033 (0)5 49 85 22 93
Fax: 0033 (0)5 49 85 29 70

 NOTES

CENTRE D'ACCUEIL DES DOMINICAINES
Dominican Sisters

The house is in a peaceful spot nestled in its own park in the small town of Corme-Ecluse. Built in 1815 it was a Dominican convent before being converted into a guest house in 2002. It offers hospitality to individuals and groups on holidays or those seeking a spiritual retreat. The area encompassing the center is replete in abbeys, Romanesque churches and archeological sites; the Atlantic beaches are less than ten miles away.

Due east of the house on the Atlantic, at the juncture of the Gironde estuary, lies the seaside resort of Royan. Fringed by beautiful beaches, especially the Grande Conche at nearly two miles long, the town is a favored summer destination. Pine trees were planted near and around the beach to secure the sand dunes. Boat tours of the estuary and islands are available.

Northeast of Corme-Ecluse is the 2000-year old enclave of Saintes. A beautiful stone archway welcomes visitors to this picturesque village abounding in medieval and Roman influence. During the Roman occupation, Saintes was the main town of the Santones tribe and preserves reminders of the Roman era, Middle Ages and 18th century. The Gallo-Roman amphitheater was built in the early 1st century and could seat more than 15,000 spectators. Musée Archéologique conserves some fine Gallo-Roman exhibits and ornate features such as columns, capitals, low reliefs and the replica of a 1st century chariot with its harness. Musée Le Présidial displays paintings from the 15th to 18th centuries by the Flemish, Dutch and French schools and 14th to 19th century ceramics from the Saintonge region. The old town is a patchwork of medieval streets bordered by 17th century houses that attest to its storied history. In the summer the town hosts a music festival. An interesting way to see Saintes and environs is by flat-bottomed riverboat along the river Charente.

Continuing northwest, La Rochelle is an attractive and unspoiled seaside town. Its cultural and architectural patrimony recalls the maritime background of the walled town. Along rue du Palais handsome Renaissance mansions and opulent 18th century residences with white frontages are steeped in memories of past owners — the shipping magnates and merchants who gained their wealth from the wine and salt

trades and later from trade with the Americas. Chambre de Commerce is a palatial courtyard in the style of a small Versailles. The shops in the arcaded streets are reminiscent of the stalls of days gone by when traders displayed their wares as soon as they had been unloaded from the ships. In certain streets the rounded "Canadian" cobblestones evoke tales of ships that took emigrants to the New World and returned to La Rochelle carrying these huge stones as ballast.

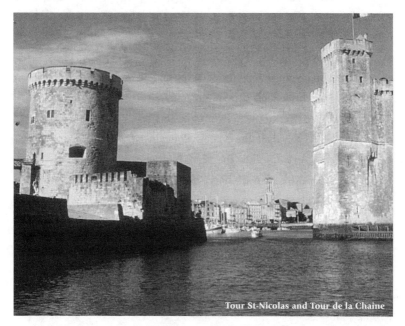

Tour St-Nicolas and Tour de la Chaîne

The impressive Tour St-Nicolas and Tour de la Chaîne have protected the town's port since the 14th century. From the parapet walkway of St-Nicolas, reached by a labyrinth of steps and stairs, is a panoramic view of the old harbor and town. The chains that once blocked entrance to the harbor at night and gave Tour de la Chaîne its name can still be seen dangling in the water. The third of La Rochelle's seafront towers is Tour de la Lanterne, also known as the "Four Sergeants Tower." For centuries a huge candle was lit nightly as a beacon for incoming craft. Built as a lighthouse in the 15th century, it was also used as a prison. Six hundred examples of graffiti have been left in it by British, Dutch and Spanish privateers, reminders of their incarceration.

Porte de la Grosse Horloge is the entrance to the old city. A bustling core it is framed by arcaded streets and medieval timbered houses with slate roofs and stone façades. Housed in an 18ᵗʰ century mansion, Musée du Nouveau Monde illustrates the links between La Rochelle and the Americas from the 16ᵗʰ century onwards.

Ile de Ré is easily reached from La Rochelle. Linked to the mainland by a toll bridge, the island is surprisingly flat. Whitewashed houses with green shutters, narrow little streets bordered with bright hollyhocks, long fine sandy beaches, colored church spires and salt pans form a beguiling palette. Ré island offers guided tours of its quaint villages, harbors and nature sanctuaries.

Accommodations
21 beds in single and double rooms, each with a private bath.

Amenities
Towels and linens can be provided on request. Private park, meeting room.

Cost per person/per night
Full board 38.00€. Other prices to be determined when reservations are made.

Meals
All meals can be provided with the lodging.

Special rules
Punctuality at meals is requested.

Directions
By car: Take A10 and exit at Saintes/Mirameau. Take N150 and D17 to Corme-Ecluse.
By train: Get off at Saujon (SNCF) and take a taxi (7 km) to Corme-Ecluse.

Contact
Secretariat
Centre d'Accueil des Dominicaines
Les Chaumes
17600 Corme-Ecluse
France
Tel: 0033 (0)5 46 02 43 00
Fax: 0033 (0)5 46 02 93 09

ABBAYE NOTRE-DAME-DE-MAUMONT
Bénédictine Nuns

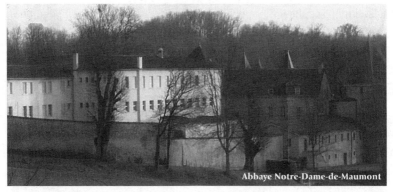

Abbaye Notre-Dame-de-Maumont

The nuns that inhabit the abbey were originally based in the town of St-Jean-d'Angely, not far from the present abbey. But as the small town grew, so did the noise and the nuns decided to move to their present location in Montmoreau. They purchased an ancient castle and farm nestled among the rolling hills of rural Charente. Taking up residence in the castle, the nuns converted the farm's large hayloft into a church. "The church is something unusual, something special," said sister Blandine. "The castle and the church do not contain any artwork but the beauty and peacefulness of the hilly, wooded site allow guests to enjoy quiet, restorative walks in nature," the sister concluded.

The city of Angoulême is not far from the abbey. The ancient town occupies a high, steep-sided plateau overlooking a bend in the Charente, and provides a natural fortress-like core for the town. Ramparts encircle the plateau and offer panoramic views. Famous for its Romanesque architecture, the Cathédral St-Pierre was begun in 1110 AD and ornamented by a carved façade representing the *Ascension* and *Last Judgment*. The fresco beneath the tympanum commemorates the recapture of Spanish Zaragoza from the Moors. Beside the cathedral in the old bishop's palace, is the Musée des Beaux-Arts. Exhibits feature 17th to 19th century paintings, many by Charentais artists. Musée de Nil recounts the

town's past as an important paper producer which perhaps led to the reason why Angoulême is now a significant center for comic book fans. On the outskirts of town is the modern St-Gobain glassworks, Europe's second biggest bottle-maker. Guided tours can be arranged through the tourist office.

South of the abbey is Aubeterre-sur-Dronne, replete with old churches and ancient monuments. Among the most scenic villages in France, its location in the south of Poitou-Charentes, overlooking the Dronne valley, makes it ideal for an architectural sightseeing trip.

Poitou-Charentes is also popular for the waterways of the Marais Poitevin, western France's "Green Venice." An inviting area of man-made canals that date from the Middle Ages when monks devised a network of intricate canals to reclaim land from the sea. The best way to experience the Marais is by boat or bicycle since waterways are plentiful and roads are scarce.

Accommodations
The guest house is a short walk from the monastery. There are 35 beds in single, double and family rooms (up to 4 beds); baths are shared.

Amenities
Towels and linens are supplied with the lodging at an extra charge. Meeting rooms are available.

Cost per person/per night
A price list is posted in each room. Rates vary from covering the basic expenses of 27.00€ plus any voluntary contribution.

Meals
All meals can be provided with the lodging.

Products of the institution
The main activities of the monastery are digital archiving, producing liturgical garments, growing fruits and vegetables for the community and bookbinding. Books are restored according to the style of its period. The sisters also maintain a shop that sells the products of other monasteries.

Special rules

Absolute silence after 10 PM.
Maximum stay one week.
Closed two weeks in January.

Directions

By car: From Angoulême take
D674 south to Montmoreau.
From there take D24 to the
abbey (keep Montmoreau and
St-Amand, not Juignac, as a
point of reference).
By train: Get off at Montmoreau
(only 2 trains a day) and call the
nuns. They will provide transporta-
tion from the train station (4 km).

Contact

Sœur Hôtelière
Abbaye Notre-Dame-de-Maumont
16190 Juignac
France
Tel: 0033 (0)5 45 60 34 38 (hôtellerie direct)
 or
0033 (0)5 45 60 30 12 (abbey)
Fax: 0033 (0)5 45 60 29 02
Email: maumont.accueil@wanadoo.fr
Website: www.maumont.com

NOTES

PROVENCE-
ALPS-AZUR

MAISON ST-DOMINIQUE
Dominican Sisters

The convent and guest house of the Dominican Sisters lies in the heart of a quaint hill-town of Provence, not far from the coast but far from the noise and crowds. The building sits atop a 1,300' hill. About 200 years old and at one time almost in ruins, the complex has been completely restored due to the efforts of the sisters and the help of a local association. The sisters manage the small guest house in a familial way and offer a relaxing and peaceful venue for visiting Provence. Set in a stage of beautiful landscapes comprised of forests and wild, rocky terrain, the site of the maison lends itself to the possibility of innumerable excursions. The ambience of the region is so lovely that it has attracted many northern Europeans who have made their home in this singular environment, a combination of mild weather, proximity to the sea and a simple lifestyle.

A picturesque village, Callas has remained intact, preserving the Provençal traditions as embodied in tall houses that sit side by side. Narrow mounting streets lead to shady squares, ancient fountains and arcades. In the center of the village stands a towering white bell tower that can be seen from nearly every part of the village. Callas is also the locale of the Pennafort gorges formed by a tributary of the Endre. An exceptional arrangement cut from the red rock, the gorges are enveloped by a vast forest of stone pines. A path leads to a waterfall and the chapel of Our Lady of Pennafort perched on a rocky spur.

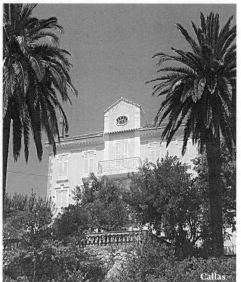

Callas

The religious fervor of the Middle Ages led to the founding of many villages and fortified buildings all sharing similar traits. The hills of the central Var are ideal for trips through vineyards, olive groves and forests. The closest

Draguignan

city to Callas is Draguignan. Capital of the Haut-Var, it forms a crossroads between the Var coastline and the Verdon region. The fortress town and 12th century regional capital received a royal charter when the county became part of France during the reign of François I. A graceful market town, the old core of Draguignan has maintained its medieval architecture as reflected in massive old doors, churches and monasteries. Among the town's monuments are the Portaiguieres and Roman gates, 17th century Minimes chapel and the Eglise St-Michel.

Les Arcs-sur-Argens

Once a lookout point against the Saracen troops, nearby Les Arcs-sur-Argens is perched on a rocky hilltop. The clock gate and its bell tower mark the entrance to the old town. A visit to the medieval section, "Le Parage," is akin to traveling through time to the Middle Ages as typified by the narrow cobbled streets overseen by a castle keep.

Not far from Les Arcs-sur-Argens is the Abbaye de Thoronet. Built by the Cistercian Order in the 12th century at the center of an immense oak woods, the abbey is a showcase of Provençal Romanesque architecture. The stark buildings exude a calm and tranquil aura, inviting contemplation and meditation. Stone and light are its only ornaments. The complex consists of workshops, a barn, cloister, small bell tower and four chapels. During the annual medieval music festival, visitors are invited to enjoy the exceptional acoustics of the abbey.

The countryside around Callas is dotted with medieval villages. The fortified town of Fayence retains its ramparts and Sarrasine gate complete with openings for dropping stones on attacking forces. Fortified Comps sur Artuby is at the entrance to the Verdon Canyons near Lake Ste-Croix. Originally built atop a rock, the village lies in the middle of untamed lands. The old town is an inviting place. Among its monuments is the St-André chapel, constructed by the Knights Templar. The eroded mountain chains, deep

St-André cOhapel

gorges, high plateaux and wooded terrain create a grand setting and an excellent base for hikers and nature lovers.

The village of Châteaudouble can be compared to an eagle's nest – it teeters atop a 426' cliff above canyons of the same name. The name "double castle" comes from the fact that there are two castles; one at the top of the village, the other on the banks of the river Nartuby. The heritage of this enclave reveals itself in streets with wide, gently mounting staircases, vaulted passages, façades sculpted with crosses (symbols of the knights of the crusades) and 12th century houses along the river's edge. Châteaudouble is a gem of Provence encased in greenery, idyllic for nature lovers. There are prehistoric caves including Grottes des Chèvres, Grottes des Chauves Souris and Grottes du Mouret as well as the hamlet of Rebouillon, an island bordered by the Nartuby on one side, the canal of the Reine Jeanne on the other.

The area north of Callas is home to three villages included in the category of "The Most Beautiful Villages in France." They lie close together and are typical of the upper Var. Each is full of charm, character and a sense of history. Bargeme dates from the 12th century. Built atop a rocky hill, it is crowned by a feudal castle. A concentration of narrow winding streets, its medieval aura is enhanced by

Bargème's feudal castle

ramparts, fortified towers and a gate. There are also several old chapels and the Romanesque church of St-Nicolas.

Over the centuries, Seillans has grown around a fortified stronghold. Nestled in a lush countryside, the village is a maze of cobblestone streets, its houses built in successive levels, harmoniously blending time-washed shades of ochre. Over the years, many artists and craftspeople have made Seillans their home. Among the most notable was surrealist painter Max Ernst who lived in the village the last ten years of his life. The Max Ernst Foundation exhibits a number of his lithographs.

Authentic and beautifully restored Tourtour is positioned at 2,066'. A stroll through the village reveals lovely old stone houses, fountains, flower-bedecked squares and magnificent panoramas.

Accommodations
15 beds in single and double rooms and two mini-apartments. All rooms have private bath; the apartments also have a kitchenette that guests may use.

Amenities
Towels and linens are supplied.

Cost per person/per night
To be determined when reservations are made.

Meals
All meals can be provided with the lodging.

Directions
By car: Take A8 and exit at Draguignan. Take N555 to Draguignan and D562 until the signs to Callas.

By train: Get off at les Arcs (SNCF) or St-Raphael (TGV) and take a bus to Callas.

Contact
Anyone who answers the phone
Maison St-Dominique
Place de l'Eglise
83830 Callas
France
Tel: 0033 (0)4 94 39 09 30
Fax: 0033 (0)4 94 76 74 30

NOTES

C.I.M.E.M.
(Centre International Marie-Eugènie Milloret)
Sœur de l'Assumption

The maison sits between the sea and the hills, a half-hour walk from la Croisette, the main street in Cannes. Boulevard de la Croisette is one of the most famous promenades in the world and represents people-watching at its finest. Running for about two miles along the coast, it follows the curve of the bay passing palatial hotels built in *belle époque* style, luxury boutiques, flowering gardens, gracious lawns, umbrella pines and towering palms.

Lodged in a quiet residential quarter, the center is enveloped by a verdant five-acre park. Palm trees and flowers frame the imposing white and green mansion that has offered hospitality for holidays, spiritual retreats, conferences and workshops since 1879. The maison belongs to the order of the Sœur de l'Assumption founded by Anne-Eugénie Milleret de Brou (1817-1898). The sister was born in Lorraine to a non-observant family. While in Paris attending a conference of Père Lacordaire, she felt her calling and decided to establish her own order (1839). Since that time the congregation has expanded and can be found on every continent. The sisters of the congregation combine monastic life with their mission as educators. C.I.M.E.N. is the training center for all the schools of the order. Mère Marie-Eugénie Milleret de Brou is in the course of canonization.

Cannes is one of the best known towns on the Riviera-Côte d'Azur, a sunny, sophisticated coast where the art of good living meets the art of Picasso, Renoir and Matisse. A landscape of palm-lined beaches, flaming violet bougainvillea and the omnipresent sparkling blue sea, today it is most famous for its film festival. The first one took place in 1946 and the tradition continues. Movie stars and starlets cram the town in mid-May when the festival is held in the huge Palais des Festivals.

There are a number of interesting monuments within the city. Château Vallomrosa has nine crenelated towers. Built in 1850 amidst a seven-acre tropical park, the building and park are listed as historical monuments.

The Bellini Chapel is an Italian Baroque affair from the end of the 19th century. There is a clock tower that houses the belfry; its façade is adorned with statues.

In 1894 a major street was named boulevard Carnot in honor of Sadi Carnot, president of the French Republic who was assassinated in Lyon. Lined with attractive homes, some are reminiscent of those built in Paris in the Haussmann era; others are defined by the eclectic, art nouveau and art déco styles.

Musée de la Castre is in a medieval castle on the heights of Old Cannes, overlooking La Croisette, the Bay and the Isles of Lérins. Built towards the end of the 11th century to defend the emerging town, the castle has retained its keep, the Romanesque Ste-Anne Chapel and cisterns. The chapel shelters a museum with an array of art and antiques in addition to an exceptional series of musical instruments.

Constructed in 1887, Eglise St-Georges was designed by English architect M. Blomfield and is conspicuous for its sobriety. The structure has not been changed in any manner and represents one of the best examples of English religious architecture. St-Michel Archangel was conceived by architect Louis Nouveau and inspired by the Russian tradition: cross-in-square plan and a glazed tile roof with an onion dome in a starry sky. It harbors icons and objects of worship.

Vieux Port is a colorful part of town, its harbor filled with fishing boats and fabulous yachts. Le Suquet, the old part of Cannes, is where the Forville Market takes place. Truly a Provençal experience, the market is open every day except Monday. The islands of Ste-Marguerite and St-Honorat can be seen from the quay and are accessible by boat.

In the 5th century AD, the monk St-Honoratus and seven of his disciples established an abbey on one of the Iles de Lérins. Sited on the smaller, forested island that still bears his name, St-Honorat was the most famous monastery in early 6th century Christendom. Despite repeated Saracen and Spanish assaults, the abbey retained eminence until the end of the 15th century when a long decline began. Of the seven original chapels scattered throughout St-Honorat, some have been rebuilt while mere traces of others remain. The island's present church was rebuilt in 1880 on the site of the former abbey church.

Lérins

The monastery's Chapelle St-Sauveur is renowned for its octagonal layout. Built in the early 11th century it was restored in 1977. Chapelle de la Trinité is noted for its trefoil plan, short nave and curious dome topping. Most likely rebuilt in the late 10th century, it is designated as an historic monument. The Romanesque fortified monastery (actually the castle keep) was erected as a refuge for the monks in the late 11th century. For reasons of security it became the true monastery in the 15th century. Today it is inhabited by Cistercian monks.

Ste-Marguerite, the larger and more crowded of the two islands, was named after Honorat's sister who established a nunnery there. The island's most popular structure is Forte Ste-Marguerite built by Richelieu to protect the Lérins from the Spanish. The fort is reputed for housing the 17th century *Man in the Iron Mask*. The mythical character brought to life by Alexandre Dumas was actually based on a real person imprisoned in the fort from 1687 to 1698. He was eventually moved to the bastille where he died in 1703. During Louis XIV's suppression of Protestantism, the king also imprisoned the Huguenots in this mighty, albeit somber, structure.

Southwest of Cannes, Fréjus was a Roman town and former naval port. Overlooking the alluvial plains that separate the Estérel and Les Maures ranges, several ancient amphorettes used for storing victuals such as wine, were uncovered in Fréjus. Plundered by the Saracens in 940 AD, the town became an Episcopal city. Its splendor remains evident in the octagonal 5th century baptistry, part of the pink sandstone cathedral. Fréjus offers visi-

Fréjus

tors a rich heritage of Roman and medieval architecture. The Roman arena, oldest in Gaul, is still used for concerts and bullfights, presentations and sporting events while the aqueduct, amphitheater, triumphal arch and other remains bear witness to the consequence of the town in Roman times. A walk along via Aurelia is like taking a step back into classical times.

Accommodations
Hospitality in the house is available year-round. Special conditions exist during the film festival. There are 85 single, double and family rooms, 40 of which have private baths.

Amenities
Towels and linens are supplied. Private park, private parking, TV room, terrace, chapel, meeting and conference rooms.

Cost per person/per night
Costs vary depending on the type of room, length of stay, number of meals and season of the year. Minimum 30.00€, maximum 62.00€ with special prices for children. Current information is available on the website.

Meals

Breakfast and dinner are always included and lunch can be provided.

Directions

By car: From A8 exit at Cannes Centre, take boulevard Carnot to avenue des Anglais. Continue on avenue des Anglais to boulevard de la République. Turn left and continue to boulevard d'Oxford. Proceed on boulevard d'Oxford to avenue Commandant Bret. Turn right, the maison is on the right. A detailed map is available on the website.

By train: Get off at Cannes and walk (10 minutes), take a taxi or bus #4 to the CIMEN.

Contact

Anyone who answers the phone
C.I.M.E.M.
37, avenue du Commandant Bret
06400 Cannes
France
Tel: 0033 (0)4 97 06 66 70
Fax: 0033 (0)4 97 06 66 76
Email: contact@cimem.com
Website: www.cimem.com

NOTES

ALPES MONTJOIE
Property of Trinitarian Monks
Managed by lay personnel

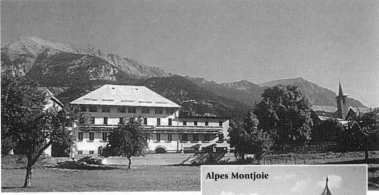

Alpes Montjoie

The maison is in Faucon-de-Barcelonnette, a village of the Alps of Haute-Provence. An ancient farm of the 18th century, the maison was donated to the Trinitarian monks who preserved the characteristics indicative of the region particularly in the vaulted dining hall. Framed by mountains and encased in a private park, the property is equipped for outdoor activities and sports. Most guests come for hiking, cycling or merely to enjoy the peaceful panoramas of the Alps.

Faucon-de-Barcelonnette is a tiny village built on the gentle slope of a hill overlooking the village of Barcelonnette. In the heart of the valley Ubaye, near the border with the Hautes Alps and Italy, both villages are ruled by two distinct seasons. During the summer the lush green country-

side provides the opportunity of hundreds of walking trails. In winter it is transformed into a winter sports center with three alpine ski stations and two cross-country ski areas.

Faucon is the oldest village in the valley and may have been inhabited since Roman times. The village enjoys a quiet ambience combined with wonderful views. Although it was an impor-
tant settlement in the Middle Ages, today it is comprised of a few scattered houses encompassed by green meadows with several high peaks as a backdrop. Despite its quiet countenance, Faucon's history is very rich. On the little square stands the proud clock tower, a square structure with a round steeple built in the 16th century on the foundations of an 11th century Romanesque church. It features a restored sundial on its façade. The interior harbors a beautiful fresco representing the *Assumption of the Virgin*. The village also lays claim to a Trinitarian convent erected in 1193 by St-Jean de Matha, native son of Faucon and founder of the Trinitarian Order. The present structure dates from the 17th century and is enriched by a verdant garden and 18th century chapel.

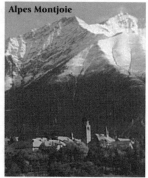
Alpes Montjoie

The larger village of Barcelonnette is a place of distinctive southern alpine charm with snowcapped mountains visible at every turn. It is a lively town in winter and summer alike with a succession of fairs and markets. The colorful house façades and pleasant cafes of place Manuel are further enhanced by a beautiful fountain. Quite surprisingly, on the avenue de la Libération, there are numerous "Mexican Mansions" constructed between 1880 and 1930 by the "Barcelonnettes" who returned home after having made their fortune in Mexico. The handsome residences were a sign of social success and were inspired by a mix of Italian, Baroque and Tyrolean styles. One residence, Villa Sapinere, houses Musée de la Vallée where three floors are open to the public.

There are several small villages in the immediate vicinity. Jausiers lies in a sumptuous natural setting of pines and vast meadows. A mountain village, its pedestrian area is fronted by houses with pastel façades. St-

Nicolas de Myre church is a sober Baroque construction. In accordance with Piedmontese style it was built without gilding or adornment.

In the Middle Ages St-Pons (along with Faucon) was a main village in the valley Ubaye. There are a few houses sprinkled around a late Romanesque church that has been denoted as an historic monument. It presents a sculpted portal from the 12th century. At the entrance to the village is a building believed to have been a former convent. The façade displays a sundial dated 1828.

There are more than 400 sundials in the Hautes Alps of which 140 are of historical importance. In a variety of colors and styles, each is an individual work of art that carries a motto. The position of each hour marker is calculated from the latitude of the village and the direction in which the wall faces. The sundial on the Fontenil chapel in Briançon reads, "Every hour wounds, the last fatally."

To the north of Faucon is the Queyras Regional Nature Reserve. At 7,000' above sea level, it is one of the highest plateaux in the Alps. Close to the Italian border and encircled by a wall of mountains, it can only be reached through the valley Guil or over the Col d'Izoard or Col d'Agnel. The villages in the vicinity are some of the highest in Europe. The Queyras attracts walkers in the summer and cross-country skiers in winter.

Accommodations
65 beds in rooms with 2-6 beds. Baths are shared.

Amenities
Linens are supplied, towels can be supplied on advance request. Private parking, private park, TV and meeting room and table tennis.

Cost per person/per night
Full board 37.00€ (summer), 40.00€ (winter).
Half board 32.00€ (summer), 35.00€ (winter).

Meals
All meals can be provided with the lodging. Picnic meals are available on request.

Directions
By car: Take A51 and exit at Tallard. Take N85 and D900 to Barcelonnette. Faucon-de-Barcellonette is 1 km from Barcelonnette. Alpes Montjoie is indicated. (Watch for two access roads and two small signs – they are easy to miss.)

By train: Get off at Gap and take a bus to Barcelonnette. With advance notice of arrival time, the personnel of the house can arrange transportation.

Contact

Alpes Montjoie
Anyone who answers the phone
La Famille d'Alpes Montjoie
04400 Faucon-de-Barcelonnette
France
Tel: 0033 (0)4 92 81 50 08
Fax: 0033 (0)4 92 81 08 32
Email: jpfalpes@wanadoo.fr
Website: www.alpesmontjoie.com

 NOTES

HÔTELLERIE NOTRE-DAME DE LUMIÈRES
Property of Oblat Fathers
Managed by lay personnel

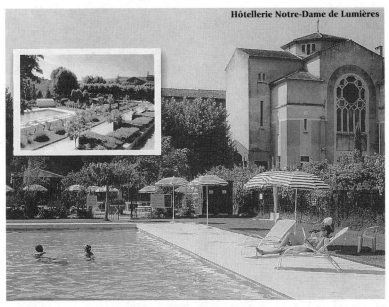

Hôtellerie Notre-Dame de Lumières

A former convent, the complex of the Hôtellerie and Sanctuary of Notre-Dame de Lumières is situated in Hameau de Lumière, a tiny picturesque hamlet of the "commune" of Goult at the foot of forested, rocky cliffs. A large parkland surrounds the premises imparting an aura of serenity and seclusion. Pleasant shoreline walks along the little Imergue river can be enjoyed by guests.

The story of the shrine began in the 17th century with a local peasant who suffered from an illness that forced her to wear a heavy metal corset. One day as she was walking near some ruins she saw a beautiful light and a child. According to tradition the peasant believed that it was the baby Jesus. As she took in the scene, her corset fell off and she was completely cured. The miracle started a pilgrimage to the site. At that time the

Carmélite friars were asked to restore and care for the chapel and at a later date the present church was built around it. The chapel is now the crypt and the church shelters a beautiful golden statue of the Virgin Mary along with many ex-voto.

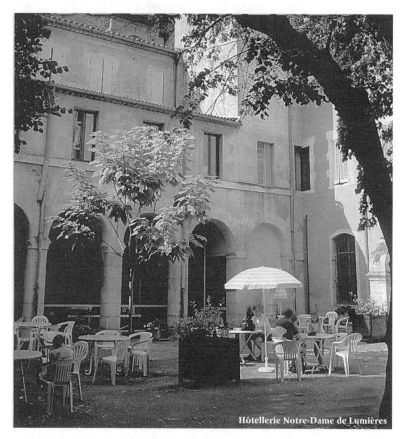

Hôtellerie Notre-Dame de Lumières

After the French Revolution, the shrine was sold and the Carmélite Order expelled. The local population bought the shrine and later entrusted it to the Oblat Fathers. It was converted into a seminary that prepared the fathers leaving the country as missionaries. In 1952 two seminaries were united and this location became a guest house for spiritual retreats. A few years ago it was completely restored and is now a two-star hotel

offering hospitality to all guests. Four friars and eleven priests of the Oblat Order live in a section of the complex. They celebrate mass every day and have a small shop with souvenirs and books on religion and psychology.

Goult is an historic fortified village in the Parc Naturel Régional du Luberon. It overlooks the northern plains towards the Plateau de Vaucluse. Restored with the utmost care, the village boasts handsome buildings made of stone and ochre. It is a venue of beguiling streets, old ramparts and a Romanesque church with archways and a clock tower. The narrow lanes of the village are lined with stone walls and delineated by arched doorways and vaulted passages.

Luberon landscape

The Luberon is in a beautiful part of Provence, just north of the Aix countryside. In the region is Mount Ste-Victoire whose regalness Paul Cézanne celebrated in countless paintings. Nearby is the 12th century Abbaye de Silvacane, one of Provence's famous trio of 12th century Cistercian abbeys, Silvacane was plundered and abandoned in the 15th century and became the parish church of la Roque d'Antheron in the 16th. The abbey is filled with soft light; its pure lines and balanced proportions creating a sense of peacefulness. Classical music concerts are held in the summer months.

With its hilltop villages and castles right in the heart of Provence, the mountainous Luberon landscape is abundant with prestigious places of cultural and historical interest. The southern slopes of the Luberon range fall towards the river Durance in stepped hills with vineyards scattered

throughout the terrain. Set amidst fields of lavender is the secluded 12th century Abbaye de Sénanque. Built in the narrow Senancole vale by the Cistercian Order, the simple, unadorned structure occupies an exceptional site in a fold of the hills, its silent and solitary locale conducive to meditation. Still a working monastery, the arcaded cloister, monks' quarters and chapterhouse feature elegant Romanesque vaulted ceilings. A shop sells the products made by the monks including honey, lavender and liqueur. Concerts of Gregorian chant are held in the large dignified church.

Harvesting lavender

The village of Lacoste is a medley of narrow streets paved in stone and fronted by ancient houses of ochre and limestone. Its 11th century castle was the former home of the infamous Marquis de Sade. Towering above the village, the castle originally had forty-two rooms and a chapel. It is currently under restoration.

Fontaine de Vaucluse is tucked in a closed valley at the southern corner of the mountainous Plateau de Vaucluse and is one of the most visited places in the Vaucluse. The castle ruins lurking on the rocks above the river are on the site of a 7th century BC oppidum (Roman site). The main attraction of the village is its spring. At the base of high, rocky cliffs, a deep pool of seemingly still water is actually a river gushing up out of the depths. A few yards from the pool, white water rapids crash down over black rocks, revealing the truth of the "still waters." Below the rapids, the river settles down to a wide expanse in front of dams and waterwheels, passing under the bridge at the center of the village and flowing downstream as a lovely river. This gigantic source of water is the most powerful in France and fifth in the world. It is at its most dramatic in spring and autumn.

Speleologists have searched futilely for the source of the spring. In 1878 a descent of 75' was made into the pool. In 1985 a small robot submarine went down over 1,000' and still no bottom. To this day it remains a mystery. The banks of the river are edged with overhanging trees and houses with lovely gardens. Just downstream from the village is the multi-arched 19th century Aqueduct de Galas.

Fontaine is home to a number of diverting museums. At Cristallerie des Papes visitors can watch glass being blown. Le Monde Souterrain de Norber Casteret is a geological museum in an underground gallery on the walk between the village and the source. Displays of speleology, caves and caverns includie information on the underground expeditions seeking the source of the river Sorgue. Musée Petrarch in the center of the village celebrates 14th century Italian poet Francesco de Petrarca who lived in a house at the same site.

A number of villages near the hôtellerie have been listed among "The Most Beautiful Villages in France." Gordes with its stone houses clinging to the side of a rocky hill ranks among them. Its hillsides are a jumble of crooked houses that come together to form a captivating picture. The hilltop village is reached by climbing winding roads past terraced houses that rise up to a mighty Renaissance château. Somewhat plain looking from the outside, the château's interior is abundanat in elegant detail and houses the contemporary paintings of Flemish artist Pol Mara. Like many other Provençal châteaux, the castle is an extraordinary cross between feudal fortress and Renaissance manor with mullion windows and pepper-pot turrets.

An historical site of note near Gordes is the Village des Bories, an unusual collection of dry-stone dwellings of peculiar geometric shapes. Although they possess a prehistoric look, most were built in the 18th century and were still inhabited a century ago. The village is now an informative museum of traditional rural life.

Menerbes is where Peter Mayle lived and wrote his books about Provence. The little village is built on a hill and encircled by resplendent countryside. The Dolmen de la Pichouno (unique to the Vaucluse) shows that Menerbes has been inhabited since prehistoric times. Excavations have uncovered the remains of villas and a cemetery dating back to the Romans. At the time of the religious wars in the 16th century, fortified Menerbes was a stronghold of the Protestant movement. The mighty citadel built between the 12th and 16th centuries still stands. As an aside: Menerbes has an unusual corkscrew museum where more than 1,000 varieties of the tool are on display. Befittingly, the corkscrew was conceived by a Frenchman in the 12th century.

Situated in the heart of one of the biggest ochre deposits in the world, the winsome hilltop village of Roussillon overlooks a remarkable sight of red, yellow and brown shades of earth contrasted with lush green pines. The vivid blue of the Provençal sky and exceptional quality of light transform the village into a magical site. Capital of ochre country, Roussillon is perched on a platform of rust-colored rock called Mont Rouge. Akin to an artist's palette, the ochre façades of its restored houses are accented by brightly painted shutters and doors presenting the full palette of ochre tints once quarried in the area. The atmospheric village square boasts its share of shops and restaurants, many with outdoor tables. A warren of narrow lanes and winding stairways lead to the Romanesque church and views of the mountains, hilltop villages and countryside of the Vaucluse.

Accommodations
160 beds in 50 single, double and family rooms, each with a private bath, direct telephone and satellite TV.

Amenities
Towels and linens are supplied. Four meeting rooms, private parking, air conditioned dining room, table tennis, fitness suite, heated swimming pool, playground and hiking/walking paths in the 75-acre park.

Cost per person/per night

Prices vary depending on season, type of room and number of meals.
Lodging only in a single room 37.50€ to 49.00€.
Lodging only in a double room 22.50€ to 29.50€.
Half board in a single room 55.00€ to 62.00€.
Half board in a double room 44.80€ to 52.00€.
Full board in a single room 59.80€ to 67.00€.
Full board in a double room 49.80€ to 67.00€.
Special prices for children. Beverages are not included. For up-to-date
prices, consult the web page.

Meals

All meals can be
provided with
the lodging.

Directions

By car: Take A7 and exit at Avignon. Take N100 and exit at
Goult/Hameau de Lumières.
By train: Get off at Avignon (SNCF and TGV) and take a bus to Goult.
Get off at Hameau de Lumières.

Contact

Anyone who answers the phone
Hôtellerie Notre-Dame de Lumières
84220 Goult
France
Tel: 0033 (0)4 90 72 22 18
Fax: 0033 (0)4 90 72 38 55
Email: hôtellerie@notredamedeLumières.com
Website: www.notredamedelumieres.com

MAISON SAINT-ESPRIT
Saint-Esprit Fathers

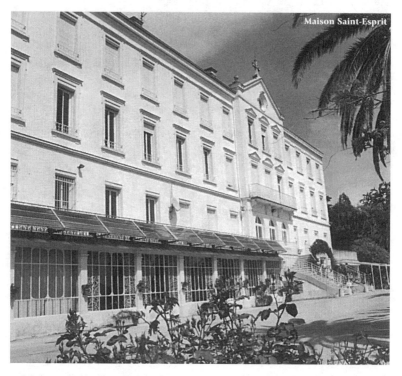

Maison Saint-Esprit

Maison Saint-Esprit is quartered on a verdant hill overlooking the Mediterranean, one mile from the center of La Croix Valmer, a small Provençal village set in a gently sloping, sheltered valley. The maison is quite large and for decades has been a landmark used by navigators cruising along the coast.

The house has just celebrated its fiftieth anniversary as a holiday destination for individuals and families and a retirement home for religious representatives and lays. The architecture of the building is typical of the area: an imposing white structure enlivened by bright yellow trim and

surrounded by its own park. The fathers of Saint-Esprit own and manage the house. They belong to a congregation of missionaries founded by Claude Poullart des Places and François Libermann. The order is actively engaged in sixty countries around the world.

The appeal of La Croix Valmer lies in its early 20th century villas and beach resort ambience. With seven naturally sandy beaches, it is reputed for the quality of its swimming waters. Gigaro beach is considered one of the best and is the most popular. Every Sunday morning a typical Mediterranean market is held at place des Palmiers. The history of La Croix-Valmer is quite ancient: the prehistoric Taillat dolmen, Roman ruins scattered over the Pardigon plain and the Lardier Napoleonic defense posts bear witness to the site's turbulent past. The origin of its name is attributed to the Roman Emperor Constantine. On a trip to Rome in 312 the Emperor is said to have seen a cross in the sky accompanied by the words, "In Hoc Vinces" - "by this sign, you shall vanquish." He immediately converted to Christianity and adopted the sign of the cross. A stone icon erected in 1893 in memory of the miracle is at the crossroads of RD 559 and RD 93 leading to Gigaro beach.

Beach at La Croix Valmer

La Croix Valmer's seascapes, local vineyards, rocky coastal footpath and beaches contribute to its charm. The headland is densely forested

with honey-scented Aleppo, umbrella pines, rockrose, ferns, wild Maures lavender and fragrant maquis. For a memorable outdoor excursion, there is a path from town leading to the top of the peninsula, winding between rocks, ferns, spiny broom and tall heather. The area is protected by the Conservatoire du Littoral which shelters over 400 species of plants in 50 acres and is a habitat for owls, passerines, blackbirds, gulls, falcons, puffins, kestrels, gannets, terns, swallows and giant cormorants.

In addition to the historic and traditional Provençal villages of the region, the Var coastline shelters a succession of tiny fishing ports. Located in the center of the St-Tropez peninsula, Ramatuelle is a tourist resort popular for its fine beaches. Ramparts enclose the historically vibrant town, a place of ancient stone houses topped by pink tiles. Built against the hills, Ramatuelle faces a wonderful vista of the Bay of Pampelonne that stretches for three miles and is carved with creeks and inlets. The town is famous for its summer jazz and light music events as well as its theater festival dedicated to actor Gérard Philippe. As an aside: the village was one of the main sites of the Allied landings on August 15, 1944.

From the top of its rocky spur Gassin offers exceptional 360° views over the entire peninsula. Its old-world ambience is manifested in the stone houses that huddle around the medieval fortress. The streets are often topped by flowering porticoes, the alleyways so narrow that one is considered the world's tiniest. The village overlooks the gulf of St-Tropez and from the fortified terrace of Les Barri, with its ancient nettle trees, there is a panorama of the Hyères Islands and the snowy peaks of the Alps.

Cogoline is a scenic village built on the hills of Les Maures mountain range. Pave-stone streets, flowery squares and arch-shaped passages bestow an age-old aura to the village. The brightly colored medieval houses showcase portals made of serpentine or volcanic rock. Cogolin has perpetuated its traditional Provençal features including a ruined castle that overlooks the village, a 14th century clock tower, drawbridge and fortifications. The 16th century Romanesque church, sundial and square belfry with its vaulted door add to the allurement.

Port Cogoline

The village is noted for its original art and crafts, in particular, hand-woven Jacquard rugs, briar pipes, reeds for wind instruments and a special dessert, *Tarte Tropezienne,* a creamy sweet cake traditionally served at Formula 1 Grand Prix races. A Provençal market is held several mornings a week at various locations. On the outskirts of town, a long lane of sycamore trees leads to the beautiful Château des Gardinieres. Built in the 12th century by Cistercian monks, it eventually became the manor house of Count Grimaldi and is now a vineyard estate open to the public.

On the beautiful wooded peninsula of St-Tropez is the perched village of Grimaud, one of the oldest of the Massif des Maures, its history dating back to the Gallo-Roman era. An enchanting medieval village crowned by a half-ruined 11th century feudal castle, Grimaud is an inviting arena of stone steps, heavy doors of studded wood, shady little lanes and flower-bedecked streets that wind all the way from the Romanesque church to the ruins of a castle. The house façades are hidden behind huge bougainvillea and offer glimpses of trompe l'œil paintings. The Romanesque church was built on a Latin-cross plan; its side chapel features a Carrara marble font. The stained glass windows were crafted by Jacques Gautier (1975).

Four miles away, Port Grimaud was reconstructed in the middle of marshes and dunes. A waterside village, it is an architectural tour de force designed by famous 20th century architect François Spoerry. A neo-Provençal style complex, it maintains a Mediterranean atmosphere. Stretching over 220 acres it encompasses nearly 2,000 homes, each with its own mooring. Evoking images of Venice, there are no roads, only canals and alleys. The village's tiny islands are linked by graceful bridges decorated with columns, trompe l'œil and arcades.

Playground of the rich and famous, St-Tropez was an ancient trading port founded by the Greeks. It is ideally situated in a gulf that was coveted by many peoples and was successively invaded by the Visigoths and then the Saracens. The fortresses built on the Fraxinet heights, now known as the Garde-Freinet, are traces of the last warriors who controlled the two steep, slopes of Les Maures range.

The town achieved fame when, in 1892, painter Paul Signac moored his boat at the small and completely unknown port. Since that time its setting has continued to attract artists and writers including Matisse, Derain, Bonnard, Marquet and Colette. It was where Roger Vadim brought his wife, starlet Bridgette Bardot, to film *And God Created Woman*.

St-Tropez still retains something of its original Provençal atmosphere in the old quarter and fishing port. The town's ancient access to the port is a maze of shady lanes, chapels, tiny squares, alleyways and secret gardens. The citadel high above the town provides stunning views over the bay and Les Maures mountain range beyond. Built by soldiers in the late 16th century, the fortress is a compelling historic monument. When it was built the hexagonal tower formed an essential part of the village's defense system. Musée de l'Annonciade preserves paintings by artists who lived and worked in St-Tropez including Signac, Matisse and Dufy. Notre-Dame de l'Assumption was built in 1784. An Italian Baroque-style church it is topped by a bell tower. The interior harbors statues and carvings from the early 19th century.

Accommodations
50 beds. Most rooms are single. Some have private bath. The maison is open year-round except in October.

Amenities
Towels and linens are supplied. Private park, private parking, TV room.

Cost per person/per night
37.00€ to 42.00€ full board.

Meals
All meals are provided with the lodging.

Special rules
Only full board is available. Minimum stay one week (it is sometimes possible to stay less). Curfew is at 10 PM. A key will be provided for a return after curfew.

Directions
By car: Take A8 and exit at Le Muy. Follow the signs to Ste-Maxime on D25. Or take A-8 and exit at Ste-Maxime and follow the signs to La Croix on D25 and then N98. The maison is at the end of boulevard des Villas.

By train: Get off at Toulon and take the bus to St-Tropez. Get off at La Croix Valmer. Once there call the house and they will arrange transportation.

Contact
Send a fax to the Père Directeur
Maison Saint-Esprit
Boulevard des Villas
BP 81
83420 La Croix Valmer
France
Tel: 0033 (0)4 94 55 10 00
Fax: 0033 (0)4 94 79 50 92

NOTES

HÔTELLERIE DE LA STE-BAUME
Bénédictine Nuns of Sacré-Cœur de Montmartre

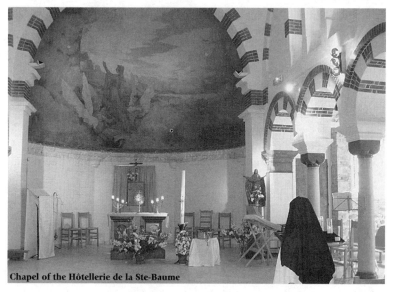
Chapel of the Hôtellerie de la Ste-Baume

The hôtellerie is managed by Bénédictine nuns. They are known for chanting the mass in French. Occupying a spectacular situation at 2,460', the hôtellerie is a forty-minute walk from the Grotte de Ste-Marie-Madeleine, a natural cave where tradition holds that Ste-Madeleine spent her last thirty years in solitude. According to Provençal legend, after the death of Jesus, the first Christians were persecuted and had to leave the Holy Land on board a precarious boat that miraculously reached the shores of France in Camargue near Arles.

The exiles became the first evangelists of Provence. It is said that Mary Magdalene preached in Marseille but later chose to live in solitude in this remote area. In 1279 the Count of Provence, Charles II of Anjou, found some relics of the saint hidden in the town of St-Maximin and decided to build a royal chapel to shelter them. With the permission of Pope Boniface VII he entrusted both the church and the cave to the Dominican Order.

From that point, pilgrimages to the church in St-Maximin and the cave became very popular among simple Christian pilgrims, kings, popes and saints and continued until the French Revolution when the site was destroyed. Rebuilt in 1859 the cave remains in the care of the Dominicans.

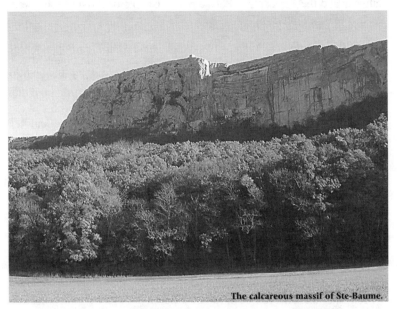

The calcareous massif of Ste-Baume.

The calcareous massif of Ste-Baume extends about 7.5 miles from east to west. It is the most spectacular of the craggy limestone massifs of southern Provence. The cave is in the middle at 2,950' and is adorned with seven stained glass windows depicting the life of the saint. The chain of Ste-Baume forms a precipice at whose feet is a protected fossil forest. This is only a small section of forest that once covered the area some 16,000 years ago. The forest ends on the plateau where the hôtellerie was built in 1859. The entire area is a haven for naturalists and trekkers.

At the foot of Ste-Baume, the close-by village of Geminos is encased by natural landscapes. A road studded with fountains leads to buildings such as the 18th century Eglise St-Martin marked by stained glass windows. Less than a mile away lies the Parc de St-Pons, grounds filled with Mediterranean flora and the ruins of the Abbaye de St-Pons, a former Cistercian convent founded in 1205.

Located on the ancient Aurelian Way between the Upper Var and the Riviera, the nearby town of Brignoles was the holiday resort of the Counts of Provence. The small medieval town comes to life on market days (Wednesday and Saturday mornings). Sights include Gothic St-Sauveur and the 12th century Palace of the Counts of Provence, home to the local history museum.

Heading east towards the coast, Bormes les Mimosas is a colorful medieval town, its ancient houses in pastel shades of pink, blue and yellow, its streets brimming with flowers. An ideal spot for a quiet stroll along narrow lanes fragrant with the scent of mimosa, there's a path that leads to the chapel of St-François de Paul. Dominated by the ruins of the castle of the Lords of Fos, there are dramatic views of the plains and Iles d'Or, an arena rich in land and marine wildlife. The islands are composed of fine sand beaches bordered by pine woodlands.

Hyères is the most southerly city of Provence and the oldest resort on the Côte. The term "Côte d'Azur," French name for the Riviera, was first coined in this resort town. Although the town is concentrated around its popular sailing harbor, Hyères also has a storied pastas evidenced by the remains of a Knights Templar castle, the abbey church of St-Paul and the 13th century Eglise St-Louis. It is also a place of palm trees, flowers, idyllic sand beaches and rocky coves.

From the hôtellerie the rewards of a day trip to Aix-en-Provence are many. The Aix countryside is a realm of elegant mansions, castles and authentic Provençal country houses. Once the capital of Provincia Romana, Aix is a veritable open-air museum. Resonant with an ancestry of thousands of years, it was occupied from the beginning of the 1st century BC by the Celto-Ligurian tribe Salyens and was a stepping stone between Italy and Spain. A noble city of aristocratic grace, it is home to many classic buildings showcasing sculpted doorways, wrought iron balconies and hidden gardens. The old part of town is compact and clearly defined by a ring of boulevards and the popular and compelling cours Mirabeau, focus of local life. Built on the site of the old ramparts, the cours is shaded by rows of gigantic plane trees. An historic landmark, it is a tableau of bustling cafes and bubbling fountains and the setting of one of the best markets in Provence.

Aix's Mazarin Quarter and the age of the mansions began in 1646. The grid pattern of the quarter was conceived by Archbishop Mazarin. A luxury housing estate for parliament members and the bourgeoisie of the period, it is organized around two principal axes: rue Cardinale and rue du 4 Septembre. The ornate façades and monumental gates of the mansions trumpeted the wealth of their owners. In 1650 a street was opened for horse-drawn carts that in the 19th century became the cours Mirabeau.

Among the beautiful homes of the cours, Hôtel de Villars was named after the Governor of Provence. Built in 1710 its stately entrance was created by George Vallon. Hôtel Isoard de Vauvenargues conceals an elaborate décor behind its severe frontage. Hôtel de Forbin is one of the grandest mansions. Built in 1656 on plans by Pierre Pavilion, its comeliness arises from the simplicity and symmetry of its design. At the top of the cours, Hôtel de Poète was erected in the early 18th century in place of an ancient water mill.

In place Richelme a food market is held every morning, a tradition since the Middle Ages. In the next square, Hôtel de Ville is an Italian baroque edifice and the locale of the flower market. The square is also home to the Tour de l'Horloge, former belfry of the town and symbol of local government power. A grandiose structure that spans the street on Roman foundations, it was erected in 1510 and preserves an astronomic clock containing four wooden statues.

Richelme food market

According to the local legend, Cathédral de St-Sauveur was built on a temple of Apollo between the 5th and 18th centuries. This architectural gem is distinguished by a Romanesque gate, a Roman wall, a richly carved Gothic gate and a church tower constructed between 1323 and 1425.

Cathédral St-Sauveur

Just north of the cathedral in a romantic wooded garden on a hillside overlooking the city, Atelier de Cezanne has been lovingly restored and looks as it did when the artist died in 1906. *The Cézanne Trail* begins at the tourist office and is indicated by bronze markers. As an aside: just south of Aix is the Abbaye de Tholonet, Cézanne's favorite place. A memorial stone bearing his effigy stands in front of a restored windmill.

Just outside the ramparts, the Church of St-Jean and the Palais de Malte were constructed in the 13th century. The first Gothic edifice in Provence, among the church's treasures is the triptych of the *Buisson Ardent* (burning bush). A 15th century masterpiece of French art it was painted for King Rene by Nicolas Froment. Palais de Malte is now the Musée Granet, named after Aixois painter François Marius Granet. The permanent collections make it one of the richest Provençal museums with works by mostly French painters of the 15th to 20th centuries. The archeological rooms exhibit Greek and Roman sculptures and explore the origins of Aix and the Celto-Ligurian civilization of Entrement. Since 1984 the museum has gathered eight paintings by native son Cézanne.

Accommodations
200 beds in single, double and triple rooms. There is also a "gite" with 60 beds where groups of 10 or more can be hosted. All rooms have a sink; baths are shared.

Amenities
Towels and linens are supplied.

Cost per person/per night
Lodging only: single 18.50€, double 12.50€, triple 11.00€.
Half board: single 33.00€, double 27.00€, triple 25.50€.
Full board: single 44.00€, double 38.00€, triple 36.50€.

Meals
All meals can be provided with the lodging.

Special rules
Curfew is at 10 PM.

Directions
By car: From Aix-en-Provence take A8 and exit at St-Maximin (exit 34).
Follow the signs towards St-Zacharie on N560 and then follow the signs
to Nans-le Pins on D80. From there follow the signs to Plan d'Aups Ste-
Baume.

From Marseille: Take A52 towards Aix-en-Provence. Take the Bretelle
d'Auriol and exit at Auriol. Right after the exit's roundabout, turn right
on D80 and follow the signs to Plan d'Aups Ste-Baume. A detailed map
is available on the website.

By train: Public transportation to Plan d'Aups Ste-Baume is difficult. A
car rental from the station at Marseille is recommended.

Contact
Sœur Hôtelliere
Hôtellerie de la Ste-Baume
La Ste-Baume
83640 Le Plan d'Aups Ste-Baume
Tel: 0033 (0)4 42 04 54 84
Fax: 0033 (0)4 42 62 55 56
Website: http://saintebaume.dominicains.com

NOTES

ASSOCIATION MARIE-CLOTILDE
Sainte-Clotilde Sisters

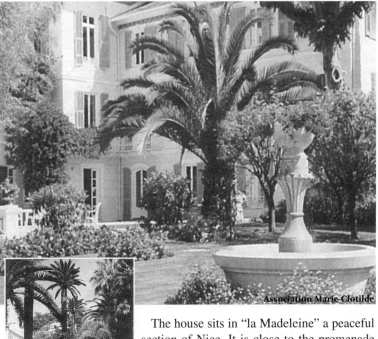

Association Marie-Clotilde

The house sits in "la Madeleine" a peaceful section of Nice. It is close to the promenade des Anglais and not far from the center of town. The grounds convey a tropical aura, one of palm trees, bougainvillea and soft pastel colors. The graciously proportioned house, with its azure blue shutters, is surrounded by a pretty Mediterranean garden. In 1928 it was enlarged, renovated and converted into a guest house for anyone on holiday. It is the property of the sisters of Ste-Clotilde who manage the institution in conjunction with the Association Marie-Clotilde. In order to be hosted, membership in the association is necessary and simple to do; all that is required is a small fee at check in.

Nice is the fifth largest city in France and among the most famous resorts on the French Riviera. Most likely a Greek colony, it was pillaged and burned by the Saracens in the 9th century. In 1543 it was besieged and burned once again by Francis I. During the first year of the French Revolution, Nice was a sanctuary for royalists.

An international city it has an historic and artistic pedigree and is celebrated for its promenade des Anglais. An inviting seafront boulevard, it follows the curve of the Baie des Anges and is always enlivened with flowers.

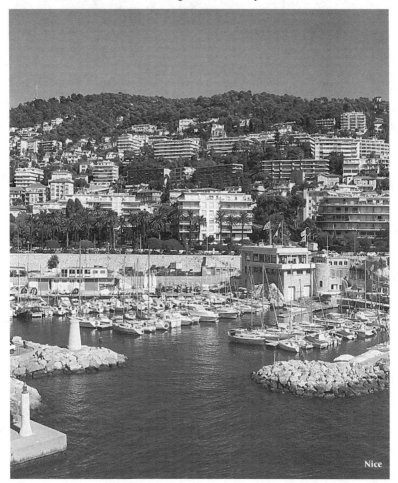

Nice

Inland view along the "English Walk."

Originally a narrow path just six feet wide, it was an Englishman, Reverend Lewis Way, who had the promenade built at his own expense in 1820. The locals immediately christened it "English Walk."

Nice has preserved many traces of its eventful past and offers a provocative mix of architecture. The town consists of two very different parts, the Vieille Ville and the newer town. The Association Marie-Clotilde is in the newer part of town. The following are highlights of that section.

Bayside view along the "English Walk."

Musée des Beaux Arts is very close to the maison. In a 19th century Italian Renaissance-style villa, the museum exhibits a collection of paintings and sculptures that spans six centuries and includes works by Dufy, Renoir, Monet, Rodin, Sisley and the Impressionists.

The sumptuous Cathédral Orthodoxe Russe St-Nicolas showcases five green-gold, onion-shaped cupolas. Constructed at the beginning of the 20th century under the patronage of the last tsar, Nicolas II and his mother, Dowager Empress Marie Feodorovna, the cathedral is the most beautiful religious edifice of its type outside Russia and the most perfect representation of Russian religious art abroad.

La Basilique Notre-Dame is the city's largest church and the oldest of the modern religious structures erected after the Comte de Nice became part of France. The stained glass windows were added in the late 19th century.

Originally founded by the Romans, the Cimiez district on the hills overlooking Nice was once the town's most fashionable quarter. The Franciscan monastery, church and museum of Cimiez are an evocation of the life of Franciscan monks in Nice from the 13th to 18th centuries. The ensemble is representative of the spiritual and social message of St-Francis of Assisi as seen through paintings, sculptures, engravings, illuminated manuscripts and frescoes. The 16th century cloister displays 17th century engravings. The cemetery is the burial place of Raoul Dufy, Roger Martin du Gard and Henri Matisse. The Garden of Cimiez is a haven of peace and harmony. In the spring the ancient pergolas are covered with climbing roses and masses of flowers perfume the air.

In the same locale, the Archeology Museum of Nice-Cimiez encompasses the amphitheater, public baths (3rd century AD), paved streets and the Palaeochristian Episcopal Group (5th century AD). The museum was inaugurated in 1989 and presents collections ranging from the Bronze and Iron Ages to the Dark Ages and includes ceramics, glass, coins, jewelry and sculptures.

Musée Matisse is in a completely renovated 17th century Genoan-style villa in the heart of the olive grove in the Garden of Cimiez. It conserves the personal collection of the great Fauvist painter who lived in Nice from 1917 until his death in 1954. Works from all periods of his life are displayed.

Accommodations
45 beds in apartments and studios with 4 to 5 beds each. All apartments have a bedroom, living room and kitchenette.

Amenities
Towels and linens are supplied.
Private parking and TV room.

Cost per person/per week
To be determined when reserva-
tions are made. Cost is dependent
upon the season.

Meals
Meals are not provided. Guests
may use the kitchen in each apart-
ment.

Special rules
Pets are not accepted. Minimum stay is 1 week; maximum stay 3 months.

Directions
By car: Take A8, exit at Nice-Centre and then follow the signs to the Madeleine Quarter.
By train: Get off at Nice and take a taxi or bus #12 or 23. Both stop in front of the house.

Contact
Anyone who answers the phone
Association Marie-Clotilde
42, boulevard de la Madeleine
06000 Nice
France
Tel: 0033 (0)4 92 15 55 00
Fax: 0033 (0)4 92 15 55 18
Email: association-marie-clotilde@wanadoo.fr

MAISON DU SÉMINAIRE
Property of the Diocese of Nice
Managed by the Association Amis du Séminaire

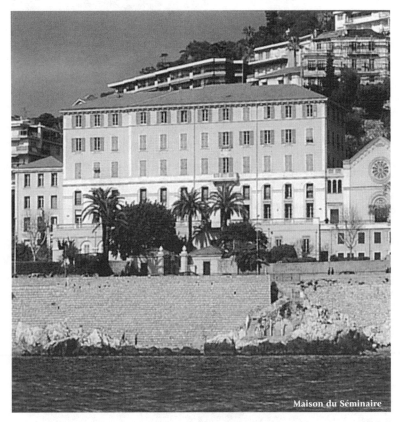

Maison du Séminaire

The ancient seminary of Nice is now a hotel possessing a wonderful position overlooking the Baie des Anges, a short distance from the famous promenade des Anglais and right beside the Port of Nice. The Maison du Séminaire has its own serene garden and a restaurant with a terrace on the sea. Its chapel is opulently embellished. The maison is close to the Vieille Ville and convenient to many monuments and sites.

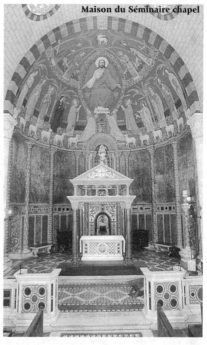

Maison du Séminaire chapel

The old quarter contains a treasure trove of Baroque art from the 17th and 18th centuries including many churches and chapels. It is also home to the Palais Lascaris. Classified as a historical monument, the Genoese-style palace combines a 17th century ensemble with embellishments and modifications from the 18th. The buildings are organized around two small inner courtyards from which a monumental stairway leads off through arched bays. The ceilings in some of the rooms are either decorated with frescoes on mythological themes or with stucco dating from the end of the 17th century. The palace is now a museum of folk art and tradition.

The long rectangular courtyard of Le Cours Saleya is one of the liveliest parts of old Nice and a major meeting place for locals and visitors alike. The Flower Market is held there every day except Monday when the Antique Market takes center stage. Every evening, from June to September, there is an Arts and Crafts Market. Nice is known for several epicurean specialties sold in and around the cours including the *pissaladiere,* an onion, anchovy and olive tart; *pan bagnat,* a vegetable and tuna sandwich; *ratatouille,* a tomato, eggplant and zucchini squash stew; and, of course, the famous *salade Niçoise.* Many of the dishes are garnished with succulent little black olives called *caillettes.*

Musée d'Art Contemporain is in a complex of four marble-fronted towers linked by glass passageways. The museum specializes in art from the 1960s to the present. Exhibits include works by Andy Warhol as well as many artists from the Nice School such as Cesar and native son Yves Klein.

Le Palais de Justice was built in neoclassical style at the end of the 19th century and is home to several theme markets. The courthouse annex occupies Caserne Rusca, the former barracks across the square. A lovely pedestrian area lies between the two buildings. The opera house was built on the site of the former municipal theater, destroyed by fire in 1881. Inaugurated in 1885 it is a prime example of *belle époque* architecture.

Religious architecture is well represented in Nice, particularly in la Chapelle de la Miséricorde. The first stone of the church was laid in 1740 and the chapel was given to the Brotherhood of Black Penitents. An architectural gem both inside and out, its Baroque style showcases distinct curved lines enhanced by a lovely golden color.

Just east of Nice, Villefranche sur Mer is one of the most entrancing spots along the Côte d'Azur. The port, citadel, old town and the gentle curve of the coast all contribute to the gracefulness of the village which dates back to 130 BC. Overlooking the old quarter and the sea is the 16th century Citadelle St-Elme. The village shelters narrow lanes, stairways and covered passages that lead to the colored façades of its ancient houses.

Thanks to its rich heritage, Menton, on the boundary of the French Riviera and the Ligurian Alps, has become one of the "120 Cities of Art and History in France." Part of Monaco until 1848 when it declared itself a free city protected by Sardinia, the town is known for its lemon groves. When the trees are in bloom, the fragrance permeates the air. The architectural legacy of the old town can be admired in the glazed tile-covered church towers and handsome façades fronting the narrow streets. Monuments include the Palais Carnoles. Executed in the style of a Petit Trianon, it is a listed historic building. Menton's 16th century fort stands guard over the harbor and a 17th century Baroque church. The former bastion is now the Musée Cocteau.

Accommodations
60 rooms with 1 or 2 beds and private bath. Two family suites with two bedrooms and bath. All rooms have TV and telephone. Most have a view of the sea.

Amenities
Towels and linens are supplied. Private parking, garden, ten meeting rooms and a restaurant.

Cost per room/per night

Single room 70.00€, half board 87.00€, full board 99.00€.
Double room 80.00€, half board 114.00€, full board 138.00€.
Triple room 115.00€, half board 166.00€, full board 202.00€.
Quad room 150.00€, half board 218.00€, full board 266.00€.

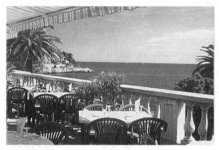

Meals

Breakfast 6.00€, lunch and dinner 13.00€ to 18.00€.
All meals can be provided with the lodging but full and half board service is only provided when staying a minimum of three nights.

Directions

By car: Take A8 and exit at Nice (either exit #50 or #55) - a detailed map is available on the website.
By train: Get off at Nice-Centre Ville and take a bus to the hotel.
Bus service connects the hotel with the center of town and the train station every half hour.

Contact

Anyone who answers the phone
Maison du Séminaire
29, boulevard Frank Pilatte
06300 Nice
France
Tel: 0033 (0)4 93 89 39 57
Fax: 0033 (0)4 93 26 79 99
Email: mds@maison-de-seminaire.com
Website: www.maison-du-seminaire.com

HÔTELLERIE NOTRE-DAME-DU-LAUS
Priests of the Diocese of Gap

The shrine of Notre-Dame-du-Laus stands on a beautiful perch in the midst of the Hautes-Alpes of Provence. As legend has it, in 1664 a seventeen-year old shepherdess named Benoîte had a vision of a "beautiful lady" which continued every day for months. The Virgin Mary asked that a church and a priest's house be built. Soon after the construction, the site became a popular pilgrimage point. The Virgin asked Benoîte to tell people who were ill to believe in their faith. According to tradition, those who believed were healed.

The shrine is a grouping of sites that leads to the basilica built by donations of the pilgrims. Various chapels related to the apparitions are peppered throughout the area. To this day a small flame in front of the altar heats the oil people use to anoint themselves. Benoîte died at the age of 71 after serving the church and the pilgrims all her life. The shrine is the most important spiritual center of the Diocese of Gap; priests, religious representatives and lays are actively involved in hosting the pilgrims.

Gap is the closest town to the shrine and the capital of the Hautes-Alpes département. Sited on the river Luye, it is the largest town in the southern Alps. It was founded by Augustus in 14 AD for its strategic position linking Turin with the Rhône valley. Its cathedral is a blend of Romanesque, Provençal and Gothic styles and, along with the town hall, is registered as an historical monument.

The 17th century castle at Domaine de Charance is the locale of the Alpine Botanical Conservatory. A venue of rocks and forests, there are a hundred peaks over 10,000' and nearly as many waterfalls and streams. Exhibits cover regional archeology, a collection of old weapons, a model of the city as it was fortified in the 16th century and characteristic Queyras furniture. One of the most curious sites of the botanical gardens are the *Demoiselles Coiffées* (young ladies with hats), towering stone pillars topped with "hats." Gap's colorful market is held each Wednesday and Saturday at place de la Republique. Visitors can sample traditional Alpine cuisine such as *Champsaur pies* or *raviolis de Gap* - a creamy potato gratin.

420

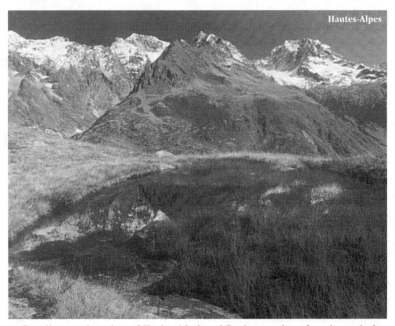

Gap lies on the edge of Ecrins National Park, a realm of peaks and glaciers at the crossroads of the routes that link the cities to the mountains. The park boasts 600 miles of footpaths covering an area of 400 square miles and is a paradise for hikers, climbers, bird watchers, botanists and geologists. At a height of between 2,400' and 13,000' above sea level, the region is a medley of contrasting scenery. From the foothills, Mediterranean lavender gradually gives way to the forests and edelweiss of the high peaks.

To the west, hidden in the heart of the southern Alps and reaching right up to the Italian Piedmont, the park of Le Queyras is protected by a wall of mountains and enjoys an ideal sunny climate. The secrets of the region are best discovered on foot. A natural conservatory of fauna and flora in the Mediterranean Alps, hiking trails lead to the center of the area and beautiful little settlements. The only entrance to Fort Queyras is by way of a medieval-style drawbridge. The imposing mass of the fort, towering above the village of Château Queyras, was intended as an advance lookout post to provide sufficient warning to the garrisons at Montdauphin and Briançon.

Briançon, keystone of the French defensive system, is an historic town of frescoes and carved wooden doors. At 4,000' it is the second highest town in Europe. Notable buildings include the Italianate Templar preceptory, the Cordeliers church, the Penitent's Chapel and the Abbey Church of Notre-Dame. The fortified village of Montdauphin took 100 years to complete and guards the Queyras and Durance valleys. Its streets are wide and straight with superb views over the Guil valley.

The Hautes-Alpes is unlike the Provence of the south. Not as well known and certainly less visited, it is a quiet refuge from the frenetic pace of the coast. Several towns in the vicinity are worthy of exploration. To the south of the shrine, Digne-les-Bains is a spa enclave and principal town of the Alpes-de-Haute-Provence département. It occupies a wonderful situation between the Durance valley and the start of the high Alps. Digne-les-Bains is the home of world traveler Alexandra David-Neel, the first western woman to visit Tibet. Her home, Samten Dzong, is now a Tibetan meditation center. Dignes is particularly well suited to geologists. The Réserve Naturelle Géologique de Haute Provence is the largest such reserve in Europe with fossils dating back 300 million years. During July and August guided day trips are organized by the tourist office. A traditional market takes place Wednesday mornings in place du Général-de-Gaulle.

"Train des Pignes" (Pine Cone Train) is a tourist train that runs round-trip from Digne-les-Bains to Nice along the Var river valley. The ninety-five mile trip takes three hours and travels through extraordinary terrain. The train's name has some colorful legends attached to it. Some believe the name is derived from the pine cones that townsmen brought back with them. Others believe that the speed of the train was so slow that it was possible for travelers to hop off and on and collect pine cones. The last holds that the name comes from a Christmas story about a gatekeeper who, while caring for his sick child, ran out of

Pine Cone Train

firewood and the crew of the Christmas eve train stopped to offer the train's coal to him. Later when the steam engine ran out of fuel, the engineers used the pine cones along the route to power the train.

There are several villages along the train
route including the tiny hamlet of Annot, a
medieval walled hamlet nestled in the hillside;
and fortified Entrevaux, recognized as a
"Village and City of Character." In the latter a
series of ramps lead to the citadel atop the
rock. Most of the buildings were constructed
between 1693 and 1705 on the ruins of the
ancient Glandeves Château. The bell tower
was built by the Knights Templar in the 11th
century.

Entrevaux

South of Digne-Les-Bains and closer to the coast are the cities of
Moustiers Ste-Marie, Aups and Cotignac. Moustiers is on a ridge in a
craggy mountain setting of lavender, thyme and cork oaks. The site
marks the start of the great gorges of the river Verdon, among the most
extraordinary land formations in France. The chapel of Notre-Dame-de-
Beauvoir commands an incredible view of the region. A renowned
ceramics center in the 17th and 18th centuries, the village became famous
for its faïence. The secret glaze was given to the artisans by a monk from
Faenza in Italy. A creative little town, artisan workshops border the quin-
tessential cobbled squares of the village.

Aups is a tiny walled village encircled by a rolling countryside of vines
and olive groves. Medieval gateways, archways and squares sprinkled
with fountains testify to its rich past. Vendors at the Thursday morning
market sell local specialties including wine, honey and oil. Every
Thursday from November to February a black truffle market takes place.
An old convent has been converted into the Simon Segal Museum where
a collection of modern art is housed.

Nestled at the foot of a sheer limestone escarpment honeycombed with
caves and the ruins of a medieval castle, Cotignac's narrow cobbled
streets and archways, intricately carved doorways and ochre-colored
stone houses epitomize the essence of Provence. As in many Provençal
villages, life in Cotignac revolves around the cours, in this instance the
cours Cambetta, a broad esplanade fronted by cafe tables beneath the
thick foliage of plane trees. The ancient ramparts have been transformed
into a theater where summer performances of music and drama are set

Cotignac

against a backdrop of the Rocher, a red-rock butte. At the foot of the Rocher are traces of caves and grottoes where people and their animals sought shelter from attacks by the Saracens and other raiders.

To the west of the shrine, Sisteron is an important mountain gateway to Provence. Fortified for centuries, and despite the bombardment during WWII, its citadel stands as a sentinel over the town and is the solitary bridge across the river Durance. Most of the town's defenses were constructed after the Wars of Religion and expanded a century later by military engineer Vauban. Three immense towers dominate the ancient core. Beside them stands the Cathédrale Notre-Dame-des-Pommiers, a 12th century church whose entryway is flanked by marble columns. Market days are Wednesday and Saturday and are held in place de l'Horloge.

Accommodations

There are several types; about 450 rooms with 1-5 beds including private or shared bath, some with telephones or other amenities. There is also a large dorm for groups of 25.

Amenities

Towels and linens are supplied for those staying in the rooms.
Groups must supply their own towels and linens.

Cost per person/per night

((Minimum and maximum depend on the type of room and the length of stay)
Lodging and breakfast: single 18.50€ to 28.50€, double 15.50€ to 21.50€, triple 13.50€ to 16.50€.
Half board single 27.50€ to 39.50€, double 25.00€ to 31.50€, triple 23.50€ to 27.50€.
Full board single 34.25€ to 50.00€, double 30.25€ to 43.00€, triple 29.25€ to 38.00€.
Cost per person per day in the dorm: summer 4.10€, winter 6.10€.
Use of the kitchen 1.50€.
Minimum contribution is 80.00€ if the group is less than 20 people.

Meals

All meals can be provided by the restaurant.
Lunch 11.00€ to 12.00€, dinner 10.50€.

Special rules

Maximum stay one month.

Directions

By car: From Aix-en-Provence take A51, exit at La Saulce and follow the signs to Briançon on N85. From there take D942 and follow the signs to Notre-Dame-du-Laus via Tallard.
By train: Get off at Gap. Take a taxi or call the hôtellerie 48 hours in advance and arrange to be picked up (11.00€ per person). There is no public transportation.

Contact

Anyone at the desk
Hôtellerie Notre-Dame-du-Laus
05130 Saint-Etienne-le-Laus - France
Tel: 0033 (0)4 92 50 30 73; Fax: 0033 (0)4 92 50 90 77
Email: accueil@notre-dame-du-laus.com
Website: www.notre-dame-du-laus.com

COUVENT DE PASSE PREST
Dominican Sisters of the Sainte-Famille

From a wooded hill of the Alpes-Maritimes (at 2,150') the convent enjoys a panorama of Cap d'Antibes and the Estérel mountains. The convent was once an orphanage (1875) established by the nuns who sought to escape the high temperatures and crowds of Monaco. At that time the area was totally secluded. Today it remains tranquil but many villas encompass the convent. The chapel of the convent has been restored in such a way that the original stones have been left exposed. "People usually like the ancient quality that remains," one of the sisters commented.

Occupying a rocky outcrop and enveloped by ramparts built on the orders of François I in the 16th century, St-Paul is one of the most beautiful hill villages in Provence and among the most popular. The majesty of the terrain and the exceptional light has inspired untold artists, painters, writers and poets. Many artists are represented at the Fondation Maeght (just northwest of town) which sustains a large collection of paintings, sculptures, drawings and other graphic works from the 20th century. An unusual modern art museum, it was established in 1964 by Paris art dealers, Aim and Marguerite Maeght. The extraordinary pink and white structure is quartered amid pine trees in a lovely garden. The interior houses fine works by Matisse, Chagall and Bonnard among others. The terraced garden is highlighted by sculptures, mobiles and mosaics by Giacometti, Arp, Calder and Miro. A tiny chapel in the middle of the complex contains Georges Braque's *White Bird on a Mauve Background* (1962) painted the year before he died. The chapel commemorates the Maeght's son whose death at an early age inspired the creation of the foundation.

From the intact ramparts of St-Paul there are wonderful views over the hills, the Côte d'Azur and the Mediterranean. With its proximity to the sea (11 miles) and countless walking paths, St-Paul is a small slice of paradise. The narrow, winding streets of the village, from the Porte Royale to the Porte Sud, reveal a bevy of medieval buildings with stone façades. The fanciful village is a delightful, albeit often crowded, maze of mosaic-paved alleys, plazas with ancient fountains, secret gardens, porches and colorful windows. On the hilltop stands a 12th century church that preserves a painting of Ste-Catherine attributed to Tintoretto.

426

At the entrance to the village is the famous Hôtel la Columbe d'Or. The owners are art collectors and were friends of the artists who lived in the village. The restaurant houses one of France's most interesting private art collections including work by Braque, Chagall, Dufy and Picasso. Lunch at the expensive restaurant is like an entrance fee to a museum and its artistic assemblage.

Not far from St-Paul are two beautiful villages. Coaraze with its medieval character is referred to as the village of sunshine. Perched at 2,100' Coaraze offers outstanding views over the valley and hills. Its 14th century church, old winding streets, vaulted passageways and enameled sundials on the façade of the old town hall add to the charm of the place.

Sitting on the peak of a rocky spur above the Loup gorge, the village of Gourdon, known as the Saracen town, towers 985' above the hamlet of Pont-du-Loup. The dramatic locale provides incredible views over the coast, from Nice to the Estére. Its old gray houses appear to be part of the rock. A popular tourist destination, the streets of the village are filled with studios and shops of local artists.

Other excursions can include the Esteron and Cheiron valleys in the nearby mountains. Gilette is an ancient village full of character crowned by the ruins of its castle. Bezaudun-les-Alpes overlooks deep, lush valleys. Topped by a rectangular 13th century tower, the castle stands at the highest point in the village, just above the church with an altarpiece by Brea. Ste-Agnes is the highest coastal hilltop village in Europe. Enveloped by a ring of peaks, it overlooks the Bay of Menton. Its fort was built as part of the Maginot Line.

Accommodations
15 beds in single and double rooms. Baths are shared.

Amenities
Towels and linens are supplied.

Cost per person/per night
To be determined when reservations are made.

Meals
All meals are provided with the lodging.

Special rules
Punctuality at meals is required.

Directions
By car: From A8 exit at Cagnes-sur-Mer and follow the signs to St-Paul/la Colle on D36. Once in St-Paul call the sisters for directions.
By train: Get off at Cagnes-sur-Mer and take a taxi or bus to the convent (it is better to take a taxi).

Contact
Anyone who answers the phone
Couvent de Passe-Prest
06570 St-Paul
France
Tel: 0033 (0)4 93 32 53 93
Fax: 0033 (0)4 93 32 83 09
Email: couventpasseprest@wanadoo.fr

MONASTÈRE DE LA VISITATION
Visitation Nuns

The monastery is relatively new. The nuns who came to Sorgues in 1955 belonged to a monastery founded in Avignon in 1624 but moved to this location seeking a tranquil spot in the countryside. Over the ensuing years the area was developed but the monastery has managed to preserve an aura of serenity within its own parkland. The six nuns who inhabit the monastery live in seclusion, so the monastery itself cannot be visited. The guest house is in a building annexed to the monastery.

With the exception of the ruins of the castle walls and a keep, little remains of Sorgues medieval patrimony. There is an immense square where streets wind up to the old village. Several fountains embellish the roundabouts and here and there are glimpses of the past. At the entrance to the village, on the Vedène road, are the gardens of Château de Brantes. On weekends the Italianate park is open to the public. It boasts stone fountains, ponds and a famous plane tree forest that claims the highest plane trees in France – 85' high, on average. At the exit of the village is an old water wheel on the banks of the river Sorgues.

Just south of Sorges is Avignon, great city of the popes. Gateway to Provence, the city is one of Europe's best-preserved architectural gems. In 1995 Avignon was recognized by UNESCO as a World Heritage Site. For centuries the city was one of the major artistic centers of France. It is graced with spectacular monuments and museums, dozens of grandly adorned buildings, ancient churches, chapels and convents dating from the Roman, medieval, Renaissance and Napoleonic eras. Together they form an incredible architectural convocation, a veritable outdoor museum.

Palais des Papes

Avignon is enclosed by vast medieval walls built in 1403 by the Anti-Pope Benedict XIII. He was the

last of nine popes who based themselves in Avignon throughout most of the 14th century. The restored gates and towers of the old ramparts ingrain the old town with a sense of unity and dramatically separate it from the modern sprawl of the city. An absorbing labyrinth of narrow streets, some are now pedestrianized and full of shops and fine old mansions.

With its high turreted towers and massive crenelated walls, the city's most dramatic monument is the landmark Palais des Papes. The interior is a honeycomb of chapels, halls and corridors. The ceremonial rooms where the popes received kings and ambassadors are enormous and opulent. The pope's quarters are covered with a fresco of birds, the floor a patchwork of tiles. Musée de Petit Palais is comprised of twenty rooms containing a collection of 13th to 16th century works of the Avignon and North Italian Schools.

Above the fortress-like palace is a series of stairs and zigzagging walkways that ascend to the Rocher des Doms, a gracious 19th century garden of fountains, classical statuary and a pond replete with elegant swans. From atop, views extend across the Rhône to a massive medieval fort in the nearby town of Villeneuve-lez-Avignon.

The Jewish community in Avignon has roots reaching as far back as the first century. The first Jewish quarter or *carrière* faced the Pope's Palace on rue de la Vieille Juiverie. By the early 13th century it was on rue Jacob and place Jerusalem where the present-day synagogue stands. This tiny area, barely 100 square yards, was home to over 1,000 people. There were many restrictions on Jewish life within the quarter. Walls surrounded it and three gates limited activity. The current synagogue was built in 1846 and replaced a much older one that burned down.

Avignon's Vaucluse region, known historically as the Comtat Venaissin, had always been a relatively safe haven for Jews. Ceded to the Vatican in 1274, it remained in the Vatican's hands until 1791 when it reverted to France. Jews in the Comtat spoke a Judeo-Provençal dialect and developed *Comtatdin,* their own liturgy. Under the protection of the Avignon Popes, the community flourished and Jews were permitted to live in Avignon, Carpentras, Cavillon and L'Isle-sur-la-Sorgue, an area known at the time as *Arba Kehilot*, the four holy communities. With the exception of L'Isle-sur-la-Sorgue, these cities still contain fine vestiges of the old Jewish quarters.

A visit to nearby Carpentras has its rewards. An historic town, its roots can be traced to the 5th century BC when it was the capital of a Celtic tribe. For a brief period during the 14th century, it became the papal headquarters. In the 19th century the city's walls were replaced by a ring of boulevards. Of the old ramparts, only the Porte d'Orange

remains. The former towers have been replaced by regularly spaced stairways. The Hôtel Dieu exhibits a noble façade of columns and pediments and sustains an 18th century pharmacy highlighted by a collection of faïence. The façades on the town's 17th and 18th century mansions boast doors and balconies restored in true Provençal tradition.

The southern portal of Cathédral St-Siffrein represents a lovely example of Flamboyant Gothic particularly noted for the handsome grain of the *Pierre du midi* (local stone). Grimacing gargoyles stand out on the gables of the chapel; the curved mullions of the windows are shaped like leaves or small flames. The engraved date stone reveals the founding of the cathedral on May 5, 1405 and the name of its first architect, Colin Thomas. The interior preserves paintings by Mignard and Parrocel. The Flamboyant Gothic door is known as the Porte Juive. Jewish converts entered the church through this portal to be baptized.

The ancient synagogue was founded in the 14th century and rebuilt from 1741 to 1743. It contains relics of the original structure, making it the oldest surviving place of Jewish worship in France. A French historic landmark, the present synagogue was partially restored in the 1930s and 1950s. Although plain in appearance, the synagogue conceals an ornate Rococo sanctuary similar to Italian synagogues of the same period. The raised *bimah* (where the Rabbi stands to read the *Torah* scrolls) is also emblematic of the style. The medieval cemetery was destroyed in 1322 and the grave markers were used to build the town's ramparts. The present day cemetery was established in 1367 but as papal edict forbade tombstones in Jewish cemeteries, the earliest stones are from the 18th century.

Every Friday Carpentras hosts a colorful and irresistible market, among the best in Provence. The entire center of town is filled with tables overflowing with produce and local crafts.

South of the monastery quaint L'Isle sur la Sorgue lies at the foot of the Vaucluse plateau in the plains of Comtat Venaissin. The river Sorgue surrounds the city while canals meander through narrow streets crossed by little bridges and highlighted by mossy waterwheels. The Collegiate Notre-Dame des Anges has an exceptional Baroque interior while the 18th century hospital pharmacy possesses a rare collection of Moustier faïence. Many of the grand

Faïence

mansions have been converted into art galleries. Hôtel Donadei de Campredon dates from the 18th century. Now a museum, it exhibits artists such as Miro, Gauguin and Dufy. L'Isle sur la Sorgue is renowned for its antique fairs at Easter and over the August 15th holiday. Nearly 300 permanent antique dealers and secondhand shops have given the small city a worldwide reputation.

Just north of Carpentras is the town of Orange. A 1ˢᵗ century AD triumphal arch, gloriously adorned with battle scenes, attests to the town's Roman origins. Standing majestically over the city, the amphitheater is listed as a "Monument of the World." Built in the early days of Christianity, it is the only Roman arena in Europe to have conserved its stage wall. Cultural events still take place in the ancient space. The old town is a patchwork of narrow streets, well-restored façades and squares.

Accommodations

17 single and double rooms with shared bath (each room has its own sink).

Amenities

Towels and linens are supplied on request at an extra charge of 2.50€.

Cost per person/per night

Lodging and breakfast 12.00€.

Meals

All meals can be provided on request. Lunch 10.00€, dinner: 8.00€.

Special rules

Curfew is between 9:00 and 9:30 PM.

Directions

By car: On A7 exit at Avignon nord and follow the signs to "Clinique Font-Vert." Once there follow the signs to the monastery.

By train: Public transportation to the monastery can be confusing. The nuns suggest getting off at Avignon and taking a taxi to the monastery.

Contact

Send a letter or email to the Mère Supérieure
Monastère de la Visitation
Domaine de Guerre
84700 Sorgues
France
Tel: 0033 (0)4 90 83 31 14
Email: maxime_ste@yahoo.fr

ABBAYE SAINT-MICHEL-DE-FRIGOLET
Canons Regular of Prémontré

Tucked away in an isolated valley of the Montagnette, the abbey is a welcoming institution stationed in a pine, olive and cypress woodland. The name Frigolet derives from a Provençal expression that means "site where thyme grows." The abbey's favorable position offers a unique perspective of the wild and fascinating panoramas of the Mediterranean flora with its fragrance of thyme, cypress and pine. Legend holds that the founders of Frigolet were a group of monks from Montmajour who caught malaria while draining the marshy soil of the Rhône and decided to recuperate in Tarascon. History on the other hand indicates that the first monks who officially founded an abbey in 1133 were a group of Canons Regular of St-Augustin. Some buildings from that period remain including the cloister and church of St-Michel and the small chapel of Our Lady of Good Remedy. The latter has attracted pilgrims for nearly a thousand years.

The abbey prospered until the 15th century at which time it became a Dean of Ste-Marthe church in Tarascon. Over the years it was gradually abandoned. In the 17th century the Hieronymite monks brought it back to life. They restored the complex, enriched the chapter room and embellished the Chapel of Our Lady with baroque decorations. In 1789 a fire destroyed the library. The French Revolution determined that the abbey be sold. In the 19th century the institution became a sweet factory, dairy works and butcher shop. In 1858 Père Boulbon bought the premises and began restoration. In 1880 the monks were expelled by the army. The events that took place at that time are described by writer Alphonse Daudet in his book *Port-Tarascon*.

It wasn't until 1921 that religious life recommenced at the abbey. Today the monks are actively engaged in the spirituality of the nearby parishes as well as the production of honey and syrup.

Despite the vicissitudes and years of strife, part of the medieval complex has been perpetuated. The original church of St-Michel was built in the 12th century in a sober Romanesque style. It was restored and enlarged in the 19th century and its fine stone roof was preserved. The cloister was also built in pure Romanesque style, visible in the few remaining friezes, masks and capitals.

The new church is neo-Gothic and built with exuberant golden decorations. Its design was inspired by Ste-Chapelle of Paris. The Chapel of Notre-Dame de Bon Remède is now incorporated by the new church and forms the apse of the left nave. Apart from the Baroque adornments added by the Hieronymite monks, it has gilded carvings donated as a sign of gratitude by Queen Anne of Austria. (She had come to pray for an heir to the throne of France and her prayers were fulfilled in 1638.)

In the Middle Ages Tarascon was enclosed by ramparts. The massive and noble Condamine Gate was one of three main gates. It was built in 1379 with a drawbridge and two towers; one with arrow slits, the other plain walls. The Jarnègues Gate is the only secondary gate that remains. It leads onto a bridge over a small branch of the Rhône. Under the vaulting stands a statue of a saint who protected the street and area.

Erected on a limestone rock on the banks of the Rhône and isolated from Tarascon by wide moats stands the very image of a fairy tale castle complete with turreted towers and mighty vast walls. Although the foundations date from the 12th century, the main section was constructed in the 15th by King René. One of the finest examples of Gothic military architecture in Provence, it was built on the site of the Roman castrum and has survived nearly intact. The interior shelters a collection of 18th century pottery, ornate painted wood ceilings and exceptional 17th century tapestries on the life of Scipio.

Many interesting towns are in the vicinity of the abbey. The fortified village of Les Baux is an unusual, mysterious place where the ruined 11th century citadel is hard to distinguish from the edge of the plateau. The town once numbered 6,000 but in 1632, Richelieu razed the feudal

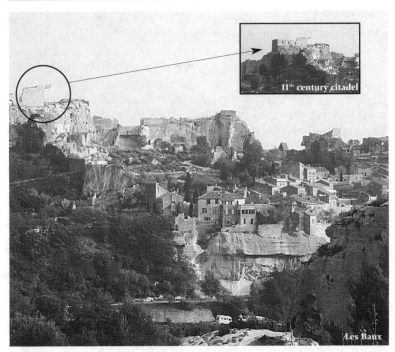

11th century citadel

Les Baux

citadel to the ground and fined the population into penury for their dis-
obedience. It wasn't until the discovery in the neighboring hills of the
mineral bauxite that the village was brought back to life. Now a popular
tourist attraction, the town is defined by lovely restored buildings and
half-ruined Renaissance houses. Musée Yves Brayer in the Hôtel des
Porcelets displays paintings of the 20th century figurative artist. Changing
exhibitions of contemporary Provençal artists are highlighted in Hôtel de
Manville.

The most compelling reason to visit Les Baux is the Citadelle de la
Ville Morte, a scene of ruins and museums. The Musée de l'Olivier fea-
tures slide shows of paintings of olive trees and their artistic treatment by
Van Gogh, Gauguin and Cézanne. The most outstanding ruins are those
of the feudal castle demolished on Richelieu's orders. And of course,
there is the mine down the hill and across from the village. An eerie
place, its caves are cool, literally and figuratively, to explore. In addition,
the site offers one of the best views of the village.

Southeast of the abbey is St-Remy-de-Provence. Birthplace of astrologer Nostradamus, the inviting old town is contained within a circle of boulevards planted with old plane trees and lined with houses from the 15th and 16th centuries. Alleyways framed by shops and restaurants lead into immaculate, leafy squares. The Musée des Alpilles features interesting displays on folklore, festivities and traditional crafts. The Musée Archeologique exhibits discoveries from the archeological digs in nearby Glanum, St-Remy's best known site. The extensive area documents a 2,500-year old civilization. The mausoleum and the triumphal arch delineate the entrance to the 7th century BC Roman town. Glanum represents an excellent example of Roman civilization and can be visited every day.

Also to the south, Arles is known for its remarkably preserved Roman arena. Occupied first by Celtic tribes, then by a Greek colony, Arles became Roman when Julius Caesar gave the colony to the veterans of his legions. For a short time, it was the capital of Roman Provence. Almost all the main sights, both Roman and medieval, lie close together in the town center. The arena is one of the largest and oldest of the Roman world and in its heyday could seat 26,000. The Roman theatre is much more of a ruin. In the Dark Ages it was pillaged, its stones used for other buildings. Of the Palace of Constantine, only the baths remain, partly ruins but still

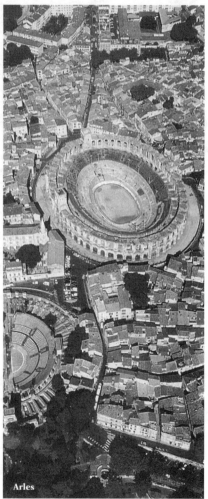

Arles

inspiring in their grandeur. In place du Forum there are two Corinthian columns, relics of a Roman temple.

Musée Arlaten recalls the culture and traditions of Provence. A folk museum founded in 1896 by the poet Mistral, its exhibits include local costumes and lace bonnets, santons and a tableau of Provençal life. It also preserves Jewish ritual and historical objects from Provence. Arles' compact town center is a labyrinth of streets filled with shops and restaurants. A popular Provençal market is held on Saturdays.

Scenic Eygalières is settled on a gentle slope behind the Alpilles mountains. It sits amidst a wild terrain of olive and cypress trees. Quaint stone houses with sky-blue shutters front the lanes leading to the ruined château, village church and 17th century clock tower.

Oppède-Le-Vieux sits high above vineyards on the slopes of the Petit Luberon. A characteristic Provençal village, it is earmarked by a warren of narrow streets and handsome, cream-colored houses tumbling down the hillsides. Many of the antique structures and the Romanesque church have been restored. Oppède is quaint enough to vie with the neighboring villages of Lacoste and Bonnieux for the title of prettiest village in the Luberon.

Somewhat further afield but definitely worth the effort is the ancient town of Uzès, near the start of the Pont du Gard. Perched on a hill above the river Alzon, half a dozen medieval towers rise above arcaded streets and the tiled roofs of the Renaissance and neoclassical houses. The fortified castle of Le Duche has been inhabited by the same family for a thousand years and is dominated by its original keep. There are daily guided tours. On Sunday mornings a traditional market is held in place aux Herbes.

Pont du Gard, a Roman aqueduct across the river Gard, was built in 19 BC to supply Nîmes with water. It consists of three tiers of arches and is 900' long and 160' high. Two thousand years after its construction, it is still an engineering marvel, as much for the inspiring technical expertise as for its architectural proportions and simple beauty. Registered as a World Heritage Site since 1985, the bridge attracts more than a million tourists each year and is the second most visited provincial monument after Mont-St-Michel.

Accommodations
The abbey offers two types of hospitality:
1) Hôtellerie Touristique Saint-Michel: These accommodations are located inside the abbey and management is handled by lay personnel. There are 21 double rooms and one small apartment with 4 beds. All baths are private.

Amenities
Towels and linens are supplied. There are meeting rooms guests may use.

Cost per person/per night
Lodging only 48.00€, half board 65.00€, full board 87.00€.

Meals
All meals can be provided by the restaurant.
Breakfast 6.00€, lunch and dinner for guests of the hôtellerie 13.00€.

Products of the institution
The shop and library of the abbey sell a large range of monastic products and books.

2) Hôtellerie Monastique Saint-Augustin is located inside the abbey. Accommodations are for spiritual retreats only. There are 12 single rooms with shared baths.

Amenities
Towels, linens and all meals (shared with the friars) are provided. Maximum stay is one week and silence on the premises is required.

Cost per person/per night
Full board 28.00€.

Note: The abbey can also host large groups of young people (scouts, etc) for summer camps. For further information see the website or contact the Frère Hôtelier via fax, letter or email.

Directions
From Avignon or Marseille: Take A7 and exit at Avignon sud and follow the signs to Châteaurenard/Graveson/Tarascon on D 28. From Graveson: Follow the signs to Frigolet (5 km).
By train: Get off at Avignon with TGV or at Tarascon with SNCF and take a taxi to Frigolet. There is no other public transportation.

Contact

1) For visitors (not retreats)
Anyone at the desk via telephone, email, fax or letter
Abbaye Saint-Michel de Frigolet
Hôtellerie Saint-Michel
13150 Tarascon
France
Tel: 0033 (0)4 90 90 52 70
Fax: 0033 (0)4 90 95 75 22
Email: hôtellerie@frigolet.com
Website: www.frigolet.com

2) For spiritual retreats
Send a letter, fax or email the Frère Hôtelier
(Reservations via telephone are not accepted)
Abbaye Saint-Michel de Frigolet
Hôtellerie Monastique Saint-Augustin
13150 Tarascon
France
Tel: 0033 (0)4 90 95 70 07
Fax: 0033 (0)4 90 90 79 23
Email: abbayedefrigolet@frigolet.com
Website: www.frigolet.com

NOTES

SANCTUAIRE NOTRE-DAME DES MIRACLES
Property of the Diocese of Nice
Managed by a priest and lay personnel

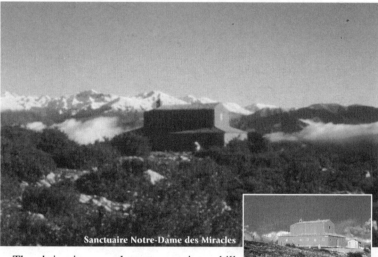

Sanctuaire Notre-Dame des Miracles

The shrine is on a plateau crowning a hill at an elevation of 3,850'. "We are exactly between the mountains and the sea," said the lady at the desk. "On one side are the mountains of the National Park of Mercantour, on the other, the Mediterranean. The view is spectacular and the entire area offers numerous possibilities for trekking."

Legend holds that in the year 850, two sailors from Spain or Portugal, were caught in the midst of a terrible storm when they suddenly saw a supernatural light on top of a mountain. The light led them towards the coast and saved their lives. Having been saved, they promised to build a chapel as a sign of their gratitude. The chapel soon became a pilgrimage site and remained popular for centuries. It was destroyed in the 18th century, reconstructed in 1806 and restored in the 1950s. Continuing the legend, people often search and find star-shaped fossils near the shrine that are believed to have been thrown by the Virgin.

Perched on a ridge at the top of a steep slope, Utelle enjoys panoramic views of the peaks of Haute Vésubie. A medieval mountain village, Utelle is characteristically Mediterranean. The entrance to the town is through an archway, remnants of an ancient wall. A charming patchwork of narrow lanes and small stepped alleyways, the unspoiled ambience of the square is enhanced by colored façades, pink and yellow trompe l'oeil murals and an impressive 19th century fountain decorated with lion heads. Eglise St-Veran is defined by a majestic Gothic archway and columns that frame a door made from twelve sculpted wood panels that relate the story of the life of St-Veran. Originally Romanesque, the church was rebuilt in the 16th century. The interior is a blend of Romanesque as reflected in its nave with columns and capitals, and Baroque as represented by sculpted vaults with figures in stucco. The White Penitents Chapel is listed as an historic monument. Baroque in style, its façade has been repainted in pale yellow. Visits can be arranged.

Within the vicinity of Utelle and the sanctuary is Mercantour National Park, a haven for naturalists. Created in 1979 it covers nearly 173,000 acres and was established to promote the exceptional mountain environment as well as enrich and protect the park's amazing variety of fauna and flora; over 2,000 plant species have been identified. Wolves, chamois, mountain sheep and ibex, golden eagles, falcons and marmots share a domain that is protected by strict regulations. Colmars les Alpes is a fortified village within the park. It showcases classical military architecture designed by Vauban in the late 17th century. The city dates from the Middle Ages and is typified by cobbled streets lined with tall houses.

Stretched between the Vésubie and la Roya valleys in the very heart of the Mercantour National Park lies an open-air museum containing the largest grouping of prehistoric stone engravings in Europe. The Vallée des Merveilles is a registered historical monument with over 40,000 rock engravings dating from 1800 to 1500 BC.

The region encompassing Utelle is a cornucopia of intriguing small towns and perched villages. Nearby Duranus is a tiny village spread amongst a wild and mountainous landscape. It is famous for the viewpoint "Saut des Français." According to legend, French soldiers defending the Comte de Nice were taken prisoners by the Barbets and thrown from the cliffs.

Lantosque sits astride a rock. In previous centuries the village was destroyed by earthquakes and even today it seems to be barely balancing on its promontory. At the top of the steps of the main street are tall houses of stone, some painted with lovely, albeit faded, warm colors. There are a number of sculpted doors, vaulted passages and an antique fountain dating from 1866. St-Sulpice features a wide façade and sculpted door from the 17th century.

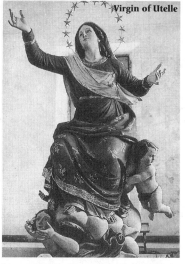
Virgin of Utelle

The medieval village of Belvedere overlooks the valley Vésubie from an altitude of 2,625'. It is not easy to climb the stairs leading to the heart of the perched village but the rewards are streets lined with tall stone houses in the Piedmontese Alpine-style. Some are connected by a *cantoun*, a roofed passageway. The square has a welcoming feel to it with two cafes, old archways and the 17th century Eglise St-Pierre et St-Paul.

The art of frescoes and murals is well represented in the area around the shrine. Typical of the painted chapels popular throughout the Alpes-Maritime between the 12th and 14th centuries, artists such as Baleison, Canavesio, De Cella and countless others created treasures of painted decoration. Excellent examples can be seen in two nearby villages. In La Brigue, Notre-Dame-des-Fontaines conserves a remarkable group of frescoes in a 12th century sanctuary entirely decorated by the Italian masters Canavesio and Baleison on the subject of *The Last Judgment*. In Peillon, at the Pénitents Blancs Chapel, a set of frescoes illustrates scenes from the *Passion of Christ*.

Nearby La Tinée valley is home to a wealth of hilltop villages. Clans stretches along the flank of the mountain in a marvelous setting of pastureland and forests. Its chapels of St-Michel and St-Antoine-l'Ermite conserve brilliant 15th century frescoes. The village of Bairols at 2,725' is reached via a winding road from the Pont de Clans. Its houses rise above a red shale box canyon.

The hamlet of Rimplas is surrounded by two rock masses and sprawls along a crest with views onto the Valdeblore plateau. Sited above a dizzying peak, Roure at 3,700' is known as the "balcony of la Tinee." The bluish red of the shale and the lauze add to the beauty of its striking 17th and 18th century structures.

Accommodations
12 beds in single and double rooms with shared baths.

Amenities
Linens are supplied, towels can be supplied on request.

Cost per person/per night
Lodging only 20.00€, half board 25.00€, full board, 30.00€.

Meals
All meals can be provided with the lodging.

Special rules
Punctuality at meals is required. Respect of the religious site is assumed.

Directions
By car: From A8 or N7 exit at St-Isidore and take N 202 to Bonson. From there take D2565 to Utelle.
By train: Get off at Nice. There is a bus that runs twice a day between Nice and Utelle.

Contact
Anyone who answers the phone
Sanctuaire Notre-Dame des Miracles
La Madone D'Utelle
06450 Utelle
France
Tel: 0033 (0)4 93 03 19 44
Fax: 0033 (0)4 93 03 11 35
Email: madone.utelle@free.fr
Website: http://madone.utelle.free.fr

MAISON LACORDAIRE
Dominican Nuns

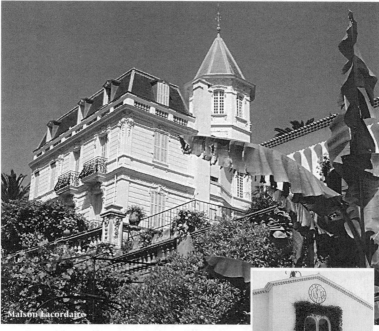

Maison Lacordaire

Chapelle du Rosaire

The complex of Maison Lacordaire is composed of two recently renovated villas surrounding the Chapelle du Rosaire, the last work of Henry Matisse. From 1948 to 1951, the artist designed and entirely decorated the chapel for the Dominican sisters. Considered one of the greatest works of 20th century art, for the artist it was "the climax of a life's work." The website of the maison contains the following: "The chapel of our Lady of Rosary, bathed with light, realized by Henri Matisse, invites you to contemplate and meditate individually or with the community." From the chapel, a second room contains an exposition of the work necessary for its implementation including drawings, lithography and models.

The maison occupies an exceptional position at 1,150'. The guest house is open year-round to individuals, groups and families for workshops, cultural sessions, spiritual meditation, relaxation and vacations. The sisters also organize guided tours of the chapel.

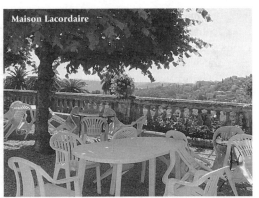

Maison Lacordaire

Henri Matisse said of Vence, "This morning while walking near my house, seeing all these girls, women and men riding their bikes to the market, I thought I was in Tahiti."

The town has a rich historic and artistic past. An important Roman town, it traces its roots to the Nerusii, a Celto-Ligurian people. In the 5th century the bishop of St-Veran saved the town from barbarian invaders. Romee de Villeneuve, representing the counts of Provence, founded a dynasty in 1232. He was a character in Dante's *Divine Comedy*. Monks of the Order of the Templars came to Vence in 1118 and remains of the ancient "commanderie" can be seen at the Château St-Martin.

Matisse

La Vieille Ville has preserved its medieval essence within the city walls and is showcased by flowered squares with carved doors and lanes edged with period architecture. The plane trees on place du Grand Jardin form an umbrella over the traditional daily market. Each summer the square is also the venue for les Nuits du Sud, a music festival.

Numerous churches bear wit-
ness to the centuries-old reli-
gious culture of the city. The
cathedral was originally built in
the 4th century on the founda-
tions of a Roman temple and
took its present form in the 13th
century. It houses many treasures
including a unique set of forty-
nine statues in polychrome wood
and a remarkable mosaic by
Chagall. The Chapel of the
White Penitents proudly displays
its dome of polychrome tiles.

Vence

Vence has always attracted
artists, painters and poets
including Dufy, Matisse, Chagall, Dubuffet and D.H. Lawrence. In 1909
Raoul Dufy stayed in Vence for the first time, attracted by the intense
luminosity of the sky and the mysterious outline of the *Baous* (high
peaks).

The surrounding countryside has remained in its natural state and is
filled with white and green oaks, Aleppo pines, rosemary, acanthus and
bellflowers. Trails lead to waterfalls and rivers, peaks and plateaux as
they travel through breathtaking scenery filled with deer, royal eagles,
owls and ermine. In the spring wild orchids add to the appeal.

In nearby Tourrettes sur Loup, the ramparts are actually formed by the
village's outer houses. Sitting on a rocky outcrop, the medieval enclave
claims a superb landscape. Called the "violet village," the tender flower
has been grown in the environs for over a century. The violet is honored
each year on the first Sunday in March with a flower festival. The best
way to discover Tourrettes is on foot. A walk around the narrow streets
reveals vaulted passageways, tastefully restored stone façades and
stepped passages bordered with flower baskets. In Grand rue, the heart of
the historic center of the village, there are dozens of workshops and gal-
leries. The 15th century Château des Villeneuve occupies a small square
and serves as the town hall.

Bar sur Loup is also close to Vence. A handsome perched village over-looking the valley Loup, it is built on a rocky spur between Grasse and Vence. Cars are forbidden in this authentic village. It is a place of beauti-ful houses, particularly those near the castle and 15th century Gothic church. There is also a panoramic view of the Gourdon and Loup river canyons.

Accommodations

30 beds in single, double and family rooms, each with a private bath.

Amenities

Towels and linens are supplied. There is a terrace and garden. The sisters organize guided tours of the chapel.

Cost per person/per night

Half board 28.00€, full board 37.00€.

Meals

All meals can be provided with lodging.

Special rules

Minimum stay 3 nights. Pets are not allowed.

Directions

By car: Take A8 and exit Villeneuve-Loubet-Cagnes sur Mer (exit # 47). From Cagnes-sur-Mer follow the signs to Vence. Once in Vence follow the indications towards Saint-Jeannet and then to Chapelle Matisse.

By train: Get off at Antibes or Cagnes-sur-Mer and take a bus or taxi to Vence.

Contact

Anyone who answers the phone
Maison Lacordaire
466, avenue Henri Matisse
BP33
06141 Vence cedex
France
Tel: 0033 (0)4 93 58 03 26
Fax: 0033 (0)4 93 58 21 10
Email: dominicaines@wanadoo.fr
Website http://perso.wanadoo.fr/maison.lacordaire

RHÔNE-ALPS

LA PROVIDENCE
Managed by the Sœurs Missionnaires Travailleuses

Ars-sur-Formans is a small town in the Ain département of Rhône-Alps. It has achieved fame as the town where the Holy Curate Jean-Marie Vianney lived and served his parishioners.

La Providence is a guest house open to all for holidays, pilgrimages and spiritual retreats. It was once an orphanage founded by St-Curé. He entrusted the orphanage to the sisters of St-Joseph who began hosting pilgrims in 1843 and slowly converted the facility into a guest house open to all. The house has now been delegated to the Sœurs Missionnaires Travailleuses. La Providence's tranquil setting is enhanced by a pretty garden.

Born in May 1786 to a family of farmers, Jean-Marie Vianney was ordained in 1815 and became Curate in Ecully. Three years later he was transferred to Ars and quickly revived the faith of his parishioners through his sermons, prayers and way of life. It wasn't long before his reputation as a confessor drew many pilgrims seeking the pardon of God. He remained entirely devoted to God, his parishioners and the pilgrims until his death in August 1859. He was canonized by Pope Pius XI in 1925 and in 1929 was proclaimed patron saint of all priests.

In the vicinity is the sign-posted *Route du Beaujolais*. Fragrant and fruity Beaujolais wines are famous the world over. The route travels through narrow winding roads in the very heart of the vineyards where the colors of light are reflected by the golden stonework of the houses and châteaux. From Villefrance-sur-Saône to St-Armour the route passes villages huddled around their Romanesque churches. One highlight for wine connoisseurs is "Hameau en Beaujolais" at Romaneche-Thorins, a living museum of wine and its history – quite literally a voyage into the secrets of wine making.

South of Villefranche, *La Route des Pierres Dorées* is named for the golden ochre rocks. Each village along the way is even lovelier than the one before. Highlights include Oingt, a restored medieval enclave perched on a spur dominating the valley of Azergues. Oingt sustains the gate of Nizy, the only vestige of the ramparts destroyed by the Baron of the Adrets in the 16th century. Streets lined with handsome houses run from Porte de Nizy to the 14th century church. Another village of golden stone is Bagnols, marked by a 15th century church and medieval castle (now a luxury hotel). Chessy-les-Mines boasts a Gothic church, Renaissance lanes and a château while Chatillon claims the ruins of a 12th century fortress and the chapel of St-Barthélemy.

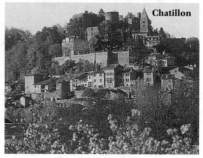

Chatillon

Villefrance-sur-Saône, capital of the Beaujolais region, was founded on the banks of the Saône in 1212 and became the capital in the 14th century. Points of interest include the Eglise Notre-Dame-de-Marais whose silhouette overshadows the town center. The former pharmacy of Belleville hospital brings to life the pharmacopoeia of the 18th century.

Le Corbusier

Ste-Marie de la Tourette

At Eveux sur l'Arbresle, just south of the Beaujolais area, Ste-Marie de la Tourette is Le Corbusier's Modernist church architecture masterpiece, ca. 1959.

Southeast of the guest house is the fortified hilltop village of Pérouges, a gem of medieval architecture and the setting for several films including *The Three Musketeers* and *Monsieur Vincent.*

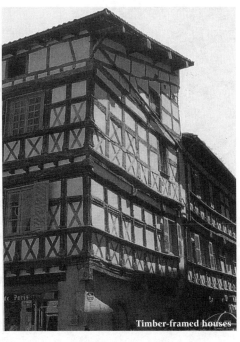

Timber-framed houses

Originally the home of a colony of immigrants from Perugia, Italy, very little has changed over the centuries. An unspoiled village; most of its structures, although traditional in style, have touches of Italianate influences. The pretty cobbled alleyways are edged by timber-framed and stone houses with mullion windows. Busy squares filled with interesting boutiques are scattered throughout the village, many with parchment-like shop signs over their doors that list the local specialties for sale, like the famous *Pérouges galette* (a sweet tart crusted with sugar and served warm). Musical evenings are hosted in the town's immense 15th century church.

Accommodations
60 single, double and family rooms and 3 dorms. 30 rooms are equipped with private bath.

Amenities
Towels and linens are supplied. There is a private garden, private parking and a large restaurant.

Cost per room/per night
Single room 24.00€ to 34.00€.
Double room 27.00€ to 35.00€.
Triple room 33.00€ to 47.00€.
Quadruple or dorm 54.00€.

Meals
All meals can be provided with the lodging, Breakfast 3.80€, lunch 11.00€, dinner: 10.50€, picnic meal 6.00€. There are special prices for children.

Special rules
The reception is not open at night. In order to leave for the evening, arrangements must be made during the day.

Directions
By car: Take A6 and exit at Villefrance-sur-Saône. Follow the signs to Bourg until Ars on D904 (8 km). La Providence is just behind the basilica.

By train: Get off at Villafranche-sur-Saône and take a bus or a taxi to Ars.

Contact
Anyone who answers the phone
La Providence
rue des Ecoles
01480 Ars-sur-Formans
France
Tel: 0033 (0)4 74 00 71 65
Fax: 0033 (0)4 74 08 10 79
Email: accueil@ars-providence.com
Website: www.ars-providence.com

NOTES

MAISON SAINT-ANTHELME
Property of the Diocese

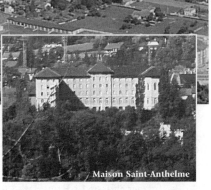

Belley

Maison Saint-Anthelme

A former seminary built in 1931 the maison became a guest house in 1966 and is managed by lay personnel. The interior houses a chapel with stained glass windows and a large religious library containing thousands of books. In front of the maison is the historic distillery Kario. Once the property of the friars of the St-Famille, it continues to produce liquors according to age-old tradition. A guided tour of the premises is available.

Belley is the very attractive capital of southern Bugey in the Ain département of Rhône-Alps. In this area, vast plateaux and vineyards coexist in an appealing terrain of pine forests and valleys. A bishopric since the 7th century, Belley was annexed first by Savoy and then by the French. The city's former political and religious prowess is evident in its monuments: the bishop's palace, St-John the Baptist Cathedral and the houses on the Grand rue that date from the 15th to the 18th centuries.

Northwest of the maison, Bourg-en-Bresse makes for an interesting day trip. Capital of the Bresse for seven hundred years, Bourg has had two centers since Gallo-Roman times, the Old City and Brou. The ancient architecture of the Old City huddles around Notre-Dame Convent and the town hall. Started in 1505 the convent's bell tower and the elegant contour of the apse stand out proudly from the other buildings. The interior is remarkable both architecturally and for the furniture on display. Around the convent, the busy pedestrian streets wander amidst wood-paneled houses,

Notre-Dame Convent

the remains of the old market and, in rue Victor Basch, 16th century stone and timber houses with interior courtyards, towers and galleries. In rue Bourgmayer private homes from the 18th century stand beside sumptuous buildings from the 17th.

In the former village of Brou is the Monastère de Brou. With its adjacent church and three cloisters, it is an architectural masterpiece of 16th century Flamboyant Gothic built at the request of Marguerite of Austria, Princess Regent of the Netherlands. In the choir of the nave lie three finely engraved alabaster and black marble tombs. A chancel screen with stone tracery separates the choir from the nave. The glasswork in the apse, chapels and stalls, the stained glass windows in the choir and the ethereal light in the nave present a beguiling picture. The museum in the monastery houses a collection of fine decorative arts from the 16th to the 20th centuries and numerous 17th and 18th century sculptures. Recently restored, the building is one of the main heritage sites in the Rhône-Alps region. Cuisine wise, Bresse is particularly known for *Poulet de Bresse*, the only chicken in the world with a controlled appellation label.

Rural Bresse Revermont is a landscape of sunken lanes and lime-washed daub and wattle farms, sometimes topped with Saracen chimneys. Here and there Romanesque churches can be seen, some of which conceal lovely frescos such as those at St-André Pressiat and narrative capitals as in St-André de Bage.

In St-Pierre-de-Curtille, immediately east of the maison, is the world-renowned Abbaye d'Hautecombe. As the mausoleum of the Savoy royal family since the 12th century, the abbey is a very popular institution. It stands on a promontory on the western shore of Lac du Bourget facing the town of Aix-les-Bains. The western shore of the lake is an abrupt and wild landscape that offers panoramas of the mountains of the Jura chain.

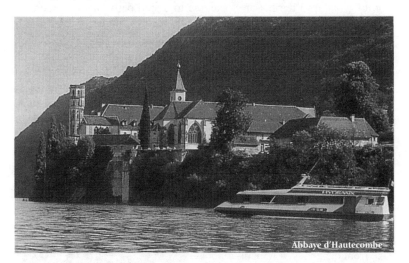

Abbaye d'Hautecombe

The abbey is a major feature on the *Route of the Dukes of Savoy* which links the important sites of the ancient states of Savoy. Founded in 1101 by the monks of Cîteaux, the abbey enjoyed its apogee between the 12th and the 14th centuries. The Commende Régime of the 15th, a disastrous administrative law of religious institutions, brought it to decline. The buildings became ruins, neglected until 1815 when the abbey was restored by the Savoy family. They constructed the building and consecrated a new church in 1826. The Cistercian monks returned in 1864 but were replaced by the Bénédictines and lastly by the Community of Chemin-Neuf.

King Charles-Felix of Savoy preserved only the external structure of the abbey. The interiors were decorated and embellished by Gothic-Troubadour and Gothic-Romantic decorations, with exuberant stuccos, festoons and arabesques. The abbey boasts three marble statues by Cacciatori, the most remarkable of which is the Pietà. On the walls are paintings by Gonin and Vacca and 14th and 16th century artwork including *The Annunciation* by Ferrari. On the left transept is the Savoy Chapel. Dating from the 14th century, it was built over the tombs of the royal family.

The entire lake is quite beautiful and can be toured by car or boat or on the pathways that start at the abbey. The religious ecumenical community occupying the abbey organizes seminars and perpetuates the site's tradition of worship. Pilgrims are welcome to attend daily mass at noon. In addition, self-guided, half-hour tours with recorded narration, in English and French, depart at 6-minute intervals. Visitors can drive to the abbey or take a 30-minute boat ride from Aix-les-Bains on one of four steamers that depart daily. The fare is 12.00€ for adults, 7.50€ for children under 12. Visitors are also welcome to dine at the "auberge" which is open from 10 AM to 5 PM in July and August. The restaurant is often fully booked so reservations are recommended. The complex is closed on Tuesdays, the "day of silence" for the community.

Many noteworthy towns are nearby. Aix-les-Bains became a must for European aristocracy when the Bonaparte family set the fashion at the beginning of the 19th century. Situated in an enviable position just across the lake from the abbey, it remains a popular summer and winter Alpine spa resort. The Romans knew the town as *Aquae Gratianae* and its alum and sulphur springs have been frequented since Roman times. Ruins of the baths can still be traced. Across from the baths is a small town hall in a 16th medieval château. Built of stone from the ruins, it is distinguished by a Renaissance staircase.

Thermal bath

In the town center, Musée Faure displays Impressionist works by famous painters including Corot, Degas, Pissarro and Cézanne and an exceptional collection of sculptures by Rodin. The funicular from town climbs the 5,125' Mont Revard for outstanding views. Of the Cistercian abbey built in the Middle Ages, only a Romanesque boathouse with extremely stark Cistercian lines remains. Market days are Saturday and Wednesday.

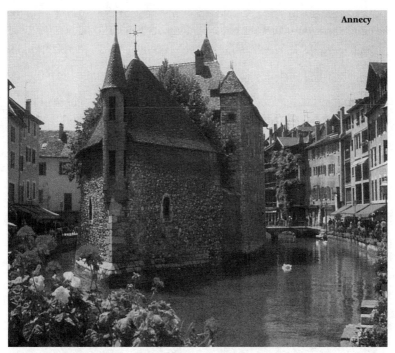

Annecy

Capital of the Haute Savoy, Annecy, another nearby town, is noted for the beauty of its lake and the magical aura of its site. The vast lake is ringed by snowcapped ridges, its alpine meadows clad in colorful flowers in springtime. Often called the "Little Venice of Savoy," the town's history dates back more than thirty centuries. It is positioned at the edge of the turquoise Lac d'Annecy. Bounded by the turreted peaks of La Tournette and the long wooded ridge of Le Semnoz, it is one of the most beautiful and popular resort towns of the French Alps.

The city has preserved its air of grace and elegance. The most compelling section lies at the foot of the castle hill, a jumble of lanes, passages and arcaded houses. It is a place of flower-lined quays and pristine canals complete with floating swans. The pedestrian-only historic quarter is fringed with buildings from the 16th and 17th centuries. The castle and four towers were built between the 13th and 16th centuries. The interior of the castle preserves a wood sculpture of St-James of Compostela.

The churches of Annecy hold many treasures. 15th century Eglise St-Maurice was built in Flamboyant Savoy style with a pleasing trompe l'œil mural. St-Pierre dates from the 18th century and possesses baroque decorations. Its choir sustains works of the school of Caravaggio, Valduggia, Fabrizzi and Lange.

An archiepiscopal see from the 5th century, nearby Chambéry has a major historic patrimony and many memorials to its prestigious past. The cradle and historic capital of the Savoy, this dignified city is crammed with courtyards and cobbled streets. Italian Chambéry was the heart of the Savoy states from the 11th century until becoming part of France in 1860. References to Italy can be seen in the elevations of the old town, painted in the colors of Sardinia and in the Piedmont-inspired 19th century main street with its "Turin" porticoes and "Italian" theater.

Château des Ducs de Savoie

Savoy ruled the kingdom of Piedmont, Sardinia and then Italy. The Gothic Château des Ducs de Savoie is a majestic memorial to the significant role played by the city and the House of Savoy. Ste-Chapelle was the castle chapel and was built in the same Gothic style. Its elegant apse has lancet windows and star vaulting. The chapel was once the repository for the Holy Shroud (transferred to Turin, Italy in 1578). The Baroque façade is by Italian architect Castellamonte. The structure is distinguished by the Grand Carillon. With seventy bells, it is one of the largest compositions of bell chimes in Europe.

Musée des Beaux Arts

Continuing the manifestation of its illustrious Italian heritage, Musée des Beaux Arts displays the richest French collection of 13th to 18th century Italian paintings including masterpieces by Uccello as well as the 17th and 18th century Florentine and Neapolitan Schools. At the center of life in Chambéry is place St-Leger with its outdoor cafes and beautiful fountains. A much beloved monument is the Fontaine des Eléphants on rue de Boigne, an elaborate homage to himself by native son Comte de Boigne.

Musée Savoisien records the lost rural life of the Savoyard mountain communities. The first floor contains paintings by Savoyard primitives and painted wood statues from nearby churches. The museum houses tools, carts, old photos and furniture.

Les Charmettes, the country home of philosopher Jean-Jacques Rousseau, is located one mile south of the city. Rousseau lived there with his mistress, Madame de Warens, for more than a decade. Rousseau called his years there, "the brief happiness of his life." The gardens are vine-covered and a small museum shelters Rousseau memorabilia.

Accommodations

123 rooms with 1 to 4 beds all equipped with a sink. 43 rooms also have
a private bath.

Amenities

Towels and linens are supplied. Private parking, private park, twelve
meeting/conference rooms, reading and TV rooms, a chapel, library and
playground.

Cost per room/per night

Lodging only 20.50€ to 38.00€ depending on the room.
Breakfast, add 3.00€.
Half board single 28.00€, double 55.00€.
Full board single 37.00€, double 74.00€.

Meals

All meals can be provided in the two restaurants.

Directions

By car: Take A43 and exit at Chimlin. Take N516 and N504 to the inter-
section with D992 to Belley.
By train: Get off at Virieu le Grand and call the maison. They will pro-
vide transportation.

Contact

Anyone who answers the phone
Maison Saint-Anthelme
37 r, Ste-Marie
01300 Belley
France
Tel: 0033 (0)4 79 81 02 29
Fax: 0033 (0)4 79 81 02 78
Email: info@maisonsaintanthelme.com
Website: http://maisonsaintanthelme.com

MONASTÈRE DE SAINTE-CLAIRE
Clarice Nuns

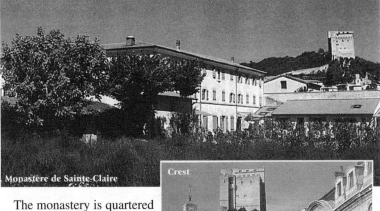

Monastère de Sainte-Claire

Crest

The monastery is quartered in Crest, a pretty medieval town of the Rhône-Alps. "At one time we were on the outskirts of town," said the Mère Abbess, "but today we are surrounded by new constructions." Nevertheless, the monastery is enveloped by its own park and offers a slice of serenity within its boundaries. The nuns invite guests to partake in the liturgy or simply enjoy the environs.

At the crossroads of two prestigious and historic routes, *Route des Dauphins* and *Hannibal Road*, the small mountain town of Crest has several stepped alleys and paths, one of which leads to the Tower of Crest, (the highest keep in France) and to ruins of a 12th century fortress. The age of the tower has been debated throughout the years. Some believe it was built in the 4th century AD to guard the Hannibal Road from Valence to Italy. The citadel sustains vaulted chambers and grim dungeons. Following the Revocation of the Edict of Nantes in 1684, a great number of Protestants were imprisoned in the cells.

Crest is a gateway town to the mountainous Park of Vercors-Royans, an arena of waterfalls and deep, narrow gorges. One of the most dramatic regional parks in France, it is a wilderness of pine and beech forests that stretch towards infinity. The winding roads of the park, the Grands Goulets, Combe Laval and the col de Rousset, are in themselves quite extraordinary. The Lapiaz wilderness provides riches of a different kind, sustaining life for 1,800 types of plants including over 60 orchids; 135 types of birds; 65 species of mammals and nearly all the varieties of deer found in France. The park is also home to a museum of pre-history and numerous Karst caves.

Southwest of the monastery is Montélimar, where every street proclaims the glory of the almond-studded nougat that has been made in the town for centuries. The Nougats Gerbe d'Or factory offers tours of the plant and samples of the end product. City of the Adhémars, it is basically pedestrian with a pleasant old core of medieval lanes fronted by 16th and 17th century buildings. The Mansion of Diane de Poitiers was built in the 16th century and showcases a graceful front elevation and mullion windows. The Musée de la Miniature is, as the name implies, dedicated to miniaturization and many of the tiny exhibits have been created by leading contemporary artists. Above the old town is the handsome Château des Adhémars. Originally belonging to the family after whom the town was named, the castle is a curious blend of architecture including an 11th century chapel and 12th century living areas. During the summer exhibitions of famous painters like Miro, Chagall and Braque are staged in the castle.

Valence

Just north of the monastery is the inviting town of Valence. Built on a series of terraces along the left bank of the Rhône, it was founded by the Romans as *Valentia Julia* in 123 BC. The old city is entirely pedestrian with some remarkable buildings including the Cathédrale

St-Apollinaire. To the south of the cathedral is the Champ de Mars, an esplanade offering views of the Rhône river valley. The architecture of nearby Maison des Têtes is a cohesive commingling of Gothic and Renaissance. The building's name derives from the sculpted heads on the front elevations. Musée des Beaux Arts preserves beautiful red chalk (*sanguines*) drawings and paintings by Hubert Robert. During visits to Italy, the painter became absorbed in antiquity as reflected in the drawing, *The Artist and the Borghesi Vase*. The unique Roman shoe museum covers over 2,000 years of the history of shoes and visits five continents. More than 10,000 items comprise the collection.

Accommodations
50 beds in single and double rooms and 1 apartment. Baths are shared.

Amenities
Towels and linens are supplied on request.

Cost per person/per night
Voluntary contribution. For additional information, inquire when reservations are made.

Meals
All meals can be provided with the lodging.

Special rules
Curfew at 6.45 PM in the winter and 7.30 PM in the summer. A later return may be arranged with the nuns. Punctuality at meals is requested.

Directions
By car: From A7 exit at Loriol. Follow the signs to Crest on D104.
By train: Get off at Crest. It's a ten-minute walk to the monastery.

Contact
Anyone who answers the phone
Monastère Sainte-Claire
53, rue Auberts
26400 Crest
France
Tel: 0033 (0)4 75 25 49 13
Fax: 0033 (0)4 75 25 28 80
Email: crest.clarisse@wanadoo.fr

VALPRÉ LYON
Assomptionist Fathers

Valpré is a center of meeting and congress built on the grounds of a verdant 15-acre parkland on a hill dominating Lyon. Valpré offers accommodations, conference rooms and catering. Situated on the west side of Lyon it is accessible to the Perrache and Part-Dieu high-speed train stations.

An old estate, the farm and the castle were initially built in 1680 and restored in 1870. From 1919 to 1949 the estate was owned by the Louis Perben family. In 1949 the congregation of the Augustins de l'Assomption acquired the property. A decade later the fathers constructed a building for training young monks. A community from the order still resides on the property and contributes to the life of the center through the organization of interactive conferences and retreats on various themes. The order also manages the Valpré library containing over 80,000 volumes.

Founded in 1850 by Father d'Alzon, the Assomptionist Congregation was greatly impacted by its founder. The order can be found in thirty countries. Their mission involves theological research, teaching, social justice, pilgrimage and ecumenism between Christian churches.

The institution is practically in Lyon, capital of Rhône-Alps. Lyon offers a cornucopia of diversions, from its world-famous cuisine to its medieval and Renaissance old quarter. While on a mission to Gaul in 43 BC, Lucius Munatius Plancus, one of Caesar's lieutenants, founded a Roman colony on a hill over-

Claudian Table

looking the confluence of the Rhône and the Saône. Named *Lugdunum* it became the capital of Roman Gaul and is now the core of present-day Lyon. The most provocative artifact from the Roman period is the bronze *Claudian Table* granting the citizens of Lugdunum the right to become Roman senators. The table is part of the priceless collection of the Musée de la Civilisation Gallo.

Lyon is organized into nine arrondissements and the best way to explore the city is on foot. Fourvière hill, the "praying hill" is defined by the extravagant 19th century Our Lady of Fourvière Basilica, beloved symbol of the city. Built at the end of the 19th century, the basilica is a revered place of pilgrimage. Mosaics and stained glass opulently fill the interior. A funicular railway, *la ficelle,* travels to the top of the hill and amazing views of the city below.

Along the Saône is the picturesque quarter of Vieux Lyon, a district of narrow cobblestone streets remarkable for their towering mansions of ocher and

Our Lady of Fourvière Basilica

pink, inviting boutiques and antique shops and, of course, dozens of restaurants serving the acclaimed Lyonnais cuisine. *Cervelles de Canut* is one of Lyon's gastronomic specialties. Not "silk worker's brains" as the name suggests but white cheese mixed with crème fraîche and herbs. A gastronomic capital of France, fine food is a formidable part of Lyon's heritage, both the traditional *cuisine des mères* and the *haute cuisine* of the city's master chefs.

Unique to Lyon are hundreds of covered passageways or *traboules* where early silkmakers once protected their precious wares and, in more recent years, where members of the French Resistance secretly met dur-

Traboules

ing WWII. An integral part of the old town and filled with artistic treasures, these fascinating hidden passages weave an unseen network behind secret doors, connecting buildings and, in some cases, entire neighborhoods. On guided tours visitors can literally travel across town via these ancient passages. The longest, at 54 rue St-Jean, traverses four buildings and five courtyards.

Between the Rhône and the Saône lies the *Presqu'île* (the Peninsula), its stately place Bellecour highlighted by an equestrian statue of Louis XIV. Place des Terreaux is overlooked by the ornate 17th century Hôtel de Ville. In the middle of the square is a monumental statue of a chariot drawn by four fiery steeds executed by Frederic-Auguste Bartholdi, sculptor of the Statue of Liberty. Palais St-Pierre, a former Bénédictine convent, is now home to the Musée des Beaux-Arts. The museum show-cases the country's largest and most important collection of art after the Louvre. Behind the town hall is the 19th century Opéra de Leon, a combi-nation of neoclassic and contemporary architecture. Lit at night, the metal and glass dome designed by Jean Nouvel appears magical.

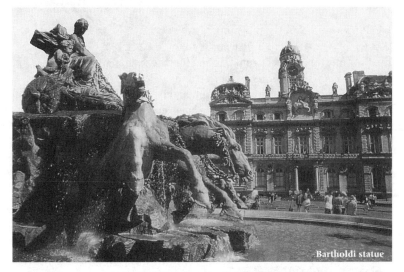

Bartholdi statue

Another monument of distinction is the Cathédral St-Jean, archbish-opric of the Gauls. Begun in the late 12th century, the cathedral has a 14th century astronomical clock that shows religious feast days until the year 2019. An esteemed center of Christendom, important councils took place in the church including the election of two popes. It is also where Henry IV married Marie de Medicis in 1600.

During WWII Lyon was a free city. As a result, all Jewish life in France was centralized there and the city was able to provide safe refuge to a significant number of Jews. Rue Juiverie. just behind the Church of

St-Paul, is a remnant of an old Jewish quarter that once contained a synagogue and a cemetery. Grande Synagogue and Consistoire de Lyon is located on the left bank of the Saône facing Eglise de St-Georges. Built in 1864, the synagogue has been designated an historic monument.

Accommodations

250 beds in single, double and triple rooms and dorms with private bath and telephone. All rooms have a view of the park; four are accessible to the handicapped and all are accessible by elevator. A dorm is located in the "Ferme" and has a kitchen guests may use.

Amenities

Towels and linens are supplied. Private park, private parking, play room, chapel, seventeen conference and meeting spaces, soccer field, volleyball court, large library, three dining rooms and an internet connection.

Cost per person/per night

Costs vary according to the service required. Normally 32.00€ to 35.00€ per person/per night breakfast included. Meals are 12.50€ to 23.00€.

Meals

All meals can be provided with the lodging. Buffet breakfast is always included.

Directions

By car: From Paris take A6 and exit at Ecully. At the roundabout go towards Ecully center. 500 m after the stoplight turn left towards Chalin. Pass under the highway and at the next roundabout take the road to Chalin.
By train: Get off at Lyon, either at the Part-Dieu or Gare de Perrache train station. From either station take the metro and get off at Gorge de Loup. From Gorge de Loup take bus # 19 in the direction of Ecully-Le-Pèrollier. Get off at the stop Chirpaz (200 m on the road to Chalin).

Contact

Anyone who answers the phone
Valpré Lyon
BP 165, 1 chemin de Chalin
69131 Ecully cedex
Hôtellerie
Tel: 0033 (0)4 72 18 05 05
Fax: 0033 (0)4 72 18 05 99
Email: accueil@valpre.com
Website: www.valpre.com

LA CHARDONNIÈRE
Franciscan Association Pauline Jaricot

Nestled in a 12-acre parkland, the guest house is in Francheville, a small town close to Lyon. Once a Franciscan convent, the complex was later converted into a diocesan guest house. Managed by an association that includes Franciscan sisters, friars and lay personnel, the center is actively engaged in organizing spiritual retreats, workshops, concerts and conferences but the house is open to all visitors. The park of La Chardonnière is particularly welcoming with a large flower-filled meadow, walking paths and a patio used as a meeting hall. The house is accessible to the handicapped.

The nearby town of Vienne has an extraordinary Roman heritage. In 47 BC Julius Caesar established the town of *Vienna* as a Roman colony. Prior to that it had been the ancient capital of a Celtic tribe known as the Allobroges. The town prospered as Rome's major wine port and *entrepôt* (warehouse) on the Rhône. Roman monuments are scattered throughout the city; the magnificently restored Temple d'Auguste et Livie (25 BC) is a perfect, smaller version of Maison Carrée in Nîmes. A handsome structure the temple was one of the largest in Romana France and could seat more than 13,000. Views of the town and river can be had from its top seats. The first two weeks of July, it is the venue of an international jazz festival.

The compact old quarter of Vienne is crisscrossed with pedestrian precincts. The town's most important monument, Cathédral de St-Maurice is a masterpiece of Romanesque and Gothic art, evidence of Vienne's rich medieval lineage. The church's interior showcases a long vaulted nave, stained glass windows and 15th century frescoes. The Eglise and Cloître of St-André-le-Bas date from the 9th and 12th centuries. The back tower of the church is a remarkable structure, studded with tiny carved stone faces. The cloister, entered through a space where temporary exhibits are held, is a beautiful Romanesque affair whose walls are adorned with local tombstones, some dating from the 5th century. One of the oldest churches in France, the former Eglise St-Pierre is home to the Musée Lapidaire with Roman relics from the 4th century.

The major museum in the city is the Musée des Beaux-Arts et d'Archeologie. It preserves a cache of 18th century French pottery as well as some 3rd century Roman silverware. Musée de la Draperie is a place of working looms (the Jacquard) and weavers. It illustrates the complete process of clothmaking as it was practiced in the city for over two hundred years.

Rome's former power and elegance can be observed in Saint-Roman-en-Gal, a commercial town directly across the Rhône from Vienne. The archeological park and museum provide insight into the sophisticated lifestyle of the Romans. There are relics of the House of the Ocean Gods and a museum with mosaics and frescoes.

West of Vienne is St-Etienne. At the gates of the Forez and Pilat, seven centuries of history have shaped the attractive face of the city that is famous for mining and industry and the capital of ribbon weaving, bicycles and fire arms. In the 13th century, it was a peaceful hamlet in the foothills of the central highlands, known essentially for the Abbey of Valbenoîte. Taking advantage of its rich geology and clear purifying waters, the monks and the local populace developed a superior metallurgical process and the Hundred Year War did the rest. Weapons, pikes and crossbows established the village's reputation.

Ribbon making started in the 18th century. The town is filled with mansions built by the ribbon makers; homes with richly decorated elevations. Musée d'Art et d'Industrie displays beautifully decorated fire arms, bicycles and over one million samples of ribbons and trimmings. The glossy black ceramic elevation of Musée d'Art Moderne is a reminder that the site was formerly an open cast coal mine. The museum's collection

includes the works of Monet, Picasso, Matisse, Legerand and Dubuffet among others. St-Jacques district is composed of pedestrian streets, typical shops and restaurants serving local fare. There is also a tramway that runs along the "Grande rue" offering wonderful cityscapes.

Ste-Croix en Jarez charterhouse

Southwest of Vienne, between the Loire and the Rhône is the Pilat Regional National Park, a terrain of vine-clad hills and high peaks. Within the park is the Ste-Croix en Jarez charterhouse. Built in the 13th century, it is typical of the monasteries of the order of St-Bruno. It was formerly comprised of fifteen small houses in which each Carthusian monk lived as a hermit. The French Revolution drove the monks from their homes but today, seven centuries after its foundation, Ste-Croix is still inhabited. The woodwork in the 17th century church is outstanding; its sacristy is embellished with 14th century frescos.

Accommodations
104 beds in single, double, and family rooms (1-6 beds);. 42 rooms (singles and doubles) have private baths.

Amenities
Towels and linens are supplied. Various meeting and conference rooms, a restaurant, private park, private parking and access to the Internet. There is also the possibility of personalized menus.

Cost per person/per night
10.50€ to 20.00€ depending on the room.

Meals
All meals can be provided with the lodging,
Breakfast 4.00€, lunch/dinner 12.00€ each.

Directions

By car: Take A6 and exit at Porte du Valvert. Follow the signs to Tassin l'Horloge and then to Brignais-Francheville. At the sixth stoplight follow the direction to Hôtel de Ville on the right, passing under the rail bridge. After 300 m the entrance to La Chardonnière is on the left side.

By train: Get off at Lyon

1) From Gare Perrache take Metro ligne towards Laurent Bonnevay, get off at Bellecour - exit « Le Viste » and take bus #30 departing from place Bellecour to Findez. Get off at the "Chardonnière" stop.

2) From Gare Part-Dieu take Metro Ligne D towards Gare de Vaise and get off at Bellecour exit « Le Viste » and take bus #30 departing from place Bellecour to Findez. Get off at the "Chardonnière" stop.

Contact

Anyone who answers the phone
La Chardonnière
65, Grande rue
69340 Francheville
France
Tel: 0033 (0)4 78 59 09 86
Fax: 0033 (0)4 78 59 93 16
Email: chardonniere@wanadoo.fr
Website: http://chardonniere-lyon.cef.fr

NOTES

SANCTUAIRE NOTRE-DAME DE LA SALETTE
Community of Missionary of the Salette Friars and Sisters

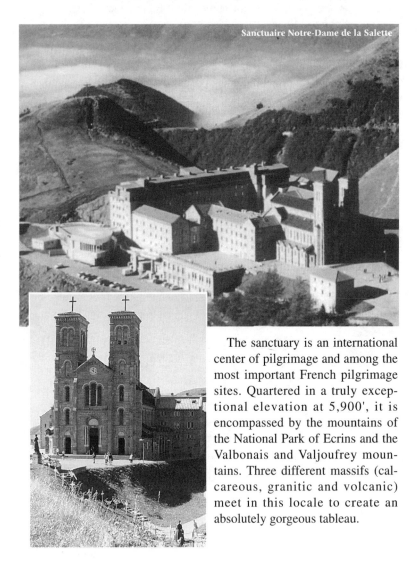

Sanctuaire Notre-Dame de la Salette

The sanctuary is an international center of pilgrimage and among the most important French pilgrimage sites. Quartered in a truly exceptional elevation at 5,900', it is encompassed by the mountains of the National Park of Ecrins and the Valbonais and Valjoufrey mountains. Three different massifs (calcareous, granitic and volcanic) meet in this locale to create an absolutely gorgeous tableau.

On September 19, 1846 two local children met a "beautiful lady" who consoled them while they were crying. Soon the site of the apparition became extremely popular and a commission examined the facts, declaring it miraculous. The first chaplains of the shrine united in a congregation of missionary friars that traveled throughout the world to communicate the message of the Virgin.

The nearby city of Grenoble can prove to be an interesting excursion. Situated on the rivers Drac and Isère and ringed by mountains, Grenoble is flanked by two outstanding nature reserves, the Chartreuse and the Vercors. An ancient city of the Allobroges (a Celtic tribe) and a Roman city, it joined the kingdom of France in the middle of the 14th century. In the 18th century, it was one of the places where the French Revolution was born. During the 19th and 20th centuries, the town was transformed by the industrial revolution.

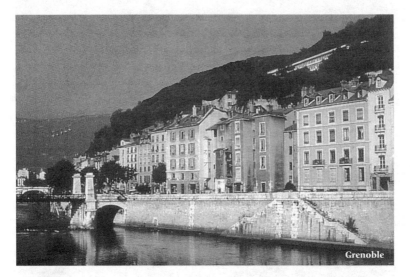

Grenoble

The belvedere on the bastille offers views of the city and mountains. It is easily reached via the *tèléférique* (cable car) starting at quai Stéphane-Jay and ending at the 16th century Fort de la Bastille, a trip not intended for the faint of heart. For land lovers, there is a pleasant, albeit steep, footpath from St-Laurent church to the bastille. The church showcases a pre-Romanesque crypt and an archeological museum.

The city's medieval section was colonized by Italian immigrants in the 19th century. The allure of the old town lies in the narrow streets leading towards places Grenette, Vaucanson and Verdun. Life focuses on a cadre of little squares - aux Herbes, de Gordes, Grenette and Notre-Dame.

Grenoble lays claim to a number of wonderful museums. Musée de Grenoble was founded in the 18th century and is among the largest in Europe. On the banks of the river Isère, there are over 4,500 paintings, 400 sculptures and 5,500 drawings including work by Chagall, Picasso and Matisse. Another section focuses on Egyptian antiquities in homage to Champolion who lived in Grenoble for many years.

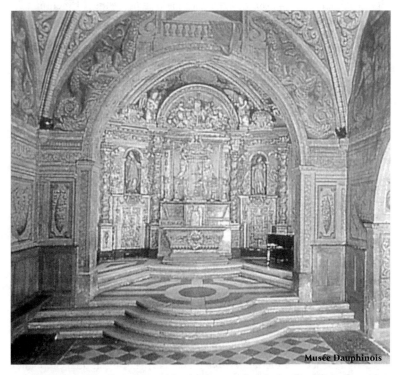

Musée Dauphinois is housed in the former St-Marie d'en Haut Convent. A portion of the convent has a Baroque decor, paintings highlighted in gold, trompe l'œil, gilded wooden reredos and an altar made from colored marbles. The museum is devoted to local history, arts and crafts. The arche-

ological museum in Eglise St-Oyand throws interesting light on religious life in Christian communities. The crypt, under the Romanesque east door of the church, is a rare example of French art in the early Middle Ages. Grenoble's newest museum, L'Ancien Evêché, is in the bishop's palace. It offers a fleeting retrospective of Grenoble's history from the Stone Age to the 17th century. Among its prized exhibits is a 16th century triptych retable known as *Tours de Pins*. The 19th century is represented by the Casamaures, a surprising arabesque work in "gray gold" molded cement, a form of art that embellishes many other buildings in Grenoble including those around place Verdun.

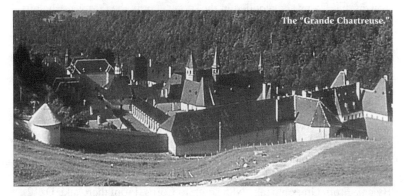
The "Grande Chartreuse."

Stretching north from the city of Grenoble, the Chartreuse is a singular mountain range of cliffs, deep gorges and green pasturelands. It was here that St-Bruno founded and built his first Carthusian hermitage, the "Grande Chartreuse." It remains the head monastery of the Carthusian Order and the place where the Carthusian monks continue to produce Chartreuse, a potent herbal liqueur. At any one time, only three brothers of the monastery possess the knowledge to make Chartreuse, a combination of alcohol, sugar and 130 plants and flowers.

As legends go, the formula for Chartreuse was invented by a 16th century alchemist in an attempt to create *aqua vitae* (the waters of life). It was believed that the waters could restore youth to the aged and endow animation to the dead. Although the end product fell short of its desired effects, the elixir was promoted as a panacean tonic by the descendant of the alchemist and, upon his death, was bequeathed to the Carthusian Order. The formula has remained a secret for nearly four centuries.

As an aside: in terms of strictness, the Carthusians are considered the highest order of the Catholic Church. Carthusian, the order's name, is derived from Chartreuse as is the word "Charterhouse" the English name for a Carthusian. The monastery is not open to the public but the Musée de la Correrie can be visited. It portrays the daily routine of the monks who live in silence and seclusion.

Accommodations

450 beds in rooms with one to six beds. Some rooms have private baths. There are also dorms and shelters available to groups of young people.

Amenities

Towels and linens are supplied in the rooms, not in the dorms or shelters.

Cost per person/per night

Single room lodging and breakfast 15.00€ to 33.00€, half board 26.00€ to 44.00€, full board 37.00€ to 55.00€.

Double room lodging and breakfast 12.00€ to 23.00€, half board 23.00€ to 34.00€, full board 34.00€ to 45.00€.

Dorm with breakfast 7.50€, shelter with breakfast 5.00€.

Meals

All meals can be provided with the lodging.

Breakfast 3.00€, lunch/dinner 11.00€, picnic lunch 6.50€.

Directions

By car: From Grenoble take N85 south to Corps. From there take D212 to the shrine.

By train: Get off at Grenoble or Gap and take a bus to the shrine. The companies are SCAL (04 76 87 90 31) or VFD (04 76 47 77 77). Information about bus timetables are on the sanctuary's website.

Contact

Anyone who answers the phone
Sanctuaire Notre-Dame de la Salette
38970 La Salette-Fallavaux - France
Tel: 0033 (0)4 76 30 00 11 (reception)
Fax: 0033 (0)4 76 30 03 65
0033 (0)4 76 30 32 90 (hôtellerie direct)
Email: reception@nd-la-salette.com
Website: www.nd-la-salette.com

NOTRE-DAME-DE-L'HERMITAGE
Notre-Dame de la Salette Sisters

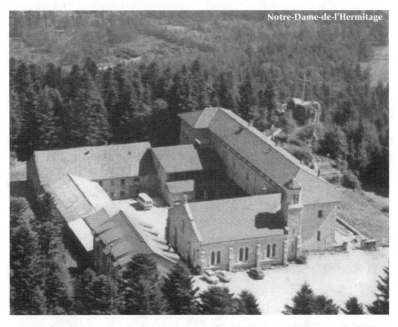

Notre-Dame-de-l'Hermitage

The shrine is an ancient pilgrimage site in an isolated locale at 3,600'. From its elevation, the complex offers a panorama over the woods and verdant hills of the Duroll and Forez valleys. The shrine was founded around the 13th century after the apparition of the Virgin Mary to a criminal. Despite the vicissitudes that vexed the shrine throughout the centuries, it has become a popular pilgrimage site. The sisters of Notre-Dame de la Salette manage the institution and offer hospitality to visitors and pilgrims.

Noirétable is a small village, one of thirteen of the Mounts of Forez. These peaceful villages punctuate the landscape with architectural treasures including Montbrison, former seat of the Counts of Forez and the Bastie d'Urfe castle. Built in the 15th century and remodeled in the 16th,

the castle is representative of the Forez. A balustrade adorned with a grand sphinx, typical of the Renaissance, connects two overlaid galleries. Additionally, there is the Park of Drosera and the megalithic formations of the medieval village of Cervières.

Dazzling snowcapped mountains, world-famous vineyards and fragrant lavender fields combine with crystalline lakes, wild gorges, Roman ruins and historic cities to imbue the Rhône-Alps with an extremely rich tableau. The region stretches from the lush farmland of Bresse, to the olive groves of the Drome Provençale. On its eastern edge, the French Alps, including the highest, Mont Blanc, pierce the sky. To the west the dramatic Ardèche cliffs plunge vertiginously earthward. And through the center flows the mighty Rhône.

Northeast of the shrine is the city of Roanne. Between the Madeleine hills in the west and the Beaujolais in the east, Roanne occupies a privileged situation on the river Loire. A crossroads in Gallo-Roman times, the city was mentioned in ancient geography by Ptolemy. There are several ruins from the Roman period in addition to traces of a medieval château and keep. An easily explored area, the old core's pedestrian-only streets are filled with 15th and 16th century houses, shops and cafe terraces. The air is permeated with the aroma of *praluline,* a brioche made with roasted nuts, specialty of the city's pastry shops and tea rooms.

Throughout the Middle Ages, the counts of the Forez and the Barons of Beaujeu were constantly at odds. While the nobles fought, the monks prayed. A dazzling array of medieval gems can be seen along the sacred routes. Some of the villages and monuments follow.

St-Haon le Châtel is among the most evocative villages in France. Superb pink fortified walls protect timber-framed houses and handsome mansions. Ambierle is a wonderful Burgundy-style Gothic church in the heart of the Roanne region. Under its varnished tile roof are polychrome skylights, wooden stalls and a reredos attributed to Van de Weyden. Charlieu possesses a prestigious heritage. Along its medieval streets are more than thirty timber-framed houses with corbelled elevations as well as beautiful buildings from the Renaissance and 18th century. The hospital museum is a faithful reproduction of life in the Hôtel Dieu from the 17th to the 20th centuries. The vast Bénédictine abbey reflects nine centuries of history starting with the famous luminous ochre stone narthex, Gothic

cloister, chapter house and wine cellar, now a sculpture and statue museum. The prior's mansion in the elegant inner courtyard dates from the 15th century.

Not far from the shrine is an area known as Le Beaujolais, a land of legends and one of the great wine areas of France. Highlighting the Saône river valley, a score of villages of the "Golden Stone" district impart an incredible luminosity to the countryside. The entire landscape is one of vineyards dotted with ancient abbeys and châteaux. But the area's historic significance cannot be overlooked. The Barons of Beaujeu warred throughout the region and left a myriad of monuments as their legacy.

"Golden Stone" district

Accommodations
35 to 75 beds (depending on the season) in 53 single and double rooms and 1 dorm with 10 beds. Baths are mostly shared. Some rooms have private baths.

Amenities
Towels and linens are only supplied in the single and double rooms. Guests in the dorm must supply their own sleeping bags. Two dining rooms and a reading, TV room.

Cost per person/per night

(Minimum and maximum range depending on the length of stay and type of bath.)

Single 24.00€ to 27.00€ half board, 32.00€ to 35.00€ full board.

Double 22.00€ to 24.00€ half board, 28.00€ to 35.00€ full board.

Deluxe 29.00€ to 32.00€ half board, 36.00€ to 40.00€ full board.

Dorm 18.00€ to 20.00€ half board, 24.00€ to 26.00€ full board.

Lodging only: single 15.00€, double 13.00€, dorm 8.00€.

Groups aged 9-18, half board 13.00€, full board 20.00€.

Bus drivers are free of charge. One person free of charge in groups of 20 or more. Local daily tax of 0.20€ per person per day will be added to the fares.

Meals

All meals are provided with the lodging. Breakfast 3.00€, lunch 12.50€ to 13.00€, dinner: 11.00€, picnic lunch: 6.00€.

Special rules

No curfew but silence is required on the premises after 10 PM.

Directions

By car: Take A72 and exit at Les Salles. From there follow the signs to Noirétable on D53. Once in Noirétable follow the signs to the shrine on D53.

By train: Get off in Noirétable and take a taxi or call the sisters and arrange for transportation. Public transportation to the shrine is difficult.

NOTE: The taxi service must be reserved in advance. At the time room reservations are made, the sisters can provide information on taxi transportation.

Contact

Sœur Hôtelière

(Call and then send a written confirmation to the Sœur Hôtelière)

Notre-Dame-de-l'Hermitage

42440 Noirétable - France

Tel: 0033 (0)4 77 96 20 30

Fax: 0033 (0)4 77 96 20 34

Email: ndh42@wanadoo.fr

SECTION TWO

Monasteries Offering Hospitality For Retreat and Other Spiritual Endeavors

Marienthal
BASILIQUE NOTRE-DAME
Bénédictine Nuns

Accommodations
All are hosted for spiritual retreats.

Contact
Anyone who answers the phone
Basilique Notre-Dame
1, place de la Basilique
67500 Marienthal - France
Tel: 0033 (0)3 88 93 90 91
Fax: 0033 (0)3 88 93 97 01

Molsheim
ABBAYE NOTRE-DAME D'ALTBRONN
Trappist Nuns

Accommodations
Open to men and women but only for
spiritual retreats.

Contact
Sœur responsible pour l'accueil
Abbaye Notre-Dame d'Altbronn
67120 Ergesheim - France
Tel: 0033 (0)3 88 47 95 40
Fax: 0033 (0)3 88 47 95 47

Orbey
MONASTÈRE SAINT-JEAN-BAPTISTE D'UTERLINDEN
Dominicains

Accommodations
Hospitality is offered to individuals or
small groups for spiritual retreats.

Contact
Anyone who answers the phone
Monastère Saint-Jean-
Baptiste.d'Uterlinden
53, Holnet
68370 Orbey - France
Tel: 0033 (0)3 89 71 23 30
Fax: 0033 (0)3 89 71 35 61

Reiningue
ABBAYE NOTRE-DAME D'OELENBERG
Trappist Fathers

Accommodations
Men and women are hosted for spiritual
retreats.

Contact
Anyone who answers the phone
Abbaye Notre-Dame d'Oelenberg
68950 Reiningue - France
Tel: 0033 (0)3 89 81 91 23
Fax: 0033 (0)3 89 81 86 07
Email: abbaye.oelenberg@tiscali.fr

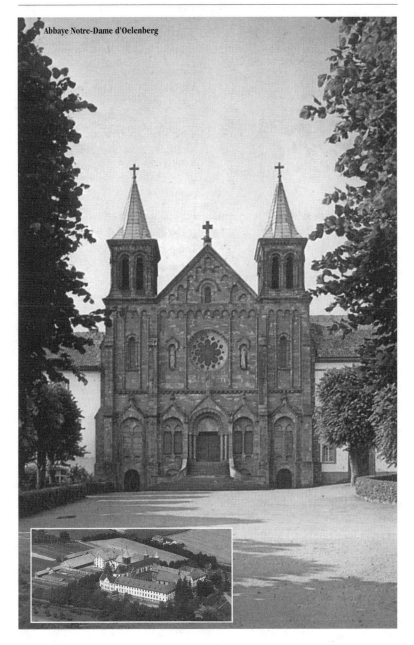

Abbaye Notre-Dame d'Oelenberg

Anglet
COUVENT DE BERNARDINES
Sœurs Bernardines

Accommodations
A few rooms open to women for spiritual retreats.

Contact
Couvent Notre-Dame de Refuge
Avenue de Montbrum
64600 Anglet
France
Tel: 0033 (0)5 59 52 81 30

Auros
ABBAYE DE SAINTE-MARIE DU RIVET
Cistercians

Accommodations
The hôtellerie is open year-round to men, women, families or groups but only for spiritual retreats. There are 26 rooms with 1, 2 and 3 beds. Voluntary contribution.

Contact
Abbaye de Sainte-Marie du Rivet
33124 Auros - France
Tel: 0033 (0)5 56 65 05 30
Fax: 0033 (0)5 56 65 05 39

Dax
MONASTÈRE SAINT-DOMINIQUE
Dominicains

Accommodations
A few beds exclusively for spiritual retreats. Men and women are welcome.

Contact
Monastère Saint-Dominique
62, rue Gambetta
40100 Dax - France
Tel: 0033 (0)5 58 56 84 60
Fax: 0033 (0)5 58 74 97 25

Echourgnac
ABBAYE NOTRE-DAME DE BONNE ESPERANCE
Trappistines

Accommodations
Hôtellerie open to women, couples and religious representatives (no single men) who want to partake in the life of the monastery.

Contact
Abbaye Notre-Dame de Bonne Esperance
24410 Echourgnac - France
Tel: 0033 (0)5 53 80 82 50
Fax: 0033 (0)5 53 80 08 36
Email: mn.echourgnac@wanadoo.fr

Maylis
ABBAYE NOTRE-DAME DE MAYLIS
Olivetains

Accommodations
Hôtellerie open year-round to men and women but only for spiritual retreats.

Contact
Abbaye Notre-Dame de Maylis
40250 Maylis - France
Tel: 0033 (0)5 58 97 72 81
Fax: 0033 (0)5 58 97 72 58

Pontenx-Les-Forges
FRATERNITÉ DE LA VIERGE DE PAUVRES
Freres de la Vierge des Pauvres

Accommodations

Open to men and women year-round but only for spiritual retreats. 3 rooms inside the monastery and 15 beds in a guest house near the monastery.

Contact

Frère Hôtelier
Bouricos
40200 Pontenx-Les-Forges - France
Tel: 0033 (0)5 58 07 45 22
Fax: 0033 (0)5 58 07 45 22
Email: fratbour@aol.com
Website:
www.cef.fr/aire.dax/pays/sjb01.htm

Rions
MONASTÈRE DE BROUSSEY
Carmélites

Accommodations

Open year-round to men and women but only for spiritual retreats.

Contact

Père Hôtelier
Monastère de Broussey
33410 Rions - France
Tel: 0033 (0)5 56 62 60 90
Fax: 0033 (0)5 56 62 60 79
Email: hotelier.broussey@carmel.asso.fr
Website: www.carmel.asso.fr

Saint-Sever
CARMÉL DU CHRIST-ROI
Carmélites

Accommodations

There are a few beds for spiritual retreats. Write to the Mother Superior in advance and specify the reason for your visit.

Contact

Mère Superieure
Carmél du Christ-Roi
10, Allé du carmél
40500 Saint-Sever-sur Adour - France
Tel: 0033 (0)5 58 76 00 15
Fax: 0033 (0)5 58 76 36 75
Email:
monastere.carmel.christroi@wanadoo.fr
Website: www.boutique-theophile.com

Urt
ABBAYE NOTRE-DAME-DE-BELLOC
Bénédictines

Accommodations

Open to men and married couples for spiritual retreats (no single women). Open year-round except December.

Contact

Père Hôtelier
Abbaye Notre-Dame-de-Belloc
64240 Urt - France
Tel: 0033 (0)5 59 29 65 55
Fax: 0033 (0)5 59 70 23 48

Urt
MONASTÈRE SAINTE-SCHOLASTIQUE
Bénédectines

Accommodations

Hôtellerie open to women, married couples and groups (no single men) for spiritual retreats. Guests partake actively in the life of the monastery. Open year-round except October.

Contact

Mère Hôtelière
Monastère Sainte-Scholastique
64240 Urt - France
Tel: 0033 (0)5 59 70 20 28
Fax: 0033 (0)5 59 29 18 64

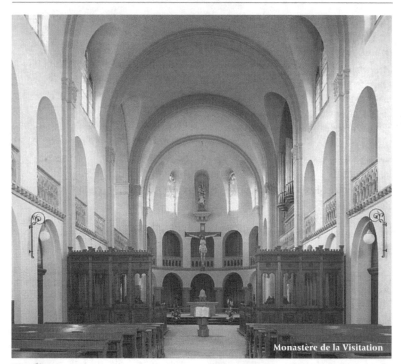

Monastère de la Visitation

Moulins
MONASTÈRE DE LA VISITATION
Visitandine Sisters

Accommodations
There are a few beds for women for religious purposes only.

Contact
Sœur Hôtelière
Monastère de la Visitation
65, Rue de Tanneries
03000 Moulins - France
Tel: 0033 (0)4 70 44 27 43
Fax: 0033 (0)4 70 44 50 81
Email: visitation.moulins@wanadoo.fr

Murat
PRIEURÉ STE-THÉRÈSE
Saint-Jean Friars

Accommodations
The institution offers hospitality for spiritual retreats. Most retreats are organized, so it is necessary to speak French.

Contact
Send an email to the Frère Hôtelier
Prieuré Saint-Jean
8, Avenue de l'Ermitage
15300 Murat - France
Tel: 0033 (0)4 71 20 18 44
Fax: 0033 (0)4 71 20 19 25
Email: hotellerie.murat@stjean-com
Website: www.stjean-murat.com

Boquen
MONASTÈRE NOTRE-DAME DE LA CROIX VIVIFIANTE
Bethléem, de l'Assomption de la Vierge et de Saint-Bruno Nuns

Accommodations

The monastery offers hospitality in eight cells where guests can share the secluded life and silence of the monastery. Both men and women are welcome.

Contact

Sœur Prieuré
Monastère Notre-Dame
de la Croix Vivifiante
Boquen
22640 Plénée-Jugon - France
Tel: 0033 (0)2 96 30 22 36
Fax: 0033 (0)2 96 30 20 58

Bréhan

ABBAYE NOTRE-DAME DE TIMADEUC
Cistercian Friars

Accommodations

The abbey offers hospitality for up to 40 people for spiritual retreats.

Contact

Frère Hôtelier
Abbaye Notre-Dame de Timadeuc
56580 Bréhan - France
Tel: 0033 (0)2 97 51 50 59
Fax: 0033 (0)2 97 51 59 20
Email: timadeuc.abbaye@wanadoo.fr

Campénéac
ABBAYE LA JOIE NOTRE-DAME
Cistercian Nuns

Accommodations

The abbey offers hospitality for spiritual retreats in two different buildings. Inside the monastery there is a hôtellerie with 24 single and double rooms; outside there is a Maison de Jeunes which can host up to 37 young people in a few rooms and a dorm. Open year-round except the first two weeks of December and the last two weeks of January.

Contact

Sœur Hôtelière
Abbaye La Joie Notre-Dame
56800 Campénéac - France
Tel: 0033 (0)2 97 93 42 07
Fax: 0033 (0)2 97 93 13 27
Email: abbaye.joie.nd@wanadoo.fr

Landevennec
ABBAYE SAINT-GUÉNOLÉ
Bénédictine Monks

This ancient spiritual center was founded by Saint-Guénolé around 485 and rapidly became 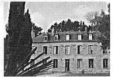 one of the most important of Brittany and France. Until 818 when the monks joined the Bénédictine Order, they lived under the rules of a Celtic congregation. In 913 the Vikings attacked the abbey and the monks were forced to take shelter in Montreuil-dur-Mer. They returned but experienced various vicissitudes throughout the centuries. In 1950 the community of Karbénéat bought the property and reconstructed the complex

with designs by Ives Michel. The remains of the Carolingian (9th century) abbey as well as Romanesque, Gothic and Maurist structures are still visible. There is a small museum, library and bookshop. The monastic shop sells pastries made by the monks and products of other abbeys.

Accommodations

60 beds in single, double and family rooms. Bathrooms are shared. The monastery does not organize any retreat but requires guests to share the silence and prayers of the community.

Amenities

Towels and linens are supplied. Groups may cook their own meals in a kitchen at their disposal.

Meals

All meals are supplied with the lodging.

Special rules

Maximum stay 1 week. Call 3 weeks in advance.

Cost per person/per night

Minimum of 27€ per person (full board) covers basic expenses. The rest is left to an extra voluntary contribution.

Contact

Père Hôtelier
Abbaye Saint-Guénolé
29560 Landevennec - France
Tel: 0033 (0)2 98 27 37 53 (Père Hôtelier)
(0)2 98 27 73 34
Fax: 0033 (0)2 98 27 79 57
Email: abbaye.landevennec@wanadoo.fr
Website: http://abbaye-landevennec.cef.fr/

Morlaix
CARMÉL
Carmélite Nuns

Accommodations

The monastery offers hospitality mainly to women for spiritual retreats. Closed in August. There are five rooms available.

Contact

"Responsable pour l'hospitalité"
Carmél
9, rue Sainte-Marthe
29600 Morlaix - France
Tel: 0033 (0)2 98 88 05 82

Plouharnel
ABBAYE SAINTE-ANNE DE KERGONAN
Bénédictine Monks

Accommodations

This modern monastery hosts mainly men for spiritual retreats.

Contact

Père Hôtelier
Abbaye Sainte-Anne de Kerhonan
BP 11
56 340 Plouharnel - France
Tel: 0033 (0)2 97 52 45 14 (Père Hôtelier)
0033 (0)2 97 52 30 75 (Abbey)
Fax: 0033 (0)2 97 52 41 20

Beaune
COMMUNAUTÉ DE BÉATITUDES
Sisters of the Communauté de Béatitudes

Accommodations
The sisters offer hospitality to women seeking a spiritual retreat.

Contact
Sœur Hôtelière
Communauté de Béatitudes
14, rue de Chorey
21200 Baune - France
Tel: 0033 (0)3 80 22 27 43
Fax: 0033 (0)3 80 22 27 43

Flavignerot
CARMÉL
Carmélite Nuns

Accommodations
The monastery can host up 8 people for a maximum of 8 days for spiritual retreats.

Contact
Sœur Hôtelière
Carmél
Flavignerot
21160 Marsannay-la-Cote - France
Tel: 0033 (0)3 80 42 92 38
Fax: 0033 (0)3 80 42 93 84

Flavigny-Sur-Ozerain
ABBAYE SAINT-JOSEPH DE CLAIRVAL
Bénédictine Friars

The abbey was founded in 719. The complex is in a wonderful setting surrounded by the medieval atmosphere of Flavigny, a small town considered one of the most beautiful of France and where the movie *Chocolat* was filmed.

The Bénédictine community hosts only men for spiritual retreats and organizes five day retreats.

Accommodations
There are single and double rooms inside or outside of the abbey.

Amenities
Towels and linens are supplied.

Meals
All meals can be supplied.

Cost per person/per night
To be determined when reservations are made.

Contact
Père Hôtelier
Abbaye Saint-Joseph de Clairval
21150 Flavigny-sur-Ozerain - France
Tel: 0033 (0)3 80 96 22 31
Fax: 0033 (0)3 80 96 25 29
Email: abbaye.flavigny@wanadoo.fr
Website: www.clairval.com

Montbard
MONASTÈRE SAINT-ELIE
Carmélite Sisters

Accommodations
The monastery offers hospitality to all those wishing to share in the monastic life.

Contact
Sœur Hôtelière
Monastère Saint-Elie
50, rue du Floquet
21500 Saint-Rèmy-les-Montbard - France
Tel: 0033 (0)3 80 92 07 40
Fax: 0033 (0)3 80 92 07 40
Email: saintelie@club-internet.com
Website: www.monasteresaintelie.com

Nevers
CARMÉL
Carmélite Nuns
The carmél is open year-round to men and women seeking a spiritual retreat.

Accommodations
There are up to 7 beds.

Contact
Sœur Hôtelière
Carmél
Rue des Montapins
58000 Nevers - France
Tel: 0033 (0)3 86 56 09 75
Fax: 0033 (0)3 86 61 40 73

Paray-le-Monial
MONASTÈRE DE LA VISITATION
Visitandine Nuns
The monastery is located in the center of Paray-le-Monial, an important monastic town that developed in the Middle Ages under the rule of the community of Cluny. Its magnificent triple nave Romanesque basilica is a smaller version of Cluny. The apse has four different levels. The façade with two towers is part of the original 10th century building. The cloisters were restored in the 18th century and blend harmoniously with the Romanesque church.

The basilica and the Chapel of Apparitions attract thousands of pilgrims every year because of the apparitions of Jesus and Mary to Sainte-Marguerite. The saint entered the monastery in 1671, 45 years after its foundation. The apparitions started in 1673 and continued through the years. During one of these, Jesus, holding his hands against his chest, asked Marguerite to honor his Holy Heart. The festivity of the Holy Heart started from this apparition.

Marguerite died in 1690 and was canonized in 1920. In the Parc de Chapelains, adjacent to the church, there is a diorama displaying the life of the saint.

Accommodations
Open to women year-round. Individual 2-8 day spiritual retreats share the seclusion of the nuns. There are 2/3 beds.

Amenities
Towels and linens are supplied.

Meals
All meals are supplied with the lodging.

Cost per person/per night
To be determined upon arrival.

Special rules
Guests live in seclusion.

Contact
Sœur Hôtelière
Monastère de la Visitation
13, rue de la Visitation
71600 Paray-le-Monial
Tel: 0033 (0)3 85 81 09 95
Fax: 0033 (0)3 85 81 21 63

Paray-le-Monial
MONASTÈRE DU ROSAIRE DU SACRÉ-CŒUR
Dominican Sisters

Accommodations
The monastery offers hospitality to both men and women for spiritual retreats in single and double rooms.

Contact
Sœur Hôtelière
Monastère du Rosaire du Sacré- Cœur
40, avenue de Charolles
71600 Paray-le-Monial - France
Tel: 0033 (0)3 85 81 09 09
Fax: 0033 (0)3 85 88 82 92

Saint-Leger Vauban
ABBAYE SAINTE-MARIE-DE-LA-PIERRE-QUI-VIRE
Bénédictine Friars

Accommodations
The friars host men and women, both individually and in groups. There are 60 beds in single and double rooms, some with private bath.

Contact
Frère Hôtelier
Abbaye Sainte-Marie-de-la-Pierre-Qui-Vire
89630 Saint-Léger-Vauban - France
Tel: 0033 (0)3 86 33 19 28 (Frère Hôtelier)
Fax: 0033 (0)3 86 32 22 33
Email: info@abbaye-pierrequivire.asso.fr
Website: http://www.abbaye-pierre-quivire.asso.fr/

Saint-Martin-Belle-Roche
CARMÉL SAINT-JOSEPH
Carmélite Nuns

Accommodations
The monastery hosts men, women and religious representatives for spiritual retreats (up to 35 beds). Closed in August.

Contact
Anyone who answers the phone
Carmél Saint-Joseph
71118 St-Martin-Belle-Roche - France
Tel: 0033 (0)3 85 36 01 43
Fax: 0033 (0)3 85 37 54 93

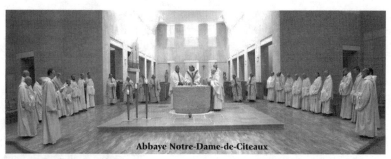

Abbaye Notre-Dame-de-Citeaux

Saint-Nicolas-Lès-Citeaux
ABBAYE DE NOTRE-DAME-DE-CITEAUX
Cistercian-Trappist Friars

In 1098 the abbey was founded in a solitary location in the middle of a forest by Saint-Robert of Molesmes and a group of Bénédictine monks. The monks wanted to strictly follow the rules of Saint-Benedict and as such established the Cistercian Order. Under the inspiration of Saint-Bernard of Clairvaux, the abbey became a powerful monastic institution. Actually a monastic state, it included more than 1000 abbeys throughout 13th century Europe.

Between 1140 and 1188 the first church was built. A sign of the growing importance of the abbey, it was where the Dukes of Burgundy were buried. In 1398 during the Hundred Year War the abbey was ransacked and the monks took shelter in Dijon. This recurred during the religious conflicts of the following centuries. In the 17th century the institution of the Commende led to the downfall of the abbey. At the end of the century the radical reformation which founded the Trappist Order restored monastic life and finances to the abbey.

In 1892 the abbey became the mother house of the Cistercian Order.
Throughout the tumultuous centuries, the original 12th century structures were destroyed. Only the 12th century Cloister of the Copyists survived and was restored in 2001. Until the 14th century when printing presses were invented, the copyist monks, illuminators and bookbinders worked in the cells of the cloister.

Only a small part of the 15th century library has survived. At one time it contained over 10,000 books. Some copies are on display but the originals are preserved at a museum in Dijon. The monks live in the newer portion of the complex. Only a part of it can be visited since most of the monks live in seclusion.

Citeaux is famous for its cheese. The monks also produce honey and caramel candies.

Guided tours can be organized from May until October: 0033 (0)3 80 61 32 58. A video illustrates nine centuries of history of the institution.

Abbaye Notre-Dame-de-Citeaux

Accommodations

The abbey, from which all Cistercian institutions derive, offers hospitality to those who wish to share in the life of the monks. Closed in January and part of February.

Contact

Frère Hôtelier
Abbaye Notre-Dame-de-Citeaux
21700 Saint-Nicolas-lès-Citeaux - France
Tel: 0033 (0)3 80 61 11 53
Fax: 0033 (0)3 80 61 31 10
Email: monastere@citeaux-abbaye.com
Website: www.citeaux-abbaye.com

Taizé
COMMUNAUTÉ DE TAIZÉ
Ecumenical Community

The Taizé Community welcomes tens of thousands of young adults worldwide for meetings lasting a week or a weekend. Throughout the year, young men and women between the ages of 17 and 30 come to pray and reflect on the sources of their faith. They take part in morning, midday and evening prayers.

Accommodations

Accommodations and living conditions are very simple: tents, cabins, meals outdoors during most of the year. At certain times there are meetings for adults. It is necessary to register in advance. For more detailed information, consult the website.

Contact

Meetings: there are operators who speak various languages.
Tel: 0033 (0)3 85 50 30 02 - English
0033 (0)3 85 50 30 01- French
0033 (0)3 85 50 30 30 - friars
Fax: 0033 (0)3 85 50 30 16
Taizé Community
71250 Taizé - France
Email: meetings@taize.fr
Website: www.taize.fr

Venière
ABBAYE NOTRE-DAME
Bénédictine Nuns

Accommodations

The monastery is open to men, women and groups of young people for spiritual retreats. Single and double rooms and a dorm available year-round except in January.

Contact

Sœur Hôtelière
Call at least one week in advance
Abbaye Notre-Dame
Venière - France
71700 Boyer
France
Tel: 0033 (0)3 85 51 35 82 (hôtellerie)
0033 (0)3 85 51 05 85
Fax: 0033 (0)3 85 51 34 97

Bouzy-la-Foret
MONASTÈRE NOTRE-DAME
Bénédictine Nuns

Accommodations
This recently founded monastery (1999) offers hospitality to men and women for spiritual retreats, individually or in groups.

Contact
Sœur Hôtelière
Monastère Notre-Dame
73, route de MI-Feuillage
45460 Bouzy-la-Foret - France
Tel: 0033 (0)2 38 46 88 99
Fax: 0033 (0)2 38 46 88 97
Email: benedictines.bouzy@wanadoo.fr
Website: http://www.benedictines-bouzy.com/

Chartres
CARMÉL
Carmélite Sisters

Accommodations
Hospitality for a small number of men and women (3 bedrooms) for spiritual retreats.

Contact
Carmél
28300 Champhol - France
Tel: 0033 (0)2 37 21 36 46
Fax: 0033 (0)2 37 36 01 07
Email: carmel.charters@wanadoo.fr

Fontgombault
ABBAYE NOTRE-DAME-DE-FONTGOMBAULT
Bénédictine Monks

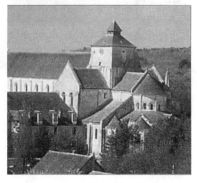

The abbey is one of the most beautiful religious sites in France. Its origins date back to the year 1000 when a hermit named Gombault took up residence. He lived in a cave near a spring, which took the name of Font-Gombault. Many joined the hermit and by the end of the 11th century, the Abbot Pierre de l'Etoile founded the abbey. The institution prospered until the French Revolution when the monastery was closed. In the 19th century, Lenoir of Fontgombault began restoration. The Bénédictine Monks of Solesmes took up residence in 1948 and have remained since that time. Many of the structures date back to the 12th century. The nave was restored in the 19th, the sacristy and chapter house in the 15th.

The monks have a farm and produce butter, cheese and vegetables for sale. CDs with Gregorian chant performed by the monks are also sold.

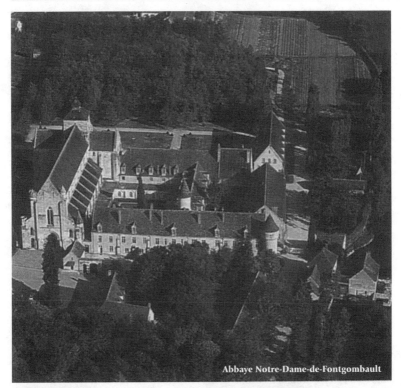

Abbaye Notre-Dame-de-Fontgombault

Accommodations

Hospitality at the abbey is exclusively for individual spiritual retreats. Both men and women are welcome. Men are allowed to share meals with the monks, while women cook their own meals in a kitchen at their disposal.

Contact

Pere Hôtelier, preferably
via ordinary mail
Abbaye Notre-Dame-de-Fontgombault
36220 Fontgombault - France
Tel: 0033 (0)2 54 37 30 98 (Père
Hôtelier) 0033 (0)2 54 37 12 03
Fax: 0033 (0)2 54 37 12 56

Saint-Doulchard
MONASTÈRE DE SAINT-DOULCHARD
Annociades Sisters

Accommodations

The monastery is open year-round for spiritual retreats. Individual retreats are mainly for women; men are welcome as part of a group.

Contact

Sœur Hôtelière
Monastère de Saint-Doulchard
Tel: 0033 (0)2 48 65 57 65
Fax: 0033 (0)2 48 02 54 49
Website: www.annonciades.org

Arcis-le-Ponsart
ABBAYE NOTRE-DAME D'IGNY
Cistercian Nuns

Accommodations

The monastery offers hospitality to men, women alone or in a group (max 20-25 people) for spiritual retreats. Maximum stay 8 days.

Contact

Sœur Hôtelière
Abbaye Notre-Dame d'Igny
51170 Arcis-le-Ponsart - France
Tel: 0033 (0)3 26 48 08 40
Fax: 0033 (0)3 26 83 10 79
Website: http://www.abbayes.net/aujour-dhui/trappistes/igny.htm

Mesnil-Saint-Loup
MONASTÈRE NOTRE-DAME-DE-LA-SAINTE-ESPÉRANCE
Bénédictine-Olivetan Monks

Accommodations

The monastery welcomes men and women for individual retreats year-round except in January.

Contact

Père Hôtelier
Monastère Notre-Dame-de-la-Sainte-Espérance
10190 Mesnil-Saint-Loup - France
Tel: 0033 (0)3 25 40 40 82
Fax: 0033 (0)3 25 40 56 35
Email: sainte.esperance@tiscali.fr

Saint-Thierry
MONASTÈRE DES BÉNÉDICTINES
Bénédictine Nuns

Accommodations

The monastery offers hospitality to men and women for spiritual retreats. It is open year-round except in January and during the summer (dates vary).

Contact

Hôtellerie
Monastère des Bénédictines
51220 Saint-Thierry - France
Tel: 0033 (0)6 18 97 55 24 (cell phone)
Fax: 0033 (0)3 26 03 99 37

Chaux-les-Passavant
ABBAYE NOTRE-DAME DE LA GRACE-DIEU
Cistercian Nuns

Accommodations

The abbey offers hospitality for spiritual retreats to men and women, alone or in a group (about 39 beds). Open all year.

Contact

Sœur Hôtelière
Abbaye Notre-Dame de la Grace-Dieu
25530 Chaux-les-Passavants - France
Tel: 0033 (0)3 81 60 41 32 (Accueil)
0033 (0)3 81 60 44 45 (monastery)
Fax: 0033 (0)3 81 60 44 18
Email: ndgracedieu@wanadoo.fr
Website: http://perso.wanadoo.fr/gon-sans/gracedieu/gracedieu.htm#haut

Lepuix-Gy
PIEURÉ SAINT-BENOIT DE CHAUVEROCHE
Bénédictine Monks

Accommodations

The monastery offers hospitality to singles, groups and families for spiritual retreats.

Contact

Père Hôtelier
Prieuré Saint-Benoit de Chauveroche
90200 Lepuix-Gy - France
Tel: 0033 (0)3 84 29 01 57
Fax: 0033 (0)3 84 29 56 80
Email: chauveroche@wanadoo.fr

Vitreux
ABBAYE D'ACEY
Cistercian-Trappist Monks

Accommodations

The monastery offers hospitality to men and women (children are not allowed) and groups, maximum 15 people, for spiritual retreats. Closed in January.

Contact

Père Hôtelier
Abbaye d'Acey
39350 Vitreux - France
Tel: 0033 (0)3 84 81 04 11
Fax: 0033 (0)3 84 70 90 97

LANGUEDOC-ROUSSILLON

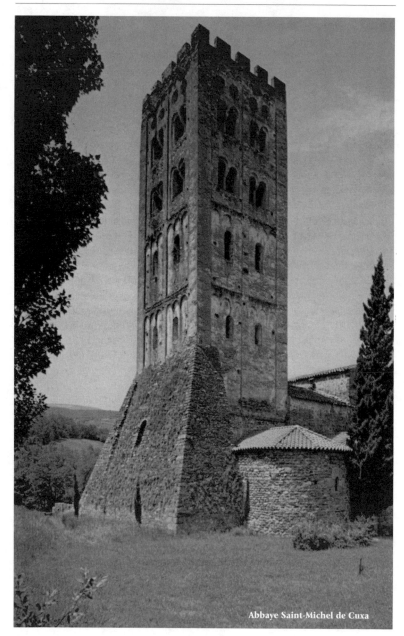

Abbaye Saint-Michel de Cuxa

Azille
MONASTÈRE SAINTE-CLAIRE
Clarice Nuns

Accommodations

The monastery offers hospitality to men and women for spiritual retreats.

Contact

Send a written request via fax or regular mail
Monastère Sainte-Claire
11700 Azille (France)
Tel: 0033 (0)4 68 91 40 24
Fax: 0033 (0)4 68 91 56 12

Codalet
ABBAYE SAINT-MICHEL DE CUXA
Bénédictine Monks

Codalet is at 359 m above sea level on the Pyrénées, not far from the Spanish border and only 4 km from Prades. An example of pre-Romanesque architecture, it was founded in 878. In the beginning the monks lived in a small complex. Over the years the importance of the institution grew and under the powerful Abbey Garin, the complex was enlarged and a new church was built. The monastery hosted the Doge of Venice who died there in 987. He was later beatified. In 1007 two chapels and three apses were added. In the 12th century a larger cloister was built in marble, its capitals beautifully decorated.

During the centuries following the Middle Ages the abbey experienced a period of decadence that lasted until the French Revolution. At that time the complex was confiscated and the capitals of the cloister were sold one by one. By 1908 there were only twelve left. In 1913

American sculptor, George Grey Barnard, bought some of the capitals and took them to New York where they formed the cloister of the "Cloister Museum." In 1919 Ferdinand Trulles bought the complex and restored the monastic life with the monks of Fontfroide. Ten years later they were replaced by the Bénédictine Order of Monsterrat (Spain). The complex underwent restoration from 1920 to 1954 and was inaugurated by Pablo Casals.

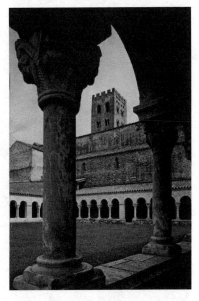

The cloister, partly reconstructed in 1952-1955 is the largest of the Pyrenean area. The capitals are engraved in pink marble with human, vegetal and animal decorations as typical of the Middle Ages. The south portal of the cloister is richly embellished.

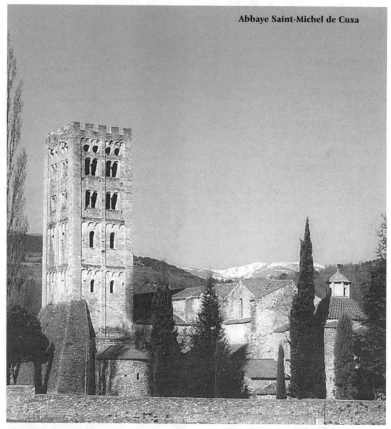

Abbaye Saint-Michel de Cuxa

The church is a compelling structure, a synthesis of three different churches. The two chapels added in the 12th century have a square plan and are located one on top of the other. The one above is dedicated to the Holy Trinity, the lower one is called the "Crypt of the Vierge" and was originally built to host the relic of the Holy Crib.

Accommodations

A few beds are available for men and women for spiritual retreats.

Contact

Père Hôtelier (the monks speak both Spanish and French)
Abbaye Saint-Michel de Cuxa
Route de Taurinyà
66500 Codalet (France)
Tel/Fax: 0033 (0)4 68 96 02 40
Email:
abbaye.stmichel.cuixa@wanadoo.fr
Website:
http://monsite.wanadoo.fr/abbaye.cuixa

Gaussan
MONASTÈRE NOTRE-DAME DE GAUSSAN
Bénédictine Monks

Accommodations

The monastery offers hospitality to men and women for individual spiritual retreats. There are 14 beds for men, 5 for women.

Contact

Send a fax or letter to the Père Hôtelier
Monastère Notre-Dame de Gaussan
11200 Lezignan-Corbières (France)
Tel: 0033 (0)4 68 45 19 92
Fax: 0033 (0)4 68 45 19 93

Nîmes
MONASTÈRE DE CLARISSES
Clarice Nuns

Accommodations

The monastery has 9 beds available for women and male religious representatives for spiritual retreats.

Contact

Send a fax or letter
Monastère des Clarisses
34, rue de Brunswick
30000 Nîmes (France)
Fax: 0033 (0)4 66 26 86 35

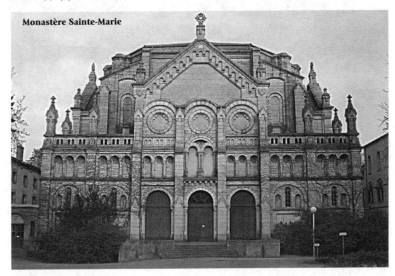

Monastère Sainte-Marie

Prouilhe
MONASTÈRE SAINTE-MARIE
Dominican Sisters

Accommodations

15 rooms available for spiritual retreats.

Contact

Send a letter, fax or email
to Sœur de l'Accueil

Monastère Sainte-Marie
Prouilhe
11270 Fanjeaux - France
Tel: 0033 (0)4 68 11 22 66
Fax: 0033 (0)4 68 11 22 60
Email: accueil@prouilhe.net
Website: www.prouilhe.org

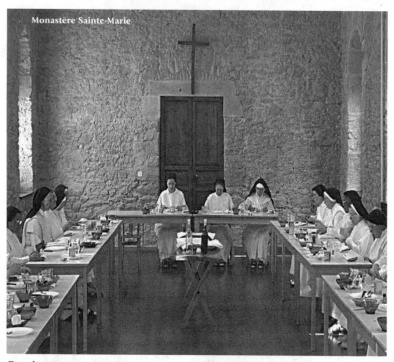

Monastère Sainte-Marie

Perpignan
MONASTÈRE SAINTE-CLAIRE
Clarice Nuns

Accommodations
A few beds available for individuals to spend a few days in retreat (groups are not accepted).

Contact
To be hosted, guests must send a letter to the monastery with a presentation by a religious representative.
Monastère Sainte-Claire
107, rue Marechal-Joffre
66000 Perpignan (France)
Tel: 0033 (0)4 68 61 29 54
Fax: 0033 (0)4 68 52 74 89
Email: clarisses66@free.fr

Rieunette
ABBAYE CISTERCIENNE
SAINTE-MARIE DE RIEUNETTE
Cistercian Nuns

Accommodations
The monastery has 5 rooms available for spiritual retreats. Men are allowed only as part of a family. Closed in October.

Contact
Call and then send a written confirmation to the Sœur Hôtelière
Abbaye Cistercienne Sainte-Marie de Rieunette
11250 Ladern-sur-Lauquet (France)
Tel: 0033 (0)4 68 69 69 06
Fax: 0033 (0)4 68 69 40 44

Limoges
CARMÉL DU MONT NOTRE-DAME
Carmélite Nuns

Accommodations

The monastery has 3 rooms available for spiritual retreats. Meals are not offered, but guests can prepare their own meals in a room at their disposal.

Contact

Write a letter or fax
Carmél du Mont Notre-Dame
Crochat
8700 Limoges - France
Tel: 0033 (0)5 55 30 22 91
Fax: 0033 (0)5 55 30 99 76
Website:
http://www.carmel.asso.fr/famille/moniale/Limoges/87000.shtml

Le Dorat
CARMÉL DE LE DORAT
Carmélite Nuns

Accommodations

The monastery has 3-4 beds available to men and women for individual spiritual retreats. Open all year.

Contact

Write or call directly
Carmél de Le Dorat
10, rue Saint-Michel
87210 Le Dorat - France
Tel: 0033 (0)5 55 60 73 65
Fax: 0033 (0)5 55 60 16 76

NOTES

Scy-Chazelles
MONASTÈRE DE LA VISITATION
Visitandine Nuns

Accommodations

The monastery offers hospitality only to women and only for individual spiritual retreats in silence. Open from June to September.

Contact

Write (preferred) to the Sœur Hôtelière
Monastère de la Visitation
Scy-Chazelles
57160 Moulins-les-Metz - France
Tel: 0033 (0)3 87 60 56 01
Fax: 0033 (0)3 87 60 31 68

Ubexy

ABBAYE NOTRE-DAME DE SAINT-JOSEPH
Cistercian Nuns

Accommodations

The monastery has 20 beds available for spiritual retreats. Closed in January.

Contact

Send an email, fax or ordinary mail to the Sœur Hôtelière
Abbaye Notre-Dame de Saint-Joseph
88130 Ubexy - France
Tel: 0033 (0)3 29 38 25 70 (Sœur Hôtelière) or (0)3 29 38 04 32
Fax: 0033 (0)3 29 38 05 90
Email: uy.compt@wanadoo.fr
Website: http://www.abbaye-ubexy.com.fr

Verdun
CARMÉL
Carmélite Nuns

Accommodations

The carmél has 3 rooms available for spiritual retreats only.

Contact

Send a fax or letter to the Sœur Hôtelière
Carmél
25, rue Saint-Victor
55100 Verdun - France
Tel: 0033 (0)3 29 86 03 97
Fax: 0033 (0)3 29 86 50 76
Email: plumlaine-at-carmel@dial.oleane.com
Website: www.boutiques-theophile.com

Vondoeuvre-les-Nancy
MONASTÈRE SAINTE-CLAIRE
Clarice Nuns

Accommodations

The monastery offers hospitality for spiritual retreats (preferably to women). Male religious representatives and married couples are also welcome.

Contact

Send a fax, letter or email to the Mère Abbesse
Monastère Sainte-Claire
24, rue Sainte-Colette
54500 Vandoeuvre-les-Nancy - France
Tel: 0033 (0)3 83 55 42 86
Fax: 0033 (0)3 83 55 21 79
Email: abbesse@tiscali.fr

Avranches
CARMÉL
Carmélite Sisters

Accommodations

Hospitality is offered to individuals (mostly women) for spiritual retreats.

Contact

Carmél
Sœur Hôtelière
59, boulevard du Luxembourg
50300 Avranches - France
Tel: 0033 (0)2 33 58 23 66
Fax: 0033 (0)2 33 58 77 99

Bricquebec
ABBAYE NOTRE-DAME DE GRACE
Cistercian-Trappist Monks

Accommodations

Located near the D-Day beaches, the abbey offers hospitality to men and women but only for spiritual retreats.

Cost per person /per night

About 30€ full board

Contact

Frere Hôtelier
Abbaye Notre-Dame de Grace
50260 Bricquebec - France
Tel: 0033 (0)2 33 87 56 10
Fax: 0033 (0)2 33 87 56 16
Email: (For reservations)
freregerardvivier@yahoo.fr

Le-Mont-Saint-Michel
FRATERNITÉS MONASTIQUES DE JERUSALEM
Bénédictine Community of Friars and Sisters

The legendary "sacred mount" is one of the most famous abbeys in all of Christendom and certainly one of the most visited monuments of France. Indisputable symbol of Normandy, the abbey stands on the top of a windswept granite islet, isolated in the middle of an immense bay whose tide is among the strongest in the world.

The magic of Mont-Saint-Michel has attracted pilgrims and tourists for over 1000 years. The monks and sisters of the Fraternité de Jerusalem preserve silence and spirituality in the heart of the island and allow visitors only for spiritual retreats in solitude.

Until the beginning of the 8th century, the granite rock was a Celtic funerary monument (Mont Tombe) but according to legend, Aubert, Bishop of Avranches had a vision of St-Michael the Archangel who told him to build an oratory on the islet.

Accommodations

l) The community offers hospitality to men, women and couples but only for spiritual retreats (in silence) from Tuesday until Sunday. Retreat guests are hosted in a few rooms annexed to the monastery and managed by lay personnel. Access to the abbey is limited during mass and prayer or when the monks or nuns ask guests to participate in daily community work.

LOWER NORMANDY

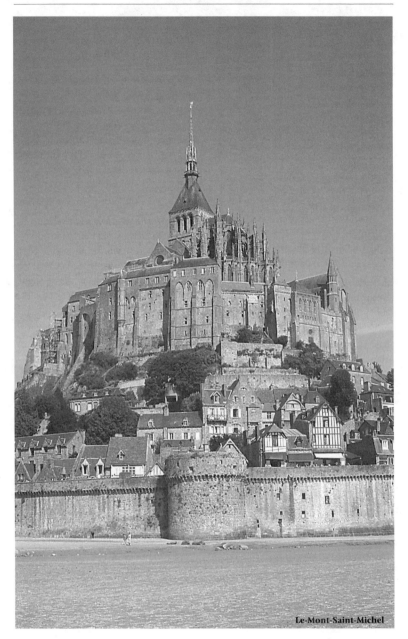

Le-Mont-Saint-Michel

Guests coming from abroad are welcome but only if they speak French.
Closed from July 14th to September 3rd.

Contact
Sœur Hôtelière
Tel: 0033 (0)2 33 60 14 47
Fax: 0033 (0)2 33 58 31 71
Email: hotellerie@abbaye-montsaint-michel.com
Website www.abbaye-montsaintmichel.com

2) The Maison du pelerin is a large room equipped with toilets, available only for groups of pilgrims (up to 50) and only for a daily stop during their visit to Mont-Saint-Michel. The cost is 1€ per person per day.

Contact
Call, write or send an email to make a reservation.
Maison du pèlerin
BP 1
50170 Mont-Saint-Michel
Tel: 0033 (0)2 33 60 14 05
Email:
sanctuaire.saint.michel@wanadoo.fr

Address for all accommodations
Fraternità Monastique de Jérusalem
BP 10
50170 Le Mont-Saint-Michel
France
Tel: 0033 (0)2 33 60 14 47
Fax: 0033 (0)2 33 58 31 71
Email: hotellerie@abbaye-montsaint-michel.com
Website www.abbaye-montsaintmichel.com

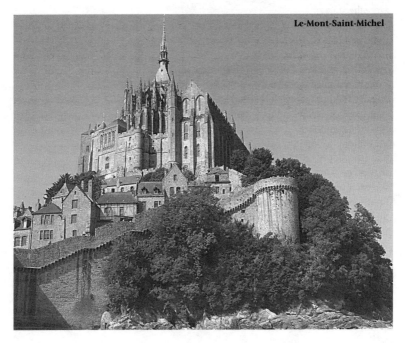
Le-Mont-Saint-Michel

Lisieux
ERMITAGE OF THE MONASTÈRE DU CARMÉL
Carmélite Sisters

The monastery of Sainte-Therese of Lisieux, patron saint of all missionaries, is internationally renowned. Sainte-Therese received the title of "Doctor of the Church," an honor only received by Sainte-Therese of Avila and Sainte-Catherine of Siena.

Sainte-Therese entered the monastery at the age of fifteen. She lived an ordinary, almost unnoticed life. During her years at the monastery, she wrote the story of her life. The book was published in 1898, one year after her death. It was extremely successful and with its success, the pilgrimages to Lisieux began. And with the pilgrims came the miracles. In 1925 Therese was canonized and an immense basilica built in her honor. Its interior harbors stained glass windows and mosaics by Pierre Gaudin, an artist who reproduced the message of Therese through his work. The bell tower houses fifty-one bells and forty-five chimes. Their lilting sounds are considered among the most beautiful in Europe. The monastery itself consists of the main building and the chapel where the saint is displayed in a glass case. The sisters organize pilgrimage retreats on request.

Accommodations
The ermitage hosts only pilgrims to the sanctuary of Sainte-Therese. There are 90 rooms with 1 or 2 beds, all with private bath. Men and women are welcome.

Amenities
Linens are provided, towels are not but they can be rented on request.

Meals
All meals can be provided.

Cost per person /per night
There is a minimum contribution of 30€ for full pension.

Contact
The Ermitage
33, Rue du Carmél
B.P 62095 - F-14102
Lisieux cedex
France
Tel: 0033 (0)2 31 48 55 10 (Ermitage)
Fax: 0033 (0)2 31 48 55 27
Email: ermitage-ste-therese@therese-de-lisieux.cef.fr
Website: http://therese-de-lisieux.cef.fr

Soligny-la-Trappe
ABBAYE DE LA TRAPPE
Cistercian Monks

Accommodations
The abbey offers hospitality to men, women and couples who wish to share in the life of the abbey. Closed in January.

Contact
Frère Hôtelier
Abbaye de la Trappe
61380 Soligny-la-Trappe - France
Tel: 0033 (0)2 33 84 17 00
Fax: 0033 (0)2 33 34 98 57
Email: la.trappe@wanadoo.fr

Albi
CARMÉL
Carmélite Nuns

Accommodations

The monastery has only 2 rooms available for individual spiritual retreats.

Contact

Call or write to Sœur Hôtelière
Carmél
17, rue de Carmélites
81000 Albi - France
Tel: 0033 (0)5 63 54 55 54
Fax: 0033 (0)5 63 38 41 16
Email: carmel.albi@free.fr

Bellegarde-Sainte-Marie
ABBAYE SAINTE-MARIE-DU-DÉSERT
Cistercian Monks

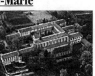

Accommodations

The abbey has 25 beds available for spiritual retreats for both individuals and groups. Closed one week during Lent.

Contact

Write or call Frère Hôtelier
Abbaye Sainte-Marie-du Désert
31530 Bellegarde Sainte-Marie - France
Tel: 0033 (0)5 62 13 45 45
Fax: 0033 (0)5 62 13 45 35
Email: abstemariedesert@wanadoo.fr
Website: http://abbayedudesert.com

Dourgne
ABBAYE SAINT-BENOIT D'EN CALCAT
Bénédictine Monks

An important abbey, it was founded in 1890 in a small village between Castres and Carcassonne and is enveloped by the green countryside of the Midi-Pyrénées.

In 1903 the abbey was closed due to the laws that suppressed religious orders. The monks were forced to live in Spain for 12 years. Since their return they have hosted guests for spiritual retreats and sessions (about 4000 a year).

Accommodations

Hospitality is offered only for spiritual retreats, either for individuals or groups. Guests are expected to participate in the life of the monastery.

Three possibilities are available:

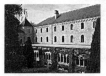

1) Inside the abbey: 20 single rooms for men only. Baths are shared. Meals are shared with the monks. Towels and linens are supplied. Under restoration: this type of hospitality will not begin until 2007.

2) Outside the abbey: Hôtellerie Neuve has 10 single and 13 double rooms with private bath. Towels and linens are supplied. Meals are shared in silence in the refectory.

3) Outside the abbey: La Grange: 25 beds in 2 dorms. Conceived mainly for groups of young people. Meals are not supplied. There is a kitchen that guests may use.

Amenities
Conference rooms, reading room, garden, oratory.

Cost per person/per night
Voluntary contribution, although a minimum contribution for the expenses is required.

Contact
Frère Hôtelier
Abbaye Saint-Benoit d'en Calcat
81110 Dourgne - France
Tel: 0033 (0)5 63 50 84 10
Fax: 0033 (0)5 63 50 34 90
Email: hotel@encalcat.com
Website: www.encalcat.com

Espalion
ABBAYE NOTRE-DAME DE BONNEVAL
Cistercian Nuns

Accommodations
The monastery offers hospitality to women, families, religious representatives (single male guests are not accepted) for spiritual retreats. There are about 30 rooms. Closed in the winter.

Contact
Write to the Sœur Hôtelière
Abbaye Notre-Dame de Bonneval
12500 Le Cayrol-Espalion - France
Tel: 0033 (0)5 65 44 01 22
Fax: 0033 (0)5 65 44 77 69
Email: abbaye.bonneval@wanadoo.fr
Website: www.abbaye-bonneval.com

Millau
MONASTÈRE NOTRE-DAME-DES-DOULEURS
Clarice Nuns

Accommodations
The monastery offers hospitality to those wishing to spend a few days praying. Open all year, maximum stay 8 days.

Contact
Sœur Hôtelière
Monastère Notre-Dame-des-Douleurs
3, rue Sainte-Claire
12100 Millau - France
Tel: 0033 (0)5 65 60 16 03
Fax: 0033 (0)5 65 60 78 30
Email: abbesse.millau@wanadoo.fr

Tournay
ABBAYE NOTRE-DAME
Bénédictine Monks

Accommodations
The monastery offers hospitality for individual and group retreats.

Contact
Call and then send written confirmation to Frère Hôtelier
Abbaye Notre-Dame
65190 Tournay - France
Tel: 0033 (0)5 62 35 70 21
Cell phone: 0033 (0)6 63 64 17 59
Fax: 0033 (0)5 62 35 25 72

Saint-André
MONASTÈRE NOTRE-DAME DE LA PLAINE
Cistercian-Bernardine Nuns

Accommodations
The monastery offers hospitality to men and women for individual spiritual retreats.

Contact
Call and then send a written confirmation to Sœur Hôtelière
Monastère Notre-Dame de la Plaine
287, avenue Lattre de Tassigny
59876 Saint-André - France
Tel: 0033 (0)3 20 51 76 20
Fax: 0033 (0)3 20 42 26 70
Email: nd.laplaine@wanadoo.fr

Saint-Martin-de-Boulogne
MONASTÈRE DE LA VISITATION
Visitandine Nuns

Accommodations
The monastery offers hospitality to women and religious representatives. During the academic year there are only 4 rooms, more rooms are available in June, July and August.

Contact
Monastère de la Visitation
9, rue Maquétra
62280 Saint-Martin-de-Boulogne - France
Tel: 0033 (0)3 21 31 35 88
Fax: 0033 (0)3 21 80 83 05

Wisques
ABBAYE SAINT-PAUL
Bénédictine Monks

The monastery is at 100 m of altitude surrounded by the verdant countryside and its own large wooded park. It was

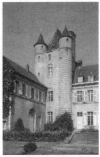

founded by a group of monks coming from the Abbey of Saint-Pierre of Solesmes in 1889. In 1901 the monks were forced to leave the abbey due to the laws against the religious orders. They returned in 1920. From 1930 until 1969 the complex was enlarged and completed. The origins date back to the 15th century when it was a castle. A keep and three towers remain. The bell belonged to the Abbaye of Saint-Bertin. The monks are famous for their ceramic works.

Accommodations
About 20 beds for individual spiritual retreats. Both men and women are welcome in single and double rooms with shared bath.

Amenities
Towels and linens are an extra charge.

Meals
All meals are supplied with the lodging.

Cost per person/per night
Provisional cost for full pension 30€.

Contact
Frère Hôtelier
Abbaye Saint-Paul
50, rue de l'Ecole
62219 Wisques - France
Tel: 0033 (0)3 21 12 28 50
Fax: 0033 (0)3 21 12 28 79
Email: info@abbaye-wisques.com
Website: www.abbaye-wisques.com

Brou-sur-Chanterine
PRIEURÉ SAINT-JOSEPH
Bénédictine of Christ Crucified Nuns

Accommodations

The monastery offers hospitality year-round for a time of silence and prayer. 16 beds, maximum stay 4 days.

Contact

Sœur Hôtelière
Prieuré Saint-Joseph
1bis, avenue Victor Thiebaut
77177 Brou-sur-Chanterine - France
Tel: 0033 (0)1 60 20 11 20
Fax: 0033 (0)1 60 20 43 52
Email: pr.stjoseph.brou@club-free.fr

Clamart
CARMÉL DE L'INCARNATION
Carmélite Nuns

Accommodations

The monastery has 4 rooms offered mainly to women and priests.

Contact

Sœur Hôtelière
Carmél de l'Incarnation
3, Rue de l'Est
92 140 Clamart - France
Tel: 0033 (0)1 46 44 30 33
Fax: 0033 (0)1 40 97 79 09

Etiolles
PRIEURÉ SAINT-BENOIT
Bénédictine Monks

Accommodations

The monastery offers hospitality to men and women for spiritual retreats.

Contact

Frère Hôtelier
Prieuré Saint-Benoit
1, allée Saint-Benoit
91450 Etiolles - France
Tel: 0033 (0)1 69 89 84 88
Fax: 0033 (0)1 69 80 31 69
Email: benoit.m.billiot@wanadoo.fr

Faremoutiers
ABBAYE NOTRE-DAME ET SAINT-PIERRE
Bénédictine Nuns

Accommodations

The guest house offers hospitality exclusively to groups of 18 people (maximum) for spiritual retreats. Groups must also prepare their own meals in a kitchen at their disposal.

Contact

Sœur de l'Accueil
Abbaye Notre-Dame et Saint-Pierre
77515 Faremoutiers - France
Tel: 0033 (0)1 64 04 20 37
Fax: 0033 (0)1 64 20 04 69

Forges
CARMÉL DE FORGES
Carmélite Nuns

Accommodations

The carmél offers hospitality only to women and only for individual spiritual retreats. There are six single rooms. Generally closed in August.

Contact

Mère Superieure
Carmél de Forges
30, rue Grande
77130 Forges - France
Tel: 0033 (0)1 64 32 18 35
Fax: 0033 (0)1 64 32 10 55

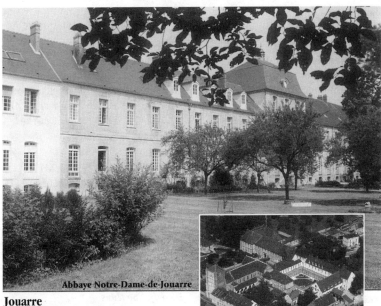

Abbaye Notre-Dame-de-Jouarre

Jouarre
ABBAYE NOTRE-DAME-DE-JOUARRE
Bénédictine Nuns

The monastery sits on a hill above the small town of La Ferté-sous-Jouarre. It was founded in 634 by Adon who then entrusted it to Sainte-Telchilde, a woman of a noble family. The monastery flourished during the Merovingian era. The crypt is considered one of the finest examples of Merovingian art. The Tour Clocher was built in the 12th century and hosts a display of the history and life of the monastery.

The nuns produce pottery and ceramic objects. Their wares are on sale in a shop on the premises.

Accommodations
There are 35 beds for spiritual retreats. Groups cannot exceed more than 25. Closed in January.

Meals
All meals are supplied. They are shared in silence.

Contact
Sœur Hôtelière
Abbaye Notre-Dame-de-Jouarre
BP 30
77262 La Ferté-sous-Jouarre cedex - France
Tel: 0033 (0)1 60 22 06 11
Fax: 0033 (0)1 60 22 31 25
Email: hotesndjouarre@aol.com
Website:
http://perso.wanadoo.fr/abbayejouarre/

Limon Vauhallan
ABBAYE SAINT-LOUIS DU TEMPLE
Bénédictine Nuns

Accommodations

Groups of no more than 30 adults or 40 young people must organize their own retreats. Individual retreats are offered only to women.

Contact

Abbaye Saint-Louis du Temple
Limon, 91430 Vauhallan - France
Tel: 0033 (0)1 69 85 21 00
Fax: 0033 (0)1 69 41 32 70
Email: limon@wanadoo.fr

Nemours
MONASTÈRE NOTRE-DAME DE BETHLÉEM
Nuns of Bethléeem of the Assumption of the Virgin and Saint-Bruno

Accommodations

The monastery offers hospitality exclusively for individual spiritual retreats to be spent in solitude. Guests are hosted in two hermitages in the forest. They must respect the silence.

Contact

Sœur Hôtelière
Monastère Notre-Dame de Bethléem
Route de Poligny
77140 Nemours - France
Tel: 0033 (0)1 64 28 13 75
Fax: 0033 (0)1 64 45 08 91

Paris
MONASTÈRE DE L'ADORATION RÉPARATRICE
Sisters of the Adoration Réparatrice

Accommodations

The monastery has 5 single rooms available to women and male religious representatives for individual spiritual retreats. Closed in July and August and the week before Easter.

Contact

Reservations should be made via telephone with the Sœur Hôtelière
Monastère de l'Adoration réparatrice
39, rue Gay-Lussac
75005 Paris - France
Tel: 0033 (0)1 43 26 75 75

Paris
PRIEURÉ SAINT-BENOIT-SAINTE-SCHOLASTIQUE
Bénédictine Nuns

Accommodations

The monastery offers hospitality year-round to men and women for spiritual retreats or a pilgrimage to the basilica of Sacré-Cœur.

Contact

Sœur Hôtelière
Prieuré Saint-Benoit-Sainte-Scholastique
3, Cité du Caré-Cœur
40, rue de Chevalier de la Barre
75018 Paris - France
Tel: 0033 (0)1 46 06 14 74
Fax: 0033 (0)1 42 23 19 33

Pontoise
CARMÉL
Carmélite Nuns

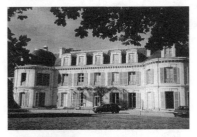

Accommodations
The monastery offers hospitality only to women and male religious representatives. There are three rooms available. Closed the first two weeks of August.

Contact
Sœur Hôtelière
Carmél
55, rue Pierre-Butin
95300 Pontoise - France
Tel: 0033 (0)1 30 32 35 21
Fax: 0033 (0)1 30 32 07 54
Email: carmel.pointoise@carmel.asso.fr

Vanves
PRIEURÉ SAINTE-BATHILDE
Bénédictine Nuns

Accommodations
The community of nuns offers hospitality for spiritual retreats to individuals and small groups (6 people maximum). Closed in July and August.

Contact
Sœur Hôtelière
Prieuré Sainte-Bathilde
7, rue d'Issy
92170 Vanves - France
Tel: 0033 (0)1 46 42 46 20
Fax: 0033 (0)1 46 45 64 14
Email: monastere-vanves@wanadoo.fr

Bazougers
PRIEURÉ SAINTE-MARIE - "LA COTELLERIE"
Petits Frères de Marie Friars

Accommodations

The community offers hospitality to men, women, families and groups of young people for spiritual retreats or just to rest. Guests are asked to participate in the liturgy.

Contact

Call, send a letter, email or fax well in advance to the Frère Hôtelier
Prieuré Sainte-Marie
La Cotellerie
53170 Bazougers - France
Tel: 0033 (0)2 43 66 43 66
Fax: 0033 (0)2 43 66 43 67
Email: hotelier@la-cotellerie.com
Website: www.la-cotellerie.com

Begrolles-en-Mauges
ABBAYE DE BELLEFONTAINE
Cistercian Monks

Accommodations

Open to men and women for individual spiritual retreats year-round except the last 2 weeks in November and the first 2 weeks of December.

Contact

Call, write or fax the Père Hôtelier
Abbaye de Bellefontaine
49122 Begrolles-en-Mauges - France
Tel: 0033 (0)2 41 75 60 46 (hôtellerie)
0033 (0)2 41 75 60 40 (abbaye)
Fax: 0033 (0)2 41 75 60 46
Email: hotellerie@bellfontaine-abbaye.com
Website: www.bellfontaine-abbaye.com

Chavagne-en-Paillers
CARMÉL
Carmélite Nuns

Accommodations

The monastery offers hospitality for individual spiritual retreats only to women and married men (no double rooms available). Guests must cook their own meals.

Contact

Write to the Sœur Hôtelière
Carmél
La Fourchadière
85250 Chavagne-en-Paillers - France
Tel: 0033 (0)2 51 42 21 80
Fax: 0033 (0)2 51 42 34 79

Entrammes
ABBAYE NOTRE-DAME DU PORT-DU-SALUT
Trappist Monks

Accommodations

The monastery offers hospitality for spiritual retreats.

Contact

Frère Hôtelier
Abbaye Notre-Dame-du-Port-du-Salut
53260 Entrammes - France
Tel: 0033 (0)2 43 64 18 64
Fax: 0033 (0)2 43 64 18 63
Email: ab.port.salut@wanadoo.fr

Flée
MONASTÈRE LA-PAIX-NOTRE-DAME
Bénédictine Nuns

Accommodations

The monastery offers hospitality in a building outside the monastery to men, women and families for spiritual retreats.

Contact
Sœur Hôtelière
Monastère La-Paix-Notre-Dame
72500 Flée - France
Tel: 0033 (0)2 43 44 14 18
Fax: 0033 (0)2 43 79 18 92
Email: Benedictines.flee@club-internet.fr

Fluçon
CARMÉL
Carmélite Nuns

Accommodations
The carmél offers hospitality to religious representatives. There are 4 rooms with access to the chapel.

Contact
Prieuré or Sœur Hôtelière
Carmél
14, rue de l'Union Chrétienne
85400 Luçon - France
Tel: 0033 (0)2 51 56 15 45
Fax: 0033 (0)2 51 56 30 35

La Meillaraye-de-Bretagne
ABBAYE NOTRE-DAME-DE-MELLERAY
Cistercian-Trappist Monks

The abbey is classified as a historical monument. It was founded in 1142 when a group of Cistercian monks from the Abbey of Potrond took up residence. They chose an isolated site amidst a thick forest, close to a pond. The property was sold after the French Revolution. The monks went to England and founded the monastery of Lulworth. In 1817 the Abbot of Lulworth purchased the abbey and the monks returned.

The complex is composed of the monastery (17th and 18th centuries) and the 12th century church. During one of the renovations to the church, the portal was executed in Flamboyant Gothic and adorned by statuary. The interiors are original and enriched by statues including the 17th century polychrome wooden statue of the Virgin Mary. The monks operate a printing facility. There is a shop that sells religious books and monastic products.

Accommodations
The monastery offers hospitality exclusively for spiritual retreats, individually or in a group. There are 50 beds in single and double rooms, some with private bath.

Amenities
Towels and linens are supplied. Meeting rooms.

Meals
All meals are supplied with the lodging.

Special rules
Participation at the liturgy is required.

Cost per person/per night
To be determined when reservations are made.

Contact
Frère Hôtelier
Abbaye Notre-Dame-de-Melleray
44250 La Meillaray-de-Bretagne - France
Tel: 0033 (0)2 40 55 27 37 (hôtellerie direct)
0033 (0)2 40 55 26 00 (abbey)
Fax: 0033 (0)2 40 55 22 43
Email: melleray@wanadoo.fr

La-Roche-sur-Yon
MONASTÈRE DE LA VISITATION
Visitandine Nuns

Accommodations

The monastery offers hospitality only for spiritual retreats. Women and religious representatives can be hosted in seclusion inside the monastery. Men and families can be hosted outside the secluded part of the monastery or in a house annexed to the complex.

Contact

Call and then send a written confirmation to the Sœur de l'Accueil
Monastère de la Visitation
36, rue Abbé Pierre Arnaud
8500 La Roche-sur-Yon - France
Tel: 0033 (0)2 51 37 10 13
Fax: 0033 (0)2 51 36 29 71
Email:
monastere.visitation85@wanadoo.fr

Laval
ABBAYE DE LA COUDRE
Cistercian-Trappist Nuns

Accommodations

Hospitality is offered only for spiritual retreats

Contact

Sœur Hôtelière
Abbaye de la Coudre
Rue Saint-Benoit
BP 0537
53005 Laval cedex - France

Tel: 0033 (0)2 43 02 85 85
Fax: 0033 (0)2 43 66 90 18
Email: hotellerie.coudre@wanadoo.fr
Website: www.abbaye-coudre.com

Martigné-Briand
MONASTÈRE NOTRE-DAME-DE-COMPASSION
Bénédictine Nuns

Accommodations

The monastery offers hospitality to women and married men for individual spiritual retreats. Closed for 3 weeks between September and October.

Contact

Write or send an Email or a fax (preferably) to the Sœur Hôtelière
Monastère Notre-Dame-de-Compassione
49540 Martigné-Briand - France
Tel: 0033 (0)2 41 59 42 85
Fax: 0033 (0)2 41 59 66 92
Email: hotellerie-martigne@wanadoo.fr

Nantes
MONASTÈRE DE LA VISITATION
Visitandine Nuns

Accommodations

Hospitality is offered to female religious representatives and women coming for spiritual retreats in seclusion. Closed during Lent and Advent.

Contact

Prieuré
Monastère de la Visitation
8, rue du Marechal-Joffre
44000 Nantes - France
Tel: 0033 (0)2 40 74 15 78
Fax: 0033 (0)2 40 74 27 57

Nantes
MONASTÈRE SAINTE-CLAIRE
Clarice Nuns

Accommodations

The monastery has 6 single rooms for guests under 35 years of age coming for a spiritual retreat. Maximum stay 1 week.

Contact

Write to the Sœur Hôtelière
Monastère Sainte Claire
20, rue Molac
BP 51619 – 44016 Nantes cedex -
France
Tel: 0033 (0)2 40 20 37 36
Fax: 0033 (0)2 40 20 36 94
Email: steclairenantes@aol.com

Saint-Georges-de-Gardes
ABBAYE NOTRE-DAME DES GARDES
Trappist Nuns

Accommodations

The monastery offers hospitality to men
and women for spiritual retreats.

Contact

Sœur Hôtelière
Abbaye Notre-Dame des Gardes
49120 Saint-Georges-des-Gardes -
France
Tel: 0033 (0)2 41 29 57 10
Fax: 0033 (0)2 41 29 57 19

Saint-Jean-d'Assé
MONASTÈRE NOTRE-DAME DE LA MERCI-DIEU
Cistercian Nuns

Accommodations

Men and women are welcome but only
for spiritual retreats.

Contact

Call or write to the Sœur Hôtelière
Monastère Notre-Dame de la Merci-Dieu
72380 Saint-Jean-d'Assé - France
Tel: 0033 (0)2 43 25 25 49
Fax: 0033 (0)2 43 25 20 36

Solesmes

ABBAYE SAINT-PIERRE DE SOLESMES
Bénédictine Monks

An imposing complex
along the banks of the
river Sarthe, it is one of
the most famous and
important of France. It was founded in
1010 by Geoffroi de Sablé and pros-
pered until the French Revolution. After
the revolution the monks returned to the
abbey. At that time, Dom Prosper
Guéranger founded the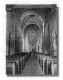
French Congregation of the
Bénédictine Monks of
Solesmes. This contributed
to the Renaissance of the
Bénédictine Order by re-
opening 21 male and 8 female monas-
teries in 10 different countries.

At its initial founding the monastery was
a small prieuré. It was only in 1896 that
the monastery was enlarged according to
the design by the Bénédictine architect
Dom Mellet. Additional enlargements
were completed in 1936 and 1955. The
exterior of the building is reminiscent of
the Palace of the Popes of Avignon and
the monastery of Mont-Saint-Michel. The

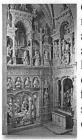

complex includes a
refectory, 30 cells, the
ancient prieuré and the
abbatial church.
Located in the transept
of the church is the
famous ensemble of
sculptures of the Saint
of Solesmes.

 The Chapelle de Notre-Dame represents the deposition of the Virgin Mary. The Chapel of Our Lord shelters the deposition of the Christ by Pierre Cheminart (1496).

The monks of Solesmes are famous for Gregorian chant and for their studies of music paleography. They also publish books under the name, Edition Solesmes.

Accommodations

The monastery offers hospitality only for spiritual retreats. There are different ways of being hosted. For accommodations #1 and #2, contact the Père Hôtelier. For accommodations 3 contact the Sœur Hôtelière

1) Men are hosted inside the abbey and can share meals with the monks. Towels and linens are supplied. Participation in the liturgy is required. Maximum stay 1 week, respect the silence. Cost per day about 28€.

2) Groups, mainly composed of young people, are hosted in two guest houses, La Marbrerie and Saint-Clement. Towels and linens are not supplied. Meals must be prepared by guests in a kitchen at their disposal. Participation in the liturgy or self-organized spiritual retreat is mandatory.

3) Women and families are hosted at the Accueil Sainte-Anne run by the Bénédictine Nuns of the Abbaye of Sainte-Cecile. Towels, linens and meals are supplied. Participation in the liturgy is required, although guests are free to visit the town. Cost per day, meals included: 28€ (provisional). Open from Palm Day until September, All Saints and Christmas Holidays. The remainder of the year, the guest house is only open to groups of twelve or more.

Contact

Père Hôtelier or Sœur Hôtelière
Accueil Sainte-Anne
21 rue Jules Alain
72300 Solesmes - France
Tel: 0033 (0)2 42 95 45 10
Fax: 0033 (0)2 43 95 22 26.
Abbaye Saint-Pierre de Solesmes
72300 Solesmes - France
Tel: 0033 (0)2 43 95 03 08
Fax: 0033 (0)2 43 95 03 08
 0033 (0)2 43 95 68 79
Email: hospes@solesmes.com
Website: www.solesmes.com

Ligugé
ABBAYE SAINT-MARTIN
Bénédictine Monks

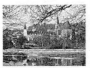

A legendary abbey and the oldest Western monastic community, it was founded by Martin in 361 AD. Saint-Martin was a soldier. When he left the Roman army, he joined with his friend Saint-Hilaire, Bishop of Poitiers. Living as a hermit in an abandoned Roman villa, Martin was soon surrounded by many disciples. This led him to establish the first monastic community. Later elected Bishop of Tours, he is considered the "Gallic apostle" who converted the French to the new religion.

The monastery attracted many pilgrims and devotees of the saint but was abandoned and destroyed during the difficult years of the barbarian invasions. Thanks to the restoration by Aumode, Countesse of Provence, the monks returned in 1003. The monastery flourished over the ensuing centuries. In 1793, as result of the French Revolution, all the buildings were sold as national patrimony. In 1853 the monks from Solesmes restored the monastic life which continued until 1903 when the monks were once again exiled. They returned in 1923.

The complex is a few km from Poitiers, in the heart of a picturesque village and valley (Valléè du Clain). Thanks to the crenelations of its tower and imposing size, it can be seen from miles away. Much of the architecture is Flamboyant Gothic having been rebuilt by the Prior Geoffrey d'Etissac at the beginning of the 16th century.

The interior of the church preserves stained glass windows representing Martin as a soldier sharing his cloak with the poor. In 1953 an exceptional series of Roman and pre-Roman edifices were discovered in front and underneath the nave of the church: a Gallic-Roman villa, a primitive basilica, a votive sanctuary, a fourth century church, a crypt and a second basilica of the 7th century.

The church of the monastery was built in 1928 and has been enriched by a series of contemporary stained glass windows created by a collaboration of the painter Pierre Lafoucrière and the Atelier du Vitrail of Limoges.

The monks are famous enamelists. The shops of the monastery have a vast selection of books and monastic products, as well as CDs and cassettes of Gregorian chant.

Accommodations
The monastery offers hospitality only for spiritual retreats. There are three possibilities.
1) Men can be hosted in 10 single rooms inside the secluded area of the monastery. They can share meals with the monks. Baths are shared.

2) Women and couples are hosted in 9 rooms with shared baths. Meals cannot be shared with the monks. There is a kitchenette that guests may use.

3) Mixed groups are hosted in a guest house 500 m from the monastery. There are about 40 beds in 12 rooms with shared baths. Meals are offered with the lodging.

Cost per person/per night
About 30€ per person, full board.

Special rules
Minimum stay two days, maximum stay one week. Generally closed the first two weeks of November.

Contact
Frère Hôtelier
Abbaye Saint-Martin
2, place A. Lambert
86240 Ligugé - France
Tel: 0033 (0)5 49 55 21 12
Fax: 0033 (0)5 49 55 10 98
Email: accueil@abbaye-liguge.com
Website: www.abbaye-liguge.com

Migné-Auxances
CARMÉL
Carmélite Nuns

Accommodations
The monastery offers hospitality to women for individual spiritual retreats in solitude. Maximum stay one week. Closed at Easter and Christmas.

Contact
Sœur Hôtelière
Carmél
39, rue de Quereux
86440 Migné-Auxances - France
Tel: 0033 (0)5 49 51 71 32
Fax: 0033 (0)5 49 54 48 86

Saint-Benoit (Poitiers)
ABBAYE SAINTE-CROIX
Bénédictine Nuns

Accommodations
The monastery offers hospitality for individual or group retreats. It is necessary to speak French.

Contact
Sœur Hôtelière
Abbaye Sainte-Croix
86280 Saint-Benoit - France
Tel: 0033 (0)5 49 88 67 04 (hôtellerie direct)
0033 (0)5 49 88 57 33 (abbey)
Fax: 0033 (0)5 49 88 91 20

Arles
PRIEURÉ NOTRE-DAME-DES-CHAMPS
Bénédictine Friars

Accommodations
The monastery offers hospitality for individual spiritual retreats.

Contact
Frère Hôtelier
Prieuré Notre-Dame-des-Champs
Bouchaud
13200 Arles - France
Tel: 0033 (0)4 90 97 00 55
Fax: 0033 (0)4 90 97 00 74

Blauvac
ABBAYE NOTRE-DAME DE BON SECOURS "LA TRAPPE"
Cistercian-Trappist Nuns

Accommodations
The monastery offers hospitality year-round to individuals and groups for spiritual retreats.

Contact
Send a letter, fax or email to the Sœur Hôtelière
Abbaye Notre-Dame de Bon Secours "La Trappe"
84570 Blauvac - France
Tel: 0033 (0)4 90 61 81 17
Fax: 0033 (0)4 90 61 98 07
Email: blauvac.economat@wanadoo.fr

Carros
CARMÉL
Carmélite Sisters

Accommodations
The monastery has 7 rooms available for men and women for spiritual retreats. Maximum stay 1 week.

Contact
Send a letter or fax to the Sœur Hôtelière or Mère Prieuré
Carmél
06510 Carros-Village - France
Tel: 0033 (0)4 93 29 10 71
Fax: 0033 (0)4 93 29 39 37

Castagniers
ABBAYE NOTRE-DAME DE LA PAIX
Cistercian Nuns

Accommodations
The monastery offers hospitality to men and women (no children) for individual spiritual retreats.

Contact
Send a fax, letter or email to the Sœur Hôtelière
Abbaye Notre-Dame de la Paix
271, route de Saint-Blaise
06670 Castagniers - France
Tel: 0033 (0)4 93 08 05 12
Fax: 0033 (0)4 93 08 35 18
Email: abbayedecastagniers@wanadoo.fr
Website: www.castagniers.net

Ganagobie
ABBAYE NOTRE-DAME DE GANAGOBIE
Bénédictine Monks

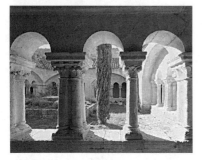

The complex is in Haute-Provence in a magnificent position on the plateau of Ganagobie with a superb view dominating the valley of the river Durance and the hills of Lauzon. The abbey is encom-

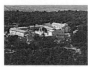

passed by the *garrigues*, typical Mediterranean flora of southern France.

The Romanesque monastery is considered one of the most imposing of the entire region. Its story began in 950 when the newly founded monastery was annexed to the congregation of Cluny.

Its apogee was reached between the 11th and 12th centuries. Due to the donations of the Counts of Forcalquier, it was enlarged and enriched with a beautiful church and cloister. In 1791 the buildings were sold and in 1794 the choir and the transept of the church were demolished.

In 1891 the Count of Malijay donated the property to the Bénédictine Monks of Sainte-Madeleine. In 1922 it was occupied by a handful of monks coming from the Abbey of Hautecombe. In 1992 the entire community of Hautecombe took up residence.

The church is an elegant part of the complex and showcases a 12th century portal embellished by five richly decorated vaults, The interior reflects the typical shape of the Romanesque churches of Provence: one nave divided into three bays and a double transept opening on three apses. The apses

were rebuilt in late 19th century, At that time 12th century mosaics were found below the floor including three large masterpieces made of minuscule stones using only three colors: black, white and red. They represent the typical characters of that age: knights, monsters, centaurs and dragons.

The monks produce honey, jam and many beauty products that are sold in a shop on the premises.

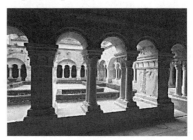

Accommodations

The monastery offers hospitality only for individual spiritual retreats. Both men and women are welcome in about 15 rooms with shared baths. Groups of young guests can be hosted outside the abbey in a guest house with 20 beds in dorms.

Amenities

Towels and linens can be supplied on request.

Meals

All meals can be provided to the guests staying inside the abbey but only men can share their meals with the monks. Women use a separate dining room. Young guests must prepare their own meals in a kitchen at their disposal.

Special rules

Minimum stay 2 days; maximum stay 1 week.

Cost per person/per night

About 30€ full board as a basic contribution. The rest is voluntary.

Contact

Send a letter or fax to the Père Hôtelier (long in advance)
Abbaye Notre-Dame de Ganagobie
04310 Ganagobie - France
Tel: 0033 (0)4 92 68 12 10 (Père hôtelier direct) 0033 (0)4 92 68 00 04
Fax: 0033 (0)4 92 68 11 49
Email: courier@ndganagobie.com
Website: www.ndganagobie.com

Gordes
ABBAYE NOTRE-DAME DE SÉNANQUE
Cistercian Monks

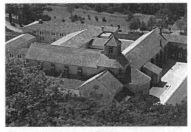

The ancient Cistercian complex is nestled in a niche at the bottom of a deep valley formed by the river Senancole. At the end of June and the beginning of July, the abbey is engulfed in lavender fields. Senanque is one of three notable Cistercian abbeys of Provence (along with Silvacane and Thoronet) and is considered the most fascinating. Its name derives from the Celtic Sagn-anc – swampy gorge. The Cistercian monks, considered experts in hydraulic engineering, drained the soil, canalized the water and built the abbey.

After its foundation, the abbey prospered until the 14th century and possessed farms, lands and water mills. During the religious wars of the 16th century, the abbey was partly destroyed by fire. In 1791 it was sold as required by the revolutionary laws, but was purchased by Alex de Louze, who preserved it and later sold it to the Cistercian community of Lerins.

The complex can only be visited with a guided tour. The Romanesque section that includes the abbey church, cloister, dormitory, chapterhouse and calefactory

is open to visitors, The tour begins with the monks' dormitory. In order to adapt the abbey to the liturgy of the monks, the dormitory was built as a continuation of the transept of the church. It is about 30 m long and at one time could lodge about 30 monks who slept fully clothed on straw beds. The dormitory is covered by broken-cradle vaulting and divided into three unequal parts by two double arches.

The church is a unique example of primitive Cistercian architecture and is in the shape of the cross. There are two Romanesque chapels once used for private masses. The dome is very simple and enhances the overall sense of purity. The simplicity of the design is a hallmark of the Cistercian ideology. Only light, a symbol of God, may modify the space.

Accommodations
The monastery offers hospitality to men and women for spiritual retreats. Maximum stay is 8 days. Minimum contribution to expenses is about 25€. Closed in January.

Contact
Frère Hôtelier (Send a fax or email to the Frère Hôtelier)
84220 Gordes - France
Tel: 0033 (0)4 90 72 02 05 (Frère hôtelier direct)
0033 (0)4 90 72 05 72 (Abbey)
Fax: 0033 (0)4 90 72 17 95 (Frère Hôtelier)
0033 (0)4 90 72 15 70 (abbey)
Email:
frere.hotelier.senanque.fr
Website: www.senanque.fr

Ile Saint-Honorat
ABBAYE NOTRE-DAME DE LÉRINS
Cistercian Monks

The Iles de Lèrins are two beautiful islands situated a short distance from Cannes and comprise a peaceful green oasis. Sainte-Marguerite is the largest with 210 hectares. Saint-Honorat is blanketed by a forest of pine and oak trees. The production and sale of wine is one of the activities of the monks.

The story of the abbey begins between 400-410 when Saint-Honorat (a noble Gallic-Roman who converted to the Christian faith), founded a Cenobite community with some companions. In the beginning the monks obeyed the rules of the Four Fathers but in the 7th century they joined the Bénédictine Order.

One of the characteristics of Lèrins is the presence of seven chapels scattered around the island. These were built in the Middle Ages as the stations of a popular pilgrimage that took place between Ascension and Pentecost. Today only four are accessible to the public. The most famous is Chapelle de la Trinité. The buildings date to the 9th or 10th century. It is also possible to visit Saint-Saveur. During the summer the monks organize guided tours.

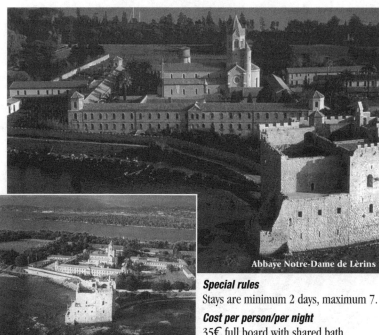

Abbaye Notre-Dame de Lèrins

Accommodations

The monastery offers hospitality to men and women but only for individual spiritual retreats. Guests are requested to participate in the daily liturgy.

There are about 40 beds in single and double rooms. Only a few have private baths (priority is given to the elderly or disabled).

Amenities

Towels and linens are supplied on request.

Meals

All meals are provided and shared in silence in the presence of one of the monks, the other monks dine separately.

Special rules

Stays are minimum 2 days, maximum 7.

Cost per person/per night

35€ full board with shared bath.
45€ full board with private bath.

Contact

Reservations must be made at least 2 months in advance. Send a letter, fax or email to the Frère Hôtelier (reaching him on the phone can be difficult).
Abbaye Notre-Dame de Lèrins
Ile St Honorat
BP 157 06406
Cannes cedex - France
Tel: 0033 (0)4 92 99 54 00
Fax: 0033 (0)4 92 99 54 01
Email: info@abbayedelerins.com

Hôtellerie direct
Tel: 0033 (0)4 92 99 54 20
Fax: 0033 (0)4 92 99 54 21
Email: hotellerie@abbayedelerins.com
Website: www.abbayedelerins.com

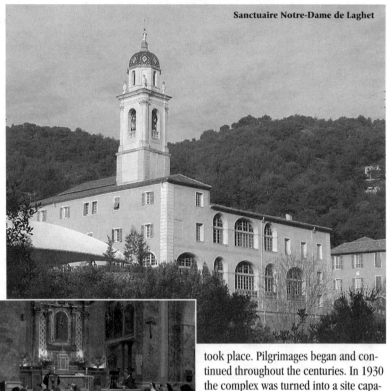

Sanctuaire Notre-Dame de Laghet

La Trinité
SANCTUAIRE NOTRE-DAME DE LAGHET
Bénédictine Nuns of Montmartre

The shrine is in a verdant locale over-looking a valley behind Nice. The story of the shrine began in 1652 when the vicar of Eze, Don Jacques Fighiera, decided to restore a rural chapel at his own expense. According to legend, shortly afterwards, numerous miracles took place. Pilgrimages began and con-tinued throughout the centuries. In 1930 the complex was turned into a site capa-ble of hosting pilgrims. In 1978 the Bénédictine Nuns of Montmartre took over management of the guest house and shrine. Every day they chant the Messe.

The complex is composed of the 17th century sanctuary and the chapel. The chapel boasts remarkable Baroque deco-rations and contains the wooden poly-chrome statue of the Virgin Mary. Over the past 350 years pilgrims have left a unique collection of 4000 ex-voto. About 800 have been classified as historical monuments and are displayed on the walls of the cloister and in the museum.

Accommodations
About 50 beds in single, double and family rooms with shared bath.

Amenities
Towels and linens are supplied.

Meals
All meals can be supplied by the restaurant.

Special rules
Guests are required to participate in mass. Maximum stay 3 weeks. Advance payment is required.

Contact
Sœur Hôtelière
Sanctuaire Notre-Dame de Laghet
06340 La Trinité - France
Tel: 0033 (0)4 92 42 50 50
Fax: 0033 (0)4 92 41 50 59
Email: sanctuairelaghet@free.fr
Website: http://nice.cef.fr/laghet

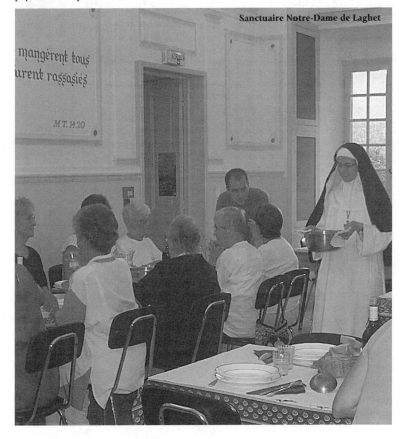
Sanctuaire Notre-Dame de Laghet

Nice
MONASTÈRE SAINTE-CLAIRE
Clarice Nuns

Accommodations
The monastery offers hospitality only to women for spiritual retreats.

Contact
Write well in advance to the Sœur Hôtelière
Monastère Sainte-Claire
30, avenue Sainte-Colette
06100 Nice - France
Tel: 0033 (0)4 93 81 04 72
Fax: 0033 (0)4 93 81 34 88

Rosans
ABBAYE NOTRE-DAME DE MISÉRICORDE
Bénédictine Nuns

Accommodations
The monastery offers hospitality only to those seeking a spiritual retreat.

Contact
Responsable pour l'hospitalité
Abbaye Notre-Dame de Miséricorde
05150 Rosans - France
Tel: 0033 (0)4 92 66 70 00
Fax: 0033 (0)4 92 66 70 02

Saint-Maximin-La-Sainte-Baume
MONASTÈRE SAINTE-MARIE-MADELEINE
Dominican Nuns

Accommodations
The monastery offers hospitality for spiritual retreats or simply to pray with the nuns.

Contact
Send a letter or fax to the Sœur Hôtelière
Monastère Sainte-Marie-Madeleine
route de Barjols
83470 Saint-Maximin-La-Sainte-Baume - France
Tel: 0033 (0)4 94 78 04 71
Fax: 0033 (0)4 94 59 77 89

Simiane-Collongue
ABBAYE DE SAINTE-LIOBA
Bénédictine Sisters
&
MONASTÈRE SAINT-GERMAIN
Bénédictine Monks

Accommodations
The monasteries offer hospitality for spiritual retreats or to those wishing to share the silence and prayers of the community. There are weekends when retreats are organized. Consult the website for further information. Closed in January. Maximum stay 10 days.

Contact - Abbaye de Sainte-Lioba
Call or send a fax to the Sœur Hôtelière
530, Chemin de Merentiers
Quartier Saint-Germain
13109 Simiane-Collongue - France
Tel: 0033 (0)4 42 22 60 60
Fax: 0033 (0)4 42 22 79 50
Email: benedictins@lioba.com
Website: www.lioba.com

Contact - Monastère Saint-Germain
Call or send a fax to the Sœur Hôtelière
530, Chemin de Merentiers
Quartier Saint-Germain
13109 Simiane-Collongue - France
Tel: 0033 (0)4 42 22 60 60
Fax: 0033 (0)4 42 22 79 50
Email: benedictins@lioba.com
Website: www.lioba.com

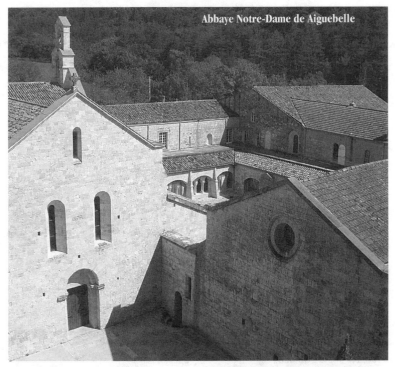

Abbaye Notre-Dame de Aiguebelle

Aiguebelle
ABBAYE NOTRE-DAME DE AIGUEBELLE
Cistercian Trappist Monks

As typical of most Cistercian institutions, this ancient abbey is nestled in an isolated valley and irrigated by three streams, hence the name "aigues-belle," beautiful waters. The abbey is near Grignan, a small town on the border of Provence. The peaceful, isolated spot invites meditation and prayer.

Aiguebelle was chosen by a group of Cistercian monks coming from Morimond Champagne in 1137. Over the ensuing centuries, the abbey was remarkably wealthy but the Hundred Year War and the plague brought the abbey to decline. In 1562 the complex was nearly destroyed by the Huguenots. In 1815 a group of Swiss monks bought the institution and the religious life recommenced. In 1850 neo-Romanesque edifices were built to replace and complete the 12th century buildings.

The 12th century abbey church is very sober with a few windows, thick walls and a vaulted roof. The façade has been recently restored. The cloister has been almost completely restored, only the side attached to the church is original. The masterpiece of Aiguebelle is its refectory.

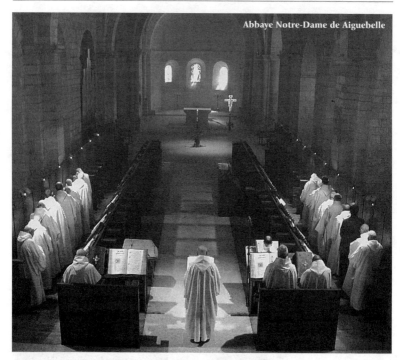
Abbaye Notre-Dame de Aiguebelle

Products of the institution
The monks are famous for their ability with herbs. They prepare Alexion, a non-alcoholic drink made with 52 herbs, essential oils and lavender essence. Products are for sale at the shop of the monastery.

Accommodations
The monastery offers hospitality to men and women but only for individual spiritual retreats. There are 25 beds available year-round; baths are shared.

Amenities
Towels and linens are supplied.

Meals
All meals are supplied with the lodging and are shared partly in silence with the monks.

Special rules
Curfew at 9.00 PM.

Cost per person/per night
Voluntary with a basic contribution to cover the expenses.

Contact
Frère Hôtelier
Abbaye Notre-Dame de Aiguebelle
26230 Montjoyer - France
Tel: 0033 (0)4 75 98 64 72 (frère hôtelier direct)
0033 (0)4 75 98 64 70 (abbey)
Fax: 0033 (0)4 75 98 64 71
Email: com.aiguebelle@wanadoo.fr
Website: www.abbaye-aiguebelle.com

Belmont-Tramonet
ABBAYE SAINT-JOSEPH-DE-LA-ROCHETTE
Bénédictine Nuns

Accommodations
The monastery offers hospitality to individuals or organized groups for spiritual retreats.

Contact
Send a letter, fax or email to the Sœur Hôtelière
Abbaye Saint-Joseph-de-la-Rochette
F73330 Belmont-Tramonet - France
Tel: 0033 (0)4 76 37 05 10
Fax: 0033 (0)4 76 37 06 41
Email: larochettemambre@wanadoo.fr

Chatillon-Saint-Jean
ABBAYE NOTRE-DAME DE TRIORS
Bénédictine Monks

Accommodations
The monastery offers hospitality to men in a guest house inside the abbey and to women and families in a guest house outside the monastery. Guests must take part in the liturgy and must speak French.

Contact
Send a letter or fax to the Père Hôtelier
Abbaye Notre-Dame de Triors
BP 1
26750 Chatillon-Saint-Jean - France
Tel: 0033 (0)4 75 71 43 39
Fax: 0033 (0)4 75 45 28 14

Grignan
PRIEURÉ DE L'EMMANUEL
Dominican Sisters of
Sainte-Marie-de-Tourelles

Accommodations
The monastery offers hospitality for spiritual retreats or for a time of meditation. Closed from September 15th until October 15th.

Contact
Send a letter or fax to
Prieuré de l'Emmanuel
26230 Grignan - France
Tel: 0033 (0)4 75 46 50 37
Fax: 0033 (0)4 75 46 53 49

Le Plantay
ABBAYE NOTRE-DAME-DES-DOMBES
Community of Chemin Neuf

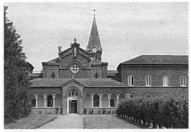

Accommodations
The monastery offers hospitality for a time of spiritual retreat and prayer.

Contact
Send a letter, fax or email
to the Sœur Hôtelière
Abbaye Notre-Dame-des-Dombes
01330 Le Plantay - France
Tel: 0033 (0)4 74 98 14 40
Fax: 0033 (0)4 74 98 16 70
Email: nddombes@chemin-neuf.org
Website: www.chemin.neuf.org

Plancherine
ABBAYE NOTRE-DAME DE TAMIÉ
Cistercian Monks

Accommmodations
Hospitality is offered for individual spiritual retreats. Maximum stay 1 week.

Contact
Send a letter, fax or email to
the Frère Hôtelier
Abbaye Notre-Dame de Tamié
73200 Plancherine - France
Tel: 0033 (0)4 79 31 15 53 (hôtellerie)
0033 (0)4 79 31 15 50 (abbey)
Fax: 0033 (0)4 79 31 19 46 (hôtellerie)
0033 (0)4 79 37 05 24 (abbey)
Email: fr.hotelier@wanadoo.fr
Website: www.abbaye-tamie.com

Pradines
ABBAYE SAINT-JOSEPH ET SAINT-PIERRE-DE-PRADINES
Bénédictine Nuns

Accommodations
The nuns offer hospitality only for spiritual retreats to individual and groups (adults only).

Contact
Send a letter or fax to the
Sœur Hôtelière
Abbaye Saint-Joseph et
Saint-Pierre-de-Pradines
42630 Pradines - France

Tel: 0033 (0)4 77 64 80 06
Fax: 0033 (0)4 77 64 82 08

Saint-Bernard-du-Touvet
MONASTÈRE NOTRE-DAME DES PETITES ROCHES
Bernardine Cistercian Nuns
The monastery is in a beautiful position on the plateau of the "little rocks" at an altitude of 3,000'. Behind the monastery is the Chartreuse Massif; opposite, the Belledonne chain of mountains; below, the Isère Valley. "It is an extremely pretty site," said the Sœur Hôtelière. "The monastery is open to all for a spiritual stay. "Guests appreciate the calm and peaceful atmosphere of the monastery. Each guest can contribute to this by their own peaceful, silent presence." Guests are invited to participate in the liturgy.

Accommodations
20 double rooms with 40 beds and shared baths; 3 dormitories (10 beds in each) with shared bath.

Special rules
Maximum stay is 15 days. Punctuality at meals is required.

Cost per person/per night
30€ full pension.

Contact
Write to the Sœur Hôtelière
Monastère Notre-Dame des
Petites Roches
38660, St. Bernard Du Touvet - France
Tel: 0033 (0)4 76 08 31 13
Fax: 0033 (0)4 76 08 32 17
Email: cte.petitesroches@wanadoo.fr
Website:
www.bernardine.org/touvetf.html

Saint-Laurent-du-Pont
MONASTÈRE DEL'ASSOMPTION NOTRE-DAME
Bethléem Monks of the Assumption of the Virgin and Saint-Bruno

Accommodations
Guests are hosted in cells, groups are not accepted. It is possible to be assisted by one of the monks. Men only, minimum stay 48 hrs, maximum stay 1 week. There are periods of the year when the monastery is closed to guests.

Contact
Send a letter or fax to the Frère Hôtelier
Monastère de l'Assomption Notre-Dame
Curriere-en-Chartreuse
38380 Saint-Laurent-du-Pont - France
Tel: 0033 (0)4 76 55 14 97
Fax: 0033 (0)4 76 55 48 56

Saint-Laurent-les-Bains
ABBAYE NOTRE-DAME-DES-NEIGES
Cistercian Monks

Accommodations
The monastery offers hospitality for spiritual retreats. Closed in January.

Contact
Write or call the Père Hôtelier
Abbaye Notre-Dame-des-Neiges
07590 Saint-Laurent-les-Bains - France
Tel: 0033 (0)4 66 46 59 00 (abbaye)
0033 (0)4 66 46 59 13 (Père Hôtelier direct)
Fax: 0033 (0)4 66 46 59 10
Email: neiges.comm.@hotmail.com

Saint-Rambert-en-Bugey
ABBAYE SAINT-RAMBERT-EN-BUGEY
Bénédictine Nuns

Accommodations
The abbey organizes spiritual retreats but guests are also welcome to pray with the nuns or be in solitude.

Contact
Sœur Hôtelière
Abbaye Saint-Rambert-en-Bugey
L'Abbaye
01230 Saint-Rambert-en-Bugey - France
Tel: 0033 (0)4 74 36 31 99
Fax: 0033 (0)4 74 36 27 20
Email: rndmabbaye@wanadoo.fr

Roybon
ABBAYE NOTRE-DAME DE CHAMBARAND
Cistercian Nuns

Accommodations
The monastery offers hospitality for personal spiritual retreats. Closed in January.

Contact
Call (don't send a fax) the Sœur Hôtelière
Abbaye Notre-Dame de Chambarand
38940 Roybon - France
Tel: 0033 (0)4 76 36 22 68
Fax: 0033 (0)4 76 36 28 65
Email: fromagerie@chambarand.com
Website: www.chambarand.com

Voiron
MONASTÈRE DE LA VISITATION
Visitandine Nuns

Accommodations
The monastery offers hospitality for spiritual retreats. Women can be hosted inside the secluded area. They must respect the silence.

Contact
Send a letter to the Sœur Hôtelière
Monastère de la Visitation
Notre-Dame-du-May
38500 Voiron - France
Tel: 0033 (0)4 76 05 26 29

Croisy-Sur-Eure
MONASTÈRE SAINT-PAUL DE LA CROIX
Passinist Sisters

Accommodations

The monastery offers hospitality to men and women but only for spiritual retreats in a guest house separate from the monastery. There are five rooms including one double.

Contact

Sœur Hôtelière (prefers contact by phone)
Monastère Saint-Paul de la Croix
19-21, route de Vaux
27120 Croisy-Sur-Eure - France
Tel: 0033 (0)2 32 36 16 63
Fax: 0033 (0)2 32 36 82 23

Le Bec-Hellouin
ABBAYE NOTRE-DAME DU BEC
Bénédictine Olivetan Monks

Founded in 1035 the abbey is one of the most renowned of the entire country. The church was consecrated in 1077. Many important figures of the Catholic Church resided here. The abbey flourished during the Middle Ages but was devastated by the Hundred Year War and the religious conflicts of the 16th century, During the French Revolution it was turned into a barracks and the church was sold as stone quarry and almost completely dismantled (some parts are still visible).

The complex is comprised of several buildings of great artistic value. A national monument, it can be visited, with the exception of the secluded section where the monks live. The Tower of Saint-Nicholas was originally built as an extension of the church. The cloister dates to the 17th century, the monastery to the 18th. The monks produce and sell ceramics, candles, books, icons and CDs with religious chants.

Accommodations

Men, women and groups are welcome for individual spiritual retreats. Men are admitted inside the monastery and can share meals with the monks.

Contact

Pere Hôtelier
Abbaye Notre-Dame du Bec
27800 Le Bec-Hellouin - France
Tel: 0033 (0)2 32 43 72 60
Fax: 0033 (0)2 32 44 96 69
Email: hotellerie@abbayedubec.com
Website: www.abbayedubec.com

Le-Bec-Hellouin
MONASTÈRE SAINTE-FRANÇOISE-ROMAINE
Benedectine Olivetan Nuns

Accommodations

The monastery has 25 beds available to those seeking a spiritual retreat. Closed in January.

Contact

Sœur Hôtelière
Monastère Sainte-Françoise-Romaine
27800 Le Bec-Hellouin - France
Tel: 0033 (0)2 32 44 81 18
Fax: 0033 (0)2 32 45 90 53
Email: bec.stefrancoise@wanadoo

Saint-Wandrille
ABBAYE SAINT-WANDRILLE DE FONTENELLE
Bénédictine Monks

The abbey is a beautiful complex founded in 649 by Saint-Wandrille. Over the centuries, the monastery was home to thirty monks who became saints of the church. The large complex offers many interesting architectural highlights including the small church of Saint-Saturnine (10-11th century), the ruins of an ancient church, a cloister, refectory (one of the oldest still in use) and many 17th century buildings which form the present monastery.

Accommodations
The monastery offers hospitality only for spiritual retreats. There are two guest houses. The hôtellerie inside the secluded monastery is open only to men (14 beds). The external guest house is open to women, couples and mixed groups (25 beds). Closed during the monks' spiritual retreat (times vary).

Meals
All meals are supplied.

Contact
Père Hôtelier
Abbaye Saint-Wandrille de Fontenelle
76490 Saint-Wandrille - France
Tel: 0033 (0)2 35 96 23 11
Fax: 0033 (0)2 35 96 49 08
Email - Internal guest house (men only):
hotellerie@st-wandrille.com
Email - External guest house:
st.joseph@st-wandrille.com
Website: www.st-wandrille.com

Valmont
ABBAYE NOTRE-DAME DU PRÉ
Bénédictine Nuns

Accommodations
The monastery has about 25 beds available to men and women seeking spiritual retreat or spiritual research. Closed in November.

Contact
Sœur Hôtelière
Abbaye Notre-Dame du Pré
12, Raoul Auvray
76540 Valmont - France
Tel: 0033 (0)2 35 27 34 92
Fax: 0033 (0)2 35 27 86 21

"Your book, *Lodging in Italy's Monasteries*, has been a great help in planning visits to Italy; the Casa was delightful and a wonderful base for visiting the city and the region."

◊

"...let me thank you for your wonderful resource book, *Lodging in Italy's Monasteries*. We stayed in Rome and had a great experience. And we are planning to stay at another in Spiazzi, Italy, this summer. Your book is invaluable to us. Again, thank you for your great resource guide."

◊

"I love your book! Thank you very much for writing it. We used it to stay at 3 places ...outside Naples at a monastery and a convent in Orvieto and a convent in Miramare. They were all very different and interesting. They saved us a lot of money, had meals available to us and friendly people staying there. The religious people were wonderful to us. We had a great time. Thank you."

◊

"Wanted to let you know that 13 of us stayed at the monastery in Orvieto for 2 nights. We really enjoyed it, the rooms are clean, the nuns are very nice and although they do not speak a word of English, we had no problem with our limited Italian. The location of this convent is fabulous, sitting right on the Piazza del Popola in gorgeous Orvieto, one of Italy's most lovely hilltowns. Highly recommended. Thank you for a great book."

◊

"My wife Anne and I have just returned from a two week trip to Spain. We stayed in 6 of the monasteries that you described in your wonderful book. I do not think that we could have had a nicer holiday! We are already planning our trip for next year and will stay in monasteries again."

◊

"I bought your books last year and used them on my month long trip to Italy and Spain. Wonderful resource. Fantastic adventure. Spiritual experience."

◊

"Let me first say that I have found your book tremendously helpful. I am planning a trip to Italy in late September and early October of this year for myself and two friends. We are going to be staying in four religious houses; in Rome, on the Island of Capri and in Siena. Three of these institutions I found recommended in your book. Thanks to your book, we are going to be able to spend an average of $27.50 (US) per night per person and see much more of Italy than had originally planned. Once I learned the intricacies of faxing to Italy (it is rather simple once you learn to put all the numbers in), I was able to make inquiries, reservations and confirm reservations easily even though my Italian is rudimentary at best. Your reservation form letter was quite useful."

◊

"Just wanted to say that your book has been a wonderful help. We leave for Spain in a few days and all the lodging is set up. I'm really excited to see the monasteries and experience a part of Spain that's not in other guidebooks."

◊

"We have been using your book extensively. Through the information in your book, we have accommodations in Rome, Naples and hopefully Florence."

◊

"I bought your book and with friends made a trip to Rome earlier in the year. We stayed at Casa Santa Francesca Romana in Rome for seven nights. It was exactly as you described in the book. We were pleased with the accommodations and the casa personnel were most helpful in making reservations, travel tips while there, etc. Prices were actually lower than you listed due to the current exchange rates. We followed directions from the Rome airport and arrived at the casa without any assistance. I have passed the book on to friends who will be staying there in December and I plan to return next year. Thanks for publishing such a helpful book!"

◊

"I have a copy of your *Guide to Lodging in Spain's Monasteries*. I am fascinated by the affordability of accommodations!!! We are hoping to travel abroad soon and this would be a great way not only to save money and have superb rooms, but also enjoy history and local hospitality. Thank you!

"PS: A friend and her husband used your book on Italy and stayed in a convent in Rome. They simply raved about the accommodations and hospitality received, not to mention the low cost which allowed them to really enjoy their visit and the local atmosphere of the city."

◊

"Dear Ms Barish, it has been 5 years since we shepherded 19 young people through Italy and we talk of the trip as if we had just returned. We are indeed planning to visit again. It seemed that each day on the road was a new adventure and that each adventure was pleasant and a lot of fun. A great part of the excitement came from the warm welcome and incredible accommodations of the monasteries that we visited. We had the privilege of staying in the monasteries in Milan, Siena, Assisi & Naples.

"What added to the experience was the preparation. Your book was so valuable in helping us make our reservations. We thoroughly enjoyed corresponding with each institution prior to our departure. We still receive letters from the convent in Naples.

◊

"We take the book down every once in a while to reminisce and day-dream about another trip. We recommend it to everyone who is interested in visiting Bella Italia. It made the experience even more romantic. Thank you so much for your work"

◊

"I have so enjoyed reviewing your guide to Italian monasteries and convents and found your sample 'reservation form' extremely helpful!"

◊

"Congratulations on creating these wonderful books so valuable to travelers such as us!"

◊

THE GUIDE TO LODGING IN SPAIN'S MONASTERIES Spend a night or a week at a monastery and you'll come away filled with the essence of Spain, its history, culture, art, architecture and local customs. Open to all without religious obligation, lodging at monasteries is a new travel experience based on a centuries-old tradition of hospitality.

You can stay in historic dwellings filled with art treasures. Stroll through charming garden-filled grounds. Admire the ancient architecture. Visit nearby castles, medieval cities, Roman ruins and legendary beach resorts. Explore idyllic islands and Moorish alcázars. Everything you need to plan your trip and reserve your room is included.

"An inside track on the unique lodging, unspoiled towns and villages, folklore and history of Spain that other travel guides overlook. This book is step one to an extraordinary adventure."

THE GUIDE TO

Lodging in Spain's Monasteries

Accommodations in historic buildings in unforgettable settings.

Inexpensive. Most less than $20/day.

Everyone is welcome.

Over 150 extraordinary monasteries, convents and casas in metropolitan cities and walled towns, whitewashed villages and quaint fishing ports.

More than 350 photographs.

Eileen Barish

ABOUT THE AUTHOR

Eileen Barish, Author

Eileen Barish is the
award-winning author
of nine travel guides
including the
*Guide to Lodging
in Spain's Monasteries*
and the
*Guide to Lodging
in Italy's Monasteries*.
She lives in
Santa Barbara, California
with her husband.